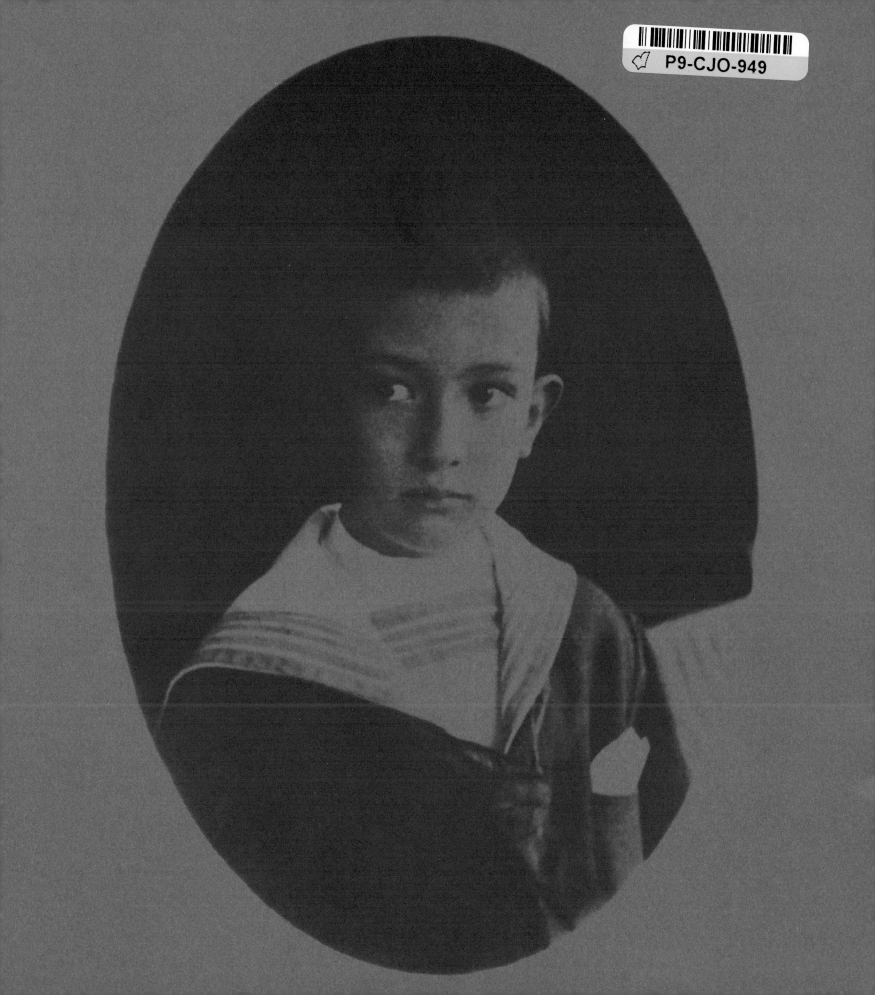

DALI

LUIS ROMERO

DALI

CHARTWELL BOOKS INC.

Translated from Spanish by Norman Coe

Published by Chartwell Books Inc.
A Division of Book Sales Inc.
110 Enterprise Avenue
Secaucus, New Jersey 07094

Spanish-language edition:
"Todo Dalí en un Rostro"
© 1975 by Editorial Blume-Barcelona (Spain)

ISBN 0-89009-229-X
Library of Congress Catalog Card Number: 78-68859

Summary

BY WAY OF PROLOGUE

After his first contact (more or less intense as regards time, depth and extent of acquaintance) with what Dalí has written or said and with what he has conveyed through paintings, drawings and all the other media of expression he has employed, any person really honest with himself may reach the conclusion that it is impossible to place the man within a geometrical frame, to pin him down to reasonably logical limits or to build up any coherent synthesis of his work and personality. And the deeper this person goes into Dalí's world, or worlds, the more this conviction will take root in his mind. For there is something in Dalí that will always escape us. Nor is it strange that this should be so, since we are dealing with the man who, in an allusion to the paranoiac-critical method, declares that with this instrument of criticism —invented by himself— "it will be possible to systematize confusion and help to bring about the total discredit of the world of reality".

In the face of the enormous —not to say insuperable— difficulties involved in explaining Dalí with even a minimum of coherence, one must resign oneself to snatching at any or all of the multiple suggestions and approximations that become so many different ways of penetrating into the painter's personality, labyrinthine and contradictory enough to begin with and still further complicated by Dalí himself —and how cleverly and tenaciously he does it!— in order to hinder anyone's efforts to find the thread that will lead into the sanctuary or sanctuaries he wishes to keep wrapped in the fog of general disorientation or unknowing. Hence the multiplicity of interpretations that exists, and the dumbfoundedness of some of the interpreters when their doubts are resolved by simplifications dictated by the humour of the moment or of the occasion.

Quoting Dalí to explain Dalí cannot be regarded as indisputably conclusive except in some particular cases, and even then only by suppressing all one's reservations. If anybody ever decides to undertake a systematic study of the artist's books, pamphlets, lectures, declarations, articles and manifestos, he will soon find that, though a certain degree of coherence in the whole is undeniable, the sum total of contradictions, obscurities, ambiguities, burlesque interpolations and quite unfounded assertions have plunged his ideas into chaos. And if he attempts to resort to Dalí's own paranoiac-critical method —even supposing that he finds such a method feasible —he will neither reach any definitive conclusion nor even begin to put the confusion to rights.

And the contradictions are not confined to ideas, proposals or interpretations, for sometimes even facts are recorded in his writings in different versions, or at any rate without that exactitude we demand of a narrator who expects to be wholeheartedly believed. It is Dalí himself who has said that the difference between true and false reminiscences is as that between real diamonds and paste: the false stones look better and have a more alluring gleam. And in the case of his spoken declarations each of his questioners will suppose that the truest version of any given fact, circum-

stance or idea is the one he heard from the lips of the painter himself (who should be expected to know, after all).

Nothing excites Dalí so much as the presence of either people or artifacts connected with what are called the communication media; in fact, they excite him so much that they lead him to adopt the most extravagant attitudes. He may be having quite a normal conversation (though the term 'normal' must always be rather elastically interpreted when dealing with Dalí), but no sooner does a photographer appear, or a journalist or anyone with a microphone in his hand, than we see a very brusque transformation scene. He immediately assumes the external attitudes — and the internal, too, I suppose— that belong to the other Dalí, to the role he wants to play before his latest audience, large or small. And the role, of course, has by now been so well learnt, has become so much a part of his personality, that he will play it up to the hilt, word-perfect and without a hitch. Which, then, is the real Dalí? And who can boast that he knows Dalí well enough to interpret him in every action or at every moment?

Not that his relations with the media are always perfect. Whenever he sees fit to do so, he shows a remarkable skill at retiring into his defensive shell. There are plenty of professional interviewers in the world today who have turned their trade into a fine art; and I doubt if anyone could find a better 'interviewee' than Dalí. But if anybody tries to interview him in a hostile spirit, and Dalí does not feel like putting up with

it, his assailant will soon find himself disappointed and will have to finish the interview by himself, with whatever inimical or sarcastic additions he may fancy. For Dalí is well able to protect himself behind a slippery, elastic mesh of words that is practically impenetrable. A past-master of dialectic fencing, and with unexpected resources at his command, he always succeeds in choosing the ground and the weapons that will ensure his triumph.

Two extreme instances of this come to mind as I write. One day a young French intellectual came to interview Dalí for a review which at that time enjoyed enormous prestige and began to ask his questions. I do not remember whether the first of these questions was too cerebral or too complicated, whether Dalí did not like it or did not understand it; at any rate he answered it in Catalan and was proceeding to deal with the second in the same language when the young man exclaimed, in some embarrassment: *Mais, cher maître, je ne comprends pas le catalan!* To which Dalí immediately replied: *Magnifique! Comme ça vous réussirez votre article encore mieux.* And that was the end of that interview. In the twinkling of an eye the defensive shell had become armourplated. The second case occurred more recently, in Paris, and involved two reporters from a worldfamous magazine with a fabulous circulation. I realized at once that Dalí knew them and was not particularly well-disposed towards them. He received them rather coldly and the first thing

8

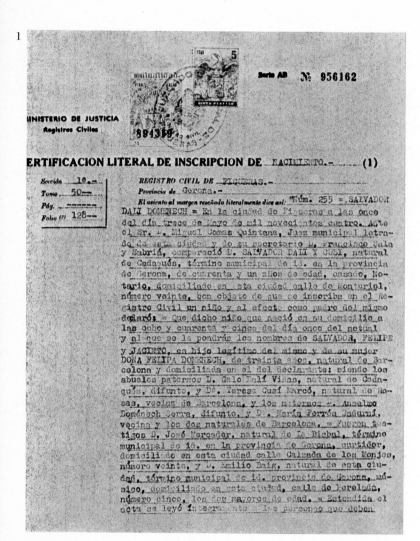

I had myself seen of the behaviour of some of those who manipulate the most powerful mass media when dealing with people they consider their inferiors by virtue of the power they think is theirs.

Dalí needs reporters as he needs the air he breathes, or the countryside around Port Lligat. And the reporters need him. The painter's best-known public image is the one they have been presenting for years. But it is, at best, a partial view —either incomplete or too dazzling.

Now that I have finally succeeded in collecting, after a great deal of toil and not a few disappointments, the material I need in order to write or compound this book, I realize that even when I first undertook the job I was not exactly starting from scratch. For in the course of the work many anecdotes have come back to me, many conversations been remembered, many scenes lived over again; and I have recognized many pictures (now in the form of slides or photographs for reproduction) which I saw being painted over the years or finished and waiting to be packed and, unfortunately for my countrymen, sent abroad.

With very little effort I begin to recall the beginnings of my friendship with Dalí. After the festivities in honour of the patron saint of the village, which were held in September and still had a fairly authentic, unforced air, with greasy poles, swimming competitions and, above all, the rowing and sailing regattas among the fishermen, Cadaqués used to be emptied of its tourists and summer visitors. Once the summer was over not many people came to visit Dalí, and it was at this time of the year that he was able to work best and hardest, until November would arrive and he would be off again to France, on his way to America. During those early autumn days we used to have long conversations on all kinds of subjects

he did was to demand twenty-five thousand dollars before he would let them take a single photograph. They objected that this was an enormous sum, though not daring to call it preposterous. "All right, then, fifty thousand dollars or no photograph." The reporters tried to reason with him, but in vain. Finally, he showed them out with the same lack of warmth with which they had been received, with the addition of some crudely ironic comments. I had not found it an amusing scene and would have been ashamed of my friend's behaviour if I had not remembered what

1. Salvador Dalí was born in Figueras, in the province of Gerona, at 8.45 a.m. on 11 May 1904.
2. Family photograph; with the future painter are his mother, doña Felipa Domènech Ferrés (native of Barcelona), his sister Anna Maria, and his father, don Salvador Dalí y Cusí (native of Cadaqués).

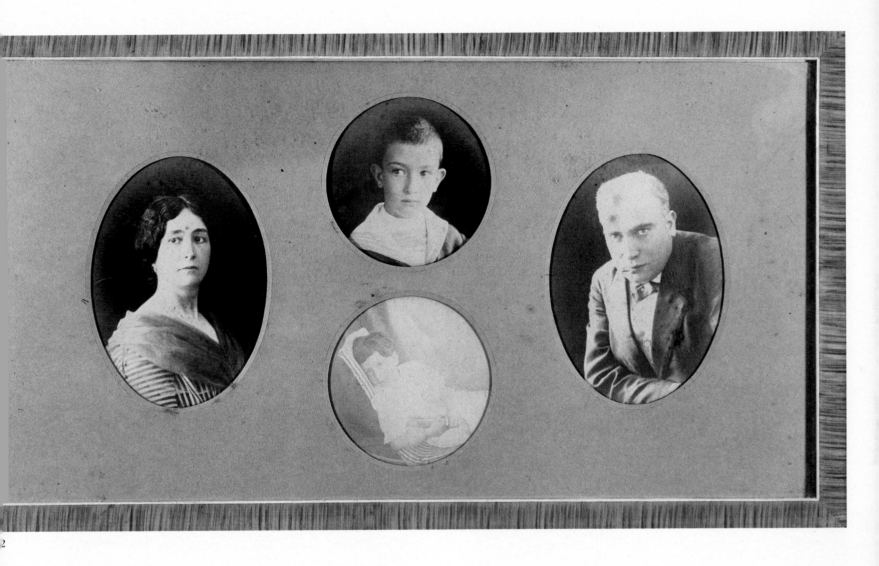

and he would show me the big canvas he had been working on during the summer and was now giving its final touches. He was not in a hurry; the afternoons were short, for now the dusk came earlier and he would go on working in his studio by artificial light.

If I visited him in the morning I rowed round the point, but more often than not I went on foot, after nightfall, along the track that leads from Cadaqués up to the cemetery and then down to Port Lligat and Dalí's house at the water's edge. Usually the north wind was blowing, and the cold

grew sharper after sunset; and some nights it was raining. But there were also nights of true autumnal splendour, with moonlight flooding the dry-stone walls, the olive trees, the whitewashed wall of the cemetery and the little hermitage of Saint Baldiri. I hardly ever met a living soul on the road, and Dalí once asked me if I was not afraid to pass the cemetery on my way home. I don't think I was ever afraid, precisely, but I remember that on the evening of one of my visits to him an old woman I knew had just been buried, and as I passed the cemetery on my way back

3

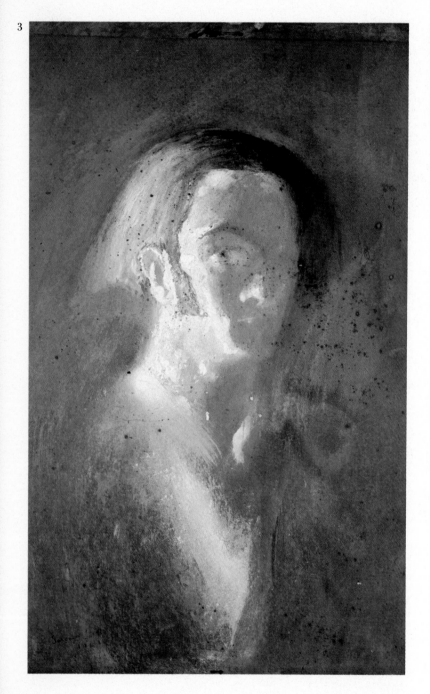

4

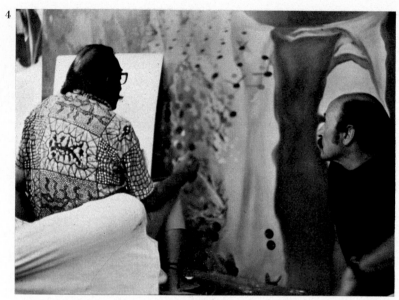

5

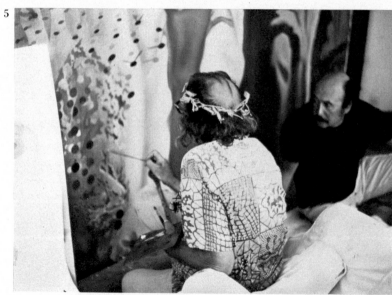

3. *Self-portrait*, 1921; oil on panel, 47.5×37 cms; Dalí Museum-Theatre, Figueras.

4 and 5. Dalí in his studio in Cadaqués working on the *Hallucinogenous Bullfighter* in the presence of the present author. Photograph by Enric Sabater. Especially for the photograph, the painter has placed on his head a crown of laurel silvered with metallic paint.

6. *Self-portrait with Raphael's Neck*, 1922-1923; oil on canvas, 54×57 cms; private collection.

6

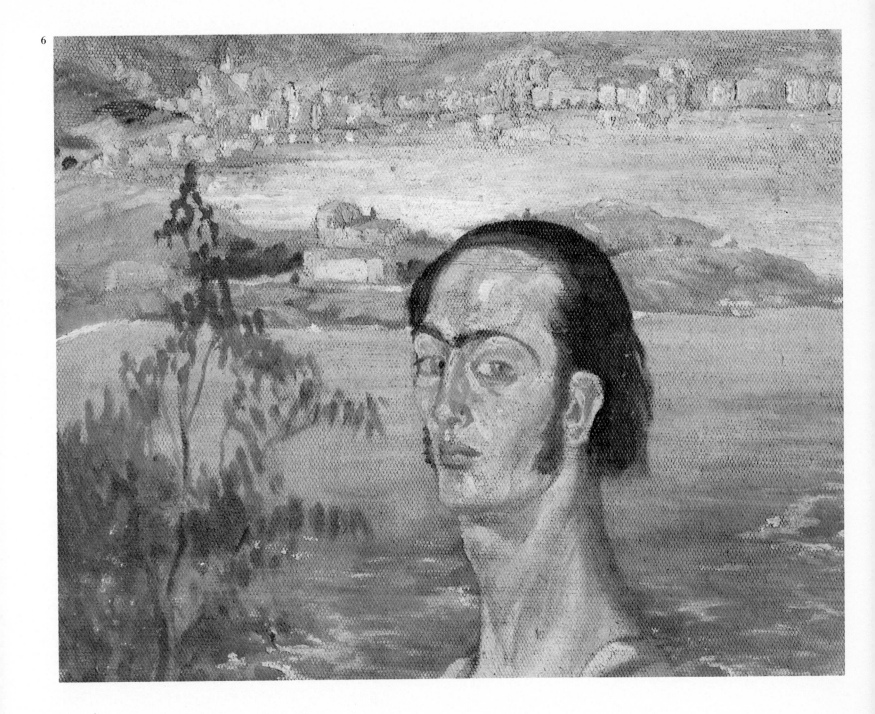

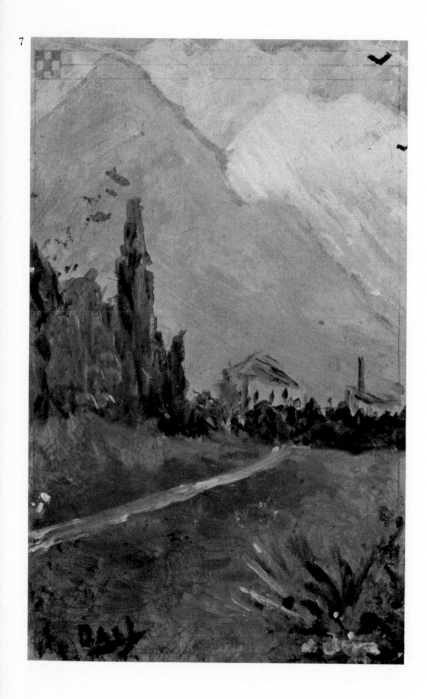

7

from Port Lligat it suddenly occurred to me that she was spending her first night alone there, the beginning of an eternity of such nights, and I felt a momentary pang of melancholy. It was beginning to rain, and the leaves and branches of the olive trees tossed wildly in the wind.

Dalí used to tell me all sorts of anecdotes and we would discuss the different events of the day: the first space trip by Yuri Gagarin in the Vostok, or the publication of Louis Aragon's novel, *La Semaine Sainte*. Dalí had sent Aragon a telegram congratulating him on having written — at last! — an authentically monarchic novel, but I never discovered whether his former friend of Surrealist days wrote to thank him. We used to talk about the people of the village and the changes that were beginning to take place there, about García Lorca, about incidents of Dalí's childhood in Figueras and Cadaqués, about Paris and the Surrealists. It was in the course of these conversations, rather than from books or reviews, that I gradually acquired what I might call my 'Dalinian culture', to use the expression coined by the painter himself in speaking of a journalist who had come to see him, and who, it seemed, was totally devoid of this 'culture'.

One day he told me he had discovered the solution to the problem of overcrowding in cemeteries, which was being much discussed by the press at the time. His 'solution' consisted in launching all new corpses into outer space, where they would spin happily round in fantastic orbits for all eternity. Another day he told me a story of his own which, I imagine, never came to be written or published. Its title was something like *Le spoutnik astiqué, l'asticot, statistique*, and it was about an armless and legless cripple looked after by a woman whose passion for cleanliness led her into paradoxical extremes of filthiness. To maintain her charge in perfect equilibrium, she kept

7. *Landscape*, 1910. This is a scene near Figueras and it is the earliest painting of those that are known and catalogued. Oil on cardboard, 14×9 cms; Albert Field Collection, New York.

8 and 9. Drawings in his school books with pages 13×21 cms; Abelló Museum, Mollet (Barcelona).

him on a flat board with a hole in it, like an old-fashioned privy, and the space under this board was used for storing various household objects, among them a butane gas cylinder, which was then a comparative novelty in this country. Then one day a stray spark found its way to the gas container and the resultant explosion blew the poor cripple so very sky-high that, without coming to any further harm, he found himself taken quite out of the influence of both gravity and time and established as a living planetary body with an orbit all to himself. This literary invention happened to coincide not only with the first space trips but also with the explosion of the first butane gas cooker in Cadaqués, the shock wave of which blew the woman who had

14

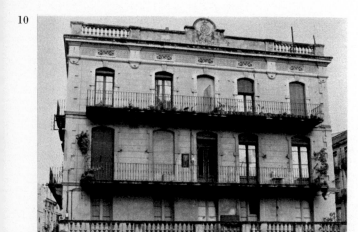

boy who, Dalí once told me, represented himself. There were other elements, too, already present or in the course of painting: cliffs, a picture by Juan Gris, flies, a beach near Cape Creus (just north of Port Lligat), some more heads of the Venus de Milo. Dalí told me to stand at the far end of the studio, though indeed it was not a sufficient distance for the eye to take in such an enormous canvas, and then asked me that compromising question he had asked me about other pictures of his: "What else do you see in it?"

It took me a little time to make it out, and in the end Dalí had to help me to see that the picture also represented the head of a bullfighter, whose face, cap and tie were incorporated in the canvas as the result of other elements.

To these double images I will be referring again in the text, and the reader will find sufficient illustrations. For the moment I feel it is of interest to transcribe the following paragraph from Dalí's *La conquête de l'irrationnel*, published in Paris in 1935: "*Paranoiac phenomena:* in the more celebrated examples of double figuration —the figuration may be multiplied both in theory and in practice— everything depends on the painter's paranoiac capacity. The basis of the associative mechanisms and the renewal of obsessive ideas make it possible, as in the case of a recent picture by Salvador Dalí still in the course of execution, to represent six images simultaneously without any of them suffering the slightest figurative deformation —an athlete's torso, a lion's head, a horse, a head and shoulders of a shepherdess, a skull. In this picture different viewers will see different images. Needless to say, the execution is scrupulously realistic." (I cannot identify this picture among the ones I know, possibly because the "course of execution" was so brief that it did not continue.)

been using it right out of her house, so the immediate sources of the story were not very far to seek.

In the early summer of 1969, we agreed that I should write a book about Dalí: a project that was somewhat vague as to its exact theme, but quite decided as to the purpose. He showed me the picture he was painting at the time: two huge Venus de Milos stood out boldly against the background of an arena encircled by the tiered seats of a Roman circus. In the bottom right-hand corner, the same little boy as he had painted in *The Spectre of Sex-appeal* and other works, a

10 and 11. House in which the painter was born in the *Calle* Narciso Monturiol, Figueras. We see the side, which looks onto a garden, (although nowadays a building has been constructed in front.) The Dalí family lived on the first floor, the one with the balustrade. In the lower photograph one can see the commemorative plaque by the main door; now it is number

12. Holding the *Hypercubic Body*, made in olive wood, 1951.

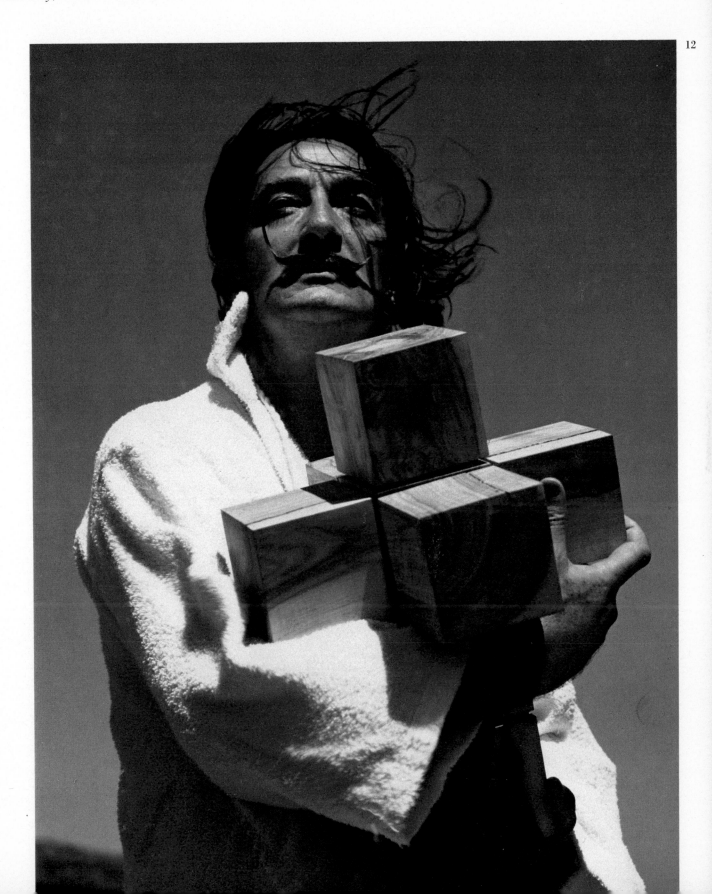

13
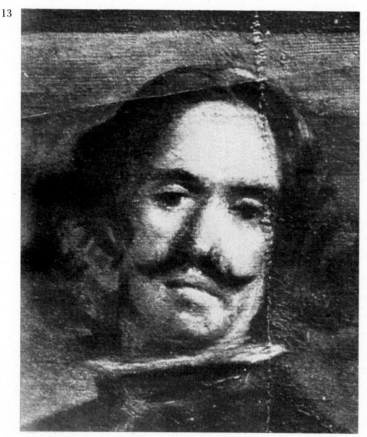

14
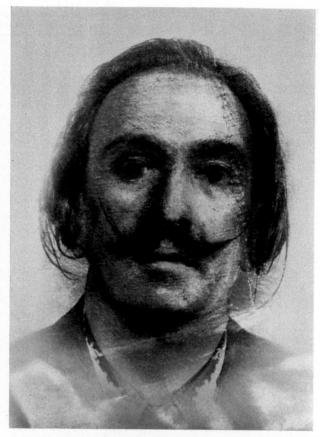

15
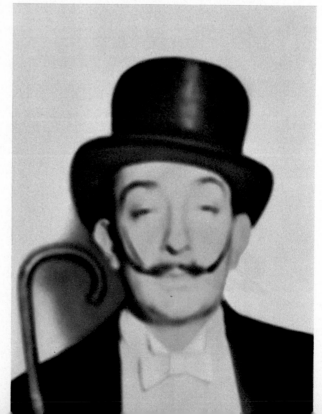

By the end of that summer the great picture of the Venus de Milos in the arena was nearing completion. Dalí had given it the title *Hallucinogenous Bullfighter* and suggested that I should take it as a basis, or a linking element, for the proposed book. This picture, indeed, brought together —repeated, alluded to or hinted at— a considerable number of Dalí's usual themes and many of his preoccupations or obsessions (*),

(*) The poet and bullfighter Mario Cabré, who was still active in the ring at that time, wrote an *Oda a Gala-Salvador Dalí* which was published by Editorial Mon in Madrid in 1952. On re-reading its ninety-six verses in the light of the *Hallucinogenous Bullfighter*, I find that the poem alludes, explicitly more often than not (Gala, angels, rocks, Venus, fossil, landscape, tear, moon), but also in more indirect, secret fashion, to most of the elements included in the picture and dealt with in this book. Thus, the bullfighter-poet unwittingly anticipated, by over fifteen years, the subject-matter of a non-existent picture. There are no taurine references at all, however, for Cabré mentions neither dedications nor death-thrusts, nor *banderillas* nor capes —nor even a bull.

13. Self-portrait by Velázquez.
14. Non-existent person resulting from superposing a portrait of Velázquez on one of Dalí.
15. About 1945 in New York.
16. In 1971, as a hippy.

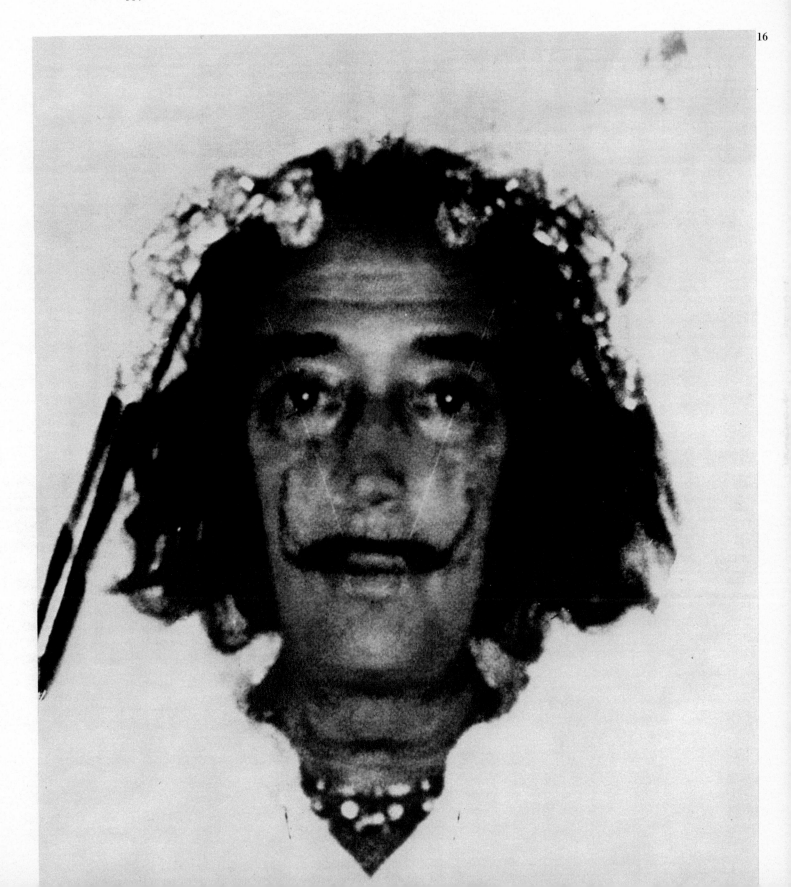

not as disconnected scraps of painting but re-created and incorporated in the fabric of an original, different work.

It was then that we had our first idea of the form this book might take, as regards both text and illustrations. I say our first idea, for, though I have tried to respect it in the form we agreed upon at the time, since I found it an excellent one as long as it did not restrict me too much, I must confess that the preparation and construction of this book have been lengthy, diffuse and anarchic. Listening now to the conversations we taped throughout the following spring, it sounds rather as if we were preparing to publish a "Dalinian Encyclopedia" in heaven knows how many volumes. Just as an example, there is one tape in which he recommends me to do some research on flies, to look up the historical and hagiographical details of the life of Saint Narcissus, the patron saint of Gerona, or to submit to systematic questioning (always supposing that I could find them!) all the people who either knew or had anything to do with Dalí during his childhood and youth in Figueras and Cadaqués, to make special trips to get photographs and a valid dossier on the 'Boy from Tona' or a voluminous collection of data regarding Narciso Monturiol and Juan de La Cierva, the inventors of the submarine and the autogiro, respectively, and then adds: "... in this book we want to have a universal appeal, and these inventors interest everybody, even the Chinese". He also tells me I will have to institute a search for various books, manifestos and opuscules that are very hard to find, as well as suggesting all sorts of journeys up and down the land to discover or verify new details. And, as I can see now, assured that I would have a virtually unlimited number of pages at my disposal, I let myself be caught up in the game. As the tapes go on, however, I find that at times it was quite the opposite, for the

envisaged book seemed to grow thinner and thinner, until it almost disappeared.

In the summer of 1970, I sometimes telephoned to Port Lligat in the early evening and made my way there laden with a tape-recorder (a contraption I dislike, and one I was then using for the first time in the course of my work), with books in which I wanted to examine the illustrations or consult the painter about details, with various papers and with photographs of works of his that I had unearthed somewhere or other. I usually found Dalí surrounded by hippies, by girls in mini- or maxi-skirts, by wealthy foreign friends or collectors, press, radio and television reporters from any or every country, curious hangers-on and, occasionally, really notable people. The eternal glasses of pink champagne dotted the dazzling whiteness of the patio. Dalí would be in his usual disguise, perhaps with some new detail or other. Gala would be sitting on a rush chair under the olive trees, if she was there at all... The door was answered by Rosa, in her rose-pink uniform. Dalí drew me aside: that afternoon we were going to work, of course, but differently... besides, the *ambiance* could not fail to interest me... I nodded: I knew the *ambiance* by heart, as a matter of fact, but I consoled myself by thinking that in Dalí's presence you never knew when the most exciting things might happen. Meanwhile he was assuring me that he had found a document that was absolutely s-e-n-s-a-t-i-o-n-a-l and of definitive importance for our book... The suspense would be drawn out all the evening, though it was hardly suspense for me, aware as I was that the famous document might be more or less interesting and important, but was for the moment being used as an alibi —and, as if that were not enough, I realized perfectly well that he knew I saw through the excuse... Captain Moore, with faultlessly cut

17. The house in Port Lligat seen from a window on the opposite shore.

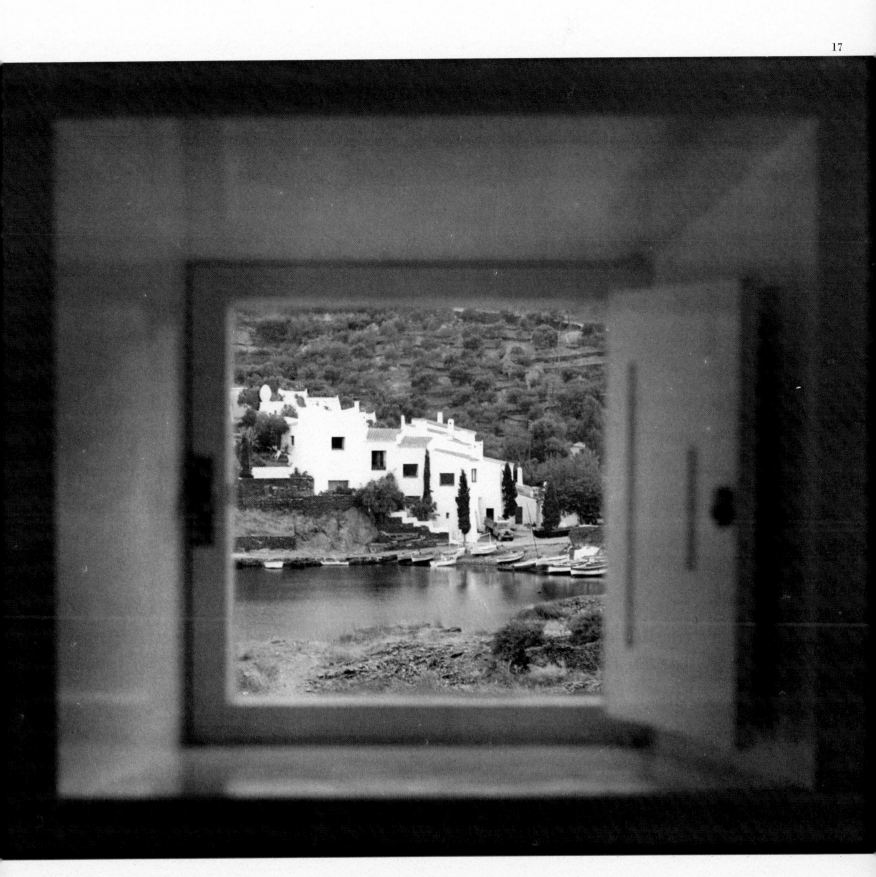

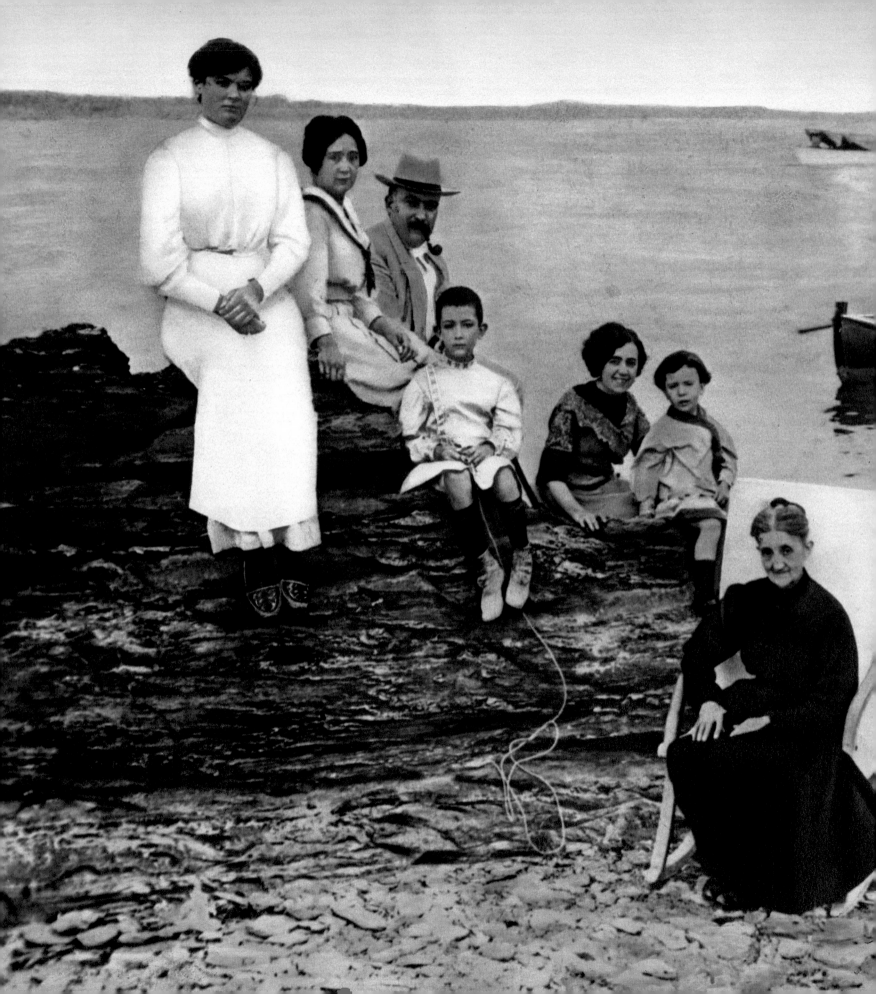

18. At the Llané. From left to right, his Aunt Maria Teresa, his mother and father, Salvador, Aunt Catalina (his mother's sister, who married his father after the former's death), Anna Maria, and grandmother Anna; in the boat is Beti, the fisherman who used to row them.
19. Mr Trayter with his pupils; Dalí, who is marked with a cross, is next to his friend Joan Butchacas.
20. The Rambla in Figueras; on the left the school of the Marists, now disappeared.

18

19

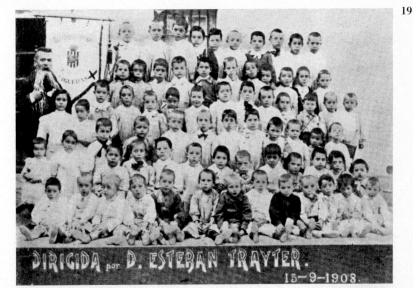

20

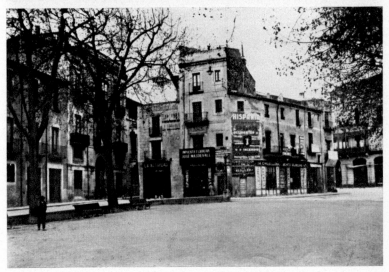

blazer and manners almost reminiscent of Versailles, would be making sure that the evening went with a swing, while Enric Sabater's sniping camera dazzled us with its flash-bulbs in an effort to record every passing moment. There was usually an attractive girl called 'Ginesta' (the girl was not always the same; the name 'Ginesta' had been given to decorative guests of other seasons); and then there was Carlos, the Indian, the traditional demeanour of his ancestors

22

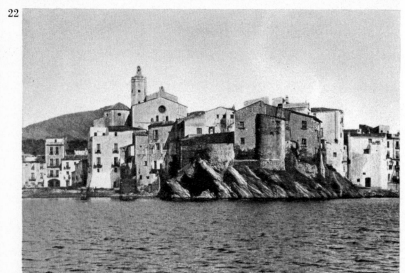

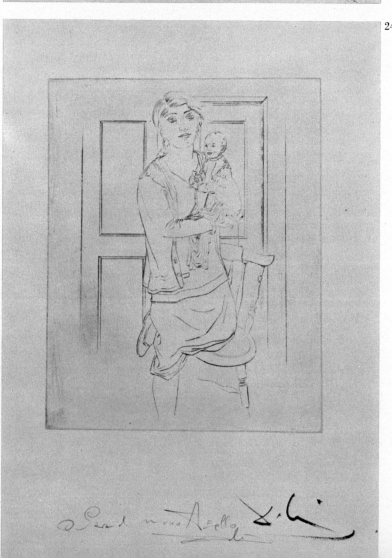

carefully adapted to the most modern youthful
attitudes; and the handsome 'Comte de Lautréa-
mont', the odd collector or publisher, an ageing
queer or two. From a loudspeaker concealed in an
olive tree came the strains of a Vivaldi concerto,
on a record which had the peculiar trick of
sounding, whether through years of scratching or
some deliberate superimposition, exactly like
sardines frying in a pan. More glasses of pink

21. The Llané; to the right the house where the Dalí family spent the summers.
22. Cadaqués about 1904.
23. Dalí with his family and Beti; ink, 14.5 × 20.5 cms; Gustau Camps Collection, Barcelona.
24. Drawing in which the child Dalí is imagined in the arms of his sister, 1925 or 1926; ink, 49 × 35; Abelló Museum, Mollet (Barcelona).
25. *Self-portrait of the Artist with his Easel*, 1921-1922; oil on canvas, 27 × 21 cms; The Reynolds Morse Foundation, Cleveland.

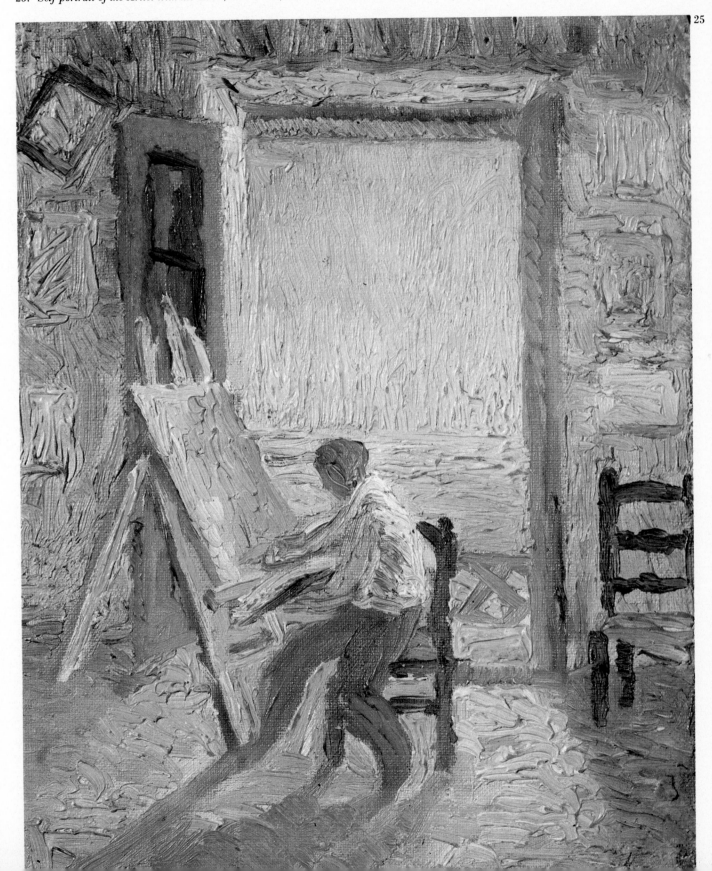

champagne, and then somebody would turn on the lights behind the yellow plastic moon overhead — originally part of an advertisement for bathroom fittings and transformed by our host's genius into a permanent spectacle. Finally, I would be shown the great document. It might be a photograph of Matisse, dressed like a banker of the thirties but with the elegance of his knife-creased trousers rather spoilt by an imperfectly buttoned fly; or a coloured photograph of that picture in the Diocesan Museum of Gerona which represents the miracle of Saint Narcissus in such extremely vivid detail; or it might be no more than a sketch, in pencil or ball-point, of one of the figures in the same picture. It was at moments like this that the great book seemed to waste away to the thickness of a leaflet. Then Dalí would fix another date for us to meet, and I would return to Cadaqués with the precious new document and the beginnings of stomach acidity after all that pink champagne —excellent thirst-quencher though it was on those hot, crowded evenings. I must admit that these evenings did amuse me; at those impromptu parties of his Dalí always seemed different —still very much Dalí, but in quite another style.

I have attempted to steer a middle course between the Great Dalinian Encyclopedia and the slender pamphlet or sheaf of notes, keeping more or less to the size of book the publisher told me he wanted at the start.

Listening to all the tapes, memories come rushing in, but I think I must confess that of all the confused piles of material at my disposal Dalí's own early autobiography, *My Secret Life*, has been more useful than any other book or review as a constant source and guide.

Of all the different characters mentioned by Dalí in *My Secret Life*, the one that has most

26. *Corpuscular Head over the Village of Cadaqués*; oil on cardboard; private collection.
27. Cadaqués in 1970.

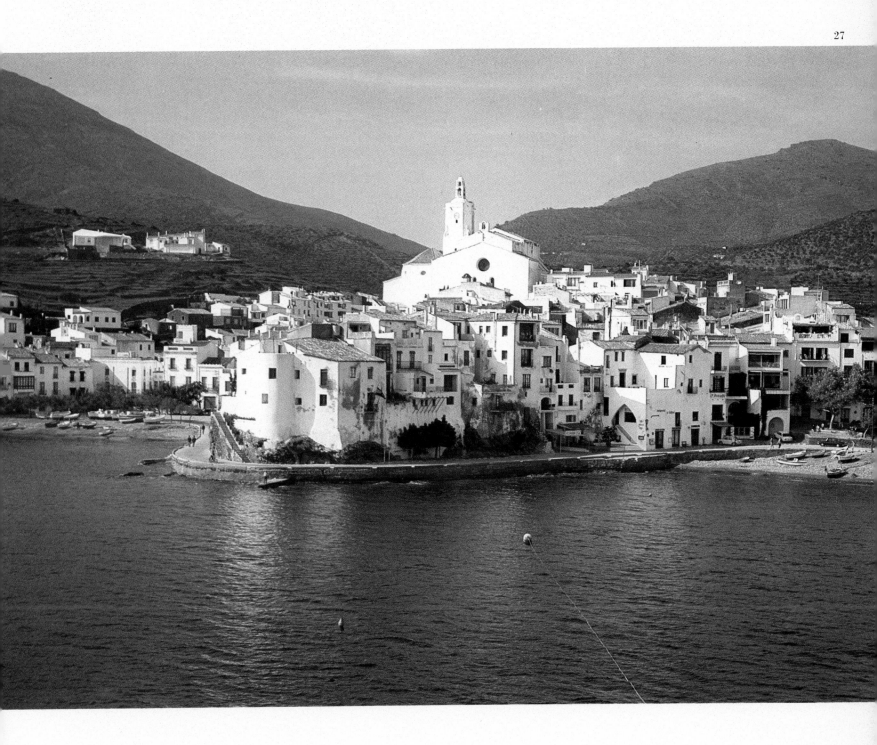

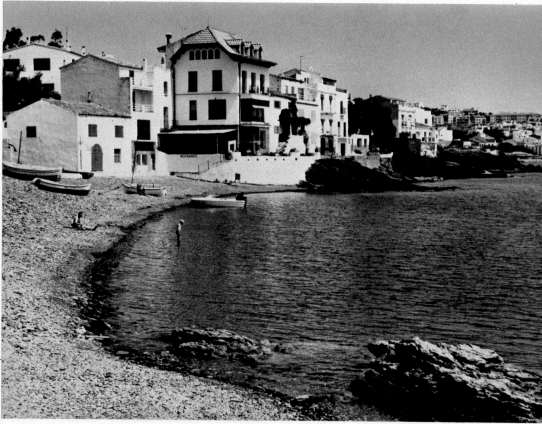

aroused my curiosity since I first read that brilliant autobiography is the child apparently nicknamed 'Butxaques' (which means 'pockets' in Catalan), who was given this sobriquet on account of all the pockets he had in his suit. This multiplicity of pockets stirred my imagination almost as much as any of the strange events and sentiments recorded in Dalí's book in connection with the boy, even though I knew they came under the heading of false reminiscences.

Finally I met the character himself, now an honest metal-worker and still living in Figueras. We had a conversation at the door of his workshop while he kept an eye on the chemical effect of some acid on metal plates, a process that was taking place in a large, smoking pan or basin placed on the narrow pavement. Our talk about

Dalí, his childhood, his family and his home was punctuated by warnings to passers-by: "Watch your step, Senyora Enriqueta! Don't fall into it!", or "Good morning, sir. I'm sorry to put you to such trouble." But I was disappointed to discover that the real, official name of this pleasant character from Dalí's childhood was, in fact, Joan Butchacas, and it would be too much to suppose that the mere existence of such a surname, soberly recorded in the local Civil Register, might have been enough to produce the fantastically useful suit, that multi-pocketed suit we all dreamt of as boys.

However unsystematically, shapelessly and perhaps incompletely, I have succeeded in amassing plenty of facts in conversations over the years

28. *Little Anna Maria*, 1920-1925. Anna Maria Domènech, a cousin of the painter. Oil on canvas, 89×63 cms; Peter Moore Collection, Paris.
29. The Llané in autumn.
30. *Beach at the Llané*, 1920-1925; oil on canvas, 63×89 cms; Peter Moore Collection, Paris.

31. High school student in Figueras in 1921.
32. *Portrait of the Artist's Father*, 1925; oil on canvas, 100 × 100 cms; Museum of Modern Art, Barcelona.

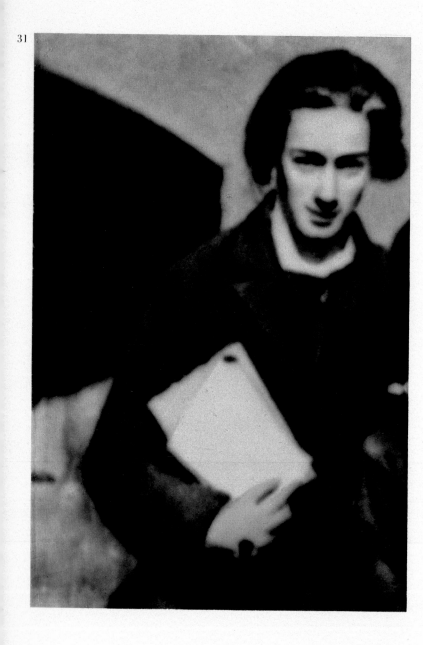

31

with people from Barcelona, Figueras, Cadaqués or elsewhere who have known the painter in the different places in which he has lived. During these years many people, indeed, have spoken to me of Dalí, and I have heard an infinite number of first-hand, second-hand and third-hand anecdotes, true or apocryphal, which I have made every endeavour to classify correctly, for it is of the utmost importance —and even more so in the case of a character like Dalí— to trace a dividing line between truth and falsehood that will be as definitive as possible, however vague and confusing its course.

Although this book is intended to deal more with his paintings and drawings, Dalí also possesses a notable literary talent which has developed parallel to his career in art. It is years now since I read his novel, *Rostros ocultos*, and I do not know whether it was a faithful and complete version of the American original, *Hidden Faces*, or whether it had suffered any of the moralizing additions and expurgations (and God knows in what language he wrote them!) already visited on that original. I have not re-read the book since then and have only retained a vague impression of a similarity to certain works by Huysmans, with echoes of Proust. More recently, I have also had an opportunity of reading an anthology that brought together some of his earliest written works.

Nobody should attempt to judge Dalí from what used to be considered the solidly-based platform of logic, and still less from the even shakier stand of what was once known as morality —whether Morality in general, with a capital M, or any of its small-type varieties: public morality, Catholic morality, puritan morality, morality of customs, etc. In one of those incursions Dalí sometimes made into the world of the theatre —which usually aroused great enthusiasm in some people and almost equal repulsion in others—

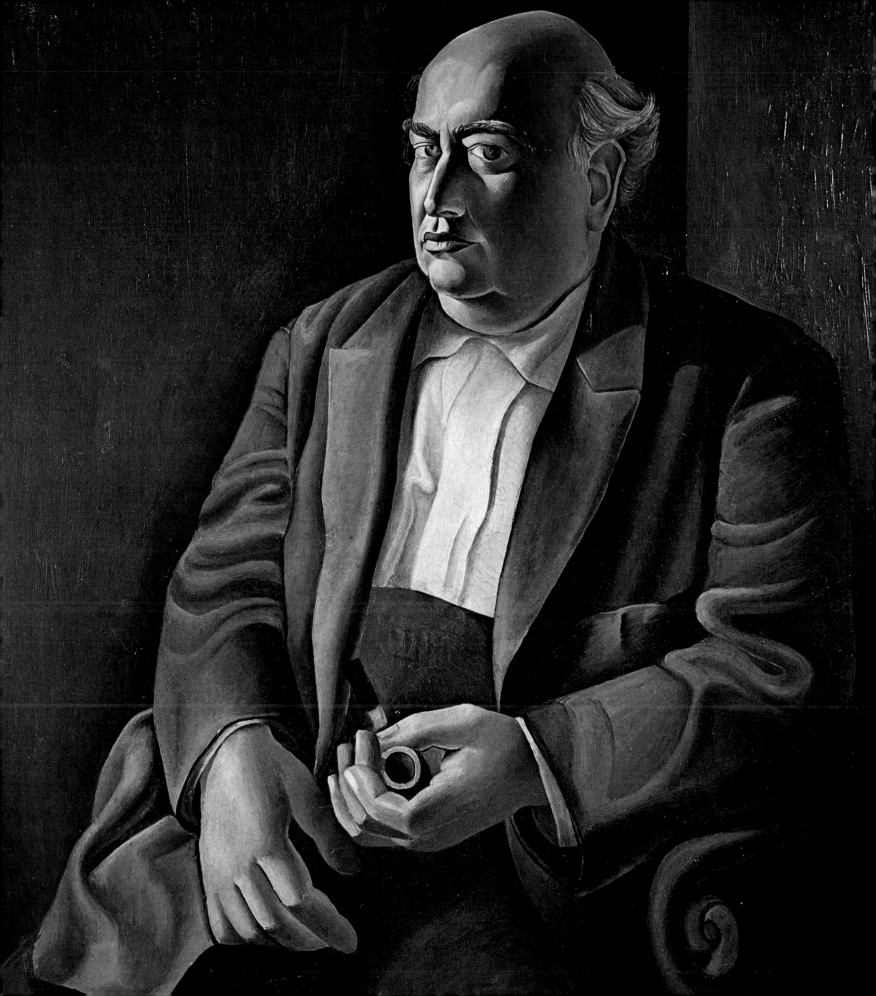

33

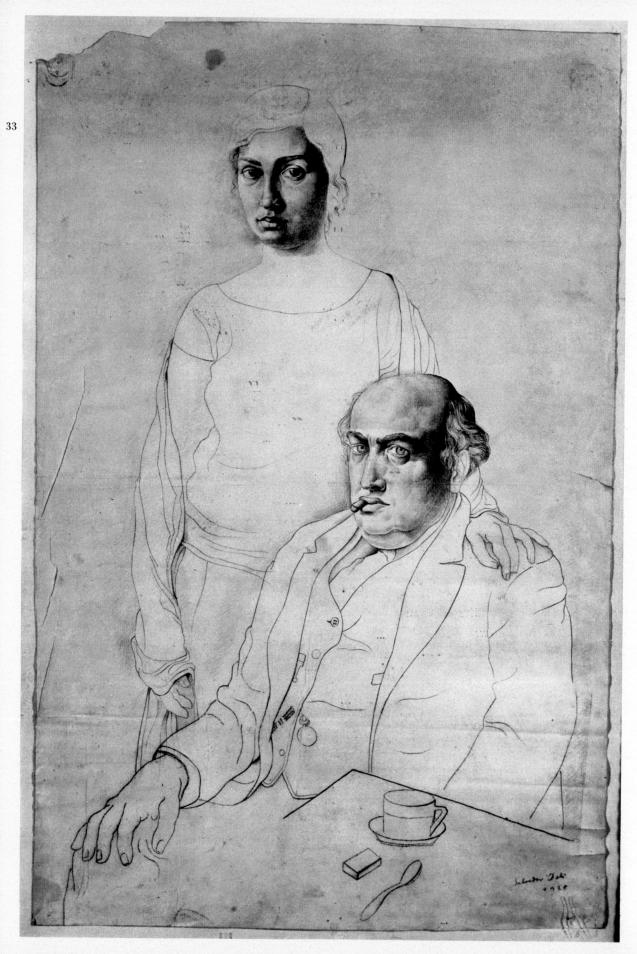

33. *Portrait of the Artist's Father and Sister*, 1925; charcoal drawing, 50 × 33 cms; Montserrat Dalí de Bas Collection, Barcelona.
34. *Bay of Cadaqués*, 1925 (?); oil on canvas, 40 × 50 cms; Enric Sabater Collection, Palafrugell. (Gerona).

34

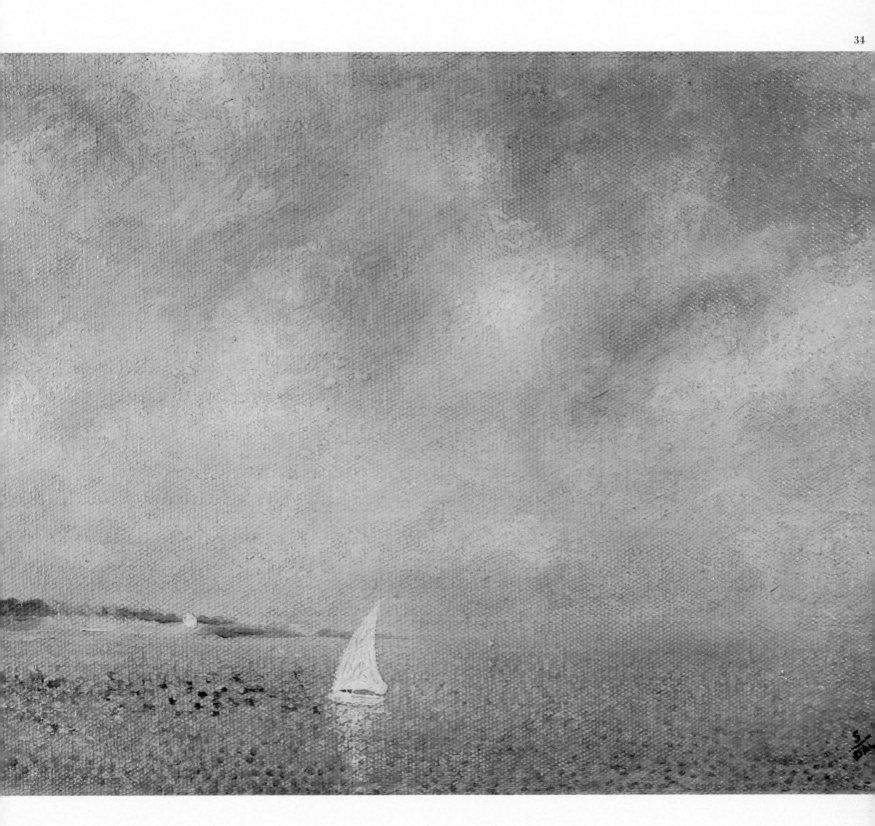

35. *Brig Anchored off Cadaqués*; oil on canvas, 26 × 31 cms; Maria Rosa Raventós Collection, Barcelona.
36. *Girl at the Window*, 1925. His sister Anna Maria. Oil on canvas, 103 × 74 cms; Museum of Contemporary Art, Madrid.

35

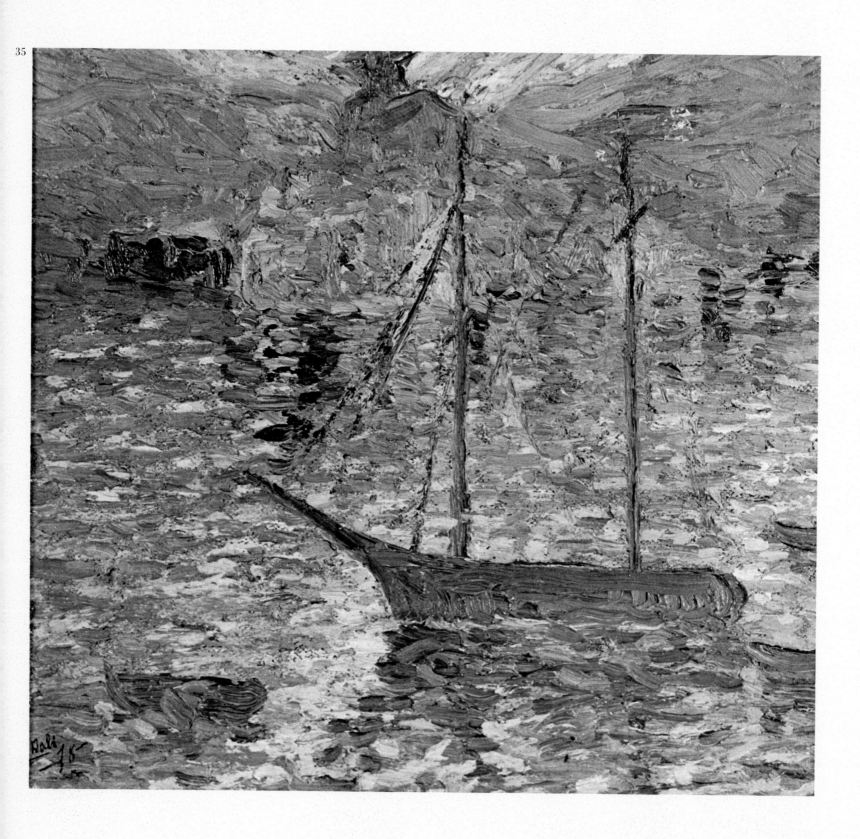

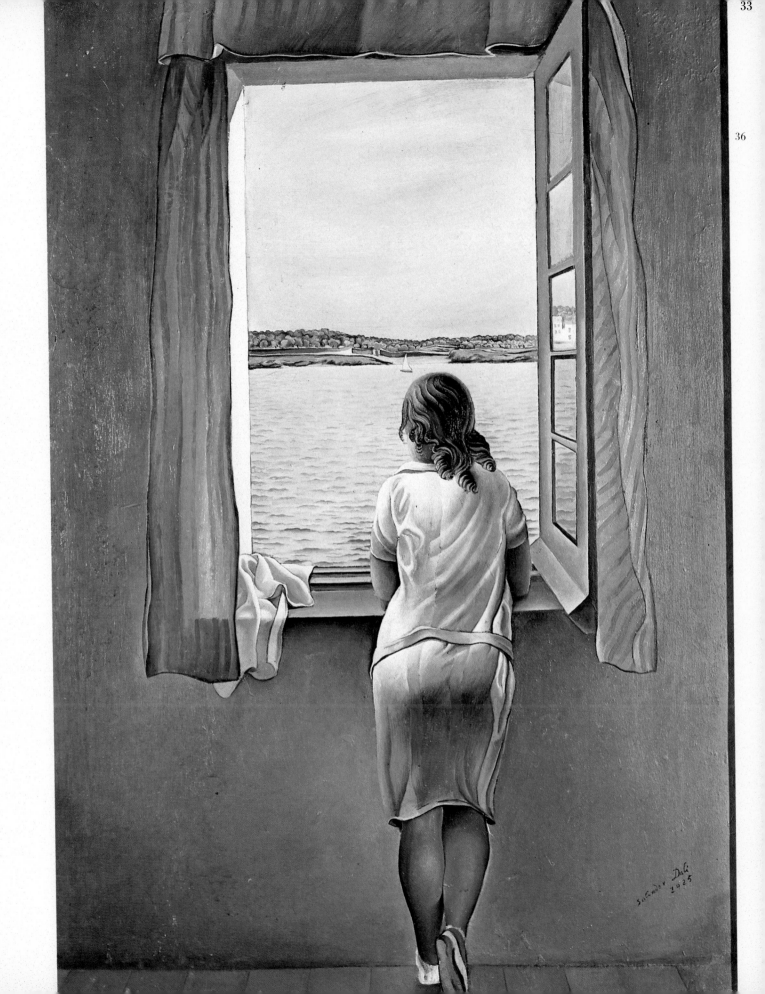

37

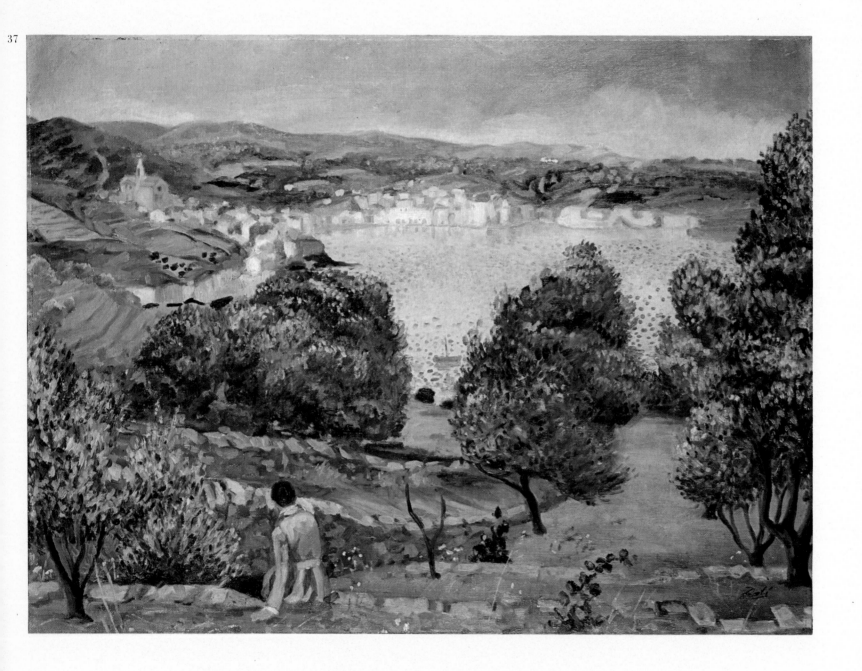

37. *Cadaqués*, 1922; oil on canvas, 60.5×82 cms; Montserrat Dalí de Bas Collection, Barcelona.
38. *Girl seen from behind*, 1925; oil on canvas, 108×77 cms; Museum of Contemporary Art, Madrid.

38

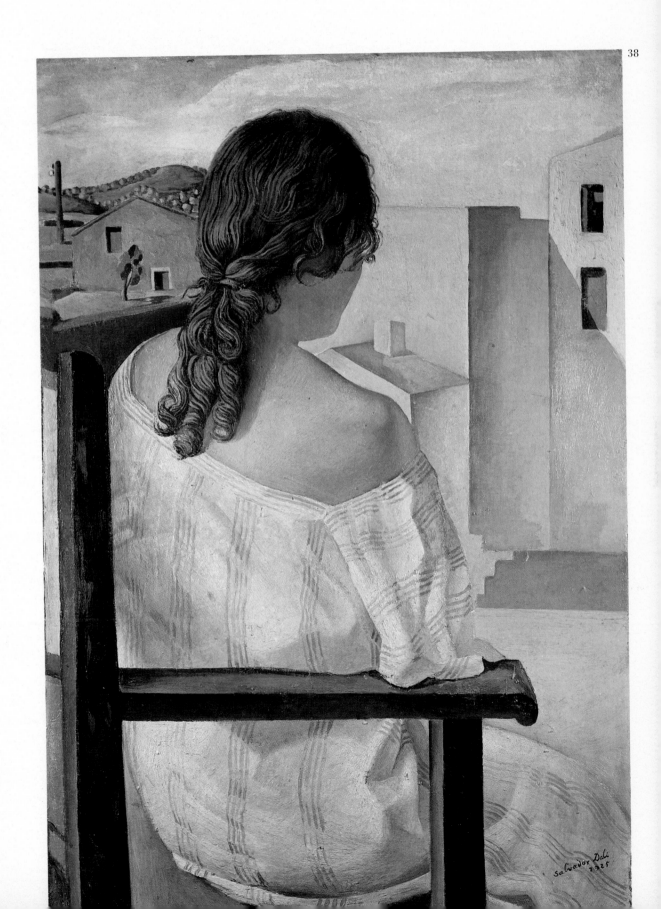

the play chosen was the popular favourite *Don Juan Tenorio*. There are two lines in this play which might well have been chosen as Dalí's motto:

Wheresoever I go,
Scandal goes with me.

It is easy enough to suppose that certain surprising powers were at work in Dalí from a very early age, and it is likewise understandable that these powers should have developed and grown stronger with the years, particularly when, far from making an effort to curb them, he did everything he could to foster them. As from a certain moment in his life, moreover, circumstances were to prove propitious to the development and manifestation of these powers, to their exhibition and resounding proclamation. Some of his present attitudes and the apparent tone of some of his reactionary declarations are no more than the half-hearted disguise of a nihilist whose fury is scarcely tempered by age, material wealth and success. His is a kind of nihilism, however, that always excludes Gala and himself from any risks involved in its most dangerous experiments. If Dalí were offered the chance of watching the burning of Rome through the eyes of a modern Nero, he would certainly not forget —nor, evidently, did the original imperial fiddler himself— to place himself at a safe vantage-point. surrounded by asbestos screens, hose-pipes and extinguishers. But I cannot see Dalí, however apocalyptic and optimistic, playing the role of Samson.

The image of Salvador Dalí as a 'nice' young man, perhaps a little wayward, a talented painter and a dutiful son, must be regarded as no more than a respectable subjective appreciation (another way of interpreting the truth), but its overall effect is belied by certain incontrovertible facts:

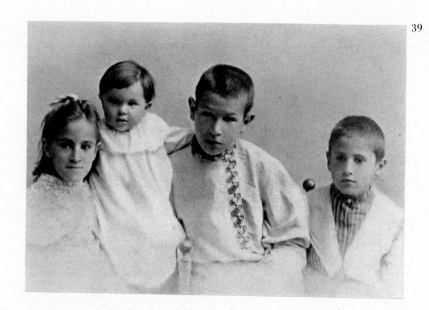

the two occasions on which he was expelled from the Academy of Fine Arts of San Fernando in Madrid, the script for *Un chien andalou*, the object that "meant nothing" and was rejected by the Sala Maragall and, most particularly, the 'letter of insults' he and Luis Buñuel sent to Juan Ramón Jiménez (later to be awarded the Nobel Prize for literature), who had received them at his home with such fatherly kindness a few days before; this last act was one of gratuitous provocation, in the best Surrealist manner, and I have an idea that García Lorca, who had accompanied his friends on their visit to Jiménez, refused to sign such an aggressive and unjustified letter.

It is quite evident that in *My Secret Life* Dalí exaggerates some of the attitudes of his childhood and youth, that he mythifies his sadistic impulses and falsifies some of the episodes; but from this book one can also deduce that those elements that were beginning to appear in his pictures were then being set free within him, growing and finding outward expression in his behaviour. There is no point in losing ourselves in the forest of hypotheses suggested by wondering what would

39. Gala, on the left, with her brothers and sister.
40. Ceiling for the Dalí Museum-Theatre, Figueras. 1970. A stretcher is holding *Hallucinogenous Bullfighter*, one of whose details can be seen.

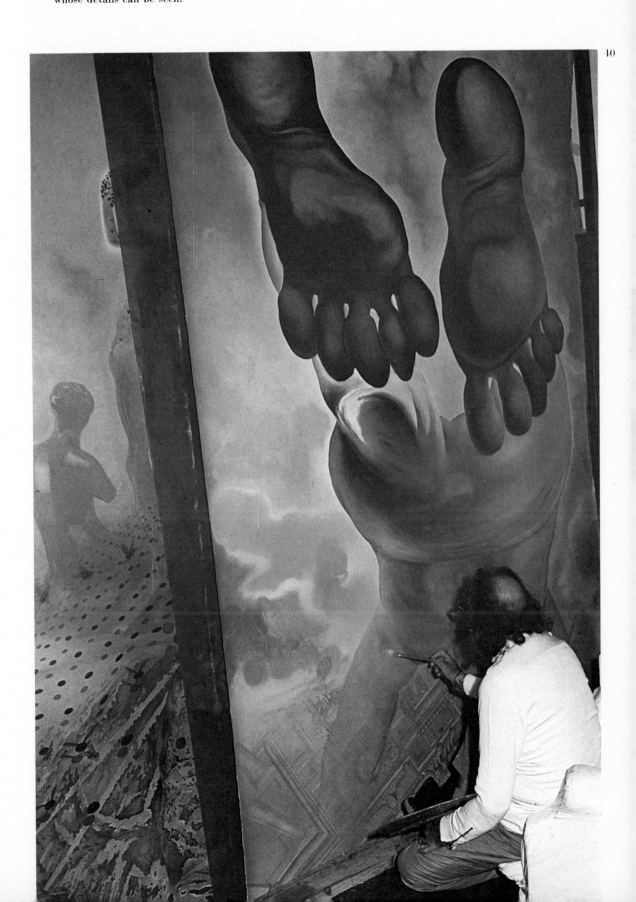

40

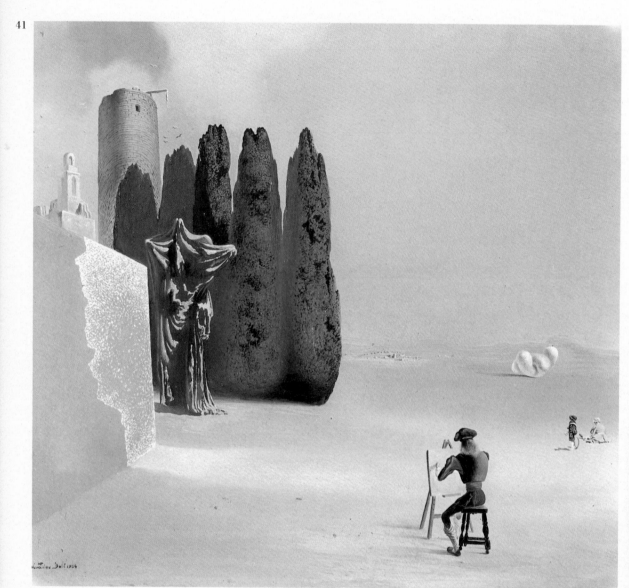

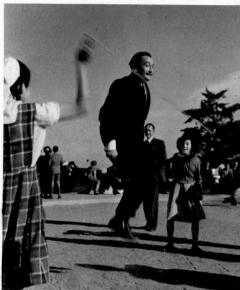

have happened if Salvador Dalí's path had never been crossed by the Surrealists or if Gala had never entered his life. Events are irreversible anyway, and the developments that could be envisaged for the future of that extravagant young man were so many and various that we cannot discount the possibility of his coming into contact with the Surrealists —and, therefore, with Gala— in some other way than he did. So,

perhaps, we had better leave well alone in this regard. Nor is this, necessarily, a question of determinism, but something much more simple and straightforward.

As Sigmund Freud said of him, after an interview in London in 1939, Dalí is a fanatic, an extremist. Should any moderation exist in him, he eliminates it or destroys it. His love for Gala, his relationship with his family, his political positions,

41. *Enigmatic Elements in a Landscape* (detail), 1934; oil on panel, 73 × 60 cms; Sulzberger Collection, Paris.
42. Skipping in the Güell Park, Barcelona.
43. In 1971, in Figueras, near the school of the Christian Brothers which he attended.

43

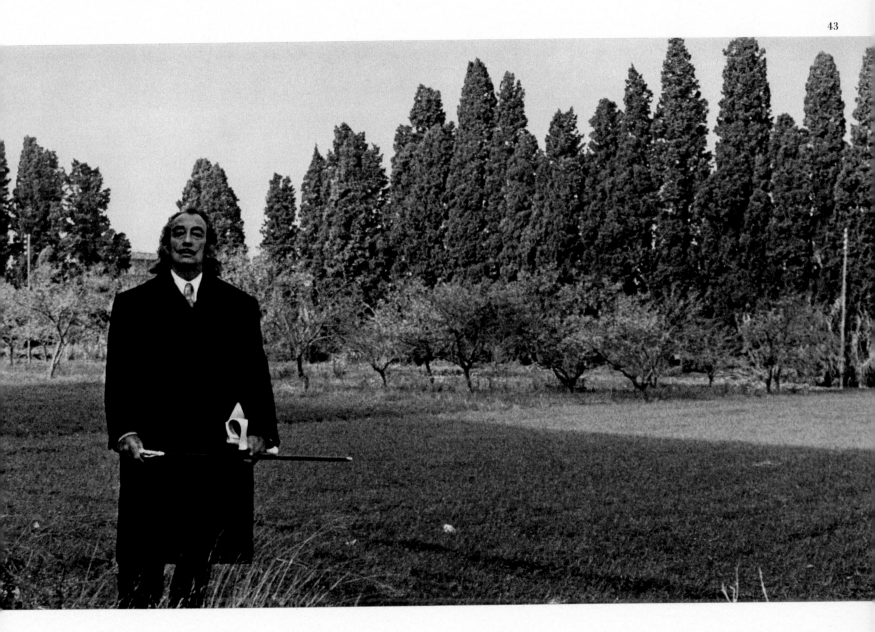

his views on art, his interpretation of history, the opinions he expresses on other artists, his scientific ideas: all of these are exaggerated, to say the least of it, in his external manifestations, which are the only ones on which we can base our opinions, even admitting that they may lead us astray. Let us, then, accept the fact that the mystification has limits in itself and that behind every exaggeration lies a truth, the exact dimension of which is the unknown quantity. How far does Dalí go in his admiration for Gaudí and his detestation of Le Corbusier? To what extent is it really true that he considers Turner the worst painter of all time? How much credit can we give, for instance, to the following passage from *La conquête de l'irrationnel*, and exactly what weight should we assign to its latent content of irony?

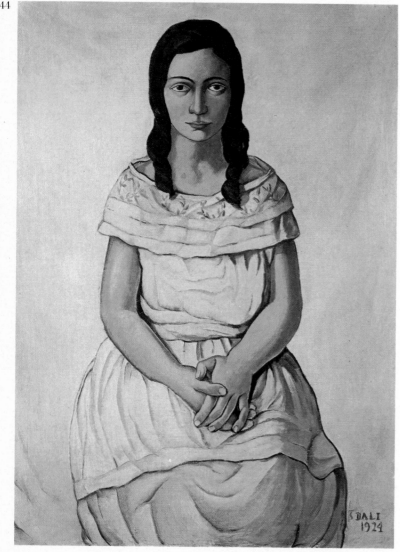

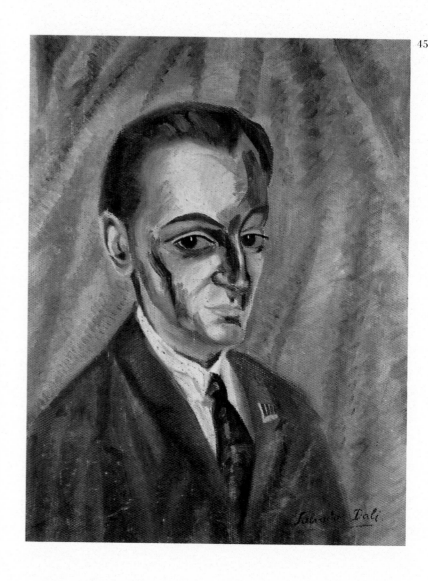

"I find it perfectly clear that my enemies, my friends and the public in general should declare that they do not understand the significance of the images which arise and are transcribed by me in my pictures. How can you expect them to understand when I myself, the one who *makes* these images, do not understand them either? The fact that at the moment of painting I do not myself understand the significance of my pictures, does not mean that those pictures have no sig-

nificance: on the contrary, their significance is so profound, so complex, so coherent and involuntary that it escapes the simple analysis of logical intuition."

I should now like to draw the reader's attention to a stage in Dalí's career which is of considerable importance, as regard both his painting and the development of his personality: the period which ended in 1929. This year must be regarded as a crucial one, for it was the year in which he met

44. *Anna Maria*, 1924; oil on canvas; Mrs Carles Collection, Barcelona.
45. *Portrait of José M Torres*; oil on canvas, 49.5×39.5 cms; Museum of Modern Art, Barcelona.
46. *The Girl with Curls*, also called *The Girl from the Ampurdán*, 1926; oil on plywood, 51×40 cms; The Reynolds Morse Foundation, Cleveland.
47. *My Cousin Montserrat*; oil on canvas, 55×50 cms; previously Alen Rich Gallery, New York.

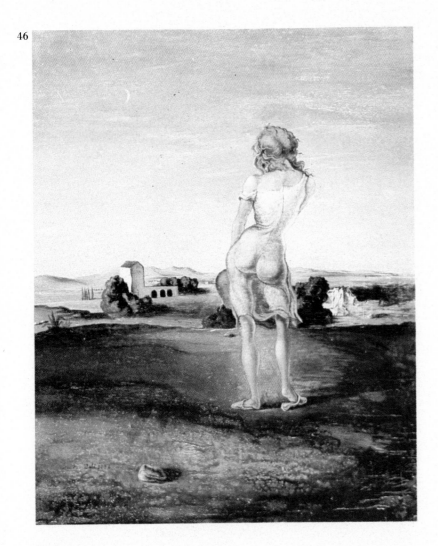

Gala, became a member of the Surrealist group, exhibited in Paris for the first time (at the Galerie Goemans), painted some important and 'defining' pictures, began to have serious differences with his family and made the most decided change of direction in the whole course of his life. But the period I wish to deal with now is, as I have said, the immediately preceding one, as from 1926, when he was expelled from the Academy of Fine Arts of San Fernando in Madrid. On account of various circumstances, among which the comparative closeness in time would not be the least, possibly in conjunction with an attitude of rejection dictated by personal motivations, *My Secret Life* contains few references to this period, the painter's adventures during those three years or even the work he did then, while deliberately emphasizing the immediately subsequent period in his career: his life in Paris and wholehearted espousal of the Surrealist cause. And, since almost all the foreign

48

48. Gala in her teens.
49. *Harbour of Cadaqués*, 1926; oil on canvas; whereabouts unknown.

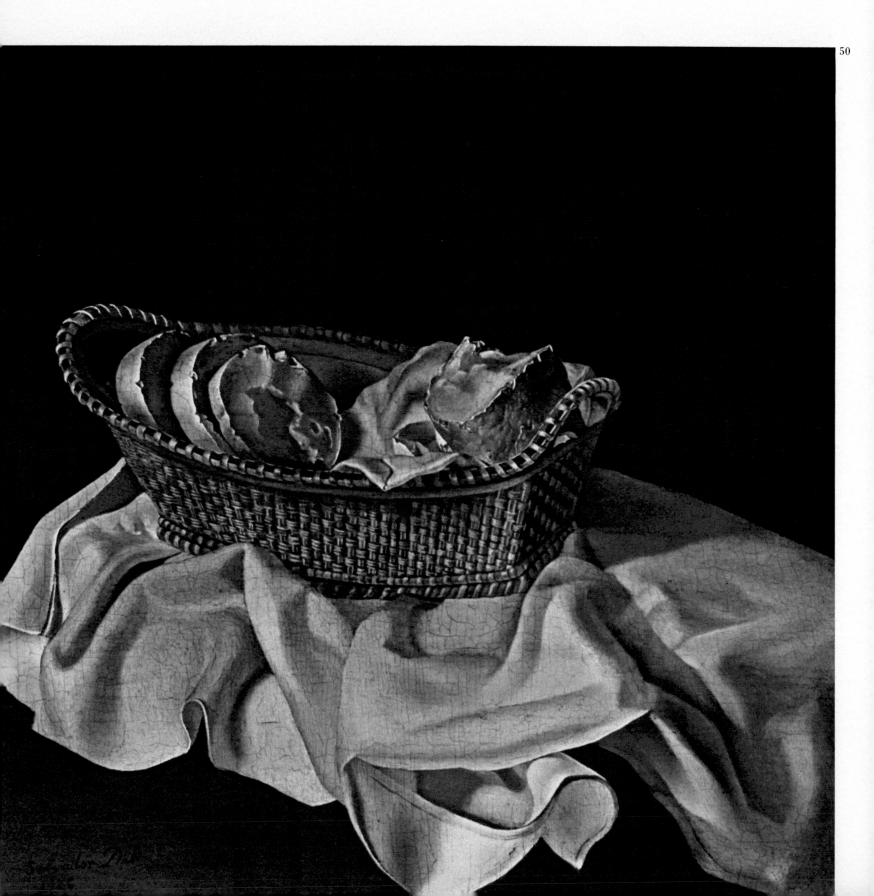

50. *The Bread-basket*, 1926; oil on wood, 31.7 × 31.7 cms; The Reynolds Morse Foundation, Cleveland.
51. *The Bread-basket*, 1945; oil on canvas, 37 × 32 cms; Dalí Museum-Theatre, Figueras.

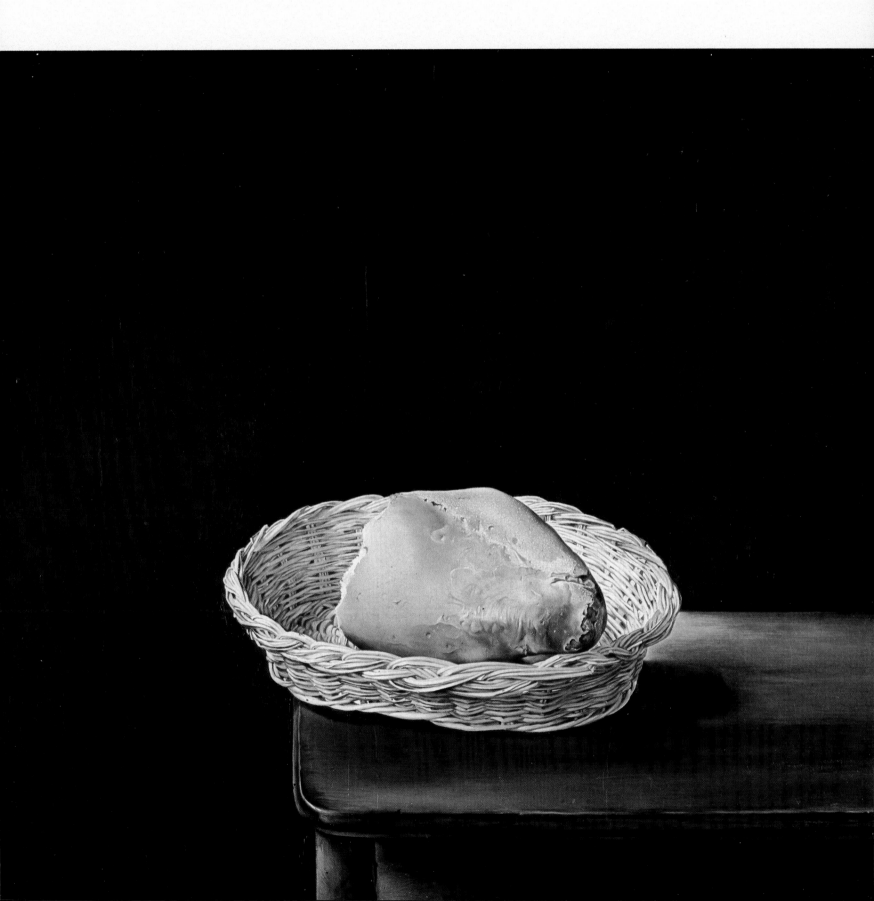

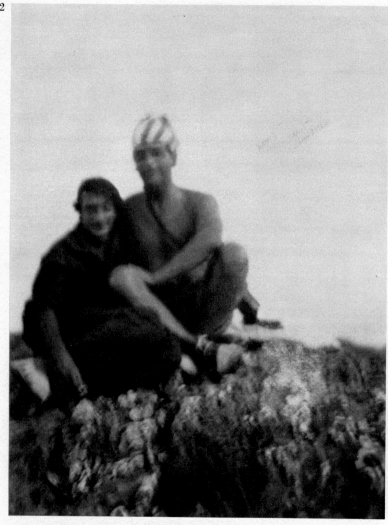

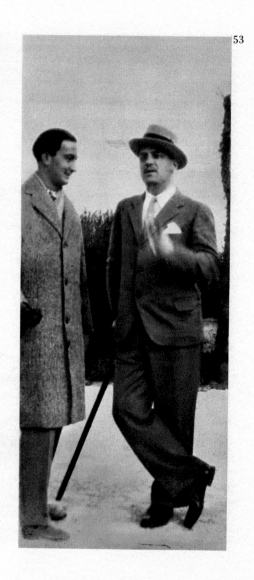

writers who have attempted —with more or less accuracy, prolixity and success— to produce biographies of Dalí have made *My Secret Life* their principal source of material, the result is that the previous period (which is also important) is very little known, if at all.

But there is one person whom I consider a most reliable witness, and who still possesses a collection of the letters which Dalí wrote to him at this time, as sincere and lucid as if in writing them he were making his confession to himself. I refer to

the Barcelona critic Sebastià Gasch. In 1953 Gasch published, in Catalan, an ambitious book entitled *L'expansió de l'art català al mon*, in which twenty-four substantial pages are devoted to Dalí. Of these the most interesting are the ones that have to do with the period during which they were close friends, when they wrote to each other frequently and, with Lluís Montanyà, drew up and signed the celebrated 'Yellow manifesto', a document more often quoted than read. The period of this close relationship between Dalí and Gasch opens and closes with letters written by the former: it

47

52 and 53. Dalí and Buñuel at Cape Creus in 1928, and in Figueras in the summer of the same year.
54. In 1952. in the Güell Park. Barcelona. created by Antoni Gaudí.

54

55

57

56

58

55 to 58. With Gala at different times and places.

59. Illustration for a book of poems by Carles Fages de Climent of Figueras, called *Ballad of the Shoemaker from Ordis*, 1954.

60. Some doggerel by Fages de Climent from 1961.

61. Surrealist composition by the photographer Cecil Beaton, about 1936; in the background the two pieces which are included in *Landscape with the Head Filled with Clouds*.

59

61

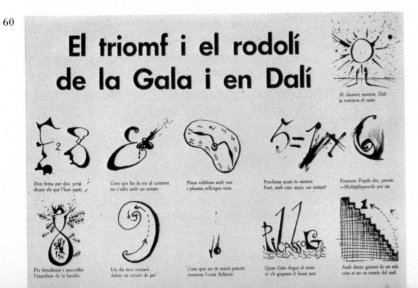

60

begins with one dated in Figueras in 1926, in which the painter thanks Gasch for an article he had written in the 'Gaseta de les Arts', an avant-garde review of the time, and ends with the one he wrote from Paris in December 1931, in an aggressive, insulting and threatening tone.

In his book Sebastià Gasch attempts to explain the Dalí of that period and quotes some significant and revealing paragraphs from these letters. He describes Dalí's physical presence very precisely and also gives a sketch-portrait of the painter's character. I have included some paragraphs from Gasch's book, and one of the letters from Dalí, by way of appendix, for as far as I know the book has never been either re-published or translated, and it deserves to be better known. Also among the appendices is a facsimile of the 'Yellow manifesto'.

The change of direction that took place in 1929 had been foreshadowed by earlier attitudes, and if a

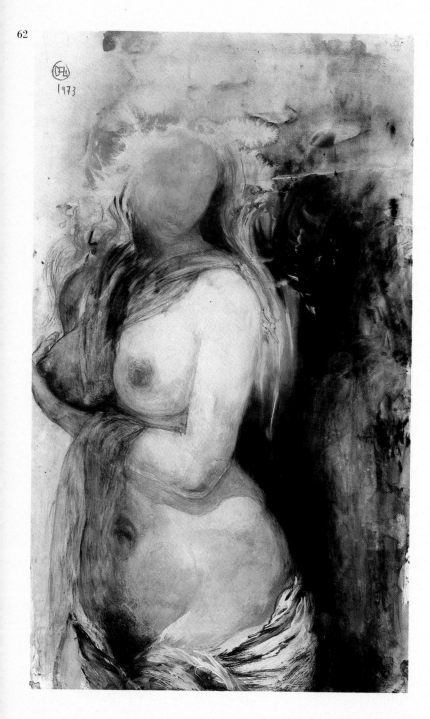

62

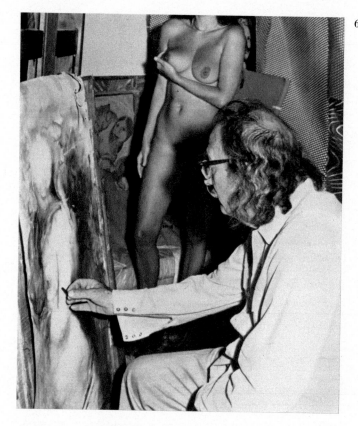

63

palmist had happened to study the hand of the young Dalí he would doubtless have predicted this change as at least a latent possibility; and in this case he would have been right. Anyone, however, who had watched this young Dalí taking those enormous leaps he was so fond of would have been wrong to predict that he would end up with his legs broken, despite the fact that the possibility of this occurring was also very evident. The fact is that prophesying as a profession requires a sufficiently broad vagueness to be open to different interpretations.

These were years during which Dalí painted some quite considerable pictures, pictures that had come a long way from his adolescent gropings and his imitations of the Impressionists. He had, indeed, become an assured professional painter, though his still vacillating spirit inclined him to a

62. *Pomona. Autumn*, 1973; watercolour and other techniques on paper; Wolf Forster Collection, Hertissen, Germany.
63. With a model in the studio in Port Lligat.
64. *Christ of the Mackerels*, in the olive grove of the house at Port Lligat, about 1969; giant sculpture.

diversity of experiences. They were the years in which he held his first exhibitions and was accorded a flatteringly warm reception by the Barcelona critics. García Lorca visited him in Figueras and Cadaqués, and Regino Sainz de la Maza played the guitar on the terrace of his house at the Llané. Anna Maria Dalí has given a personal, affectionate and nostalgic portrait of her brother as he was at this time, though it is a vision that hardly coincides with these words from Sebastià Gasch's description: "... what one may assert, without the slightest fear of being mistaken, is that this irony had the quality of absolute cruelty: a glacial, impassive, terribly serene cruelty. Everything Dalí said or did revealed a total absence of heart."

In such a contradictory character, of course, the splendidly affectionate feeling for his family evoked by his sister could coexist to some extent with the hardness that we find in the reminiscences of his old friend. In a comparatively recent book *Dalí*, speaking to the writer Louis Pauwels, recalls the state of his feelings after he had been disowned and thrown out of his home by his father: "Though rejected by him, in spite of everything I still held him in my heart, full of reverence for his strong personality, because I absolutely needed his weight and density, to give me some sort of *point d'appui* in the midst of my vacillating mental structures."

No student of the work of Dalí can give less than his full attention to a period in the painter's career which is notable for such important works as *Character on Rocks* (also known as *Cliffs*), *The Girl from the Ampurdán* (or *The Girl with Curly Hair*), *Venus and the Sailor*, *The Bread-basket* (the earlier version), *Barcelona Mannequin*, *Port of Cadaqués*, *Bather*, *Big Thumb*, *Putrefied Bird and Moon*, *Ashes*, *Venus and Amorini*, *Honey is Sweeter than Blood*, some of his Cubist compositions and several of his best drawings.

65. *The Supper*, 1955; oil on canvas, 167×268 cms; Chester Dale Collection, National Gallery of Art, Washington.

65

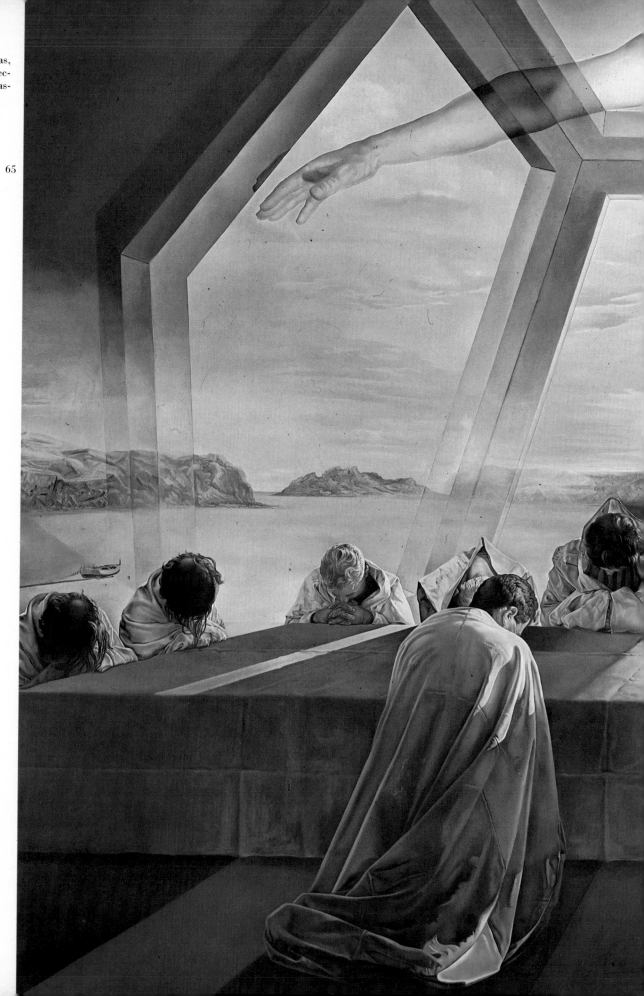

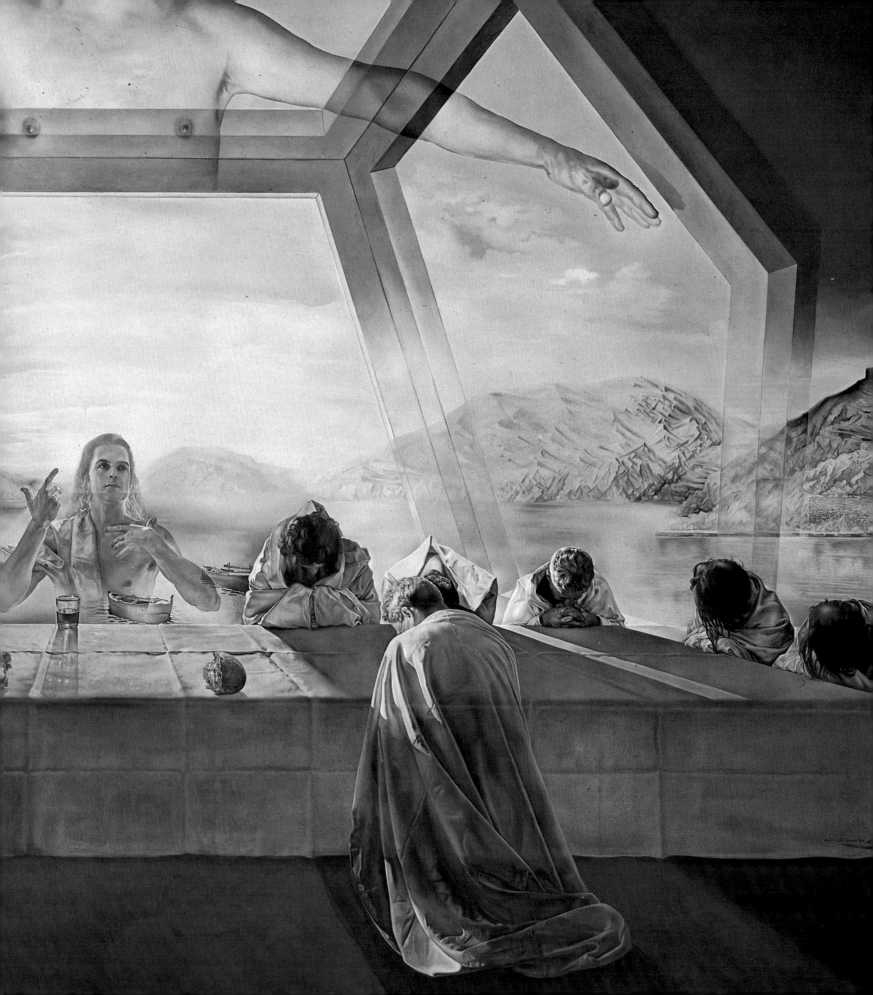

66. With wig and double moustache.
67. Bathing in Port Lligat, 1953.

67

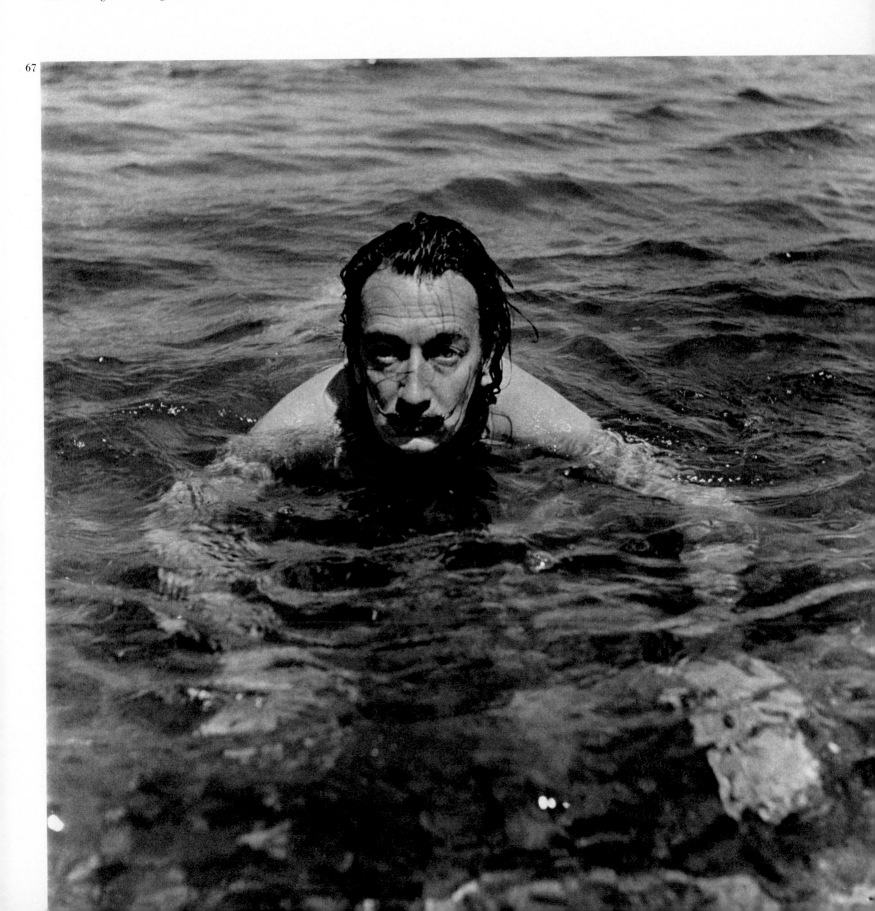

68

69

In drawing attention to this period in his life and mentioning some of the most important works that he painted at that time (works which, despite the painter's youth, reveal a considerable degree of maturity), it is by no means my intention to diminish the stature of the Dalí who began to emerge towards the end of 1929. Dalí had begun to paint as a Surrealist before this and had, indeed, already begun to act in a more or less restrained surrealistic way; but his settling in Paris, his living with Gala, his *official* entry into the ranks of the Surrealists, into the Breton 'clan', meant a complete change of life, a door leading to still more devastating inconformities and the possibility of fulfilling himself in all directions after a fashion which, though no freer, would be restricted by *different* inquisitorial imperatives, ones more in harmony with his expansive purposes.

In an illuminating and well-documented study, published in the Madrid review 'Arte' in 1933,

68 and 69. Photographs dedicated by Moshe Dayan and Francesc Pujols.
70. With Man Ray in Paris.
71. Accompanying the Duke and Duchess of Windsor in Port Lligat.
72. Cover of *Time*, December 1936, with the portrait by Man Ray.

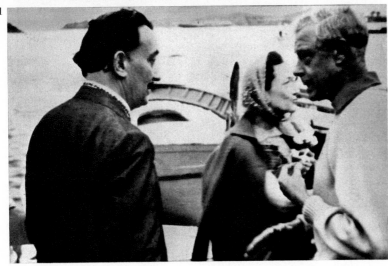

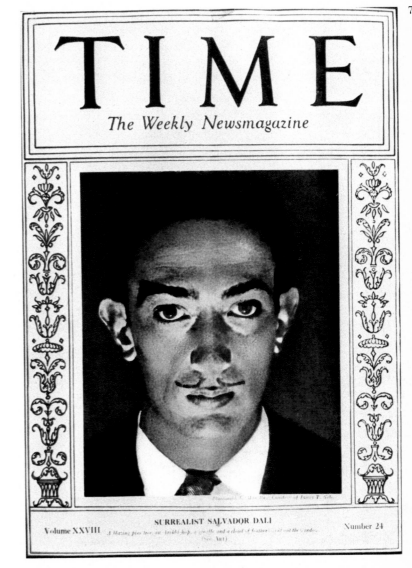

Guillermo de Torre, who had known Dalí at the Students' Residence in Madrid ten years earlier, wrote: "His adventurous drive and questing eagerness have led him in little more than five years —the years between adolescence and the full prime of youth— over vast regions of plastic art, regions that differ but do not diverge." Later, in his references to the *present*, he says: "... the transition effected by Dalí, however extreme, was not entirely unforeseeable. In his spirit, even more than in his pictures, there was already something of instinctive violence, a certain propensity to pathos, an unrestrained love for mystery and adventure, all of which necessarily predestined him for that tremendous laceration of the imagination which was Surrealism. His spirit of rebellion drove him to batter down in his frenzy that door that separated him from the unforeseen dimension of the world, to plunge headlong down the hill of the Freudian dream world..." Finally,

the same writer states: "To achieve this, Dalí did not hesitate to renounce all his elegances and virtuosities. Or, rather, he succeeded in translating them into the new structure and significance of his works." It would be useless to attempt to understand Dalí, as a person and as a painter, without knowing his geographical and family circumstances. It would be meaningless and gratuitous to form any judgment that did not take into account his personality and character. But it would be equally unwarranted to do so —from 1929 onwards— leaving out all mention of his enthusiastic commitment to Surrealism or playing down the importance of that explosive, destructive, fruitful and wholly reckless irruption of youth into the history of culture and art. Was Surrealism a failure?

This is a question many people must have asked over the last twenty or thirty years, but perhaps it is one that evokes Byzantine, polemical and equivocal answers. The contradictions inherent in the very essence of this movement, in its political purposes, its combative strategy and even the formulation of its dogmas, made it quite unviable and condemned it to certain failure, if by failure we mean the impossibility of adjusting the disproportion between eager purpose and tangible achievement. No one movement, not at least since Romanticism, has had such a decisive influence on the life, the arts, the letters, the very style of its time —or has set ringing, in consequence, such decisive echoes in the future, a future which is now the present. In its political aspect it certainly failed, except in the revolutionary character of its destructive revisionism; in literature, painting and sculpture, and in the shadows they cast on daily life, Surrealism was an active force, a revulsive, a fountainhead of inspiration and a general blind striking out at the world with unheard of energy and aggressiveness.

By reason of his generation and his temperament, the torrent that was Dalí was predestined to rush into the choppy, troubled, destructive and yet prolific waters of the great river of Surrealism; and so it came about. And when Dalí gradually drifted away from orthodox Surrealism, he was still marked for ever by the experience —all the more so because, if Surrealism could be described as a disease, it would have to be admitted that Dalí has been prone to it from birth; he is, as it were, a chronic Surrealist.

Whenever any aspect of his painting, his attitudes, his writings and declarations or his behaviour proves difficult to understand, it is not a bad plan to look at it in the light of Surrealism. In this book, apart from a few exceptions, I have endeavoured not to use this light explicitly, but I trust that the reader may do so for himself and that this light may help him at all times to distinguish all the different nuances in something that is presented here from a more down-to-earth viewpoint, from a platform more acceptable to the general reader.

73

73. Gala's feet.
74. *Ampurdán Landscape*; Indian-ink blotches, 27×52 cms.

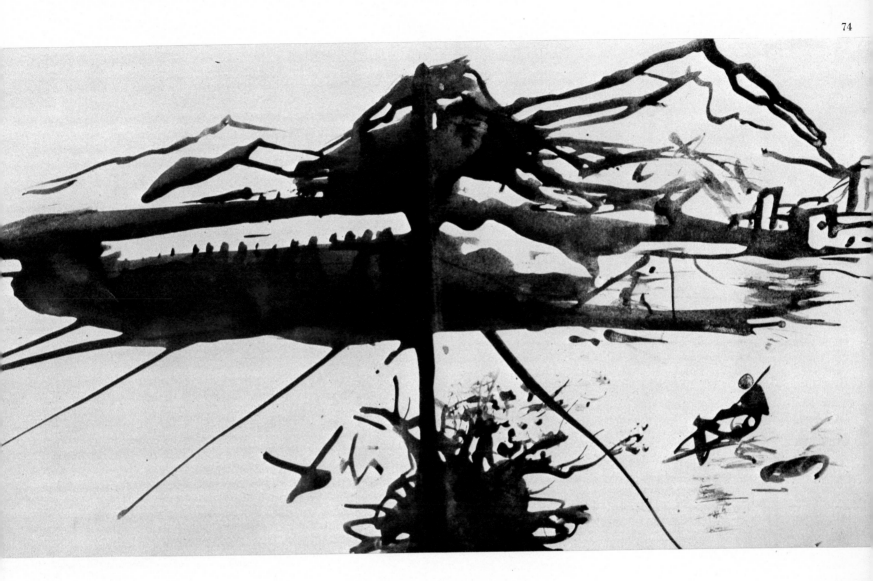

"Como si fuera un

desde el principio

Primero: El
por su M
en el amor a la Madre Pat

Segundo :
que le enseño de pequeño todo lo que sabe

tercer:
de mi vida asegura
el Triunfo

Cuarto: E
de Nuestr

en el Franco que im
momento preciso en
PINTABA "LA HORA DE LA MONARQU

"PROLOGO" **Sólo si**

hubiera hecho constar CRONOLÓGICAMENTE:

A irreverestesico de Dalí

de E ... que en el momento de su Muerte se sublima

... ... a su Profesor Señor Nuñez

... pasión, que en el momento mas peligroso

existencia "Tanto física como moral i

MAXIMO

genio olimpico, Velazquen... sosegado

... Monarquia ... GENERALÍSIMO

... y su modesto servidor ... sueño de Dalí

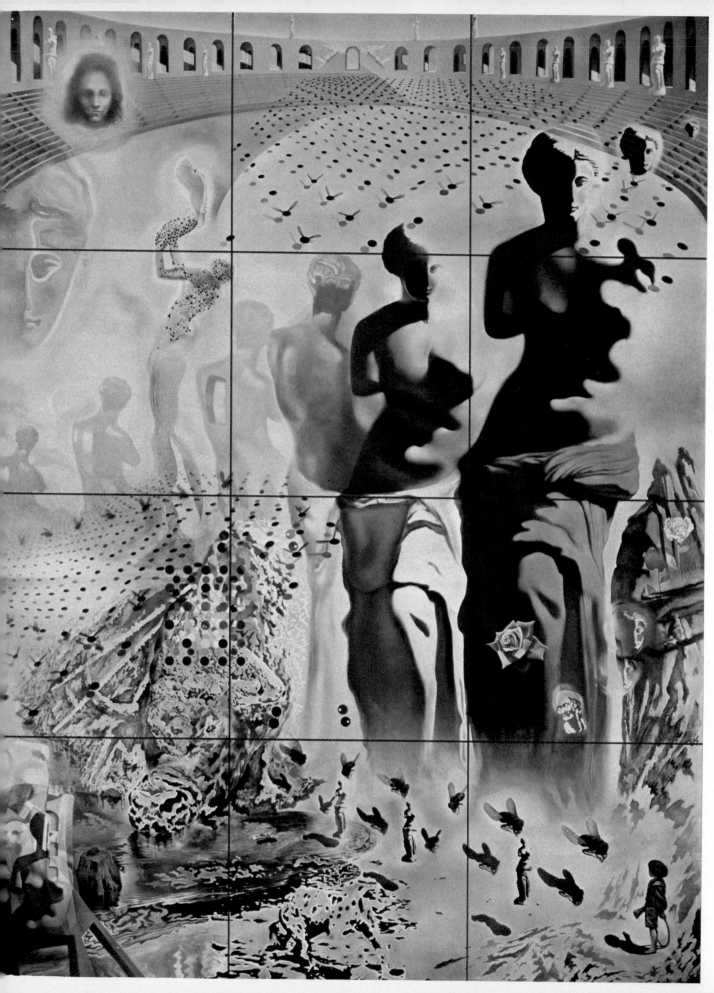

75. *Hallucinogenous Bullfighter*
in sections one metre square

I say what your person
And your pictures say to me
(Federico García Lorca,
Oda a Salvador Dalí. 1926)

When we say that Salvador Dalí is one of the most extraordinary characters of our time, we are not revealing anything new; even his detractors, however reluctantly, are prepared to confirm as much. That Dalí is one of the few great painters of this disconcerting century seems likewise evident enough, though those same detractors may begrudge him such high honour. Both as a man and as a painter —and there is no necessity to make too much of a distinction between the two— he has achieved universal fame and success.

What is the secret of Salvador Dalí? Could any mere eccentric, however talented and ingenious, hold the attention of the public and attract the interest of the world's mass media if he were not also an exceptional painter with a remarkable personality (1)? Can there be a dissociation between his attitudes, his writings or his declarations —in a word, his perpetual *happening*— and all that he has painted and drawn? The first of these questions, which is the real one, is answered by the negative reply implicit in the other two.

The secret of Dalí, the secret of his success and of the fascination that he has for so many people, should be sought in his painting and in the close bonds that exist between his painting and his personality. And it is not very cogent reasoning to argue the fact that in those comparative tables of excellence which he has drawn up in some of his books, for the purpose of establishing the artistic 'standing', so to speak, of various painters (including himself), we do not find the full measure of his authentic personality.

Thus, in the work entitled *Fifty Magic Secrets for Painting* he awards himself nineteen points out of a maximum of twenty, while Picasso receives seven and Mondrian is fobbed off with three and a half; in another of his books, however, he gives only three points out of ten to Dalí the Surrealist painter, though increasing this score to eight for his later work. That faithfulness to oneself that we are accustomed (without too much attention to semantic accuracy) to call 'authenticity' is something that is reached by very devious paths, and a lucid, dispassionate analysis would produce the most unexpected results in each case. The personality of Dalí more often than not quite superficially treated in newspaper or magazine articles which are themselves aimed at a rather flashy success, has not yet been sufficiently analysed, has not been taken beyond the stage of insinuations, subjective and partial visions, or attempts which, whether on the right track or not, have been given up before being followed to their ultimate consequences. The ambition, conscious or unconscious, of all those journalists, photographers, radio or television interviewers, is to be somehow 'touched' and made more important by the Dalí glamour, just as Dalí himself (who is no exception to the general rule of famous men and, indeed, takes it to preposterous lengths) uses the interviewer for his own publicity purposes.

An extrovert in public and private, in writing or by word of mouth, loquacious to a fault in front of a microphone or a television camera, he is at the same time, and contradictorily, a great

76

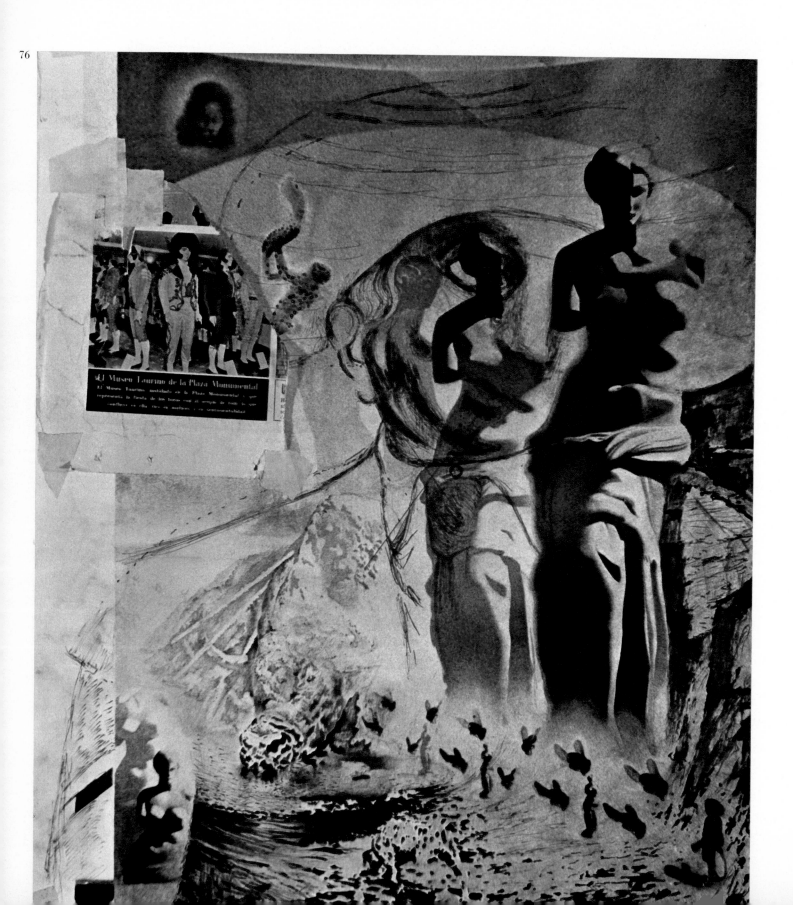

76 to 78. Tests, trials, progress... In the centre, Dalí posing in front of the unfinished painting, in a photograph by Meli to which the painter has added a few designs with a biro.

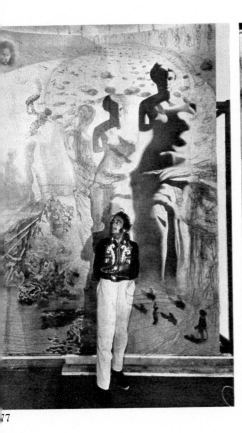

77

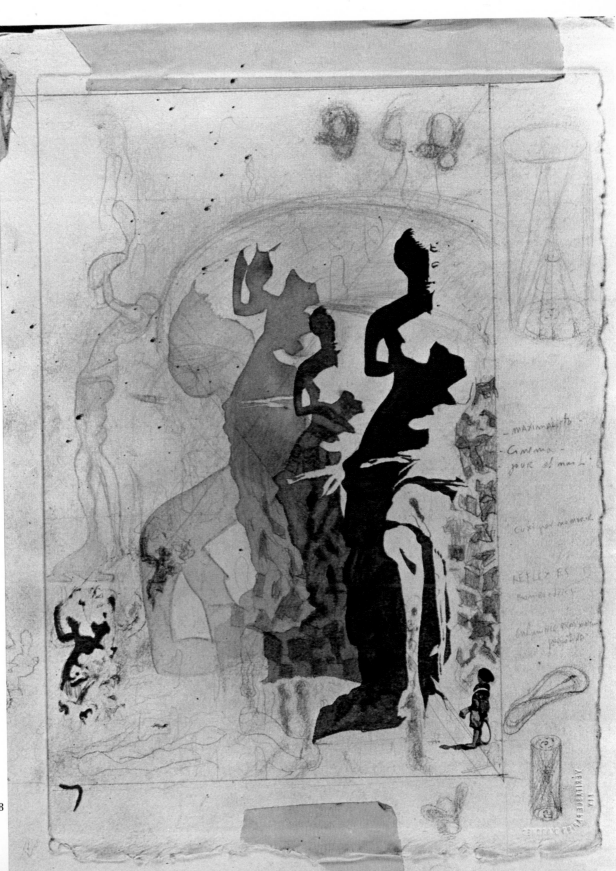

78

79. The child Dalí, detail of *Hallucinogenous Bullfighter*.

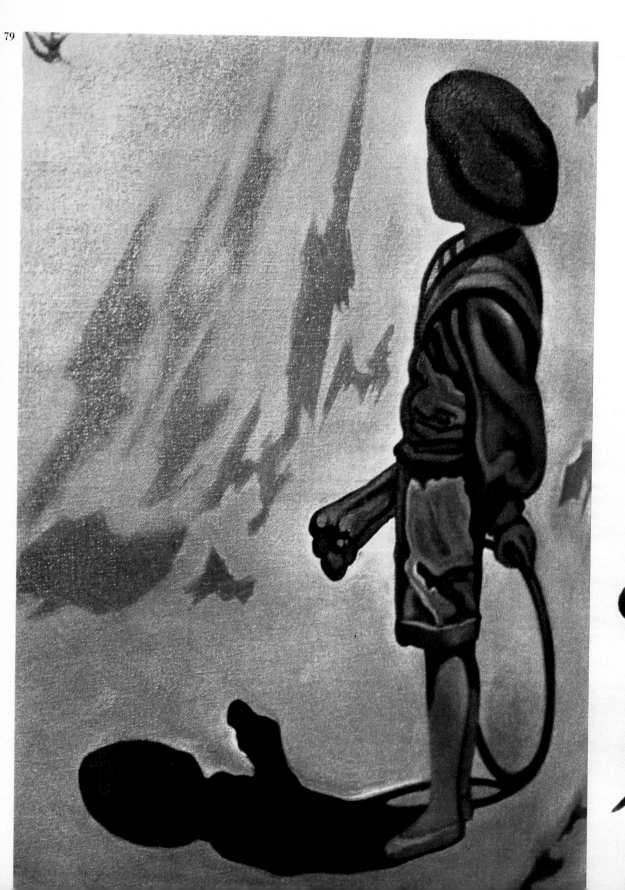

79

SEIS AÑOS DEFECABA EN

ïos MAS inverosimiles DE LA CASA:

JON DE LA BIBLIOTECA O EN LO ALTO

RMARIO. CORRIA DESPUES A LA SALA

E HALLABA REUNIDA LA FAMILIA i MEJOR SI

S: CRITABA! YA

HE HECHO! Y HUIA A ESCONDER

i CRIADAS ATRIBULADOS SE LANZABAN

O CESANDO HASTA ENCONTRAR MI

TESORO"

TINUADO HACIENDO ESPIRITUALMENTE LO MISMO PINTO MIS RELOGES BLANDOS

YA LO H HECHO ¡ME OCULTO ¡¡ ¡AHI¡ A ESO!"

80. *Hallucinogenous Bullfighter*, 1969-1970; oil on canvas, 4×3 metres; The Reynolds Morse Foundation, Cleveland.

80

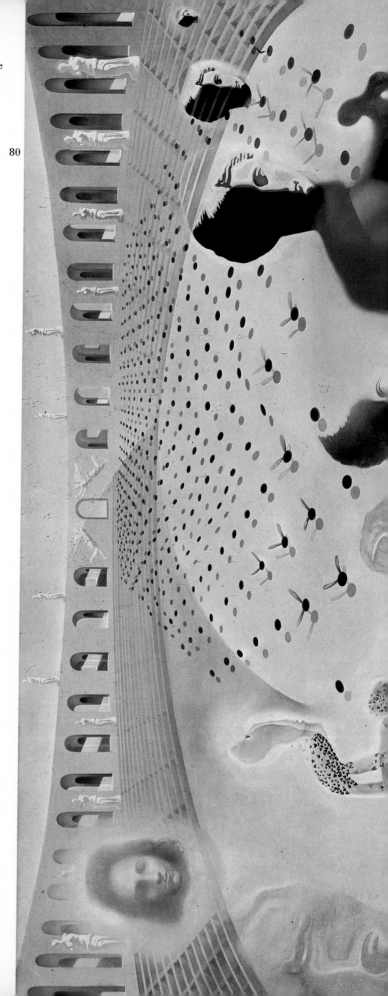

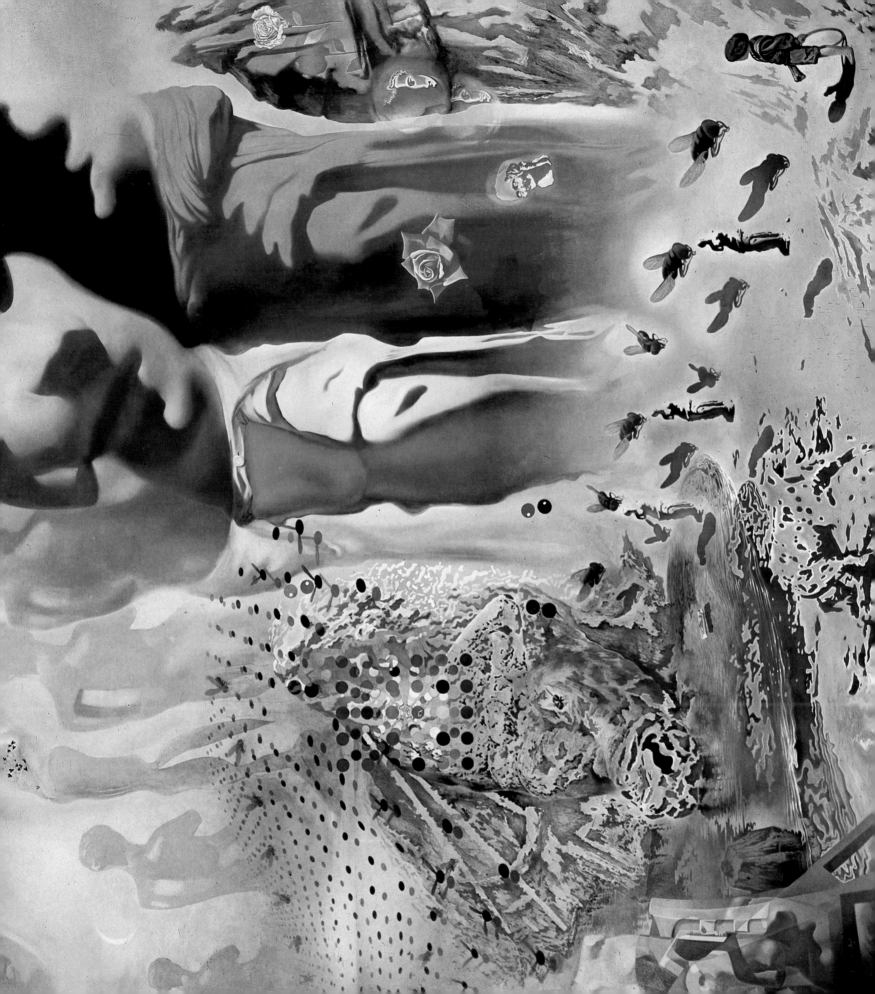

introvert, a constitutionally shy man who has overcome his shyness. The innumerable facets of this intense, overflowing personality, when they do not dazzle us, become part of a trick that verges on the impossible: behind the last of the facets already known or sensed, a new one will always rise, foreseeable or unexpected, which it will be impossible for us to classify as something quite unknown or as a repetition, distorted or not, of the ones we already know (2).

It might seem that Dalí exhibits himself in all his nakedness, that he hides absolutely nothing in his pictures, writings or declarations, such is the intimacy of every kind that he reveals. But this is not really the case, for, though he certainly reveals a great deal, and carries his audacity, sincerity or shamelessness to greater lengths than anybody else, what he reveals is never as total as he would have us believe.

It is as if a music-hall *artiste* appeared to be naked but was hiding her skin under tights almost invisible to the curious and lascivious eye of the spectator. But it is still more complicated: as well as real, brazen nakedness he puts on clever, well-disguised shams, and thus he manages to protect his ultimate intimacy by deliberately creating confusion.

But in Dalí, apart from these large doses of confusion and the conscious or unconscious para-doxes, there exist certain constants and these will be our central concern in this book, which has as its *leit-motiv* one of his greatest paintings, the one he was working on when this book was conceived —though the final product has developed somewhat away from our original idea. The study of these constants was an idea which, deriving from the painter himself, had already occurred to me; and *Hallucinogenous Bullfighter* is so rich in its implications that this scheme struck me as excellent.

"One only needs to look at a painting by Dalí to be convinced that, more than anything else, this painter has an inescapable vision which exists in a world invented by himself." This is Jean Cocteau speaking, and he adds: "Dalí is unable to choose; he lives in a closed world." This latter seems excessive, unless this ineluctable, closed world is conceived as being very extensive.

Dalí's enemies would claim that he repeats himself, he plagiarizes himself. I would go even further: Dalí copies himself. A prime example of this is the figure of the little boy in a sailor suit, with a hoop and a bone (instead of a stick), who is looking at something. This little boy is to be seen in the lower right-hand corner of *Hallucinogenous Bullfighter* and he is placed in a particular setting. What is he watching, this little boy who is in fact Dalí himself? He is looking at everything: at the Venus de Milos, at the bullfighter's face, at the cliffs which surround him and become the skirts of the Venuses which, in their turn, form the bullfighter's cloak, green tie and shirt, and further on reappear in the shape of rocks which form the bull, with *banderillas* in his neck, falling forward in his agony onto the sand of the arena, and this is the limpid water of a little bay near Cadaqués.

All of this is expressed in a brilliant pictorial game which constitutes a display of interlinked metamorphoses. He is also watching the lonely bather, the flies, the roses and the head of Voltaire which form the embroidery of the cloak, and the shadows of the small Venuses which turn out to be silhouettes of the peasant woman from Millet's *Angelus*. And he looks at Gala, whose head, lumi-nous rather than illuminated, is in the opposite corner of the painting, a portrait part real and part imagined which occupied him for a great many hours as if none of his repeated attempts could satisfy him. It is a face which does not belong to Gala as she is now, as she was then, or as she has

ever been; it is his abstraction of Gala, his Gala idea.

The boy in the sailor suit, this self-portrait that the painter is so fond of, appears in many of his earlier paintings. The most widely known is *The Spectre of Sex-appeal*, painted in 1934. So does Dalí repeat himself? Does he copy himself? This cannot be maintained with complete certainty just because the identical image —probably reproduced with a photographic model in mind— is found in one or more other paintings.

By varying the composition, and thus the setting or circumstance, the image of this absorbed and meditative child-spectator changes in meaning and importance. His apparition in what I would prefer to call the Spectre of *Anti*-sex-appeal on a beach is not the same as in the present case, where he is found before the figures of the Venuses (which also form the bullfighter's face), the radiant head of Gala, and all of the painting's fascinating and hallucinogenous world. Nor is it identical with Dalí the child watching Dalí imagined as a Renaissance man in front of his easel, painting enigmatic aspects of a landscape where, as well as a ghost, one can clearly make out the tall Böcklin-like cypress trees from the School of the Christian Brothers in Figueras. Neither is it to be identified with Dalí in sailor suit and cap sitting in an abandoned boat on the beach at Rosas with a little girl who, in his 1936 painting *Paranoiac-astral Image*, is Gala.

We have already encountered this little boy with a hoop —though he is never playing with it— in an earlier composition, *Gala with Two Lamb Chops Balanced on her Shoulder*; not in a sailor suit here but in a school or summer smock and wearing a wide-brimmed hat to protect him from the sun. He is partly hidden by the broken parapet of a well which is in front of his present home, in what

was the nearest thing to a street to be found among Port Lligat's old fishermen's cottages. Here there is no spectre of sex-appeal, only Gala's face with the placid expression of someone sitting with her eyes half-closed in a spring or autumn sun and enjoying it. The boy with the hoop, in the hat and smock, is standing in a place which was then remote and primitive; there is nothing to oppress or embarrass or surprise him.

Dressed in the same hat and smock, this time almost microscopic in size and with an elongated shadow of him and his hoop produced by the setting sun, we see him in another painting of the same year, *Triangular Shadow*.

The diversity of circumstances in which he is presented changes our assessment and appreciation of this character and I interpret the continual presence of the little boy, a rare form of self-portrait, as a timeless signature, as a shout, or perhaps a whisper, in which the painter tells us: I have been here before!

We see another scene with a different intention in *Midday*. On the beach at Rosas, whose immensity is usually overstated or at least accentuated, Dalí, this time in his sailor suit, regards the skeleton of a solitary boat which stands out against the shoreline. With her back to us, sitting in the position that fisherwomen adopt when mending their nets, enigmatic and lost in thought, we see the figure of Llúcia, his old nurse, but without the hole in her back which he had given her in his archetypal creation, *Weaning from the Food Chair*, painted some time previously.

There are many paintings and drawings which include this child self-portrait, especially the series of splendid miniatures which he painted in 1936 and which have a nostalgic air, despite the fact that in all the engravings by which he is assessed Dalí claims he has been completely unsentimental.

By giving different meanings to the same figure in each work where he appears, Dalí avoids the danger of repetition and monotony. The total effect is that we feel a positive sensation every time we find the little boy with the hoop, as if the painter made himself known to us through an agreed sign, offering us a clue, helping to introduce us into the secret intimacy of the painting; or, even more, seeking our aid in unravelling it. Because this discreet call, this leading us by the hand down memory lane sets off —for anyone who knows the life and work of Salvador Dalí— a succession of reminiscences, associations and suggestions.

One cannot escape asking oneself the question: Considered from the point of view of art, how far is it permissible to resort to extrapictorial aspects in order to arouse these feelings in the spectator? It is difficult to assess any painting, whether it he yesterday's, today's or tomorrow's, from a purely analytic standpoint stripped of all subjective and extrapictorial impurities. This task, (which is to be praised rather than despised, since it is one —though only one— of the several ways in which a painting should be judged,) is served by those aseptic, surgical and pontifical critics who, with a beam of light or of X-rays, contribute not to the diagnosis of an illness, since none exists, but of the painting's health and vigour. Whoever stands and looks at a painting must see it as a window open on a world different from his own, one with which he wants to communicate and which he wants to question, because in communication there are more questioners than answers that are received.

Resorting to imagery which, although rough and ready, is nevertheless enlightening, it could be said that Dalí does not repeat or copy himself; he utilizes his own materials taken from his psychic and pictorial world, materials which belong to his personal cosmogony. One could compare him with Balzac, whose characters appear in various novels bringing a consistency and unity to the whole.

The works of Dalí would form a kind of *Comédie humaine* in paint, mingled with subconscious imagination and a raging sense of urgency. In his paintings he leads us into a world discovered and interpreted by him and transformed into shapes, characters and scenes which reappear again and again.

Hallucinogenous Bullfighter would admit, as a partial definition, comparison with a work of architecture constructed from noble materials salvaged from the demolition of sumptuous buildings designed by the same architect, worked by identical craftsmen, carved by one single sculptor. However, in this case an extra benefit accrues, for the materials of construction have been acquired without demolishing anything.

The evocation of infancy, which is personified in the boy with the hoop, appears in different elements found in his work considered as a whole. Going just a little further back in time we have to take note of another little boy, ill-defined more often than not, a mysterious, distant figure which is to be found in *Imperial Violets*, *The Hour of the Chapped Face*, *The First Days of Spring* (the painting which the poet Robert Desnos wanted to acquire), and more clearly in *Atavistic Vestiges after the Rain*, where his father leads him by the hand —(in other works it is a woman, his mother or nurse)— through a deserted countryside, or beach or plain, a child still lacking in will-power, defenceless in a world which, like a suit made to fit an adult, seems too baggy for him.

In referring to landscapes, so important in the works of the painter, we must realize that these scenes —the Ampurdán plain, the bay at Rosas, Cadaqués, the coast at Cape Creus, and Port Lligat— which have influenced him throughout

his life, physically and geographically as well as symbolically and metaphysically, are firmly rooted in the intimacy of childhood and youth, and form a principal part in his conception of the world.

In this book we shall not seek a profound, exhaustive analysis, not even in general terms, of the works, much less the personality, of Salvador Dalí (3); by choosing inlets which afford us an access, we shall enter into his pictorial ambit and thus open for the reader his private, restless universe, always rich and thought-provoking, of which he is the creator and sole master. We shall be sparing both in praise and blame, and the little of either that does appear will not be through carelessness but rather because the author has no good reason to maintain a position of dispassionate objectivity; moreover, the fact of having dedicated time and effort to the compilation and writing of this book already expresses an obvious stance.

In 1948 Dr A Oriol Anguera published a shrewd work entitled *Lies and Truth of Salvador Dalí*, which he promised to follow with more substantial and better documented studies. In it he stated: "In his painting Dalí conceives within a Freudian framework which he constantly uses just as someone who is short-sighted constantly wears his spectacles. And since Freud's articulated imagery serves to trigger off his deliberations from subconscious, erotic depths, Dalí, whenever he wants to, looks for and finds unconscious and libidinous sources which nourish his paintings..."

Without denying the interest of Dr Anguera's analysis, I would say myself that his excess of scientific rigour leads him to many questionable conclusions among some evident truths. I would dare to add that another psychologist, Dr Romaguère, when he writes about Dalí from his point of view, suffers from a similar defect, because the systematic application of rigid theories can complicate, for the lay reader, even the most

simple and obvious truths. It may be that Dalí, sometimes more consciously than others, uses a Freudian framework, but every generalization is dangerous (4). When I started this book, it occurred to me to make a list of Freudian symbols; I confess that it has been of no great use to me, although I have not spurned or completely rejected it. However, in the paintings which I am considering, those with the little boy, I fail to see either the workings or the consequences of the Freudian framework.

The evocation of infancy, one of the constants in Dalí's work, rather suggests nostalgia for a happy, uncomplicated childhood, under the sign of a loving mother, shielded by the protective figure of his father, the public notary of Figueras and Cadaqués. Even today, for the people of the village, the latter is 'Señor Dalí', because the painter is 'Dalí', just 'Dalí'. Considering the period when many of these paintings were produced, a time when the relations between father and son had been broken off, could we trace in them veiled allusions to a *paradise lost?* The shadows cast by the little boy with the hoop and the child with his father —who is pointing with his finger to signs belonging to an enigmatic world— are not the shadow of Freud but of these very figures at dusk, the hour when don Salvador Dalí Cusí would take his son for a walk outside Figueras, on the beach at Rosas or along the shore at Cadaqués.

William Tell is a link belonging to the same chain as Guzmán the Good, from the *Manual of the History of Spain*, as Saturn, as Abraham, from the schoolbook *Sacred History*, all of whom figure in the canvases painted after Salvador, the son, had shaved his head and, instead of the apple, placed a sea-urchin on his egg-smooth head (5). And, while not forgetting that —whether intentional or not— Dalí is a strongly autobio-

graphical painter, I further maintain that it is difficult to measure time in terms of before, or after. The child gripping his father's hand, dressed in his sailor suit, holding his hoop, or wearing a wide-brimmed hat, belongs to this relative *before*, although they were painted *after*.

The child-Dalí is the subject and protagonist of the hallucination, and this happens in a painting as recent as this one of the bullfighter. The child's figure is the most important and meaningful of all those which appear in this work, including the carefully worked head of Gala. This should not surprise us since we know that the man who painted it is egocentric in the extreme; he was the same as a child and, whether it be seen as a virtue or a vice, he has never changed.

We do not know much for certain about Dalí as a child; only rarely can one glimpse the ultimate secret of his infantile spirit. What has happened in his case is that legend and myth, with which he is closely related, have become superimposed on history in the memories of those who know him.

Regarding his sister Anna Maria, several years younger than he, he refers to her earliest years in terms of hearsay, or on the impulse of memories. Dalí recounts some reminiscences which he regards as false and others which, while more or less veridical, are the product of subsequent elaboration. But some photographs are quite telling, and certain of the facts and scenes which he describes are to be believed. For instance it may be accepted as true that Dalí was a singular child, shy, introverted and capricious, that he was doted on and greatly spoiled, that he loved his mother tenderly and that he admired his father who was to have such an influence on his later character and behaviour, both through inheritance and its opposite, that is, through similarity and the reaction against it.

And what of the stones, those stones that move and float in the air of this picture and which are found in great numbers in many of his oil paintings? Displaying exquisite craftsmanship and superrealism, they have, whether through paradox or foresight, an extremely urgent quality. They have rounded edges which are so perfect that they seem artificial, and they abound more than anywhere else in the painting of the bay at Cadaqués which (for this very reason) is locally known as the *Sweetdish*. The name of the beach led Dalí, as a child, to believe that it really was made of sugared-almonds, or some other sweets, and even today they produce in his mouth a suggestive, cathartic effect which, when translated into the fiction of the canvas, provides a touch of mystery which their oblique shadow serves to accentuate. It was during his surrealist —or his most surrealist— period that he used this motif with such great polish and delight.

Another of the themes which stand out in *Hallucinogenous Bullfighter* is the flies, which here are stylized and organized in formations of discs that cast their own shadows and which remind one of other paintings where their bodies decompose or re-compose, and in which Dalí seeks to explain the orgiastic and discrete nature of matter with its vibrant molecular structure. (He has said —but I do not know if it is his own idea— that the composition of the atom may be compared to a buzzing swarm of flies.) Besides the stylized flies are others treated with superb realism worthy of a primitive, like the one which forms the eye of the bull, or the line of them heading towards the boy spectator with an aggressive attitude appropriate to fighter planes.

Dalí, el sexo fósil
y
las piedras-confites,
y
semas, moscas

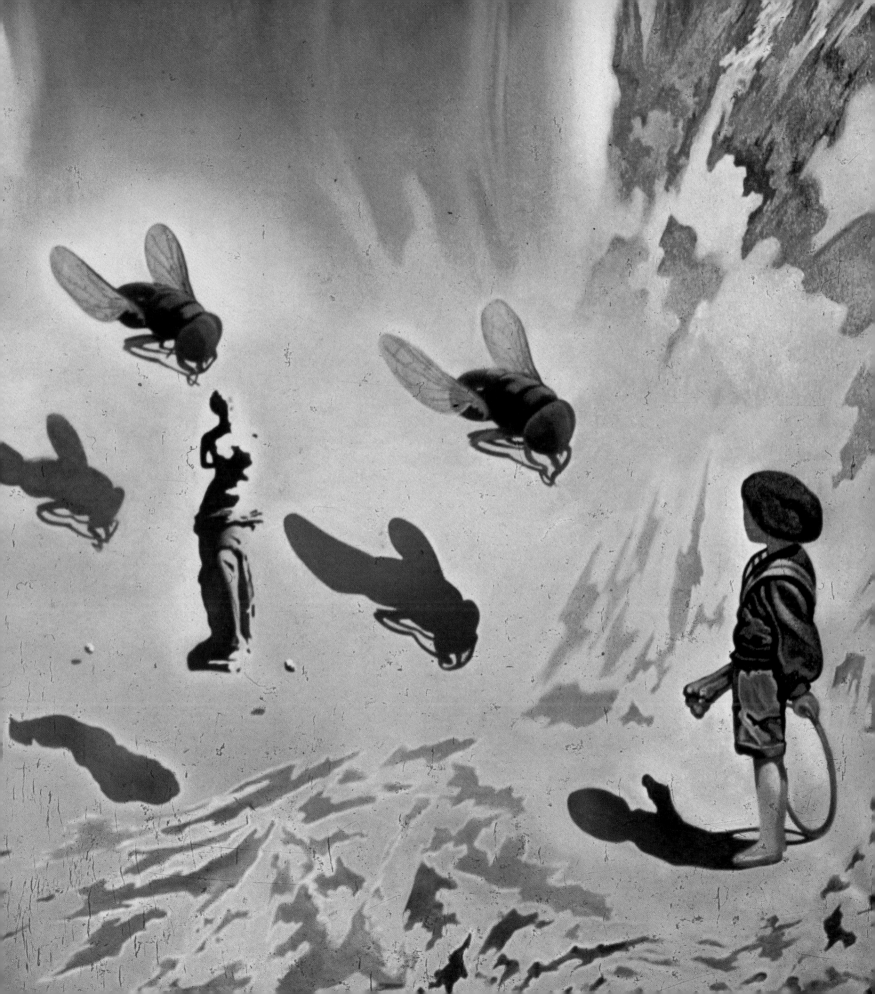

81. First section of *Hallucinogenous Bullfighter*.
82. *Gala with Two Lamb Chops Balanced on her Shoulder*, 1933; oil on plywood, 31 × 39 cms; private collection.
83. *Spectre of Sex-appeal*, 1934; oil on wood, 18 × 14 cms; Dalí Museum-Theatre, Figueras.

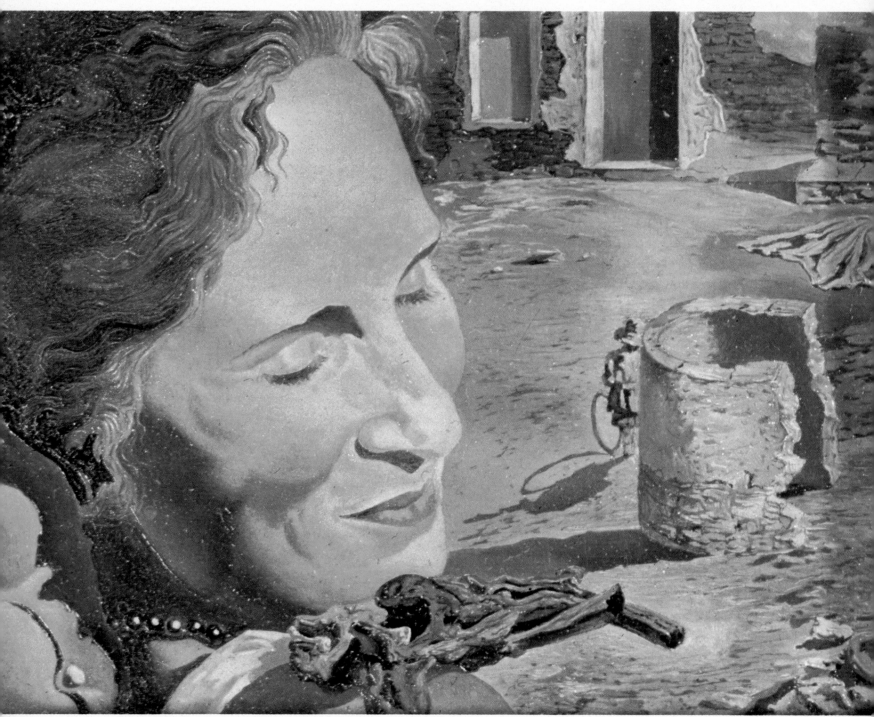

Flies and ants are among Dalí's favourite motifs. But their symbolic significance differs. "What do the ants mean?" I asked him on one occasion. "Death, decay..." But in the painting we were discussing there were no ants.

Spain has always been, and to a lesser extent continues to be, a country of flies. In a village like Cadaqués, where there is little water but a great deal of fish which is gutted on the seashore or at people's front doors, flies were obsessively present. Dalí has said a great deal about flies and has produced an apologia in *The Diary of a Genius* where he declares: "They are the Muses of the Mediterranean. They brought inspiration to the Greek philosophers, who spent their leisure hours lying in the sun covered with flies." Again, on another occasion, he said that he used to imagine Velázquez painting surrounded by flies. And when he allowed his moustache to grow to an extraordinary size, he attributed to it, among other virtues, that it attracted and settled flies making it easier for him to paint. The constant presence of flies possibly fascinated him during his childhood. Years later, at autumn time in Port Lligat, when he had worked until the late afternoon he would sit in the sunshine at the door of his house, with the fishermen nearby mending their nets sheltered from the north wind, and he would eat sea-urchins, which attract insects, and thus he could follow better than anywhere else their flight and their rapid and precise movements, for though catching flies is often considered a simpleton's pastime, it can also provide study for an acute observer.

The omnipresence of flies in Cadaqués —nowadays much reduced— was not the only thing that attracted his attention during that period of fixation of his ideas; one thing which contributed with greater force was the miracle of Saint Narcissus, the bishop of Gerona who was martyred

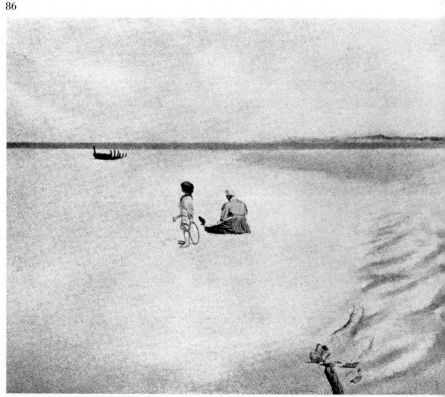

84. The well at Port Lligat.
85. *Dalí and Gala in 1933.*
86. *Midday*, 1936.
87. *The Three Ages: Old Age, Adolescence, and Childhood*, 1941; oil on canvas, 50×65 cms; The Reynolds Morse Foundation, Cleveland.
88. *Homage to Millet's Angelus*, 1934. The humerus of the figure on the right is the stick which the child uses for his hoop in *Spectre of Sex-appeal* and other works. Pen drawing, 19×12 cms. Previously Cecile Eluard Collection, now Reynolds Morse Foundation, Cleveland.

87
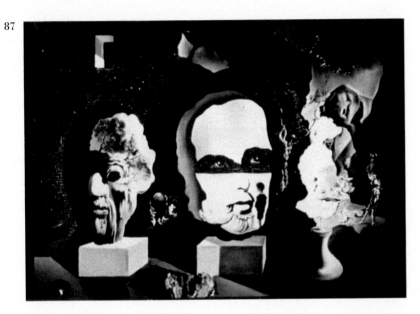

88
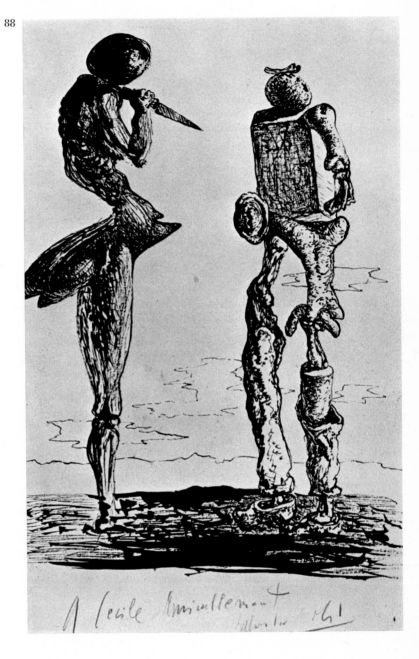

in 307 during the persecution initiated by Diocletian. He was greatly interested in this miracle, which he heard recounted by the women of the house, although this was tempered by an ironic touch resulting from the sceptical comments added by his father.

The uncorrupted body of Saint Narcissus is conserved in Gerona and it was endowed with the power to produce flies carrying horrible plagues whenever the occasion demands. If we are to believe Bernard Desclot and other contemporary chroniclers, this is what happened during the French invasion led by Philip the Bold, who was forced to retreat to France with his army and died while fleeing, as Dante relates. The miracle recurred on 12 July 1653 when Gerona was again besieged, this time by the French forces of Louis XIV. Colbert, an erudite minister, relates: "... your enemies produced the urn of a bishop saint of the city, and at once such a great number of flies arose and fell upon your army that all the cavalry was destroyed... and they were thus forced to raise the siege." (However, as if the French could not learn their lesson, a century and a half

89

91

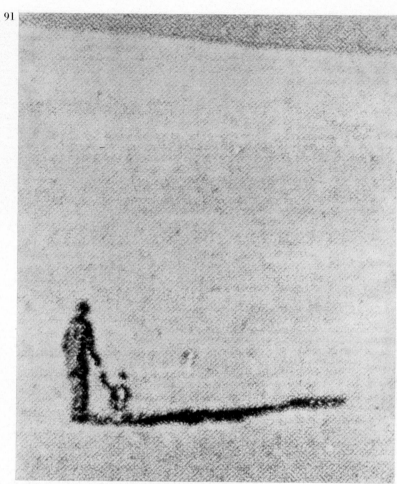

90

92

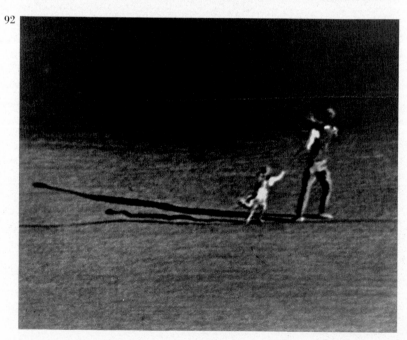

89. Detail of *The First Days of Spring*.
90. *Dalí as a Child, with his Father*, about 1971; Indian ink; private collection.
91. Detail of *The Hour of the Chapped Face*, 1934.
92. Detail of *Imperial Violets*, 1938.
93. When the notary don Salvador Dalí y Cusí expelled his son from home and family, the latter decided to cut his hair short and to place a sea-urchin on his head after the manner of the son of William Tell. Incidentally, he also had his photograph taken with a starfish on his chest.
94. *The Shadow of Night Advances*, 1931; oil on canvas, 61 × 50 cms; The Reynolds Morse Foundation, Cleveland.

93

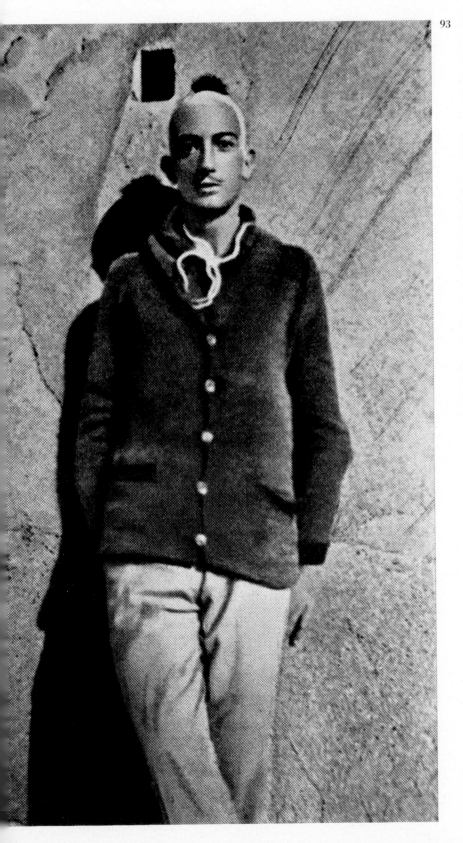

94

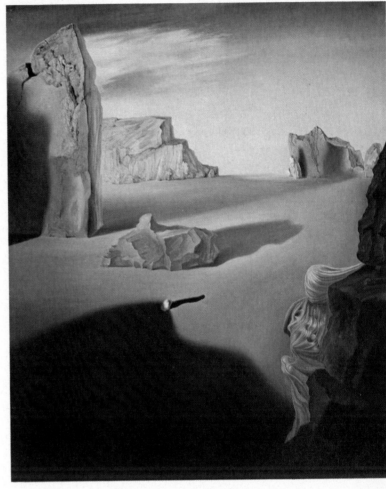

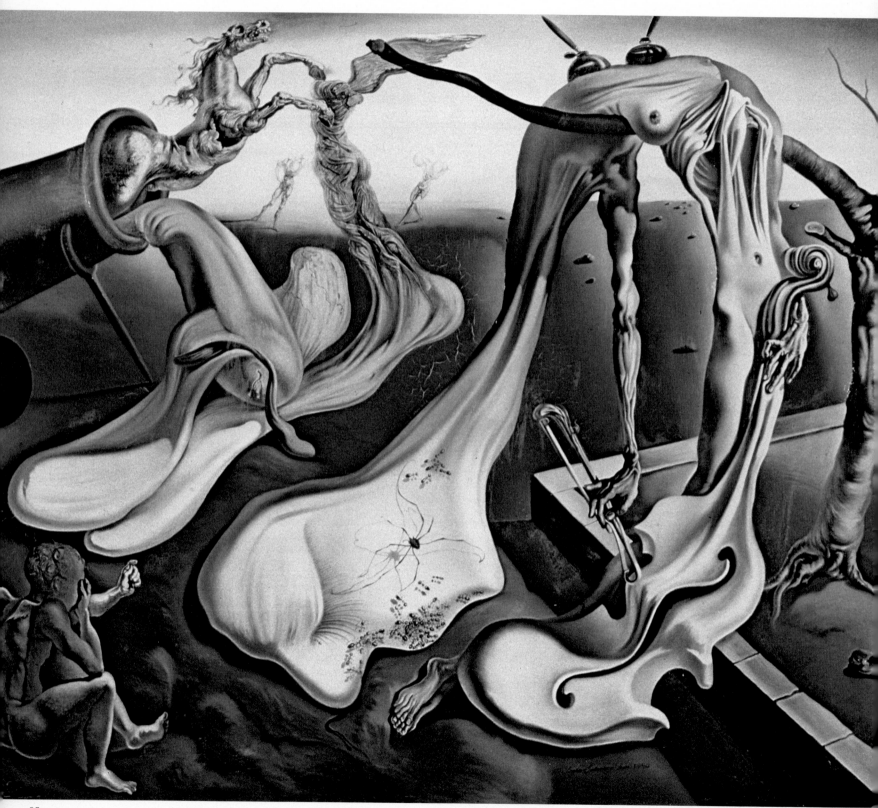

95. *Spider of the Afternoon, Hope!* oil on canvas, 41×51 cms; The Reynolds Morse Foundation, Cleveland.
96. Detail of *The Enigma of Desire*, oil on canvas, 110×150 cms; O Schalag Collection, Zurich.
97. Stone.

96

97

86

98. Detail of *Solar Month*, 1936; 60 × 46 cms; The Edward James Foundation, Brighton Art Gallery.
99. *Half a Giant Cup Suspended with an Inexplicable Appendage Five Metres Long*, 1932-1935; oil on canvas, 51 × 31 cms; private collection, Basel.

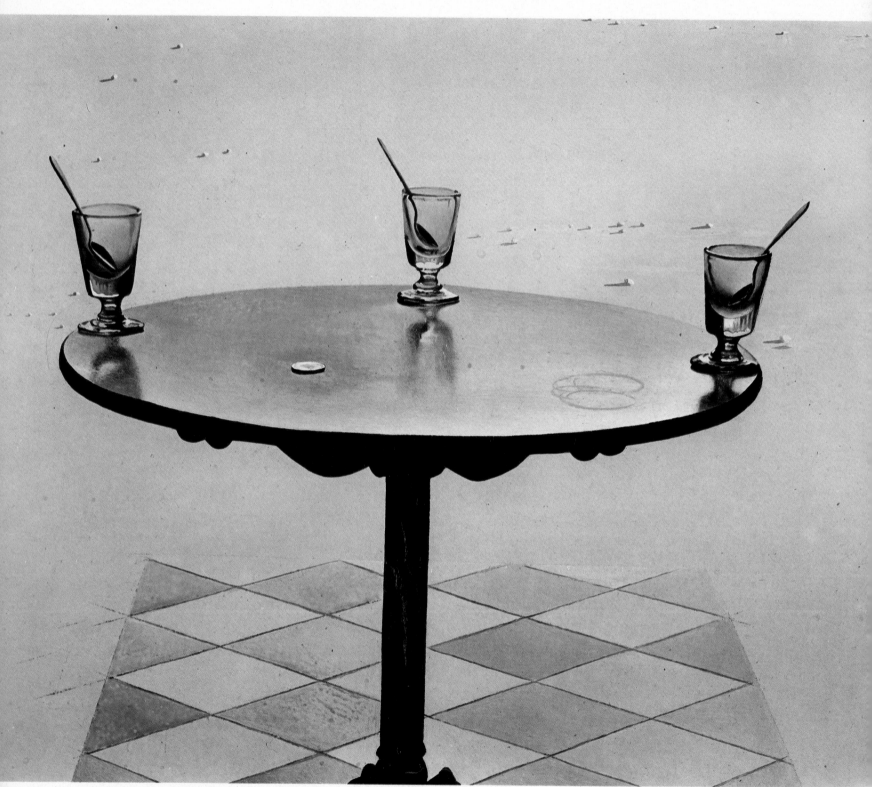

98

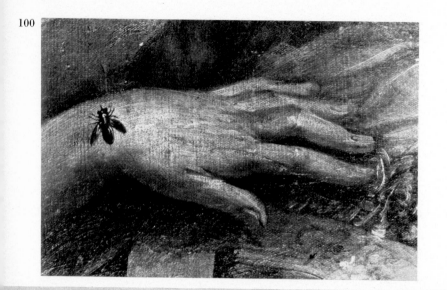

100

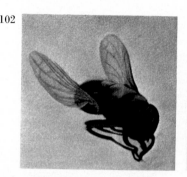

102

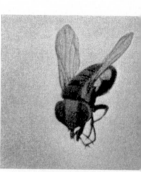

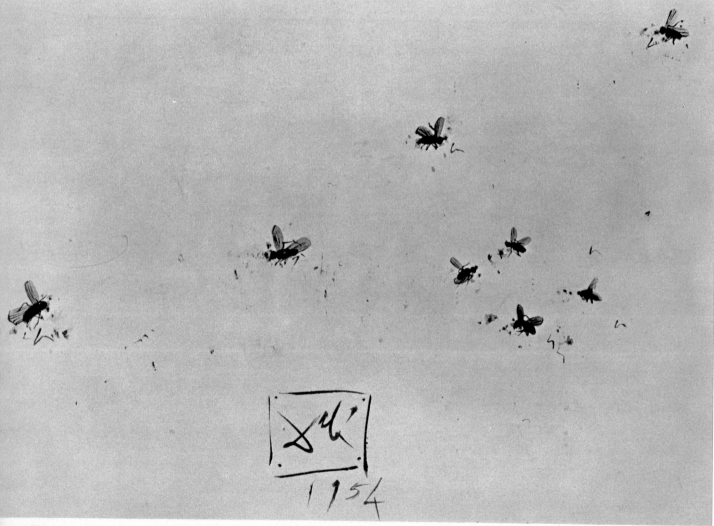

101

100. Detail of the hand of a French soldier attacked by flies of Saint Narcissus during the siege of Gerona by troops of Philip the Bold.

101. *Seven Flies and a Model*, 1954; pen drawing, 15.2 × 22.8 cms; The Reynolds Morse Foundation, Cleveland.

102 to 104. Various flies.

105. Fly of Saint Narcissus.

106. *Miracle of Saint Narcissus*, Gerona Cathedral.

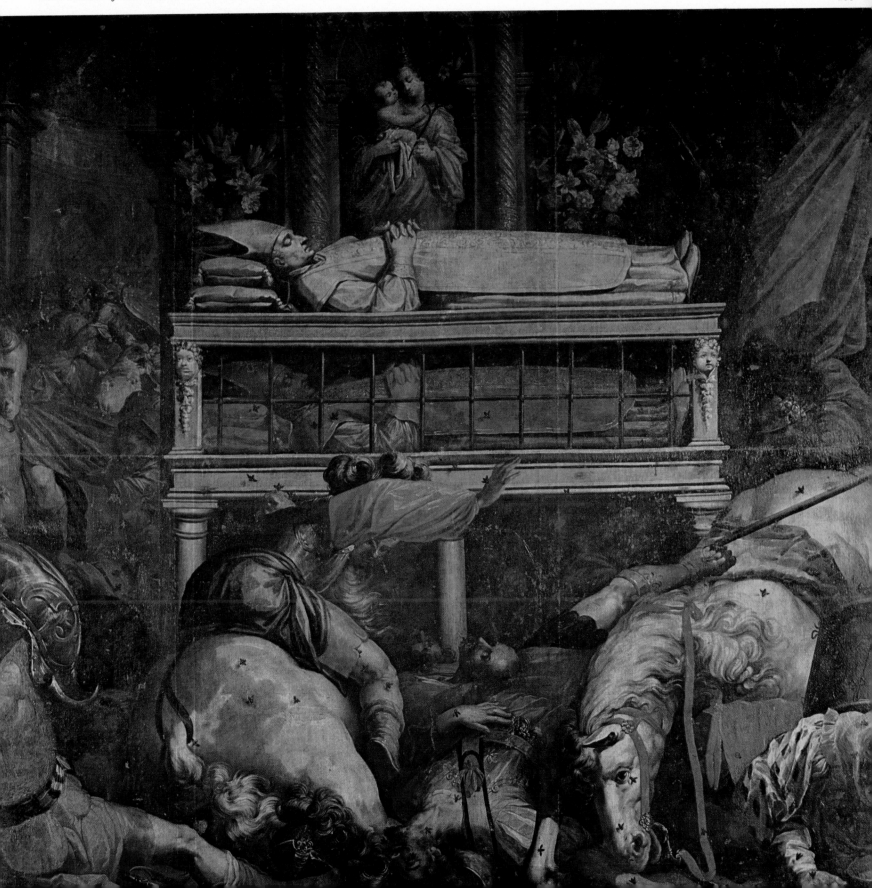

107. Fly from *Hallucinogenous Bullfighter*.
108. *Inaugural Goose-flesh*, 1928; oil on canvas, 75.5 × 62.5 cms; Ramón Pichot Collection, Barcelona.

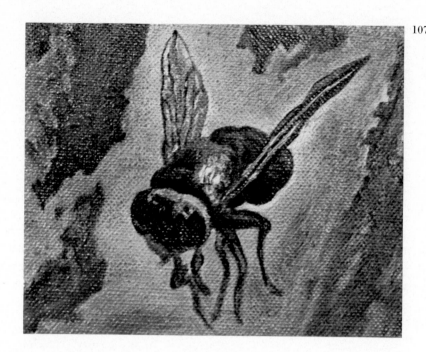

107

later the troops of Napoleon Bonaparte returned, and while the miracle might have occurred again, this time it was without success.) In Gerona there exists a painting which portrays this event with a realism similar to the photographic testimony of today. I am unaware what ground Dalí has for claiming, without asking himself whether they need one, that Saint Narcissus is the patron saint of flies.

One must not suppose that his fondness for flies and the curiosity which they arouse in him applies indiscriminately to all of them. In one of his writings he insists that he detests those of the town, preferring above all those of Port Lligat which he describes as belonging to the olive trees, even though, if truth be known, there are on the beach rotting fish and other mouldering remains much to the delight of the local fly population.

While we were discussing the present work, Dalí pointed out that it would be fitting to have our photograph taken surrounded with flies. The bait which he proposed in order to attract them in sufficient quantities for the illustration was such that I found it disagreeable, and so did Enric Sabater, who was to take the photograph. Artur the fisherman had been given the job of providing it and setting it in a suitable place, and I imagine that he found it even more disgusting. I did not show either surprise or disgust, but nor did I betray my resolve —which I had already made— on no account to get too close to the thing. Then the photograph was put off to the following day when it was forgotten altogether. I now tend to think that he was not so much interested in the photograph as in an opportunity to display his ironic humour and pragmatism.

By way of an appendix to *The Diary of a Genius* there is a short piece written by the sophist and satirist Luciano de Samosata entitled *In Praise of Flies*, in which he alludes to the eyes composed of parabolic curves. There are certain aspects of Dalí's preoccupation with flies which are of a scientific nature and I must confess that I am unable to comment on these since I have not studied them in depth. They refer in particular to the eyes and to the parabolic curves in which they are arranged and which he somehow relates to the roof of the station at Perpignan, that centre and fount of the Universe, that charismatic spot where he has made —by means of the creative fever which takes hold of him— momentous prophesies and discoveries. One of his large-scale canvases is called *The Station at Perpignan*. Neither the station nor Perpignan is explicitly represented, but I refer to this painting because we might find explained there something of what I have alluded to.

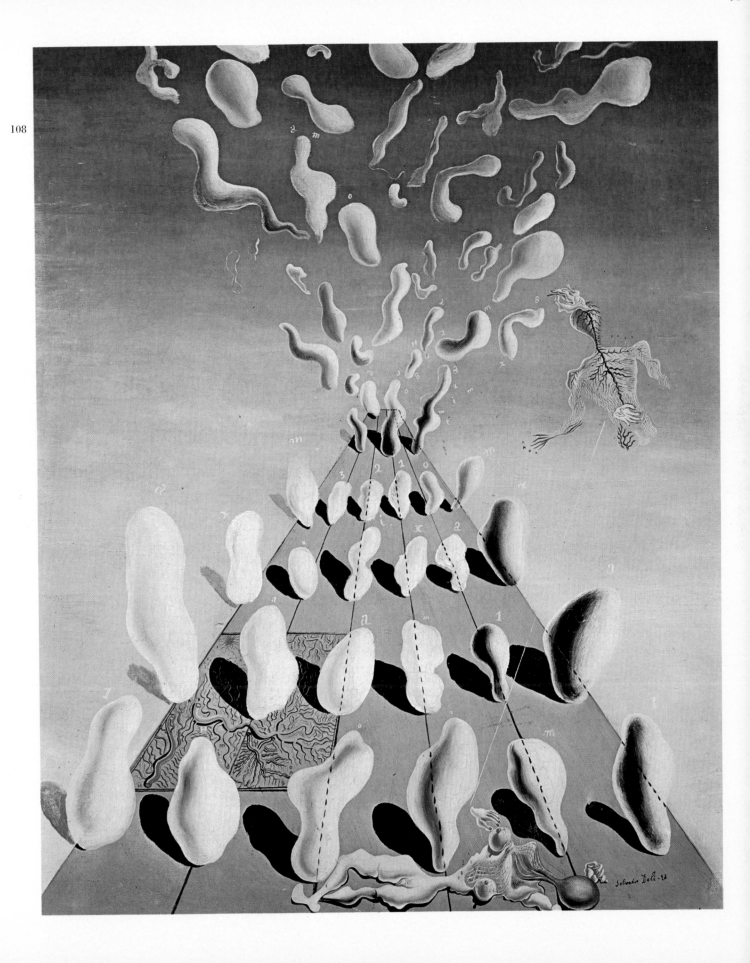

109. *Sfumatura*, 1972; paper singed and smoked with candle flame.

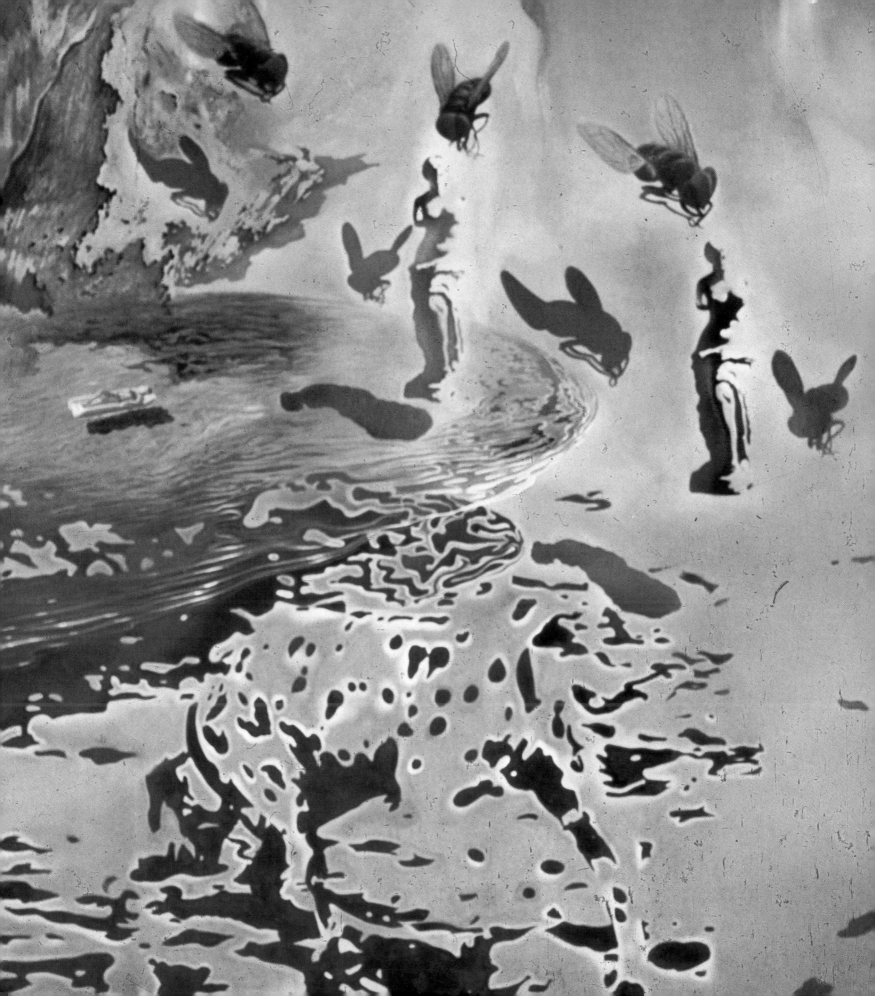

ICTINEO-MONTURIOL

SECCION VERTICAL por el eje. Fig.ª 1.

SECCION HORIZONTAL por el eje. Fig.ª 2.

Escala de 3 cm. por metro.

35

110. Second section of *Hallucinogenous Bullfighter*.
111. Plans for Narciso Monturiol's submarine *Ictineo*; Maritime Museum, Barcelona.
112. Multiple imaginary artistic impression of the *Ictineo* in the depths of the sea; Maritime Museum, Barcelona.
113. *Narciso Monturiol* (1819-1845), painted by R Martí Alsina (1826-1894).

In *Hallucinogenous Bullfighter* Dalí identifies the flies with a helicopter or, to be more exact, with de La Cierva's autogiro. Here again, in this identification, we find reminiscences of his infancy and youth, the periods to which he remains most faithful.

His enormous, boundless interest in inventions and scientific discoveries, something which he inherited from his father, leads him to concern himself with two Spanish inventors. One of these is Juan de La Cierva, who in 1923 succeeded, by attaching revolving cross-pieces horizontal to the line of flight, in producing an aeroplane which could land on a shortened runway. This machine is to be considered a forerunner of the helicopter, which moreover, of course, combines immobility in the air and vertical take-off. The other inventor is Narciso Monturiol whom, by his own admission, he admires to the point of envy.

Let us note first that he was a native of Figueras and that the street in which the painter was born was also the birthplace of his illustrious compatriot and is in fact named for him. Strictly speaking, Narciso Monturiol was not the sole inventor of the submarine, but he was one of the most outstanding of those who, throughout several centuries, succeeded in navigating under water. Another man who was successful in this was the Dutchman Cornelius van Drebbel, who in the first half of the seventeenth century persuaded King James I to board his submarine which was propelled under the Thames by twelve oarsmen. A century and a half later the Englishman Day died as a result of his own invention. Monturiol, who was of Ampurdán stock, was unquestionably a genius, and his contribution to submarine navigation deserves to be remembered. He had his successes and his disappointments, but his achievements were manifest. Tradition has it that he conceived and perfected the construction of his

113

submarine while observing the divers who fish for coral on the coast near Cape Creus. His memory still lives on in Cadaqués, the place to which he was banished. According to what Dalí has told me, a woman named Lola Litus put up her complete savings to form a limited company which was founded at the time for the construction of the submarine. Shares were taken up by many people from the area, from Barcelona, and from further afield. In the Ampurdán it must have been accepted as absolute truth that Narciso Monturiol was the inventor of the submarine, and we may surmise that Dalí's father and his friends in Figueras were admirers of this wise, persevering inventor.

98

114. The engineer Juan de La Cierva y Codorniu (1895-1936), inventor of the autogiro.
115. Autogiro.

114

It must be remembered that the *Ictineo* succeeded in remaining under water for several hours and reached a depth of some fifteen fathoms, and that this anticipated by several years Jules Vernes' fictional *Nautilus*.

The autogiro and the submarine are two Spanish inventions which fill Salvador Dalí with great pride. In terms of symbolism and associations, the autogiro, as the mystical device par excellence, represents man's most exalted, most angel-like facet: the sublime; whereas the submarine is the subconscious, sinister and ill-defined. Speaking of Spanish mysticism, which ascends vertically from the submarine to the heavens of the autogiro, Dalí has written: "My entire life has been determined by two opposing ideas: height and depth." De La Cierva's autogiro, Monturiol's submarine; Mazda and Ahriman, without any ethical implications; Apollo and Dionysus; the classical and the baroque; the Renaissance and Surrealism. The latter are the personal analogies of the author; only the first two are expressed by Dalí.

115

Where —one might ask oneself— is the submarine? Below the surface, and perhaps represented too by the dog beside the sea, composed of watery materials and reflections, for we know that a dog is lying asleep below the surface, which is deceptively smooth, like a sheet that can be lifted up. In general, the ultimate source of Dalí's dogs is Titan, a Saint Bernard belonging to the Pichots, a family whose members are present in his most intimate and poignant memories.

Dalí's entire *œuvre* oscillates between the autogiro and the submarine, between the sublime and the debased, between the extremes of beauty and ugliness, like a shuttle from the angelic to the satanic; the peak and the abyss. In many paintings and situations the balance is destroyed, producing confusion. And this leads one to ask oneself: Is the balance destroyed in some unconscious way while the painter stands at his easel in his studio? Or is it the manifestation of a conscious and controlled force which he drives so deep as to shatter the beautiful, to fling filth, disease and putrefaction against formal beauty and spiritual allusion in order to debase them? From what depths springs his current rejection of love and sex, given that he previously thought so highly of them (6)? Are echoes of frustrations at play here or is it a matter of atavistic regression to mediaeval Christian values, as if he were trying in his own way to revive outward aspects of the Dances of Death?

116. Drawing on an artist's palette, 1964. 29×25 cms; Fanny and Salvador Riera Collection, Barcelona.
117. Dalí as a child with a dog.
118. *The Night of Death*, 1934; Indian-ink drawing, 98.5×72.1 cms; Museum of Modern Art, New York.
119. *Horse*, 1922; Indian ink, 14.5×21.5 cms; Ramón Estalella Collection, Madrid.
120. *The Dream* (detail), 1937; oil on canvas, 50×77 cms; Edward F W James Collection, Sussex.

116

118

117

119
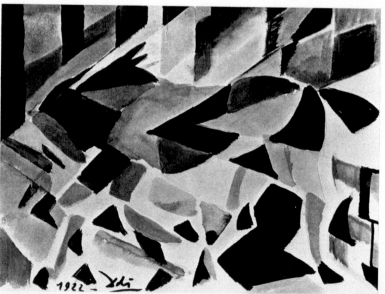

Nothing pleases Dalí so much as coincidence, to which he attributes a certain magical force. If sunshine is allowed to fall on the Venus de Milo when she is hung by a thread in a certain position, the resulting shadow is the silhouette of the peasant woman in Millet's *Angelus*. Mere coincidence would appear to make the splendid, carnal goddess retain some connection with the praying and apparently chaste French peasant woman, unless, as Dalí claims to have shown in his essay *Le mythe tragique de l'Angelus de Millet* (to which he attaches great significance owing to his application of the paranoiac-critical method) (7), Millet's entire *œuvre*, not just his early paintings, is filled with a violent sensuality which goes way beyond simple pornography. The book, in an excellent edition published by Pauvert, is the transcription of a manuscript which Dalí lost while seeking to flee from France after the invasion but which was discovered and published many years later.

Millet's paintings, especially *Angelus*, which is his most widely circulated and best known work, have been the subject of Dalí's constant attention, and this attention can be traced in one form or another in his paintings and drawings.

Millet the myth gives rise to Millet of the wheelbarrow, and Dalí has made cutting comments about it in speech and in writing and even in graphic form by transposing the sack into a woman inspired by one of the former's own drawings. (In this connection one should also consider the tragico-grotesque composition *Atavism at Dusk*.) We know that he worked on the script of a film, in which Ana Magnani was to play the lead, called *The Barrow of Flesh*, the story of a woman who falls in love with a wheelbarrow. In *Le mythe tragique de l'Angelus de Millet*, he points out certain aspects that this painting shares with cherries, which were fixed in his mind by a subjective and

121

122

103

121. Detail of the bather in the cove at Perona.
122. *The White Calm*, 1936; oil on wood, 41×33 cms; Edward F W James Collection, Sussex.
123 to 128. Rocks at Cape Creus.

129

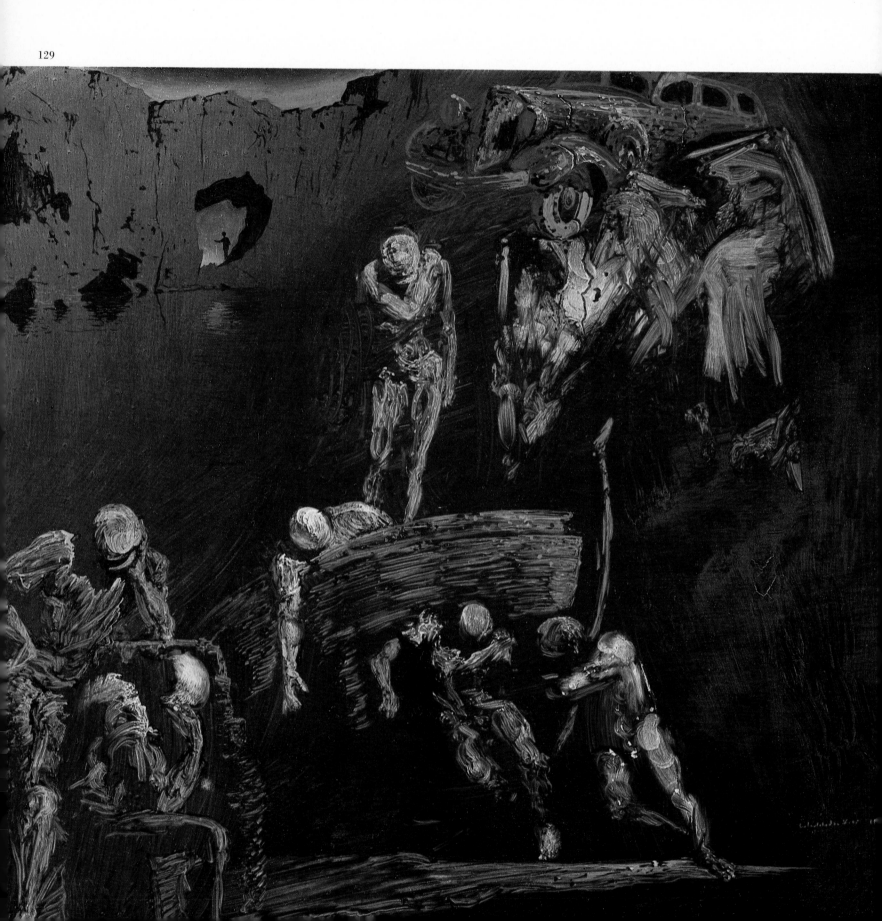

129. *The Fossil Car from Cape Creus*, 1936; oil on canvas, 31 × 37 cms; Edward F W James Collection, Sussex.
130. In their boat *Gala*.
131. Detail of *The Supper*.
132. Sailing with Gala, about 1958.
133. Beti, about 1912.

131

132

134. *The Return of Ulysses*, 1936; Indian ink, 24.8×37.2 cms.
135. *The Angelus*, by Millet; The Louvre, Paris.
136. *Archeological Reminiscence of the Angelus by Millet*, 1933-1935; oil on wood, 31.7×39.3 cms; The Reynolds Morse Foundation, Cleveland.

134

135

136
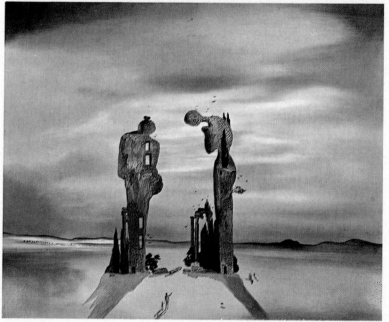

momentary vision of two coffee sets. These were on display in a shop window in Port de la Selva. The *Angelus* was reproduced on the coffee-pot and twelve cups of one set, while the other was decorated with cherries. These Dalinian associations come about by means of the paranoiac-critical method, and he attributes to cherries a powerful erotic force as well as the power to arouse the cannibalism (8) latent in all human beings. I am referring at some length to cherries, which in fact play little part in Dalí's work and none appear in the painting that is serving as our guide and script, although indeed there are two pairs of twin balls whose treatment reminds us of this fruit. The peasant woman is present only as a shadow, and even this is spurious for it really belongs to the Venus de Milo.

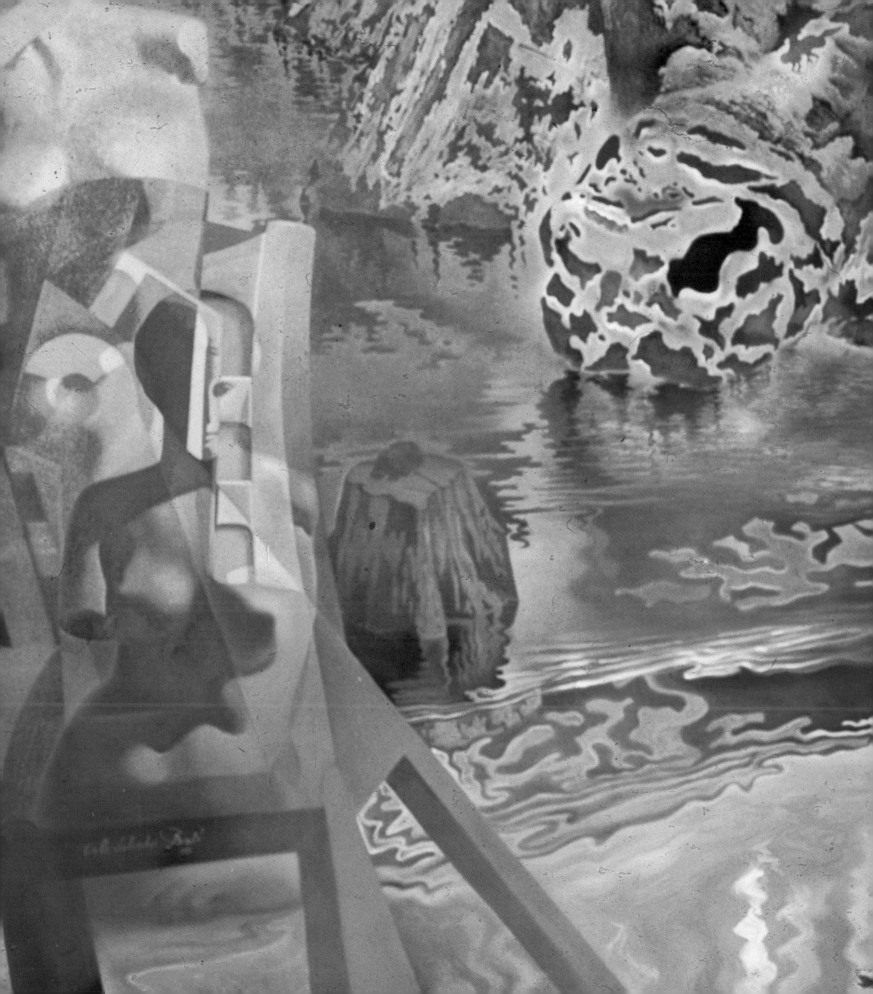

10

137. Third section of *Hallucinogenous Bullfighter*.
138. *Chair Constructed from Spoons*, 1970. Preparation for a bronze casting, 120×35 cms; M Berrocal Collection, Verona.
139. Illustration for *50 Magical Secrets*.
140. *The Eight-day Clock*, 1923; charcoal, 31.5×24.5 cms; Ramón Estalella Collection, Madrid.
141. *Still-life on a Chair*, by Juan Gris; Museum of Modern Art, Paris.
142. *All Shapes Derive from the Square*, 1923; ink drawing, 23×21 cms; Jordi Gimferrer Collection, Bañolas (Gerona).
143. *Cubist Self-portrait*, 1926; gouache and collage, 105×70 cms; private collection.

138
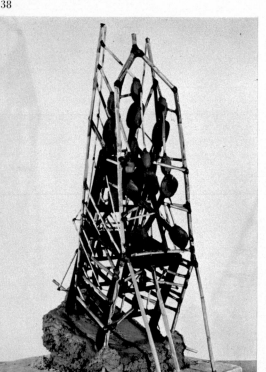

140

142

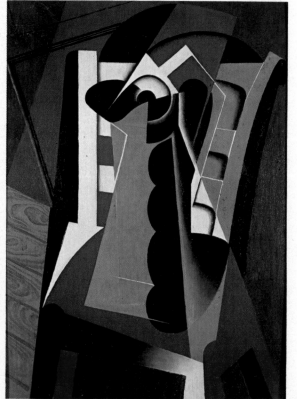

139

141

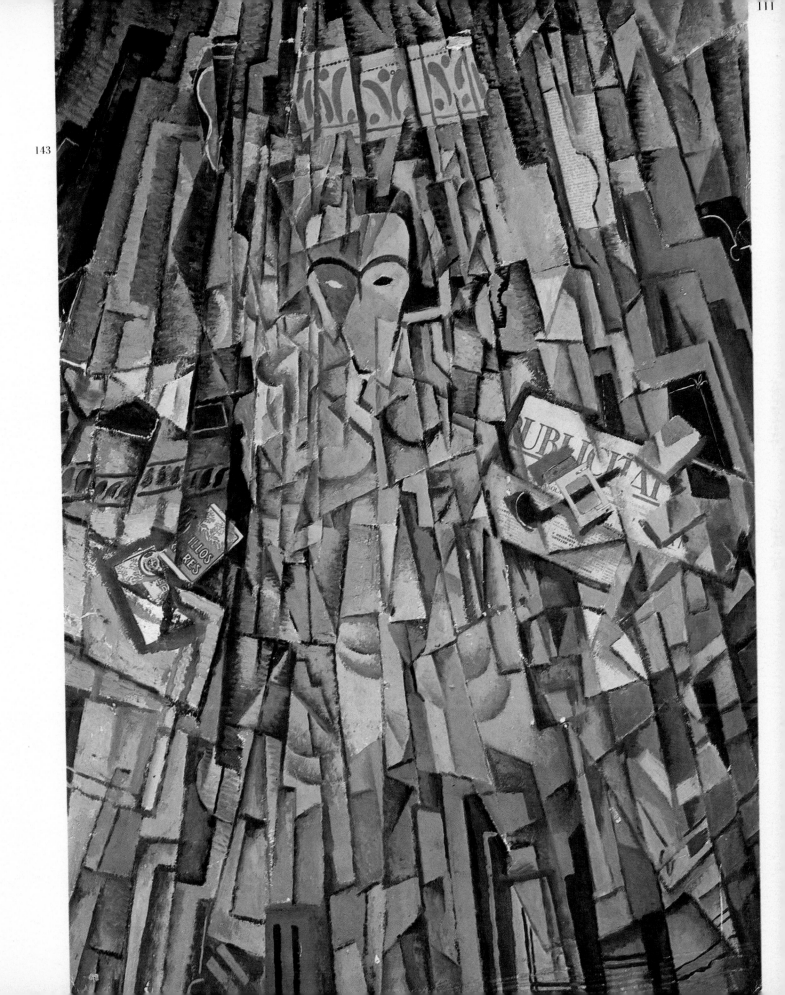

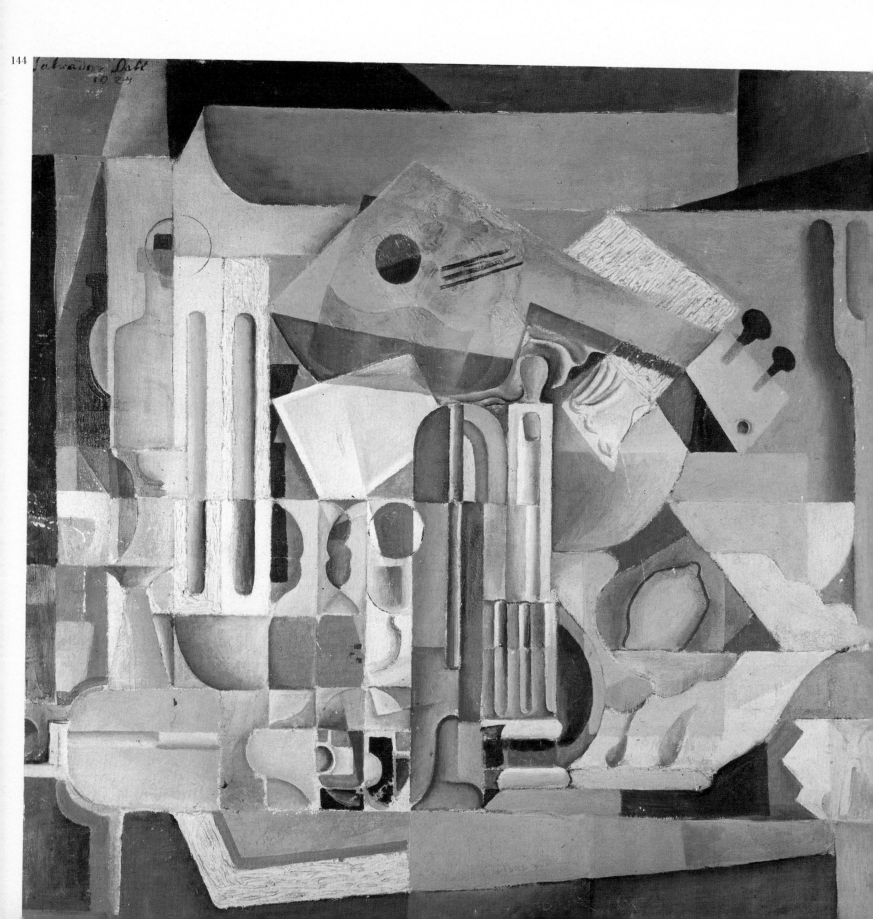

144

144. *Purist Still-life* 1924; oil on canvas, 100×100 cms; Dalí Museum-Theatre, Figueras.
145. Detail of *Head of a Woman*, 1927; oil on canvas, 100×100 cms; Dalí Museum-Theatre, Figueras.
146. *Anatomic Study*; charcoal drawing, 32×21.5 cms; Gustau Camps Collection, Barcelona.

145

146

In the bottom left-hand corner of the painting one can see a copy of *Still-life on a Chair*, a picture by Juan Gris which is displayed in the Museum of Modern Art in Paris. He has respected the water-jug of the still-life, but the cubist elements have been incorporated into the two torsos of Venus which he has added. The upper one, which is decapitated, seems to echo the metaphor expressed almost half a century before by García Lorca: "Venus is a white still-life."

The Cubist movement attained its greatest dissemination and acclaim during Dalí's childhood and youth. In Cadaqués Picasso reached the abstractive zenith of his Cubist trajectory in a painting which indeed bears the title *The Port of Cadaqués*. In his youth Dalí painted admirable Cubist pictures, and others which were inspired by Cubism but where he managed to capture and express his own conception of bodies and landscapes. Among the earliest which are known to us are *Purist Still-life* and *Pierrot and his Guitar*. Picasso stayed in Cadaqués during the summer of 1910, but Dalí has no memory of his stay, being still just a child. He admired him when he did discover him, allowing himself to be influenced both in his Cubist paintings and those of a different stamp and style. I have asked myself if there exists in Dalí's belated Cubism, apart from the understandable mimicry and the desire to protest which constantly arises in him — parallel to or identical

114

147

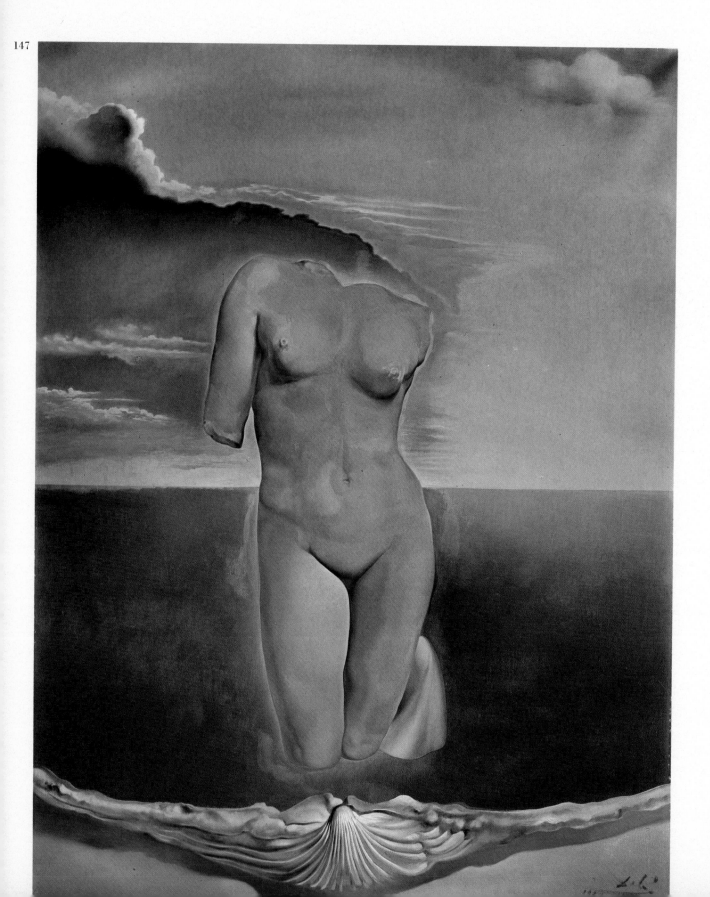

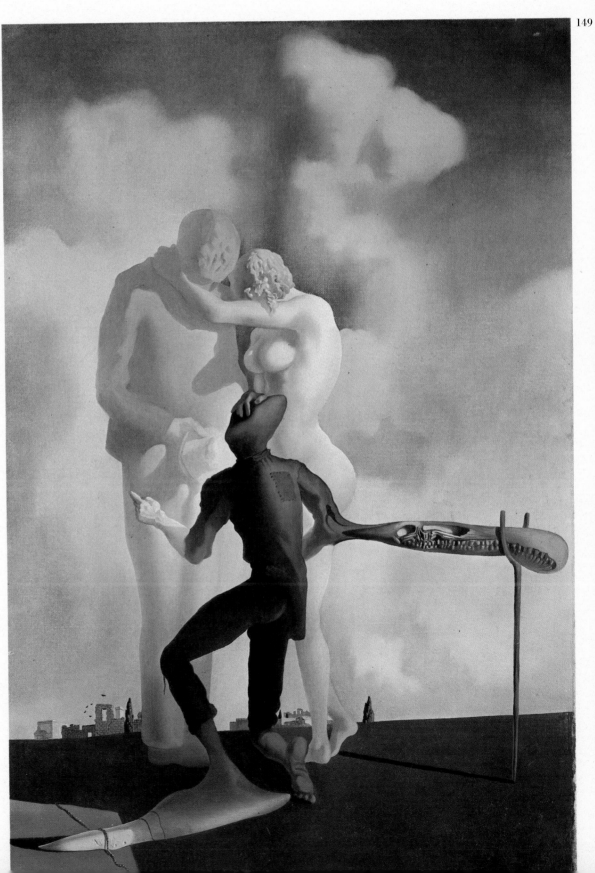

147. *Rhinoceros Goose-flesh*, 1956; oil on canvas, 93 × 60 cms; Bruno Pagliai Collection, Mexico.
148. Detail of *Meditation on the Harp*.
149. *Meditation on the Harp*, 1932-1934; oil on canvas, 67 × 47 cms; The Reynolds Morse Foundation, Cleveland.

150. *Cliffs*, 1926; also called *A Figure on the Rocks*. The landscape is Cape Norfeu, not far from Cadaqués. Oil on panel, 26×40 cms; M Minola de Gallotti Collection, Milan.
151. *Cala Nans Adorned with Cypresses*; oil on canvas, 40×50 cms; Enric Sabater Collection, Palafrugell (Gerona).

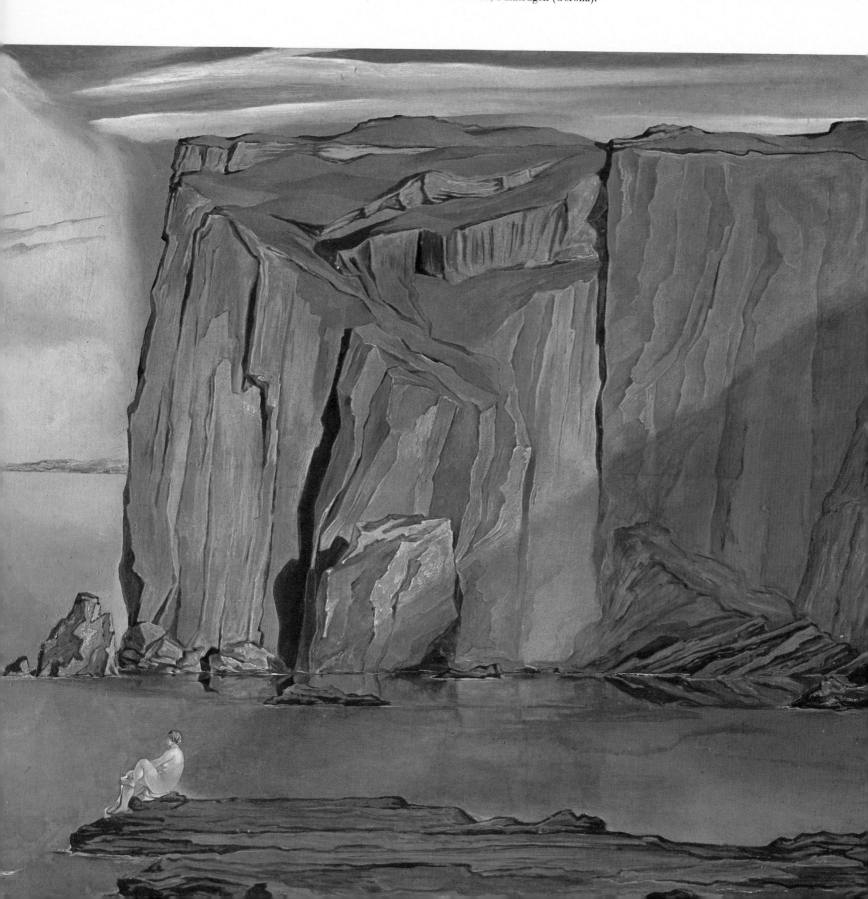

150

151

with his wish to shock, to arouse admiration, disagreement or rejection —a shrewd, satirical intent which may be glimpsed like a wry smile in at least some of these compositions.

I point out this trait of his because Dalí has a side which is witty, pungent, and full of humour, sometimes revealing itself in peals of laughter, sometimes in jokes and amusing references to people, present or absent, not even sparing those from times gone by. I remember a conversation when he explained, with many gestures and poses, how Michaelangelo used to prepare the walls with spit before painting his frescos. His sarcasm regarding Piet Mondrian is well known: by removing one letter from his Christian name he produces a play on words which is captured in some languages though not in others. Dalí is gifted with the shrewd, infectious humour of the Ampurdán, sharpened by his dealings with the fishermen (9) and peasants as well as with the clever people of all conditions and nationalities who form his constant entourage. This humour,

which runs the whole gamut from irony to slapstick, turns up evasively and disturbingly in his painting, is more conscious and obvious in his writings, and even more so in what might be called his public appearances — as a lecturer, or on television or radio. But he is at his most witty in private conversations or social gatherings, when his anxiety to put on a great show disappears, or at least is reduced to normal proportions.

He does not mind being called a clown; in fact he finds it quite flattering. Not many people could keep up a pose which, quite apart from his painting, has kept an audience amused for forty years! As a child his father used to warn him that if he didn't mend his ways, he'd end up like the 'Boy from Tona', a kind of wandering troubadour and cure-all who at the time enjoyed great popularity all over Catalonia. He made no reply, since he did not dare to admit to his father that nothing would give him greater pleasure than to end up (or start, for that matter) like the glorious 'Boy from Tona' (10).

One of the few people whom Dalí has admired, and one of the even fewer whom he continues to admire, is Pablo Picasso, although this does not hinder him from telling jokes at the other's expense. In an article to mark Picasso's ninetieth birthday in November 1971 Time magazine recalled a comment Dalí made in the course of a lecture given some twenty years before in Madrid: "Picasso is Spanish, so am I; Picasso is a genius, so am I; Picasso is a Communist, neither am I." Or again, while claiming that he himself was called Salvador because he was destined to be the saviour of painting, he maintained that Picasso was called Pablo, like Casals, like the Pope, "indeed, like everybody!"

He got to know Picasso on his first visit to Paris when he was accompanied by his sister and

152

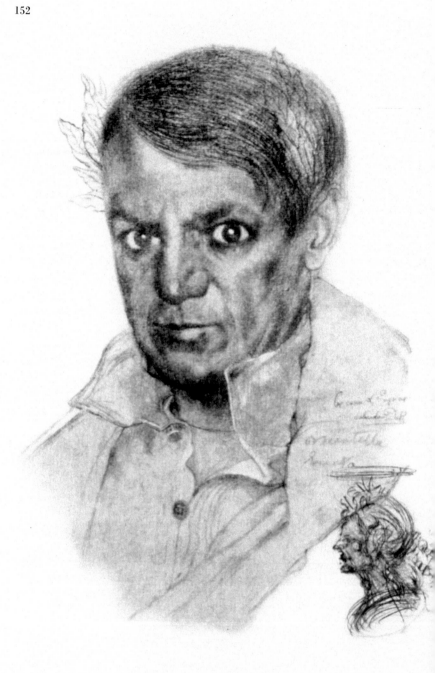

Picaso es comunista...
Yo Tampoco:

153

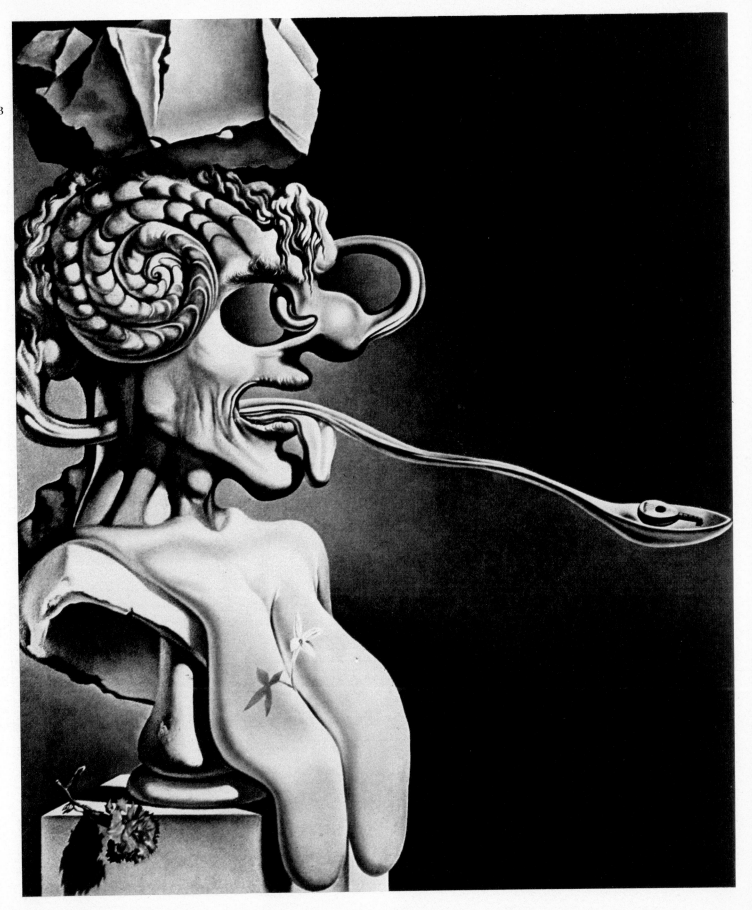

his Aunt Catalina. He recalls the year as 1927 but, as always with Dalí, dates are difficult to pin down; and asking him a second time is almost always futile. Those who have written about him are rarely in agreement about dates either, and are often mistaken and self-contradictory. He has referred to the journey in an amusing private conversation, claiming that they went on as far as Belgium, and that the motive or pretext for the trip on the part of his female companions was to obtain a set of silver cutlery, but this was subsequently to meet with such insoluble difficulties at the Customs that knives, forks and spoons, all were ruined. But in *Salvador Dalí through the Eyes of his Sister* the relevant date is 1926, and no mention is made of silver cutlery.

In *Secret Life* he describes his visit to Picasso. He was taken along by Miguel Ángeles Ortiz, a painter from Granada to whom his friend García Lorca had dedicated certain poems. Dalí was as excited as if he were to be received in audience by the Pope, and he took with him, carefully packed, a little painting called *The Girl from Figueras*. (Max Gérard has confused this with *The Girl from the Ampurdán*, whose earlier title was *The Girl with Curly Hair*, and which is now in the collection of Mr and Mrs Reynolds Morse of Cleveland.) When they got to Picasso's house in the rue La Boétie, Dalí (still according to his own version) declared: "I have come to see you before going to the Louvre", to which Picasso replied: "You've done quite right!" Then he studied for a long time the painting which the young man had brought, but did not make any comment. After that they went up to the studio on the next floor and Picasso showed him all his paintings. "In front of each new canvas he gave me a look which was so piercingly keen and intelligent that it made me tremble." When Dalí left the studio, he had not made any comments either.

154

155

154 and 155. *Scenes from the Ampurdán*, 1925; oil on cardboard, 22×27 cms; M Abadal y de Fontdeviela de Argemí Collection, Barcelona.
156. *Cala Jonculs*; oil on canvas.

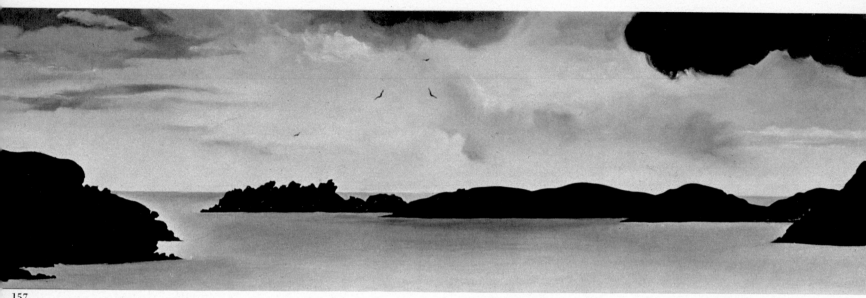

157

158

Port Lligat
es una superstición
S. Dalí

159

157. *Landscape at Port Lligat*, detail of 318.
158. Photograph of the same scene.
159. The painter's boat.
160. *The Christ of Saint John of the Cross* (lower section), 1951; oil on canvas, the complete picture measures 205×216 cms; Museum and Gallery of Art, Glasgow.

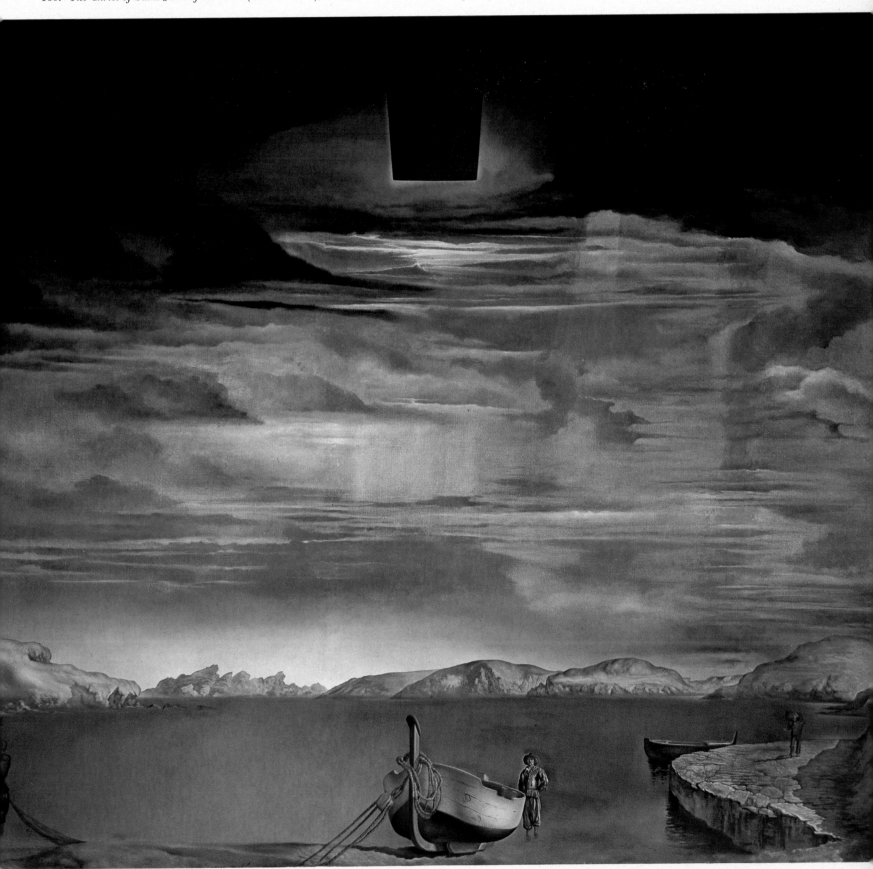

161. *The Phantom Wagon*, 1933; oil on wood, 19 × 24.1 cms; Edward F W James Collection, Sussex.
162. *Geological Justice*, 1936; oil on wood, 11 × 19 cms; Edward F W James Collection, Sussex.

161

162

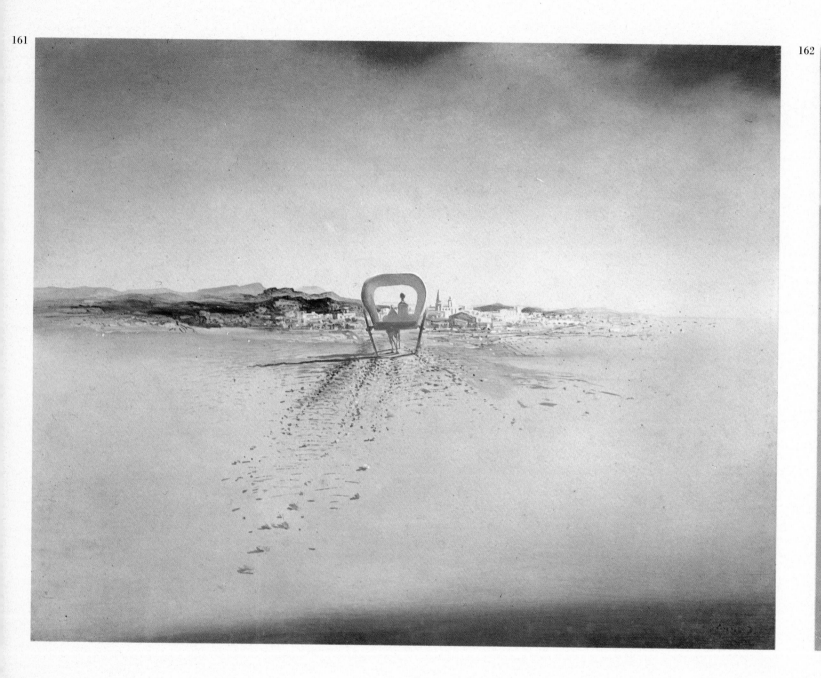

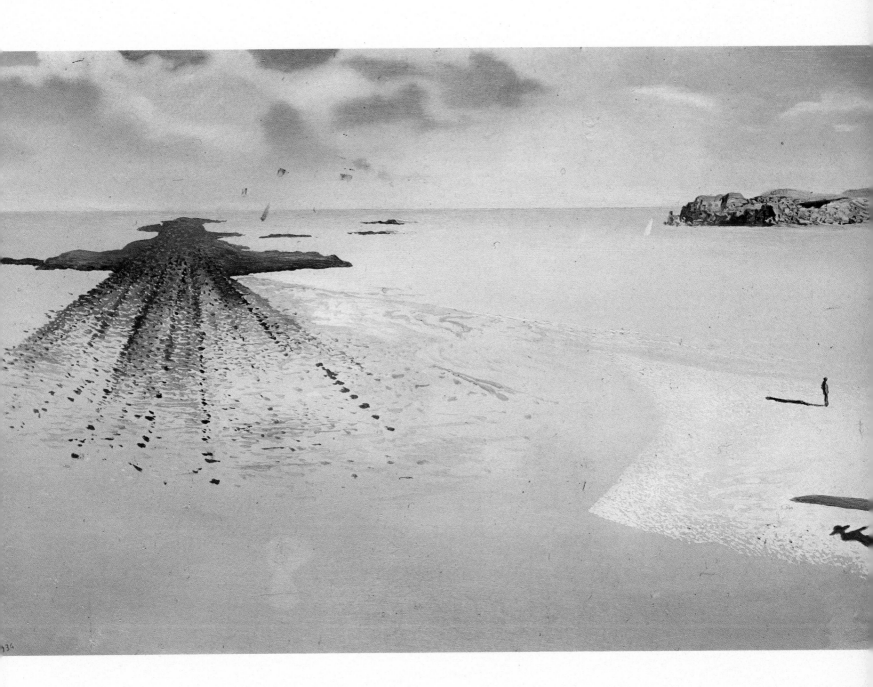

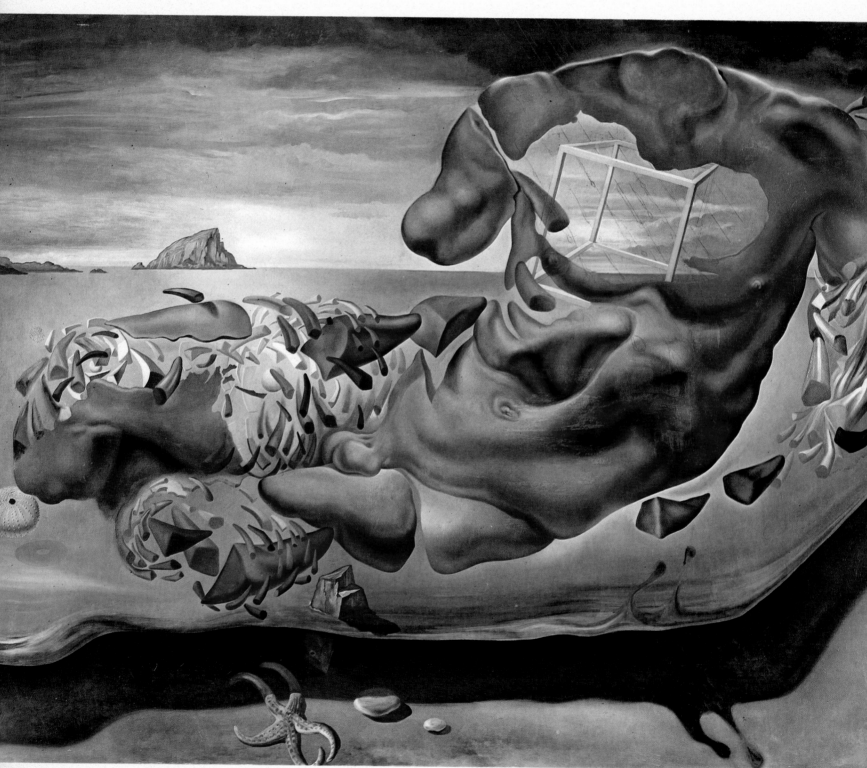

163. *Rhinoceros Disintegration of Phidias*, 1964; oil on canvas, 99 × 129 cms; private collection.
164. Rock called Cucurucú in the bay of Cadaqués, which appears in the painting to the left and in many others.
165. Profile of the same in Indian ink.

Years later, in fact quite recently, I asked him which among all the many people he had met had impressed him most, and whether there was anyone he considered a genius in the true meaning of the word. "Picasso," he said without any hesitation. I went on to ask him about Chaplin, remembering that, as a child, Charlie's performances had aroused his enthusiasm and that the actor had treated him so kindly in the United States. Although Dalí had previously spoken of him with great praise, this time he replied laconically: "I've met many people like Chaplin", which only served to underline his remark about Picasso (11).

In the chair with the water-jug and the torsos of Venus he pays homage to Juan Gris for, as Dalí has explained, "my first Cubist paintings were directly and intentionally influenced by Juan Gris". These pictures were painted in his room at the Students' Residence in Madrid, probably in 1922. In the case of two of these Cubist pictures he tells us that the materials cracked and fell to pieces on the floor. In the present book I have included a cubist drawing, dated 1923, which has certain echoes of Futurism. He called it, in Catalan, *The Eight-Day Clock* and it shows the clock on the wall with a cat curled up and motionless below.

Chairs have always been something which have fascinated the restless and multi-faceted Dalí. There is one which he had cast in bronze from an original which was created out of wooden spoons. Although they turn up less frequently than bedside tables (which is Dalinian furniture par excellence), chairs can be found in certain of his compositions, and these have a personality all their own. I have read somewhere a quotation from Eddington: "According to the concepts of

164

165

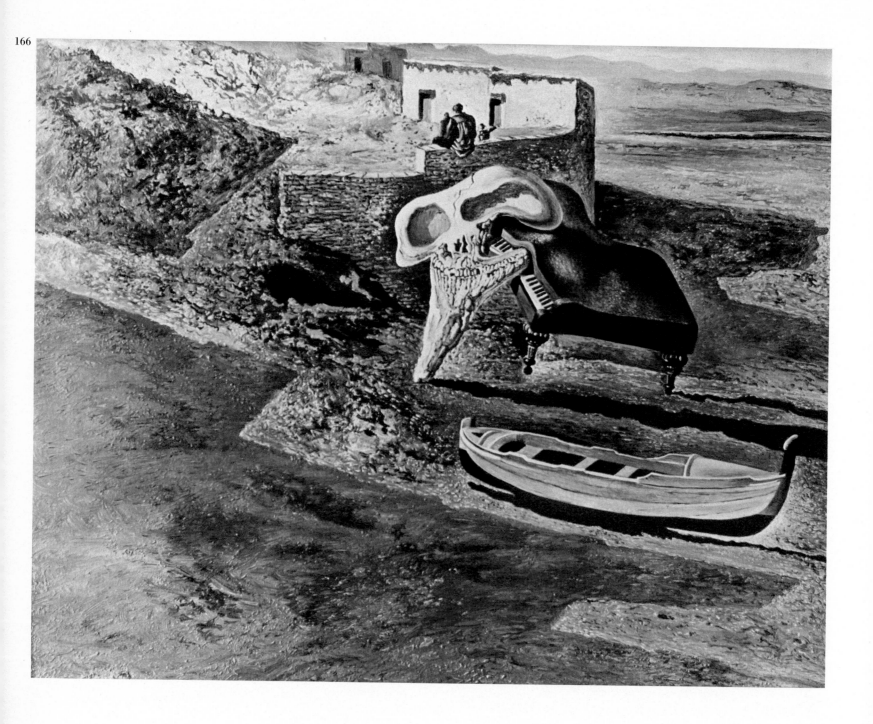

166. *Atmospheric Skull Sodomizing a Grand Piano*, 1934; oil on canvas, 14 × 18 cms; The Reynolds Morse Foundation, Cleveland.
167. In Port Lligat, with the fisherman Pere Barret.

nuclear physics, a chair would appear to be a swirling mass of tiny flies."

The Girl from Figueras used to belong to Alejandro Plana, though I am unaware of its present whereabouts. It was a small oil painting and its theme was inspired by the view from his house, the second of the two houses which they lived in in *Calle* Monturiol. There is the Plaza de la Palmera, with a large Ford advertisement, and a girl who used to sit on her balcony in the afternoons doing appliqué lace.

The faithful rendering of landscape is something of paramount importance in tracing the development of the life and work of Dalí. We could not have chosen the bullfighter painting as characteristic, and therefore valid, unless the composition had contained these cliffs, this familiar bay, or the curve of the beach. A rugged coastline, in one form or another, turns up repeatedly throughout his work, starting when he was a young man already capable of painting pictures which were very soon greatly appreciated; for although he was not seen as a childhood prodigy outside the family circle, he certainly was an adolescent prodigy and something of a prophet in his own country: first in Figueras, later in Barcelona, Madrid and the rest of Spain (12).

Dalí's landscapes are closely bound up with his childhood and youth, indeed with his whole life. The Ampurdán plain dominated the view both from the terraced roof of his home and from the rising ground of the Windmill, the farm belonging to the Pichot family where he spent some time as a child; in the distance the mountains of la Mare del Deu del Mont, Sant Pere de Roda, and further off the peak of the Canigó. It is a landscape which rises from the depths of his familial origins, full of earthy associations. His great-great-grandfather, Pedro Dalí, a smith by trade, moved from his native village Llers,

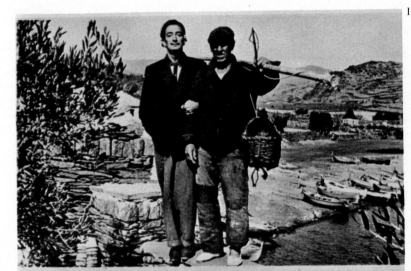

167

CADAQUÉS Salvador Dalí y un Pescador de Port-Lligat Ed. José Costa
Prohibida la reproducción

near Figueras, to Cadaqués early last century. Salvador himself was born in Figueras. Along its whole length the High Ampurdán plain reaches east to the sands washed by the waters of the Mediterranean. He has used this scene of the bay at Rosas stretching out to the horizon in his paintings. Another setting is Cadaqués: the village, the coastline from Norfeo and the bay at Jonculs to Cape Creus, and further on to the rocks of Pla de Tudela, Culip and Culleró, whose suggestive shapes have had a great influence on his pictures.

But the scene which turns up most frequently and with greatest realism is Port Lligat, the little cove close to Cadaqués where he has had his home and studio since 1930. The silhouette of the little island of La Farnera, the outline of the island, the beach with its grounded boats, the windmill without arms at the top of the hill with its terraces of ancient dry walls, the primitive pier or jetty. He has remained faithful to these settings ever since he first started to paint, though at times they appear transformed and re-created. They

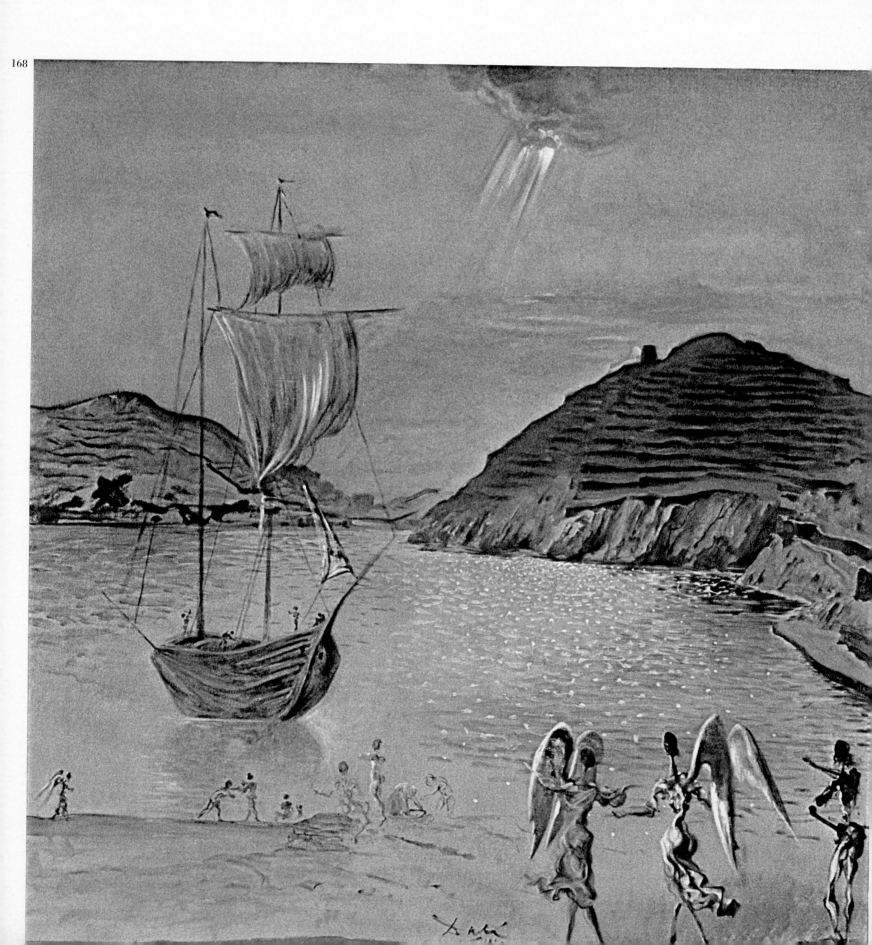

168. *View of Port Lligat with Guardian Angels and Fishermen*, 1950; oil on canvas, 61 × 51 cms; Albert Lasker Collection, New York.
169. Port Lligat from the beach.

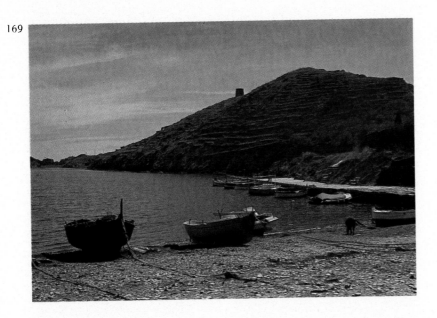

169

to those roots which he accepts as his own; the majority of the exceptions belong to his Surrealist period when a break with his emotional past, related to the imperatives of the school, was influential in his choice of themes.

But the reappearance of these scenes never leads to monotony. With what pulsating emotion we observe the transfigured plain crossed by one solitary little wagon! The wagon is on its way to Figueras which takes on an unsuspected magical dimension —paraphrasing some words of García Lorca, we could say:

Figueras, distant and alone...

The lower third of the *Christ* in the museum at Glasgow, considered on its own independently of the whole, is a perfect landscape. We recognize Port Lligat, with the little black and yellow boat belonging to Gala and Salvador; but the fishermen are dressed in clothes of a different epoch, and this is sufficient to transmute the landscape because the men and their temporal setting are also part of it. For those who know Port Lligat and the people there, this increases the vitality of the whole. Let us leave aside the figure of Christ, since these fishermen are unaware of it; these three figures fill us with a sentiment which some feel as peacefulness but others find disturbing. Nothing has changed in Port Lligat, but we nevertheless sense the passing of centuries. This sensation is not the same as one feels before a painting by, say, Alenza, since in those every Madrid scene takes place in days gone by: the changes in the town affect the buildings, their arrangement, and the streets and squares; it is a scene which we feel has disappeared for ever; the leap across time seems quite normal. The same could be said of an old painting or drawing depicting the Pont Neuf, the Louvre, the castle of Sant-Angelo, or the

always have a special touch as if by some decree they had to be these settings and no others. The cliffs of Norfeo, Cucurucú, and the arid rocks of the Encalladora or those of Pla de Tudela, all have a swollen, morbid appearance in contrast to the hard edges of the slate. He himself has written: "My long meditative contemplation of these rocks has made a powerful contribution to the blossoming of my aesthetic morphology of hard and soft."

Various fascinations have influenced the painter's mind, from Italian Renaissance architecture, which he must have known from illustrations in the family library, and which he later found in a surprisingly metaphysical form in the urban landscapes of Giorgio de Chirico, to the etherial transparency of Vermeer, the aggressive expressivity of American advertising, Pop art and Op art, and visual aspects of the art which has been called abstract but which he has used in a representative manner capturing its evanescent informalism in concrete shapes. With few exceptions he has remained faithful to his landscapes, and there are not many pictures in which we find something radically different from the scenes which belong

island of Manhattan. Looking at these, one would feel a harmonious nostalgia rather than shock.

The Port Lligat of the *Christ* bears no direct relationship with another Port Lligat, the one in which a skull-like form is attempting to sodomize a grand piano —what a crazy, macabre idea! We recognize the dry wall, the boats grounded on the beach, but the unwonted action has a transforming influence on the landscape converting the scene into the representation of an impossible circus trick, because on that beach there are no grand pianos, much less randy skulls of this size or with such unspeakable drives.

The rock which appears in *Birth of a Divinity*, the same one that serves as the background in *Disintegrating Rhinoceros of Phidias*, is Cucurucú, the tiny island at the mouth of the bay of Cadaqués, lying a mile or so from the window of the family home at the Llané, and thus forming for many years a part of his everyday scene. His grandmother, Anna, had a secret liking for this rock, and one day when it was hidden by fog, by way of pulling her leg, they told her that it had been blown up by the Anarchists, and the old lady, who by that time was a little out of touch with reality, believed them. A similar rock may be seen floating above the sea-bed when Dalí —as a little girl— lifts the surface skin of the water and uncovers the dog that is asleep underneath, the same dog which is found at the foot of the *Martyrdom of Saint Cucufate*, a picture by the sixteenth-century German painter Ayna Bru, which can be seen in the Art Museum of Catalonia. This dog caused a minor scandal in local art circles when certain excessively erudite individuals accused Dalí of plagiarism. But he had confined himself to painting that dog, the dog that was sleeping, under the water. If he had decided to plagiarize, he would have chosen as his model a

dog more difficult to identify, and not one which appears in a museum in Barcelona (13).

What relation could be established between the idealized and indefinite Port Lligat which serves as the background of the Saint Helen-Gala, and the landscape of another painting where a high-masted ship is arriving at a Port Lligat which suggests an angelic and delightful Cythera?

Every time he paints Port Lligat he reveals a new landscape to us which we recognize from its shape, its ruggedness and certain other details. Each version is distinct not only because of the different actions and people which are included, but also because the painter always uses different lights and reflections, changes in the density of the air, varying degrees of substantiality in the rocks or in the bareness of their edges, the continual change of hours and seasons, the rays of the sun, and the passing clouds. For the spectator, Dalí's eye becomes a super-eye which sees the same landscape in a variety of weathers and states of mind.

Many painters have set up their easels before these same places. At the end of the last century Eliseo Meifrén won a medal at the National Exhibition in Madrid for a canvas named *Port Lligat*; and referring to Cadaqués and its coast I have written elsewhere: "I personally believe that this must be one of the most frequently painted spots in the world." But Salvador Dalí, especially since he left behind his landscape period, that is, for over fifty years, has turned this landscape into a scene, or, if you prefer, an event; he is the one who has most richly reflected this conjunction of sea, shore, sky and rocks. Perhaps his secret may be revealed to us by a passage from another author, Oriol Anguera, who had already taken his doctorate when he wrote: "... judging from some of his paintings, one must assume that the world as seen through his retina is more lumi-

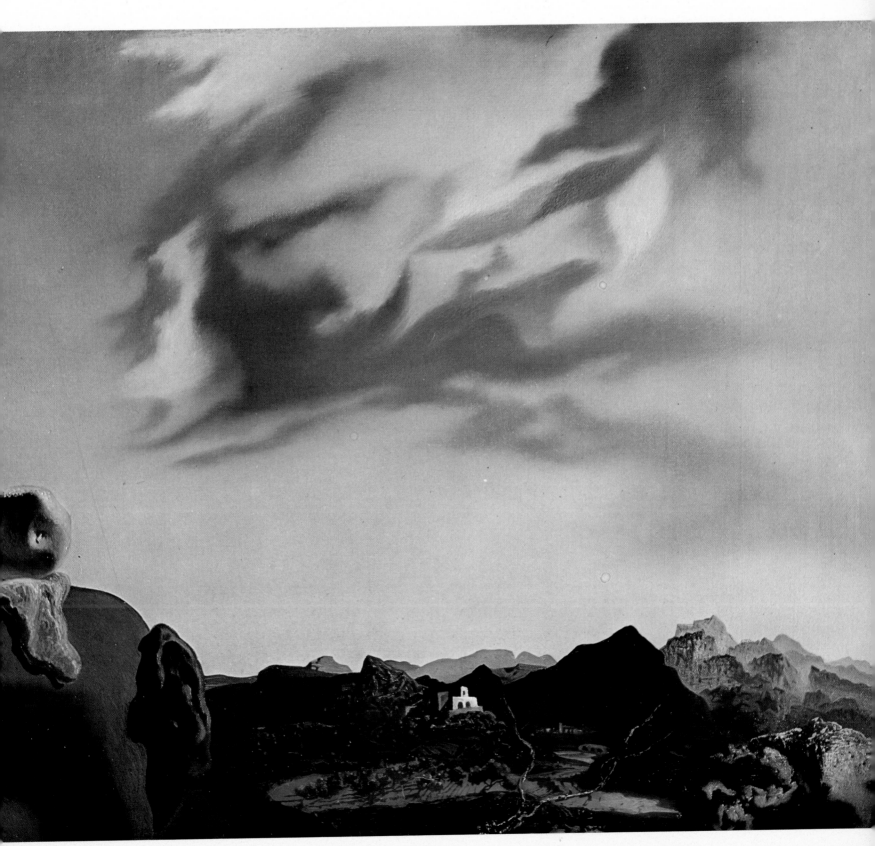

170. Detail of *Cannibalism in Autumn*, 1936-1937; oil on canvas, the whole measures 80×80 cms; Edward F W James Collection, Sussex.

nous, the air more limpid, the bodies more corporeal. It must be delightful to contemplate the beach at Cadaqués through the retina of Salvador Dalí; and we can grasp something of this delight through his pictures." Precisely! And one might add: What of the hand, that industrious, indefatigable, talented hand which realizes the vision of his retina or the driving idea of his brain?

In the Gulf of Rosas the contours dissolve in the distance, but one can make out, remote and poetic, the outline of the horn which forms its southern limit, and certain details including the pointed crown of the castle of Torroella de Montgrí. The brush strokes become softer, and because of the *ambiance*, the little boy, or old Llúcia, or the solitary figure on his bicycle, all take on a secret, magical air.

Certain paintings from his Surrealist period, for example *Cannibalism in Autumn*, are set in chaotic and desolate surroundings which could well have been inspired by the rugged hills which form Cape Creus; sparse in vegetation, dusty, rocky and volcanic, with a dramatic, almost unreal aspect, they are blighted by the oblique sun of morning or evening.

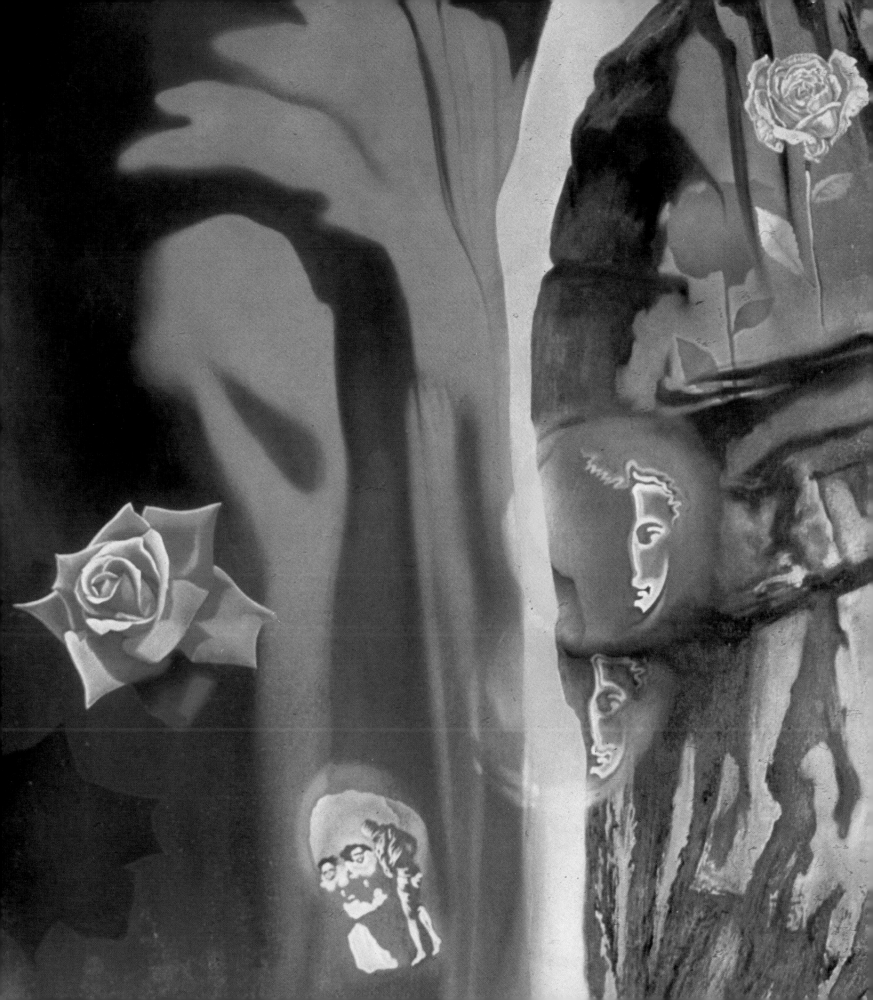

138

172

173

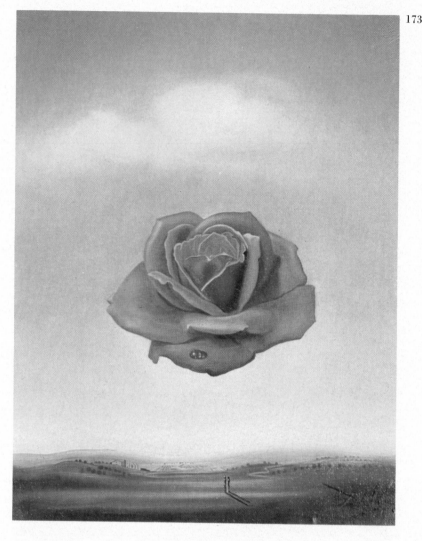

The painter, who is also a talented writer, has asserted that the most beautiful shapes are a product of inquisitorial processes, that is to say, difficult, painful processes in which one is required to overcome bitter and deliberate hardships, forming a kind of test to which Nature subjects all matter during its evolution and development. And he adds, as if he wished to establish the bases of a theory justifying criticism: "How often it happens that some matter, endowed with a force that is too great, destroys itself! While another piece of matter, only wanting to do what it can, and better adapted to the pleasure of forming shapes, or somehow recoiling in the face of the tyrannical shock of space, can invent its own idiosyncratic way of life." Is he trying to justify criticism as we normally understand it, or is this an autobiographical confession alluding to more subtle and intimate shocks which space has caused the artist?

Among the forms which he derived from this inquisitorial process is the rose. One perfect rose, executed with academic precision, floats close

175 and 176. *Rainy Taxi.* A creation that consisted of a taxi inside which it rained constantly. Exhibited in Paris and subsequently twice reconstructed in New York. It is a perfected reminiscence of the fossil car which Dalí sees in some of the rocks at Cape Creus. A new version exists in the Dalí Museum-Theatre, Figueras.

177. *Virgin of Guadalupe,* 1959; oil on canvas, 130×98,5 cms; Alfonso Fierro Collection, Madrid.

to the head of Voltaire, in a plane which is more advanced than the rest of the painting. Behind it appears another rose with a stalk which throws a shadow on the rocks of the landscape.

I identify this rose with the one in *Meditative Rose,* painted in 1952; one step further and we arrive at the mystical rose which is a symbol of Mary. He took this step one year later in the *Virgin of Guadalupe,* (a large oil painting made for Mr and Mrs Guest,) in which the robe is circled by two rings of roses suspended in the air. Although Dalí maintains that "every flower, even the rose, exists in a prison, because from the aesthetic point of view liberty implies lack of form," nevertheless the rose in the *Hallucinogenous Bullfighter* surpasses the others in its formal beauty, and in its insistently fleshy sensuality. We would say that it lies at the very antipodes of any inquisitorial process. We would rather place it in a lovers' Garden of Delights, or relate it to the allegorical-amatory *roman* of Guillaume de Lorris, and perhaps more than with anything else in literature, with those roses of García Lorca which are connected with Salvador Dalí: "... a rose in the sublime garden that is your desire," and the shared rose of youthful, passionate friendship: "Always the rose, ever our North and our South." (There exists, incidentally, a variety of rose which is named for Dalí.)

As I understand it, this flower had for him, and continues to have, the courtly associations which others have often attributed to it, as if the rose and love were identical. After his amorous explosion of 1929, which somewhat surprisingly was to culminate in the cove of Es Cayals at Cadaqués, and on the occasion of the journey that he made to Paris, he entered a florist's shop and asked the price of a beautiful bouquet of roses: three francs. He ordered ten bouquets like it which were to be delivered to Gala. The florist was taken aback

177

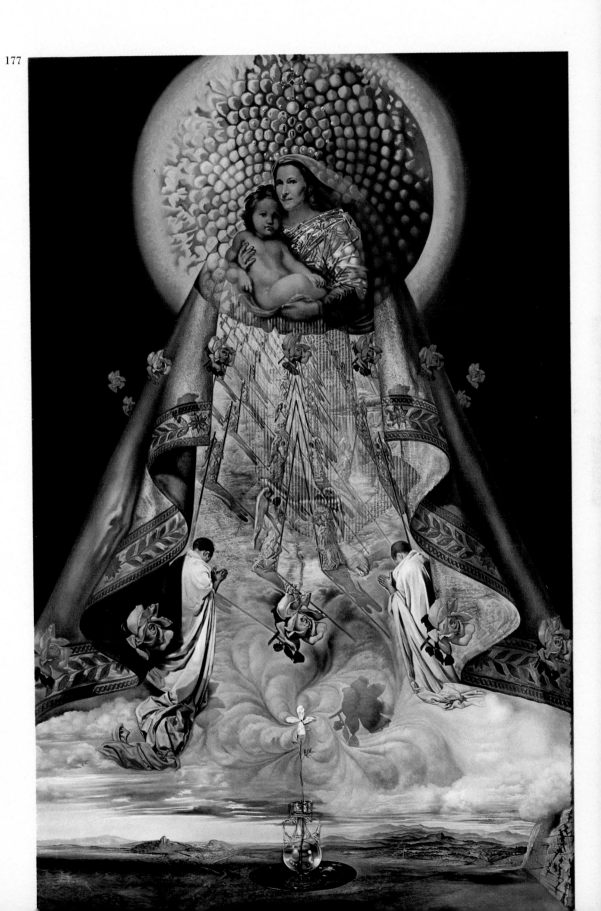

142

178. Detail of *Evocation of Lenin*.
179. *Evocation of Lenin*, 1931; oil on canvas, 114×146 cms; National Museum of Modern Art, Paris.
180. *Slave-market with Invisible Bust of Voltaire*, 1940; oil on canvas, 46×65 cms. The Reynolds Morse Foundation, Cleveland.

179

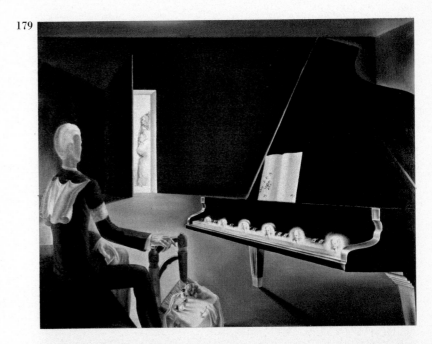

180

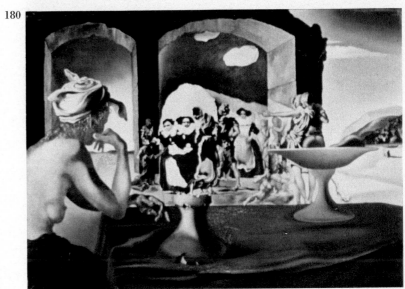

144

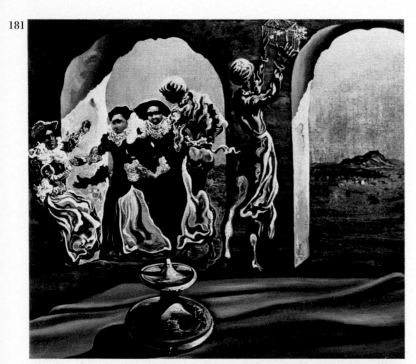

181

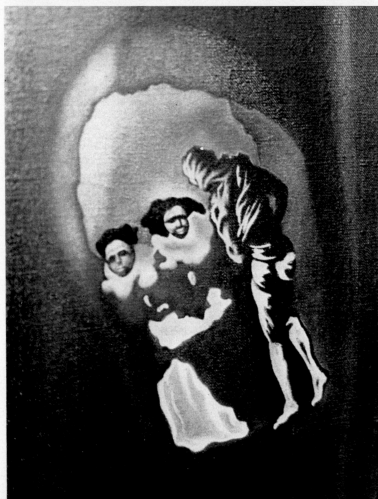

182

since at that time three thousand francs was a large sum of money. Dalí had misunderstood the price of one flower as the price of a whole bouquet; so he asked for roses worth two hundred and fifty francs, which was all that he had on him at the time. This anecdote illustrates the amatory signifance that roses have for him. It also demonstrates the confusions that he suffers in financial affairs, despite the fact that in his scale of values money occupies a place of the first order (14).

When he told me of Lola Litus' investment in the 'Submarine Navigation' company, he quoted the sum as four hundred thousand pesetas, while Artur the fisherman, who as a native of Cadaqués is well aware of its lore, puts the sum between fifty and one hundred thousand. In one conversation with me Dalí was for a moment confused as between one hundred and twenty five pesetas and one hundred and twenty five thousand! (In the anecdote of the florist, one may also note that the bouquets must have been unusually large.)

We have wandered somewhat away from the mystical rose without stopping to consider that in the litany we find allusions and eulogies which we know refer to the divine, but which nevertheless give off a secular odour, and this is because man is only able to express himself in imagery pertaining to our world. Few painters have succeeded in overcoming these restrictions of expression, and one of these would be Fra Angelico who, according to Juan Ramón Jiménez, painted heaven on his knees. But Dalí, in his religious and mystical pictures, has not escaped from these limitations of expression. The difference between *The Madonna of Port Lligat* and the *Atomic Leda* are more a matter of clothing, or the lack of it, than anything fundamental. The same could be said about *Christ of Saint John of the Cross* and the *Hypercubic Figure*, whose divine or mystic aspects

181. *Bust of Voltaire Disappearing.* 1941; oil on canvas, 46.3 × 55.2 cms; The Reynolds Morse Foundation, Cleveland.
182. Voltaire in the version by the sculptor Houdon, which appears in *Hallucinogenous Bullfighter*.
183. Detail of *The Resurrection of the Flesh*, 1940-1945; oil on canvas, 91.5 × 74 cms; previously in the Bruno Pagliai Collection, Mexico.

183

are to be found by penetrating beneath their intrinsic, ragingly human qualities (15). The position that we are calling mystical —which begins to reveal itself in the late forties after a secular period lasting several years— does not have any of the macabre effects associated with the work of, say, Valdés Leal, and in his paintings we find no reminders of the Dances of Death which we referred to above. There are no bones, cripples, ashes or putrefaction; instead we see beautiful, Renaissance images, transfigured landscapes, sumptuous costumes, and the figures in harmonious or triumphant attitudes. This painting is closer to Raphael or Murillo than to the gloomy painters of the seventeenth century; it has more of the spirit of Easter than that of Ash Wednesday or Lent. It is true that the journalist Del Arco stated at the time that it was a pity that he did not believe in God (16), but Dalí is full of contradictions, and in fact this period included a visit to the Pope in Rome and culminated with the consecration of his marriage with Gala (17).

I first met Dalí during this period which we have called mystical. It was some little time after the publication of the Manifesto written at Neuilly during the nights of 14 and 15 April, 1951, the famous, mystical Manifesto which begins: "In 1951 the most subversive things that could occur to an ex-Surrealist were two in number: first, to become a mystic; second, to know how to draw, but both of these essential prerequisites have hit me together and at the same time..." I met him one Sunday morning in front of the church in Cadaqués; Català Roca introduced us and then took a photograph of us. He was wearing a shirt that today's hippies would have admired and he was carrying a rough stick in the form of a crook and an enormous book about Vermeer de Delft, which was equivalent to some peculiar kind of ostentatious prayer-book. When High Mass began he entered the parish church, which is famous for the lavish gilt of its magnificent Baroque altar. During the service, the fishermen with their bass or tenor voices intoned a Gregorian mass, the same men who on summer nights would sing *habaneras* round a pot heating up the rum for their aromatic *cremat* ('burnt punch'). In the dark church with

184. With the author of the present work in 1952.

185. *Women with Flowers for Heads Finding the Skin of a Grand Piano on the Beach*, 1936; oil on canvas, 54×65 cms; The Reynolds Morse Foundation, Cleveland.

184

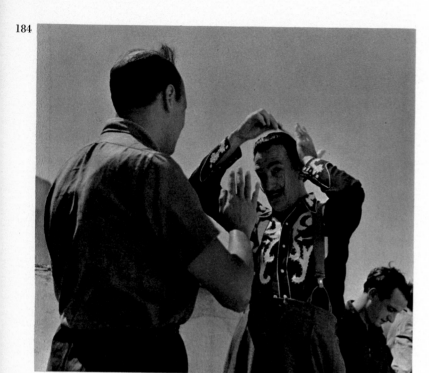

185

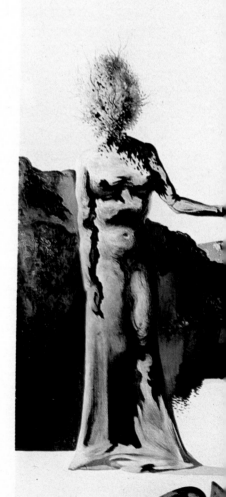

its smell of incense, sumptuous and poor at the same time, the latin incantations were redolent of a more hopeful world beyond this one.

Directly linked to the phosphorescent heads of Lenin, Dalí in 1940 painted the head of Voltaire which appears —but why?— in a slave market. The head is the optical effect of an irregular arch in a wall, in front of which are two figures whose ruffs suggest that they might be lawyers, ecclesiastics or landed gentry from some previous epoch —although their exact identification remains obscure— as well as an Arab-like figure, seen from behind. In order to secure the desired effect (which must have derived from some chance 'hallucination'), he executed a number of sketches, which still survive. There is a notable similarity to the bust by Houdon. Moreover, if one looks at the picture with eyes half-closed the effect is amazing: the arrangement of white gives the figure a truly ghostly appearance. (I am referring

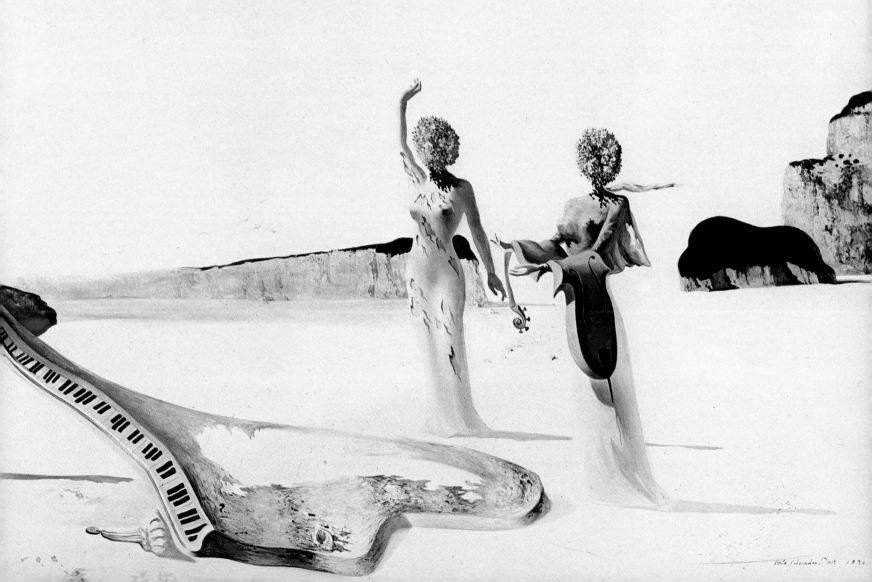

to a reproduction, since the original is unknown to me.) The pen drawings which illustrate *Secret Life* include another face of Voltaire, although here the elements which make up the face are more diffuse.

Regarding the dates for these faces of Voltaire there is much confusion which is difficult to resolve. It would appear that the Indian-ink drawing in *My Secret Life* was earlier than the oil painting *Slave Market with an Invisible Bust of Voltaire* but I could not guarantee this as fact. One of the book's footnotes says: "The invisible image of Voltaire may be compared with the mimicry of the leaf-insect which is invisible because of the similarity and confusion which it creates between itself and the background." He is referring to the insect that he discovered as a child. It blended almost perfectly with a particular plant and he exploited this in certain experiments or tricks to which he subjected his family and friends. But he also connects mimicry, and by association the bust of Voltaire, with his fondness for disguises, which started in his childhood and has lasted to the present day.

Voltaire, (of whom one might make the same comments as of Quevedo, namely that apart from in France itself he is more discussed than read,) must have been a prestigious name among the liberal bourgeoisie in Figueras, who were the obverse side of the same coin as the conservative bourgeoisie, the minor differences of opinion that separated them being more of a speculative than of a practical nature, though there were presumably also differences of wealth. Within the circle of his father's friends he must have heard many favourable comments about Voltaire; and he himself has said that he read the *Dictionnaire Philosophique.*

Voltaire was one of the most daring and restless spirits of his age. It has been said that he became famous "*par un renom composé de gloire et de scandale*". Leaving aside his polymorphic talent for every category of thought and literature, his life was an authentic, fascinating, and prolonged adventure. He was an enemy of the Jesuits, but at times he showed signs of a jesuitical spirit, in the pejorative sense of that word. Dalí enjoys using the terms 'jesuitical' and 'inquisitorial' but his use of them has no negative connotations, something which is due rather to his different ethical standpoint than to a semantic shift in their meaning.

Since we have already alluded to Dalí's predilection for disguises, we may recall that the name Voltaire was a masquerade for the brilliant and daring young man François-Marie Arouet, but it could hardly conceal his real identity. In the pictures, Voltaire wears no disguise; on the contrary, his likeness stands out among disguises which are somewhat enigmatic. It seemed appropriate to me to question Dalí as to his relationship or standpoint vis-à-vis Voltaire. He replied immediately: "The same as Voltaire's with regard to God", and then he related the following anecdote: "The philosopher was walking along the street with a friend one day when they saw a priest on his way to someone's sick-bed with the viaticum. Voltaire took off his hat, at which his friend asked why he showed such respect given his standpoint regarding the Church and religion. Voltaire replied: "God and I always greet each other even though we never speak." Then he commented at some length on the correspondence between Catherine the Great of Russia and Voltaire, a relationship which had led him to see parallels between, on the one hand, the empress and the philosopher and, on the other, Gala and himself. This led me to suspect his vague identification with Voltaire, even though he did not say so explicitly. And, at times, Dalí's systematic optimism shows certain Panglossian qualities.

BOTÓN CORBATA

Y

CEREZAS

ESTEREOSCÓPICAS

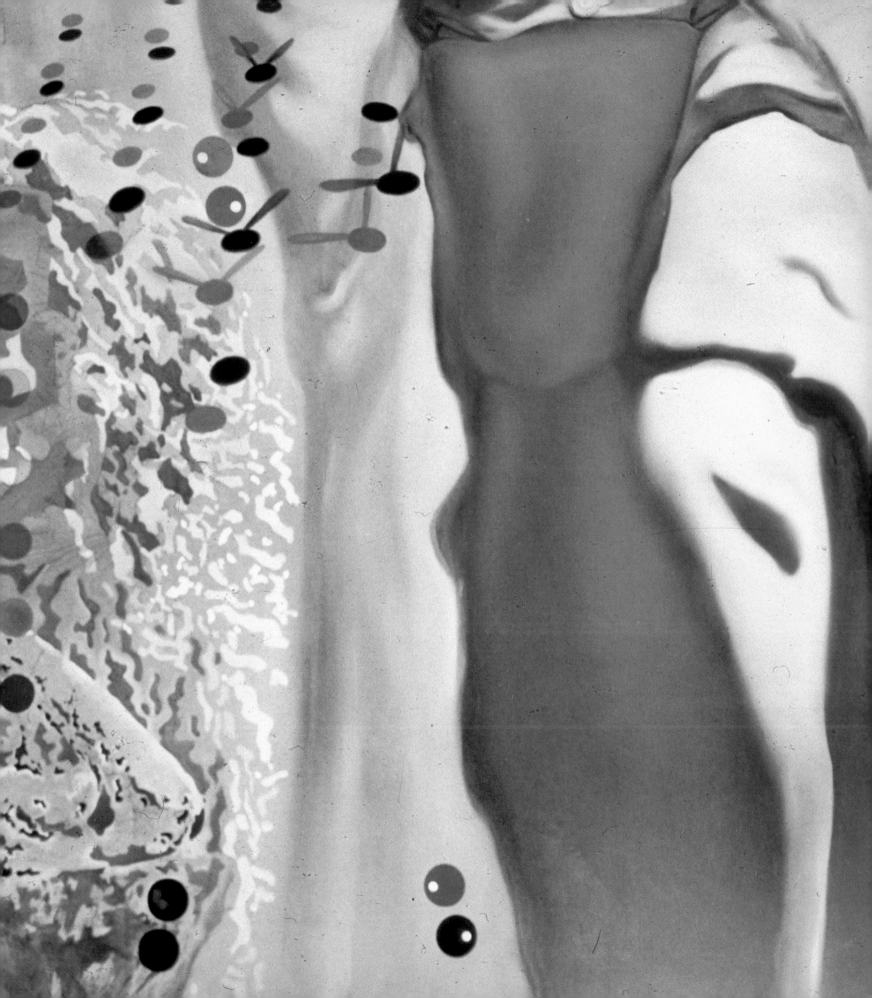

187

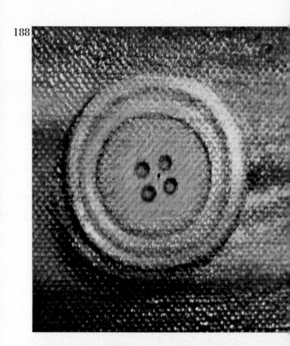

188

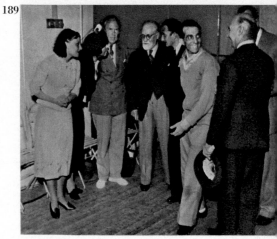

189

186. Fifth section of *Hallucinogenous Bullfighter*.
187. Matisse's fly.
188. Collar button of the bullfighter's shirt.
189. Matisse with Dalí, Leonidas Massine, Lord Berner, and others.
190. Detail of *Sistine Madonna*, 1958; oil on paper, the whole measures 223 × 190 cms; Henry J Heinz II Collection, New York.

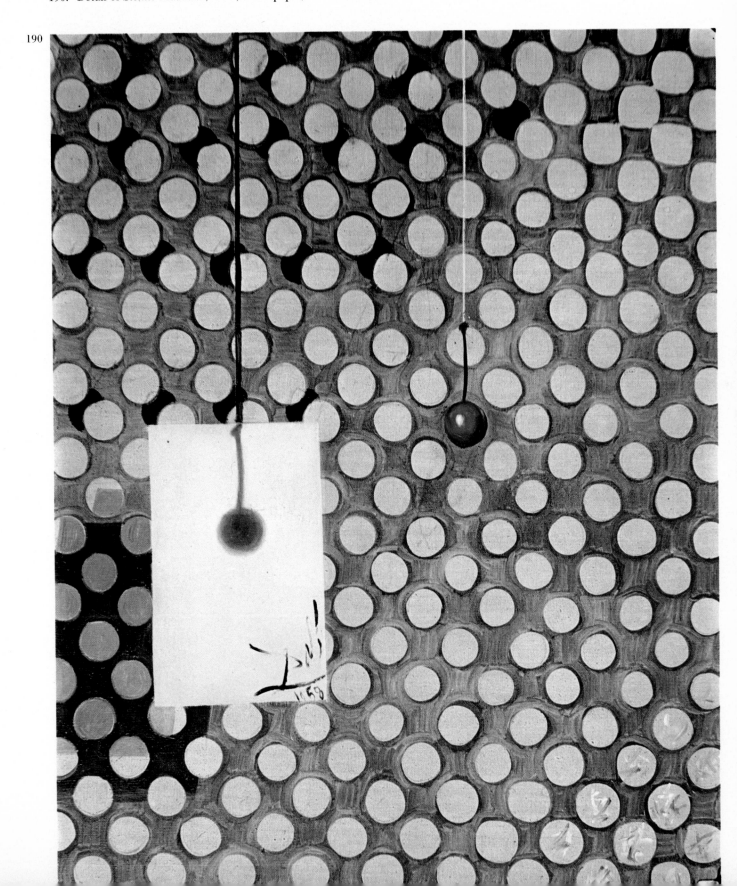

190

154

Beneath the bullfighter's chin there are the button and the button-hole of his shirt collar, painted with the patient application of a miniaturist. It is one of those buttons that tempt you to reach out your hand and grasp them. "That button," Dalí told me, "was inspired by one in the fly of Matisse, the illustrious seaweed painter. It is the button in the fly of the French bourgeoisie, since they always forget to fasten them."

To demonstrate his point he showed me an old photograph, and then he spoke at length about the French bourgoisie, archetype for the whole world, and about the pretentious vulgarity of their preferences in art. Then he returned to the subject of Matisse, whose paintings he compared with those ostentatious vases to be found in the houses of the nouveaux riches, people who have been mass-produced in a great hurry, and whose economic strength has failed to get them past the anteroom of snobbery.

Dalí, born into a bourgeois family and educated in a bourgeois *ambiance*, feels proud of having betrayed his class. Moving between the autogiro and the submarine, he prefers the aristocracy and what used to be called the common people; in politics he classifies himself as monarchist and anarchist. Once again shades of de La Cierva and Monturiol.

No one would have arrived at the relationship between the buttons and the photograph, if I had not been in a position to reveal to the world his own explanation. For my part, I feel that if the button has risen in the human anatomy from the level of the fly to the collar, this is due to the fact that a bullfighter's trousers, or rather breeches, have a blind front not only for aesthetic reasons to do with the light dancing movements that are required in the arena, but also out of sheer practical necessity, namely to avoid the tip of

the horn catching when the bullfighter gets so close that the horns brush past his body.

Dalí once showed me a cybernetic machine with buttons for its keys which he had had constructed according to one which he found in an engraving in an old, rare book, and this had been drawn, as I remember, according to theories of Ramon Llull. Since he was reading the book at the time, it was impossible for me to borrow it, and thus I never succeeded in understanding the relation between the keyboard of the cybernetic machine (a curious device which I believe was designed to think), Matisse's fly and the philosophical theories of Francesc Pujols, the Catalan writer and philosopher who was a friend of Dalí and whose doctrines he found fascinating. Since Pujols' philosophical writings were never published, he was a kind of Socrates, much given to story-telling and with an ironic humour, but my admiration for him is tempered by the fact that I never had occasion to hear him speak. I found it impossible to understand this abstruse theory, which was inadequately explained, concerning a little machine with a keyboard of buttons and an engraving in a book from the eighteenth century.

Before leaving the subject of buttons, we will mention that there exist others in Dalí's works, although there are not very many, and they are never as carefully worked as this one. The best and most important examples are those on the unbuttoned jacket of *The Chemist from Figueras who is not Looking for anything at all*. This character is like something out of Zola, strange in the middle of the desolation of this landscape in which we can recognize certain geographical features. This picture, despite the irony suggested by its title, reveals a sharp poignancy, like the cry from the depths of man's solitude, like a warning about the uselessness of exertion, of seeking to overcome

191. Jewel; gold, rubies and pearls; Owen Cheatham Foundation.
192. Book on the painter Gerard Dou from the Gowans series of art books.
193. Detail of *The White Calm*; see 122.

91

192

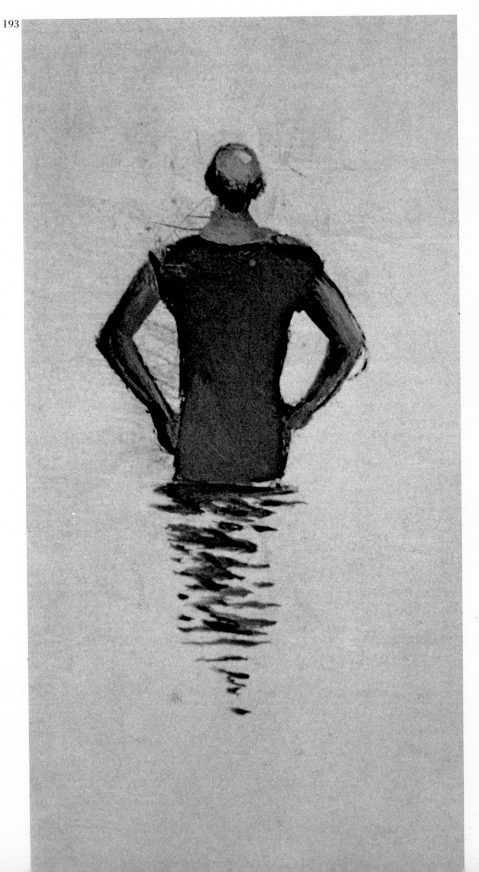

193

194. *The Chemist from Figueras who is not Looking for Anything at All*, 1936; oil on wood, 30 × 56 cms; Edward F W James Collection, Sussex.
195. *The Ants*, 1937; Indian ink on paper, 66 × 49.5 cms; The Reynolds Morse Foundation, Cleveland.

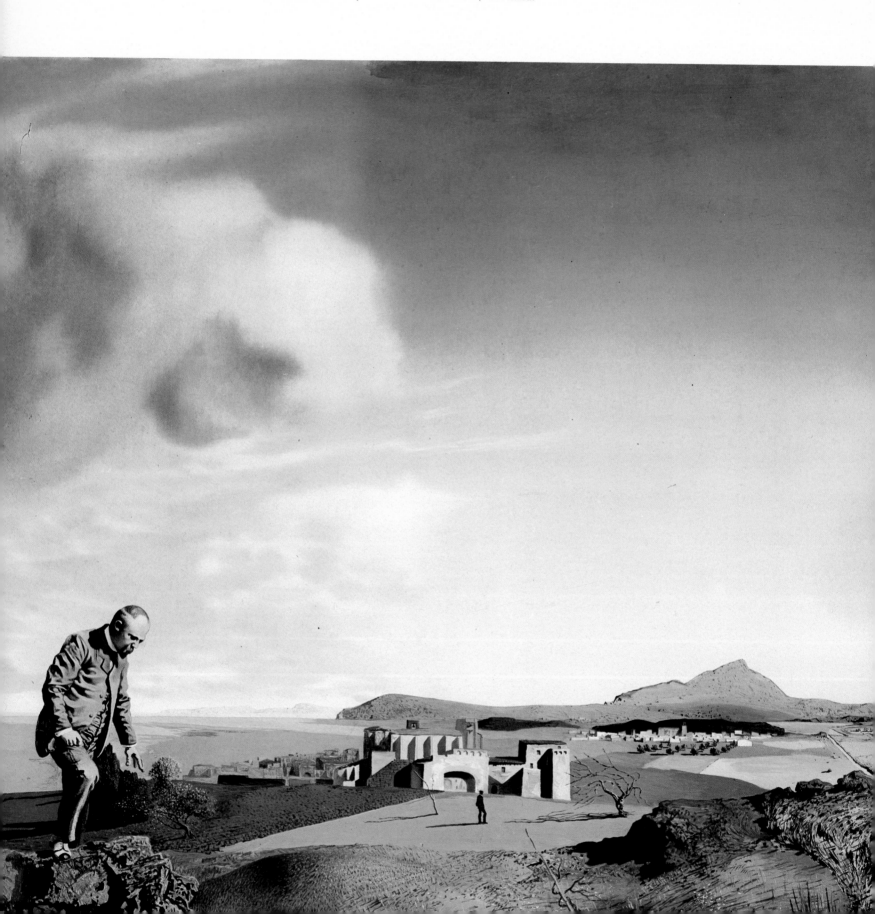

194

195

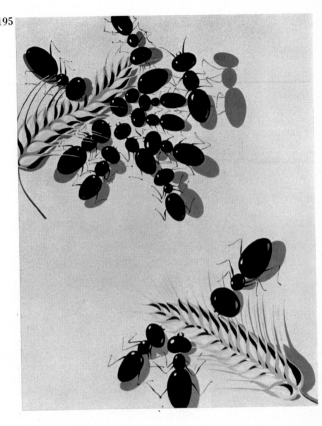

196

197

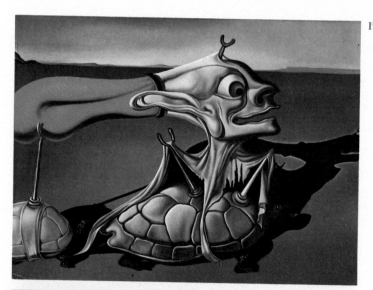

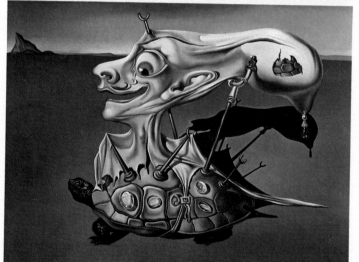

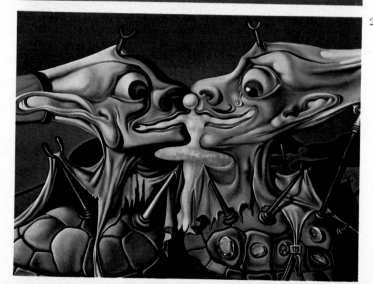

196. Detail from the diptych *Couple with their Heads Filled with Clouds*. The figure lying down, rather than a little Lenin, is Ramón de la Hermosa, who for Dalí was a paradigm of sloth; Brighton Art Gallery.

197. Detail of *Study for the Outskirts of the Paranoiac-critical City*, 1935; Edward F W James Collection, Sussex.

198 to 200. Colour drawings for a Walt Disney film, *Mystery*, which was never completed.

201. Detail of *Vertigo*, 1930; oil on canvas, 60 × 50 cms; Carlo Ponti Collection, Rome.

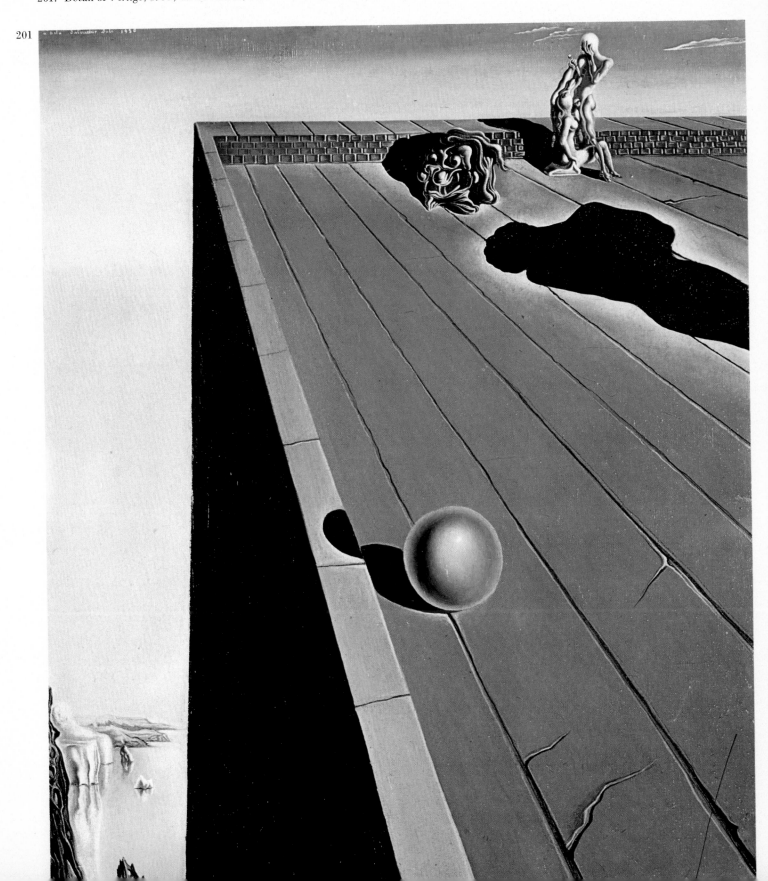

201

one's limited and mortal condition. And Dalí, merciless, does not grant the chemist the favour of a white lie which would allow us to believe that he really was looking for a button, or a needle in a haystack.

From this button, from the neck of the bull-fighter, the tie plunges down and at its side float the two pairs of spheres or cherries. Dalí has said that they are stereoscopic and I assume that they would take on the character of a relief if they were seen through a special lens; for relief is one of the painter's obsessions and his latest work consists of two paintings, seemingly identical, which when viewed through an arrangement of mirrors become superposed and the images are seen in relief. Thus he achieves the coveted third dimension. This is a new aspect of his perpetual searching drive, al-though, as I see it, it represents the first steps of something which remains to be perfected rather than the ultimate achievement.

While he was looking at the works of the Dutch painter Gerard Dou, (which appear in the Gowans art series that his father bought him as a child,) he told me that he had arrived at the conclusion that Dou was the first stereoscopic painter. Several of his paintings which seem to be versions or replicas of the same theme lead Dalí to assume that, viewed through some as yet unknown combination of lenses or mirrors, they would show up in relief. Gerard Dou was born in Leyden in 1613, and Cornelius van Drebbel, whom we have already mentioned in connection with the sub-marine, died in Leyden in 1636, having invented an optical apparatus which some consider to have been the first microscope. At all events the micro-scope was a Dutch discovery from the same epoch as Gerard Dou, Dalí's painter of the third dimen-sion.

(I now tend to think —and writing is thinking aloud— that it is apt to observe, to measure and to consider Dalí from many different points of view or through imaginary lenses and mirrors in order to see his true dimension and his real importance; and it is this *stereoscopic* view which the present text always seeks to present.)

bandrillas geologicas i

la estocada infinita

simulada por

¡ MADROÑO

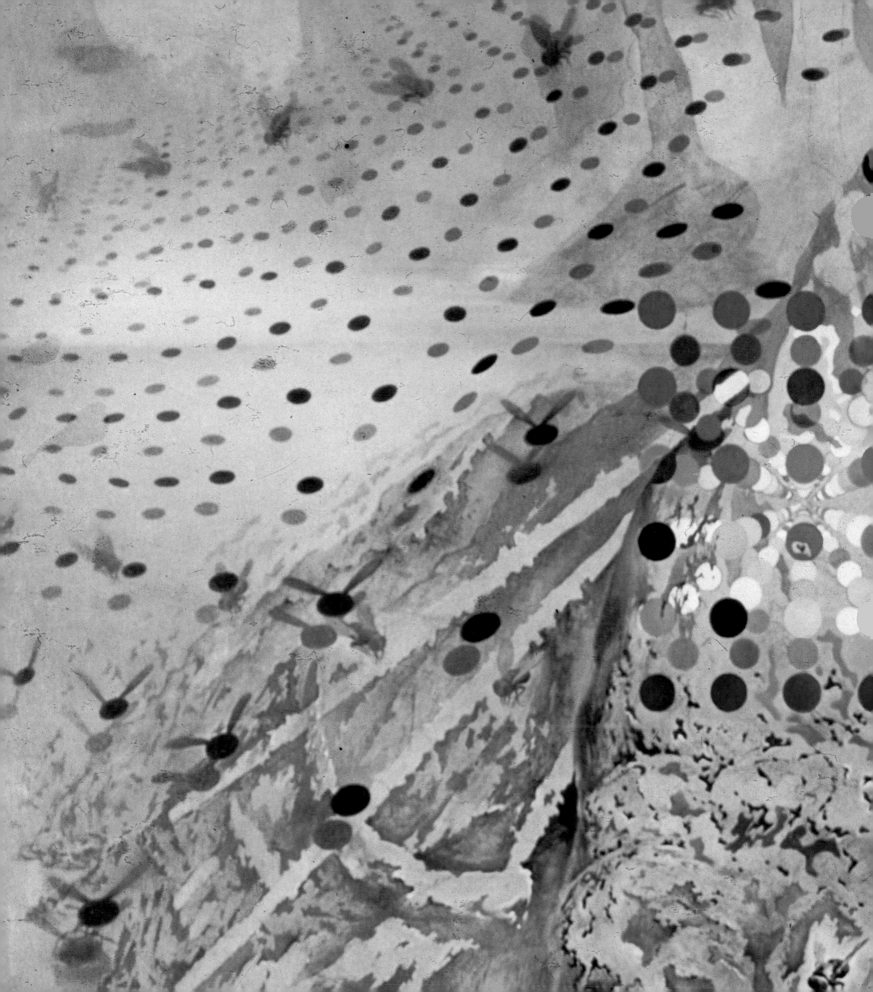

202. Sixth section of *Hallucinogenous Bullfighter*.
203. *Quick Still-life*, 1956; oil on canvas, 125 × 160 cms; The Reynolds Morse Foundation, Cleveland.

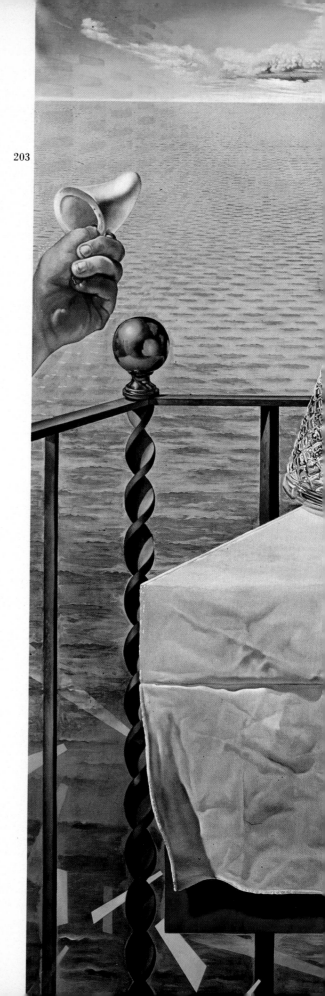
203

The bull dies, the bull is dead, the bullfighter
is dying; the bull kills, or killed, the bullfighter,
and the bullfighter has killed the bull. As T S
Eliot has said:

The present and the past are both present in the
 [future,
and this future is contained in the present...

The bullfight ends with one thrust which
really should be fatal (for the stabs of the assistants
are of only minor importance), and this is the
insurance policy that guarantees the beast the
inescapable culmination of its fleeting mission.
And for Dalí this thrust is infinite, an endless
convergence of spheres which our vision can
never grasp because of its own limitations. These
convergent spheres, which are mortal and bloody
(though elsewhere they form the tassels of an
epaulette, and for me have the air of a little
jacket painted by Goya, which lends a touch of
timelessness to the attire), correspond in other
pictures to different combinations and take on
other meanings.
 And if the *banderillas* are shown as geological,
it is because they correspond to cataclysms, to
erosion and decay in the rocks of Cape Creus, a
landscape which we recognize here and which he
had earlier represented in one of his large works,
The Ecumenical Council. As for the head of the
bull with a fly for the eye, is it the head of the
Minotaur, thus converting the bullfighter into
Theseus, whose death inverts the legend? We may
recall that the monster of the labyrinth lent its
name to a famous review which had Salvador Dalí
among its contributors.

In large areas of the picture, as a background
which at times blends and merges into other
images, like the rocks, or is transformed into

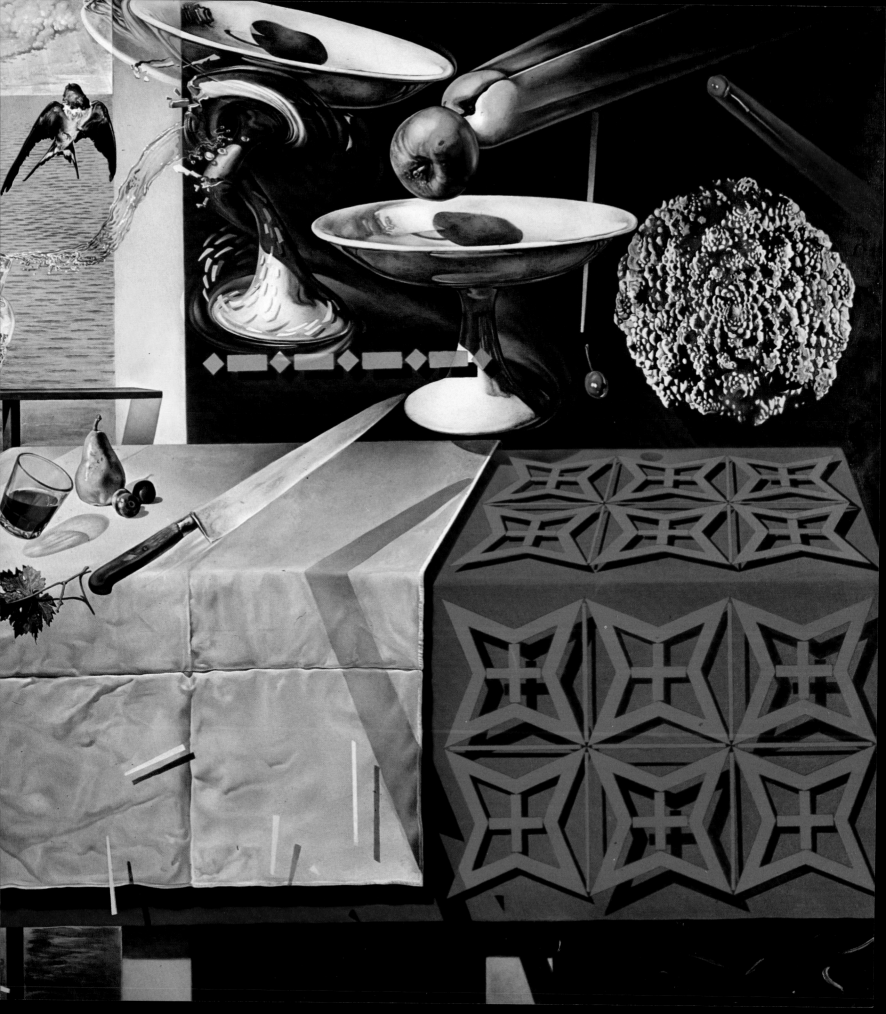

204

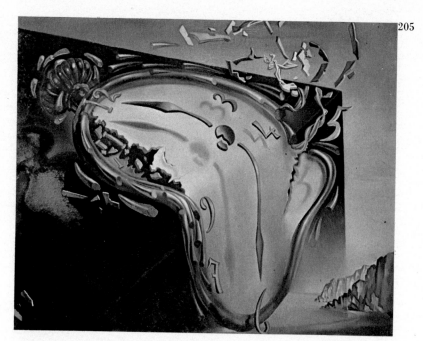

205

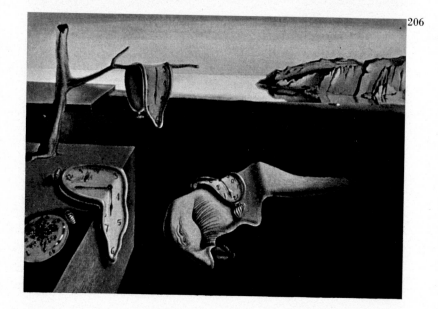

206

autogiro-flies, we see circles and shadows of circles, artistic rather than scientific allusions, a plastic stylization of Dalí's conception of the structure of matter, in the scientific line more of Democritus than of Aristotle.

Leaving aside the stereoscopic character which the painter attributes to spheres, balls, or twin cherries, the spherical shape is reiterated in the work of Dalí, with greater insistence in some periods than in others. In his Surrealist period, it is the perfect geometrical form, abstract and mysterious (as in *Vertigo* and other paintings); it can become pearls that are teeth— 'pearl teeth' —one of his best known pieces of jewellery, or the bald spot of the bather in *White Calm*, the dancer's head in *Mystery* (the film he drew for Walt Disney), or the black grapes which form an anthropomorphic cluster revealing the image of the fisherman, Ramón de la Hermosa, a paradigm of idleness who is mentioned in *Secret Life*. (I have met his son, Quimet, who seems to have inherited a

204. Detail of the *Sistine Madonna*, 1958.
205. *Soft Watch at the Moment of its First Explosion*; oil on canvas; private collection.
206. *The Persistence of Memory*, 1931; oil on canvas, 25 × 36 cms; Museum of Modern Art, New York.
207. *Disintegration of the Persistence of Memory*, 1952-1954. Also called *The Chromosome of a Highly Coloured Fish's Eye, Initiating the Disintegration of the Persistence of Memory*; oil on canvas, 25 × 33 cms; The Reynolds Morse Foundation, Cleveland.

207

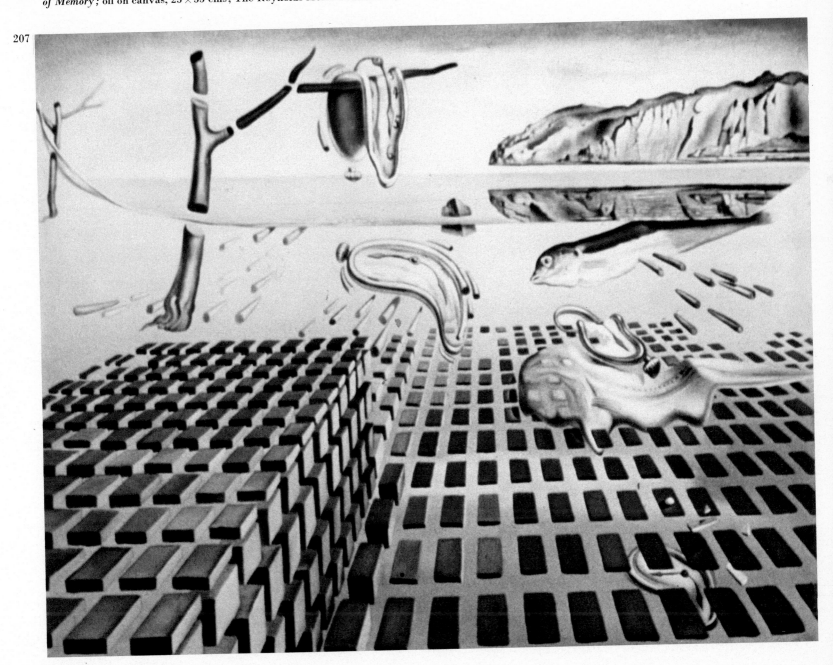

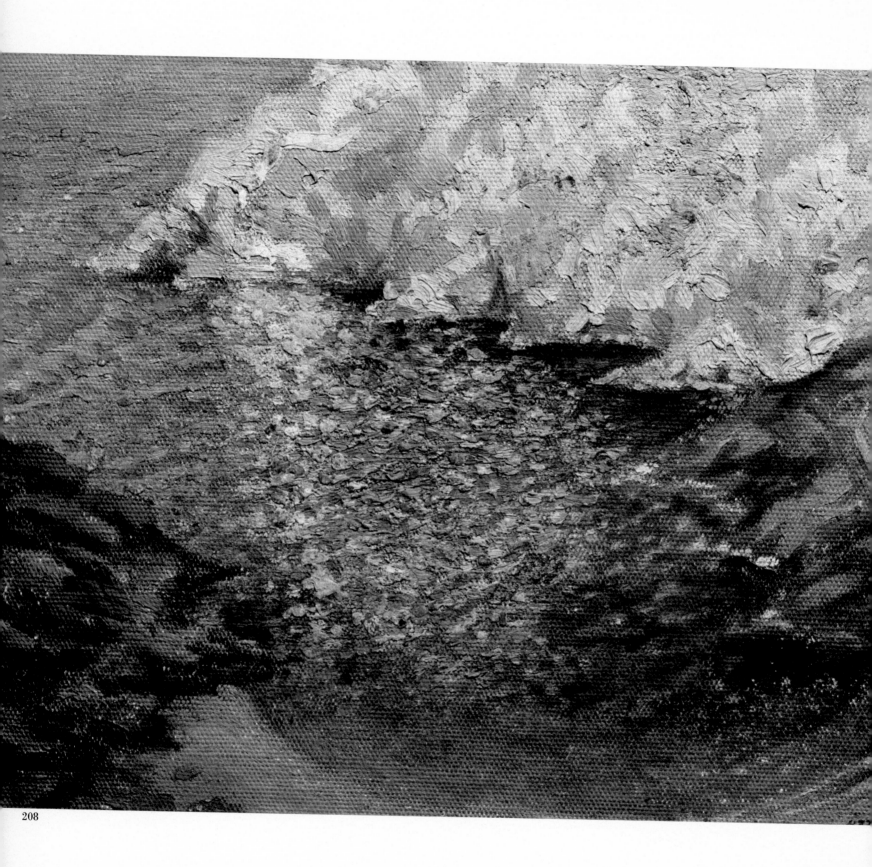

208. *Cala Nans*, on the reverse of the portrait of José M Torres. Oil on canvas, 39,5 × 49,5 cms; Museum of Modern Art, Barcelona.
209. *Ecumenical Council*, 1960; 399 × 297 cms; The Reynolds Morse Foundation, Cleveland.

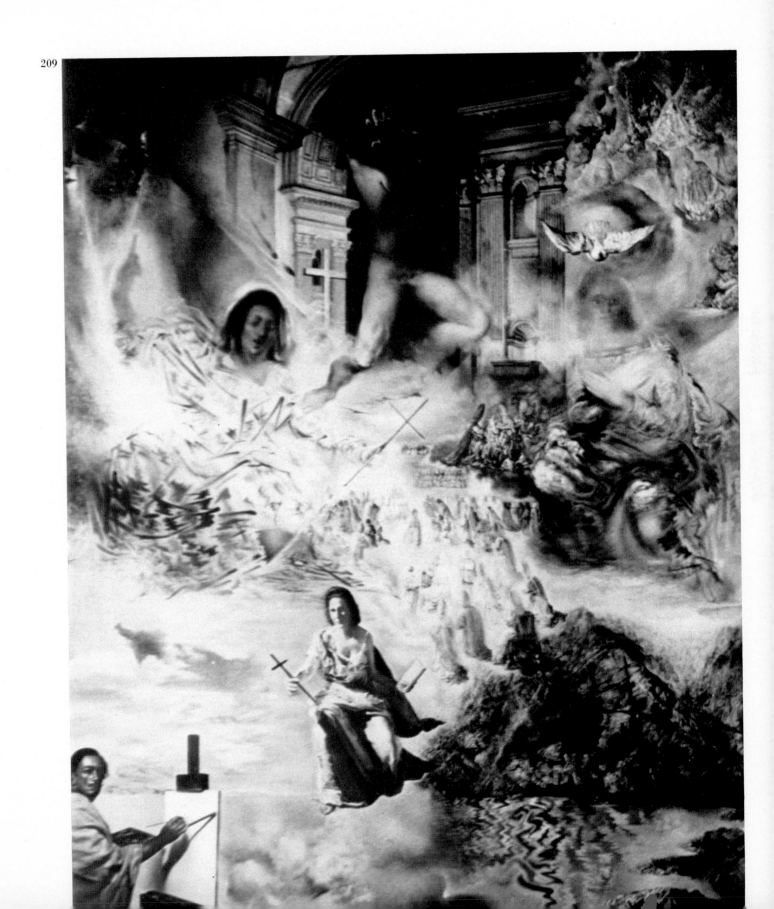

209

170

large measure of his horror for all forms of activity.) Balls form the eyes of the invisible man and the matronly nipples of *España*, while in *Molecular Celestial Figure*, a succession of spheres of different sizes forms a horse. In addition to the ones that converge on infinity, many more paintings could be cited, but let us end by recalling that pair of spheres which in *Centaur* are the accentuated buttocks of this strange, hybrid creature, and between which he has set a rudder.

Dalí likes to quote a phrase from Fra Luca Paccioli, the Renaissance mathematician and author, who wrote, among other books, *On Divine Proportion* —illustrated by Leonardo da Vinci— in which he establishes a direct relationship between the sphere and monarchy. In my opinion, more than of the monarchy, the sphere is a symbol and representation of the Empire, which is the kingdom of kingdoms, since the orb is the symbol of emperors, both ancient and not so ancient. This orb symbolizes the terraqueous globe and the astronomical universe, it is a form pregnant with symbolism and propitious in divination; it has a singularly disturbing attraction and it is ludicrous, sporting, circensian, architectural, industrial, mythological, physiological. And gold coins, which greed likes to keep rolling, present an illusion of a golden sphere.

In the painting which is serving as our vehicle and thematic index, the central figure —or protagonist we could call him in keeping with the authority of the title— is the bullfighter who is implicit in several of the elements which go to make up the canvas. His hat is formed by the contour of the arena and the edge of the shadow which falls across it, and its decorative dots are provided by the autogiro-flies. The facial expression is serene, resigned. With his red cape over his shoulder, he is making his ceremonial entry, per-

haps preparing to salute the president, or he may be leaning on the fence studying the bull that has just been released from the pen. He knows that he is going to die this very afternoon, that he will die in this bullring. A tear trickles down from his right eye, whose pupil forms the cheek of the central Venus, a somewhat caricaturist detail which almost passes unnoticed.

Themes related to the art of bullfighting are rarely found in Dalí's work (18). Some years ago he endeavoured, with Luis Miguel Dominguín, to organize a *corrida* whose principal innovation with regard to the bullfighting would have consisted in the dead bull, instead of being dragged out by the mules, being suspended from a helicopter and taken straight up into the sky. The bull was then to have been deposited on the mountain of Montserrat, there to be devoured by birds of prey. The idea, more belonging to imaginative fiction than to painting, caused indignation in influential sectors of Catalan public opinion, since the presence of a bull's carcass was deemed offensive in the heart of what is considered to be a sacred mountain range. It was a matter of no great importance, and if I bring it up now it is one of the very few points of contact between Dalí and bullfighting, except that he enjoys the spectacle of the *corridas*. I believe that he succeeded in trying out this business with the helicopter in a town in Colombia which was surrounded by less controversial mountains. I am unaware as to whether this method has caught on anywhere; nor do I feel that it would be an improvement on the traditional mules in their harnesses decorated with tassels and bells.

Some time later his attraction turned to a pistol which shoots anaesthetic cartridges used in capturing rhinoceroses alive. In a series of experiments that took place in the United States, he succeeded in firing so as to produce the shapes he wanted.

210. Detail of *Hallucinogenous Bullfighter*, depicting bull composed of rocks with *banderillas* and dagger.
211. *Saint Surrounded by Three Pi-mesons*, 1956; oil on canvas; private collection.

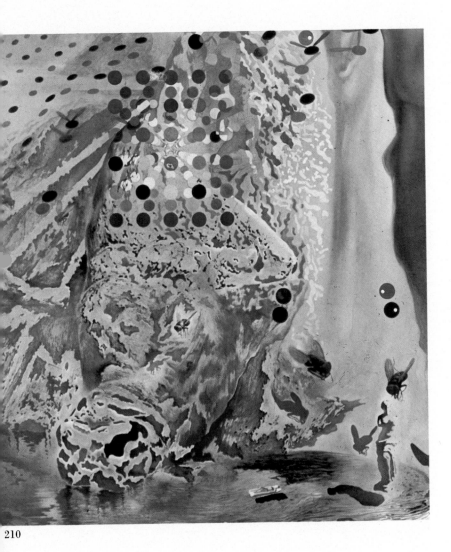

210

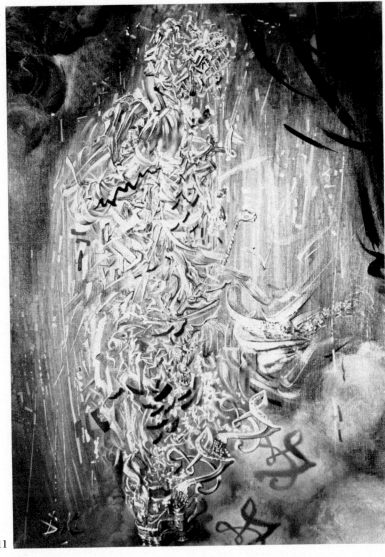

211

He filled the cartridges with Indian ink and his target was a white canvas. One of the figures which he achieved was a bull with *banderillas* and swords in the back of its neck, and suspended from helicopter-mules. It is a widely known picture which was reproduced in a bullfighting poster and was used to decorate the menu of a well-known restaurant in Figueras. As far as the bull is concerned, I suspect that the original had been retouched.

The bullfighter, who "because he is about to die is already dead", represents his brother, the other Salvador Dalí Domènech, who was born and died before he came into the world. The parents liked to think of him as a reincarnation of his dead brother, due to the understandable paternal illusion of seeing a close spiritual and physical likeness in their two sons. To feel regarded, in the eyes of other people, as someone else, someone who, to make matters worse, was dead, was a

172

212. Fly on his moustache.
213. *Honey is Sweeter than Blood*, 1927. García Lorca called this painting *The Wood with Objects*, but the original title is a quotation from Lidia Nogués. Previously belonged to Coco Chanel.

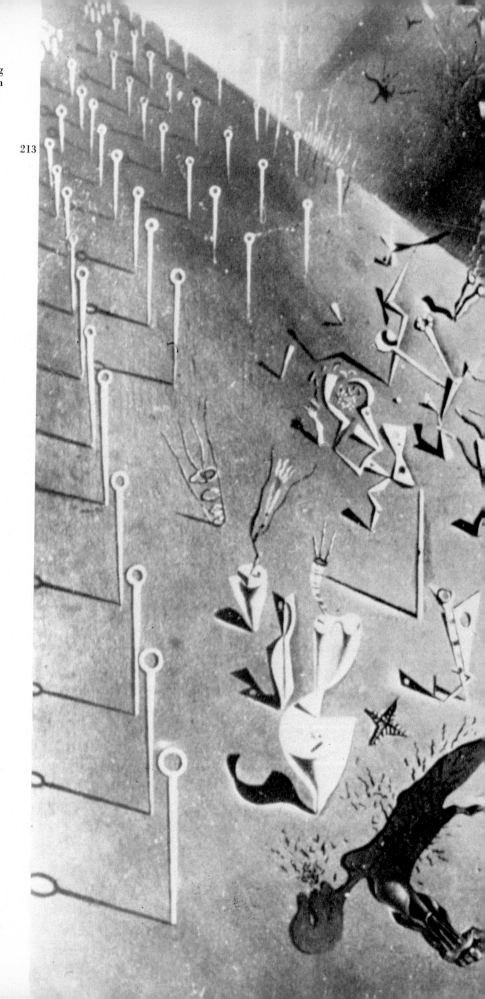

213

212

BRAVO!
L'Home que cagaba a la
"Sala mercé" d'en Gaudí

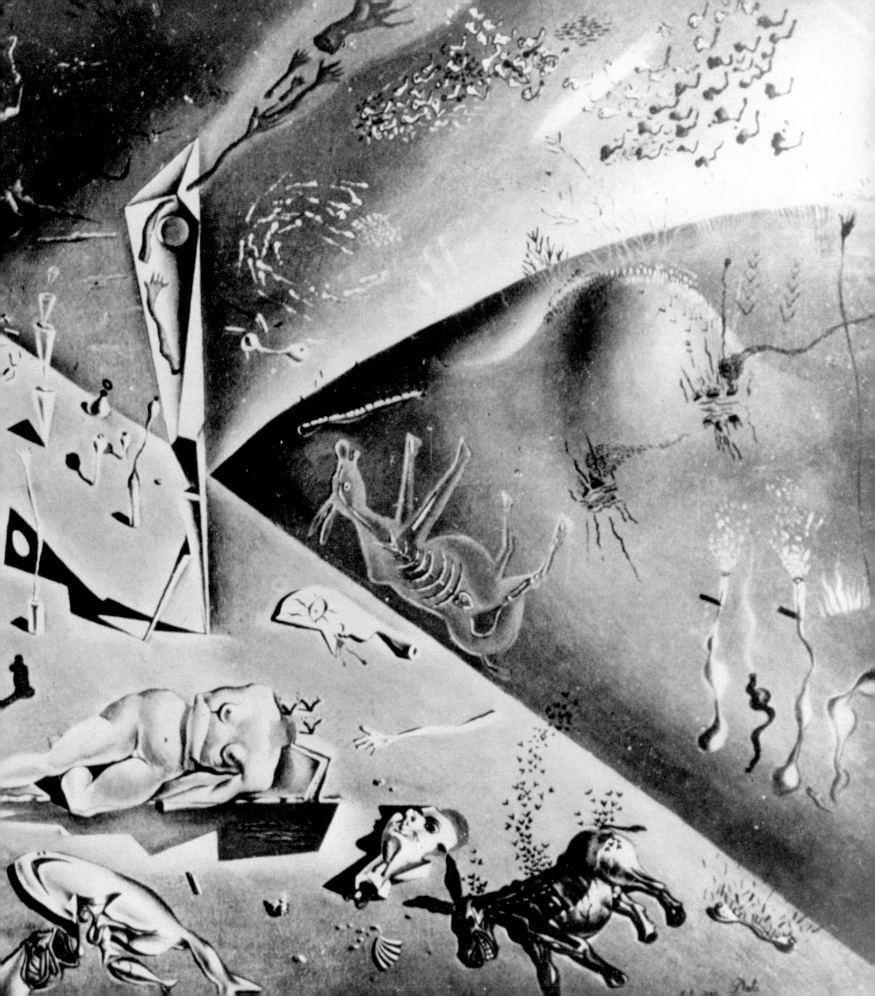

214. Detail of *Hallucination of Gala*; oil on canvas.
215. Detail of *Hallucinogenous Bullfighter*, part of the infinite wound.
216. *Galatea of the Spheres*, 1952; oil on canvas, 65 × 54 cms; private collection.

214

215

problem which exercised a strong influence on the formation of his character. Perhaps he exaggerated, or rather, now exaggerates, this identification with his dead brother who bore the same name, but he relates that his first rebelliousness was directed against it when he suspected traces of it in the loving eyes of his parents as they looked at him. The bullfighter is his brother, whom he has represented in another painting, and whose image he seeks to exorcize because he —Dalí the living, the one who is energetically alive at every moment— is the other bullfighter, painted in full, who is saluting the illuminated vision of Gala.

The bullfighter is also García Lorca, who was the poetic ambassador of death in the world of the living, and whose poetry, bruised with foreboding, we find painful since we know that Death was soon to claim him. Death is a living presence in Lorca's poetry; one could create a whole new poem out of his references to it. Dalí explains that sometimes, at the end of an evening together, when it was time for Lorca to go, he would stretch out on a sofa, claiming the attention of the whole group. Little by little —and he would illustrate this in words— he would become serene, dying. Death, or its appearance, would seize him. They would fold his hands and maintain a vigil. Death advanced from the depths of his body and began its destructive task. They would put him in the coffin and nail down the lid. They would take him down the stairs as carefully as professional undertakers... It was a harrowing performance, when reality was forgotten in this serious, macabre imitation. Dalí and the other friends were frightened, but Lorca would go on, and the funeral procession

216

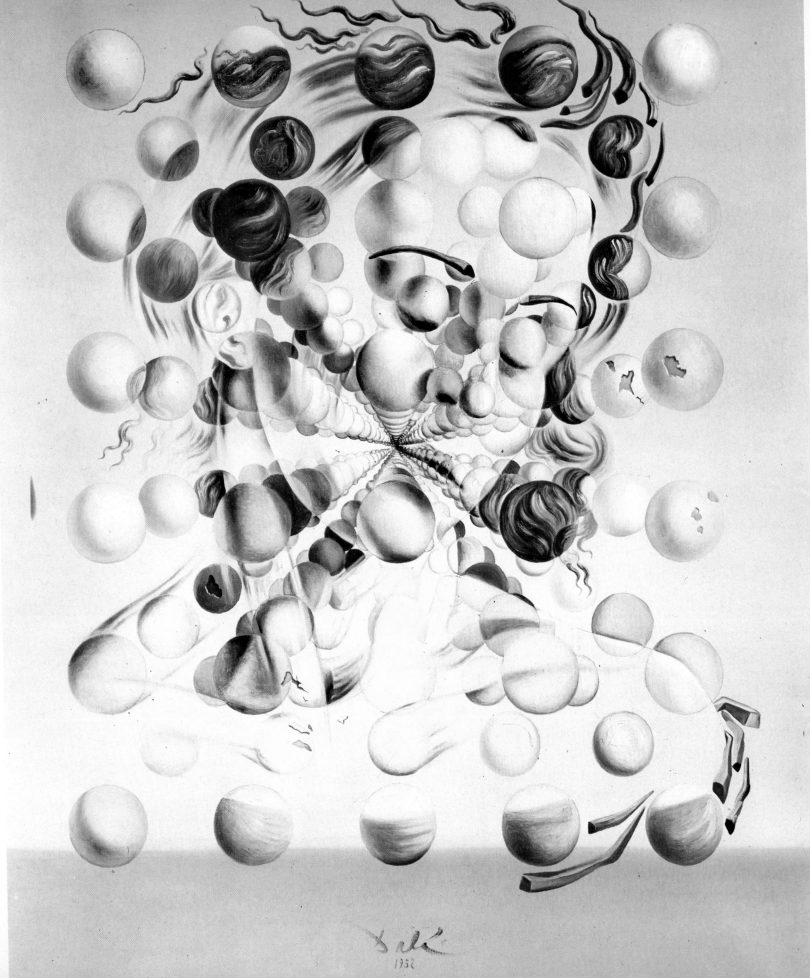

217. *Apparatuses and Hand*, 1927; oil on wood, 52 × 47.6 cms; The Reynolds Morse Foundation, Cleveland.
218. Detail of *Hallucinogenous Bullfighter*; the bullfighter's face.

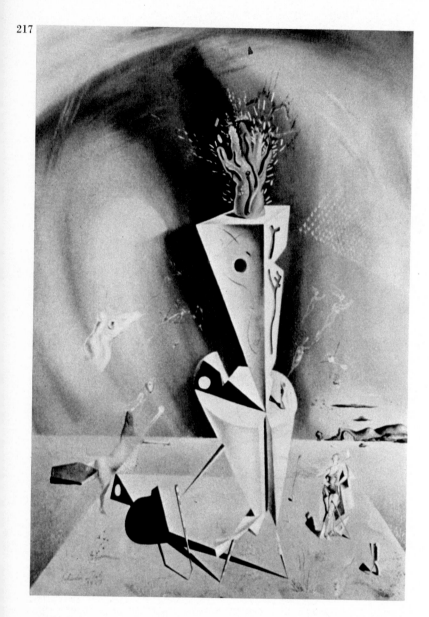

217

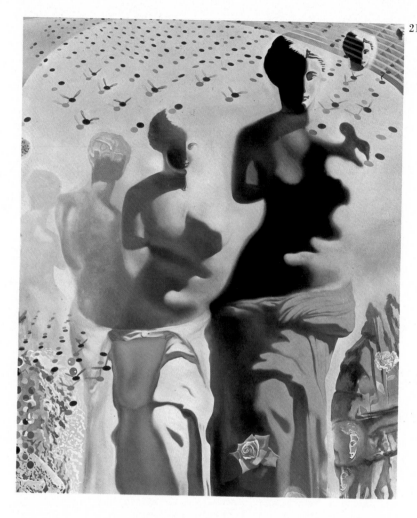

218

would proceed along the pavement of some steep Granada street. The corpse was shaken about because of the pot-holes, and these jolts would finally break down the gravity of his face... Though the tension and anguish froze the first smiles, they soon became irrepressible. Lorca rejoined the others, smiling, happy, full of life. With this theatrical show, he managed to convey to his friends the distress which until then had threatened him alone, his personal fear of death.

By forcing the others to share the burden of his foreboding, he himself managed to revive a little (19). The young bullfighter who is about to die is also René Crevel, his poet friend who committed suicide. As his personal contribution to pictorial Surrealism, this man had published *Dalí ou l'antiobscurantisme* (20).

He is also Prince Alexis Mdivani, who met his death while driving his Rolls-Royce along a road on the Costa Brava, at a time during the thirties

Rostro orgánico de las nubes en

el cuerpo de tierras

junto a la roca

que emerge

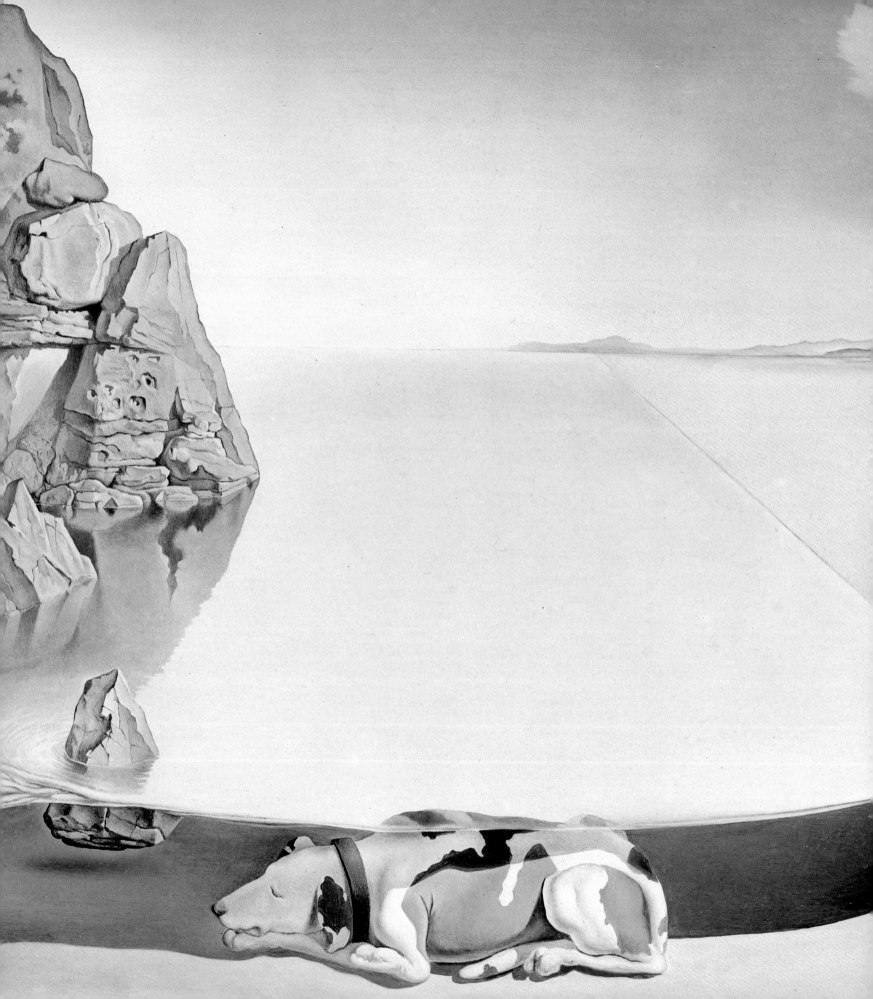

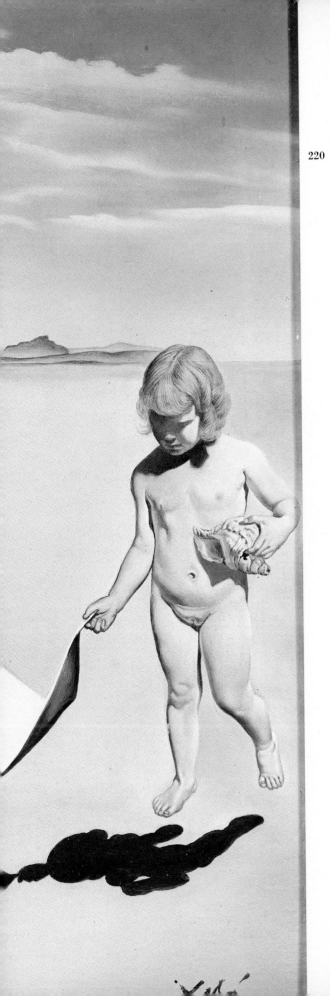

181

219. Seventh section of *Hallucinogenous Bullfighter.*
220. *Dalí at the Age of Six, when he Thought he was a Girl, Lifting the Skin of the Water to see a Dog Sleeping on the Sea Bottom,* 1950; oil on canvas, 80 × 99 cms; Comte François de Vallembreuse Collection, Paris.
221. *Martyrdom of Saint Cucufate,* by Ayna Bru; Sixteenth Century; Art Museum of Catalonia, Barcelona.

220

221

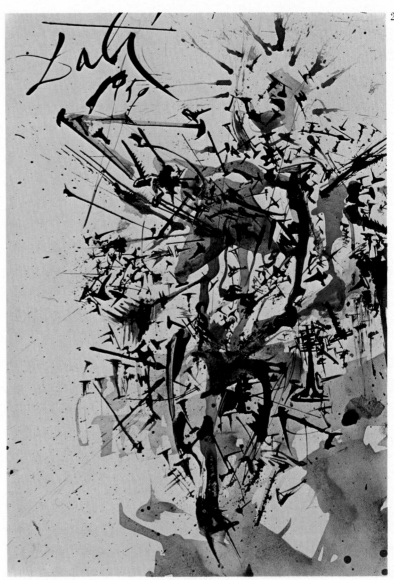

when life for these rash, brilliant young men was one endless party, or at least appeared to be. And Pierre Batcheff, the actor in *Un chien andalou*; and, more recently, Bob Kennedy, whose death put an end to many hopes. The bullfighter with the serene features, whose stoicism gives way to a resigned tear, is the paradigm, the sum total, of so many young friends who have been left behind, inscribed in the register of death. In the same way, it personifies those who died beyond the uncertain limits of youth, because if we have known someone when he was young, only rarely does the passage of time allow us to notice his age. The figure of the bullfighter is like a funereal statue on the pantheon of friendship, with which Dalí exorcizes the spirit of his fear of death, just as the coffin ritual used to serve García Lorca.

The same obscure signs which in García Lorca are transformed into poetry, in Salvador Dalí become a figure and an attitude of rejection: figure in the mysterious *Hallucinogenous Bullfighter*, attitude of rejection in his setting aside a considerable sum, already deposited, for the storage of his corpse to preserve it until such time as scientific advancement has found a cure for whichever illness turns out to be his last. Thus he would succeed in erasing the black blot of

222. Detail of *Saint Sebastian*.
223. *Saint Sebastian*, 1959; ink and watercolour on cardboard, 23.5 × 17 cms; private collection, Barcelona.
224. Detail of *Soft Construction with Cooked Beans (Premonition of the Spanish Civil War)*, 1936; oil on canvas, 100 × 99 cms; Louis and Walter Arenberg Collection, Philadelphia Museum of Art.

224

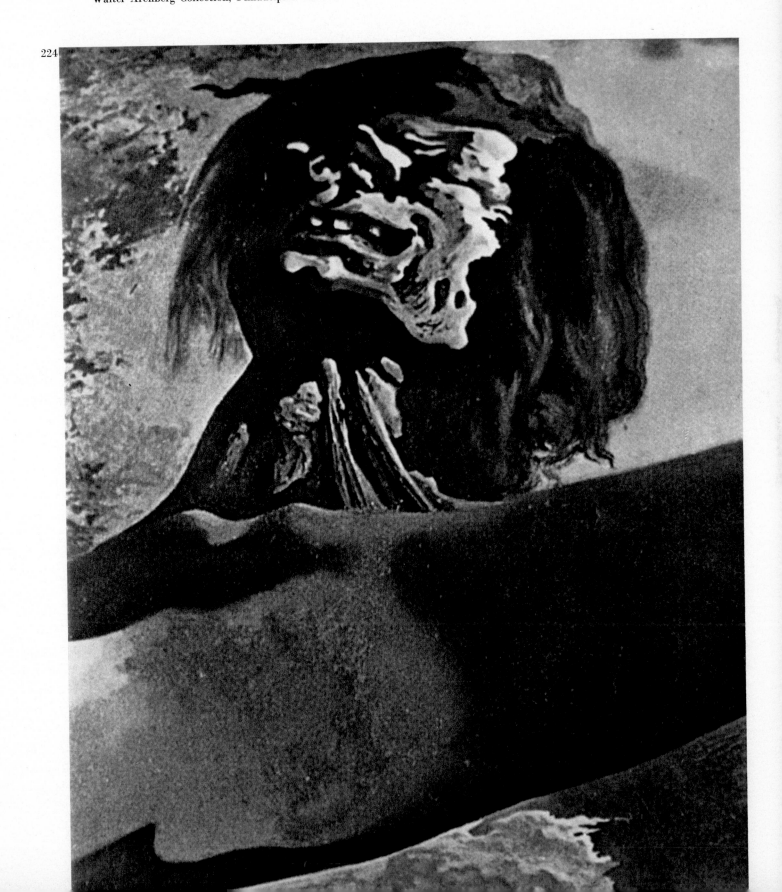

184

225

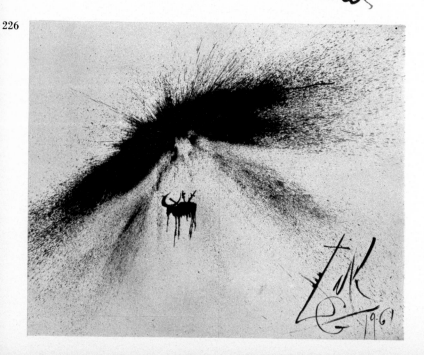

226

Tauromaquia
"Greta de los crótalos"

death and would achieve survival, (at least in theory, which is something.)

The figure of the bullfighter, indefinite and equivocal because of the way it is composed, and because, at one and the same time, it is and is not the breasts, arm-stump, stomach and shadow of the Venus de Milo. (We would include her flesh too, whose colour and texture is there, except that we know that the Venus was made of marble.) Moreover, it is the outline of her hip and the colour of the sand in the arena.

This Apollonian face gives the picture its title, although its exact significance remains obscure and it lacks antecedents in earlier paintings which would serve to explain it. We can make out the mouth of the bullfighter, which is almost serene, his nose, and the perfect line of the chin. But the

227

eyes elude us because they are not exposed to the light of day and are not open to our scrutiny. Who are these eyes looking at? Perhaps at the boy in the sailor suit, the single spectator of this hallucination —unless he forms part of it.

According to my personal vision, the face of the bullfighter changes its expression in another dynamic, impetuous sequence, so fleeting that we can hardly fix it on our retina. It is the moment when he will be gored. The melancholic, serene premonition, the resigned attitude, is followed by the grimace of pain and the imminence of death. The grimace, which suddenly gives the face expressionist features, is found in the Venus at the right of the painting, almost at its edge. The face is turned upwards and one can hear a cry of complaint or protest. On the Mount of Olives the prayer has given way to the lament of the crucifixion: "My God, my God, why hast thou forsaken me?" for every man who dies is an infinitesimal part of Jesus Christ, who was created in the image and likeness of Man, just as Man had been created in the image and likeness of God; if in discussing Eternity we may speak of before, after and likeness.

The death of the bullfighter in the arena has been one of the constants in the life and art of Spain. With the possible exception of certain engravings by Goya and Picasso, it has not provided the theme for any masterpieces. We should recall, however, that Julio Romero de Torres, who had a widespread reputation and was even considered a genius, painted *majas* and bullfighters, and flamenco scenes from the tragic Andalusia of the cheap ballads, and he was one of Dalí's teachers at the Academy of Fine Arts of San Fernando. Raquel Meller found acclaim in concert halls throughout the world for her song *El Relicario*, which recounted the death of a bull-

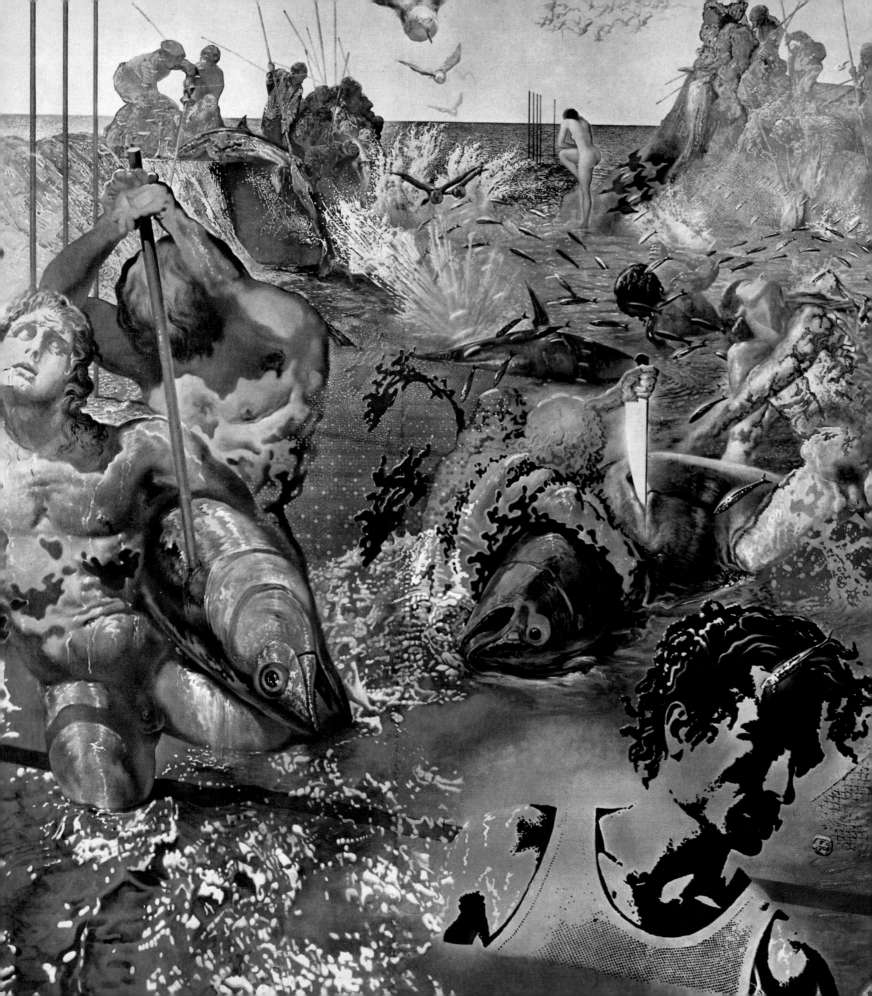

228 229

230

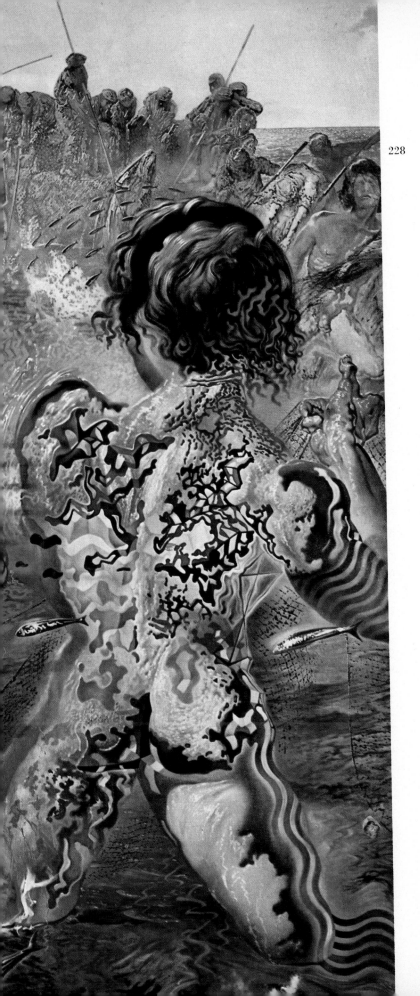

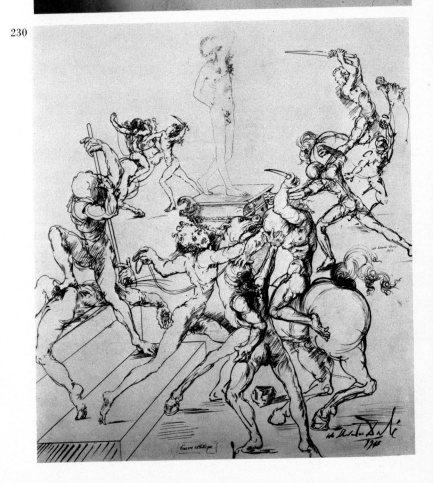

231. *Study for the Apotheosis of Homer*, 1943; coloured inks and sepia, 65.5 × 70.5 cms; private collection, New York.
232. *Triumph of the Whirlwind*; 30,5 × 38 cms; Peter Moore Collection, Dalí Museum-Theatre, Figueras.

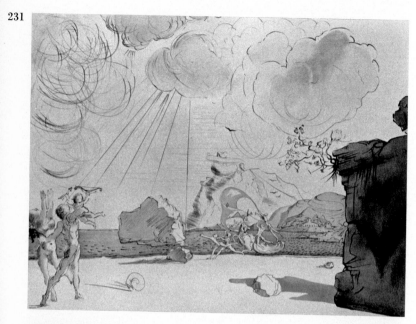

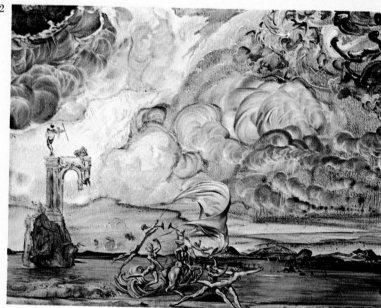

fighter and the effect this had on his sweetheart. It was sung by all the popular singers of the day and soon everybody was singing it, and this at a time when the gramophone did not have a monopoly but still competed with the street organs. *El Relicario* achieved lasting popularity; even today it is known to millions of Spaniards and to many people from outside Spain whose memories stretch back for more than half a century. This song was far from being the only one of its kind; little Spanish girls of the previous generation used to sing in a ring the romance of the death of El Espartero. Many novels were written, the most widely read being *Blood and Sand* by Vicente Blasco Ibáñez, which years later was made into a film with Rita Hayworth and Tyrone Power playing the leading roles. But apart from the exceptions which I have mentioned, and others which may have inadvertently slipped my memory, the death of the bullfighter has inspired no masterpieces in painting, literature, music or the cinema, although it has led to some works of a certain merit and to others that, by dint of wide circulation and popularity rather than their intrinsic merit, exercised an influence on the masses, among whom I would include many groups of well-informed people (21).

In present-day Spanish society, the death of a bullfighter has lost some of its impact among the flood of news which arrives rapidly and efficiently from all over the world, and which daily batters our senses. But let us return in time to 1935 when the bullfighter Ignacio Sánchez Mejías, a friend of many artists and intellectuals, in attempting to make a very daring pass, was gored and died in the arena of Manzanares in La Mancha. Having previously retired, he had felt the call to make a come-back, but it was the call of death. The shock of emotion which his death produced was translated into couplets and verses, one of

El Ropero y su
lágrima premonitoria

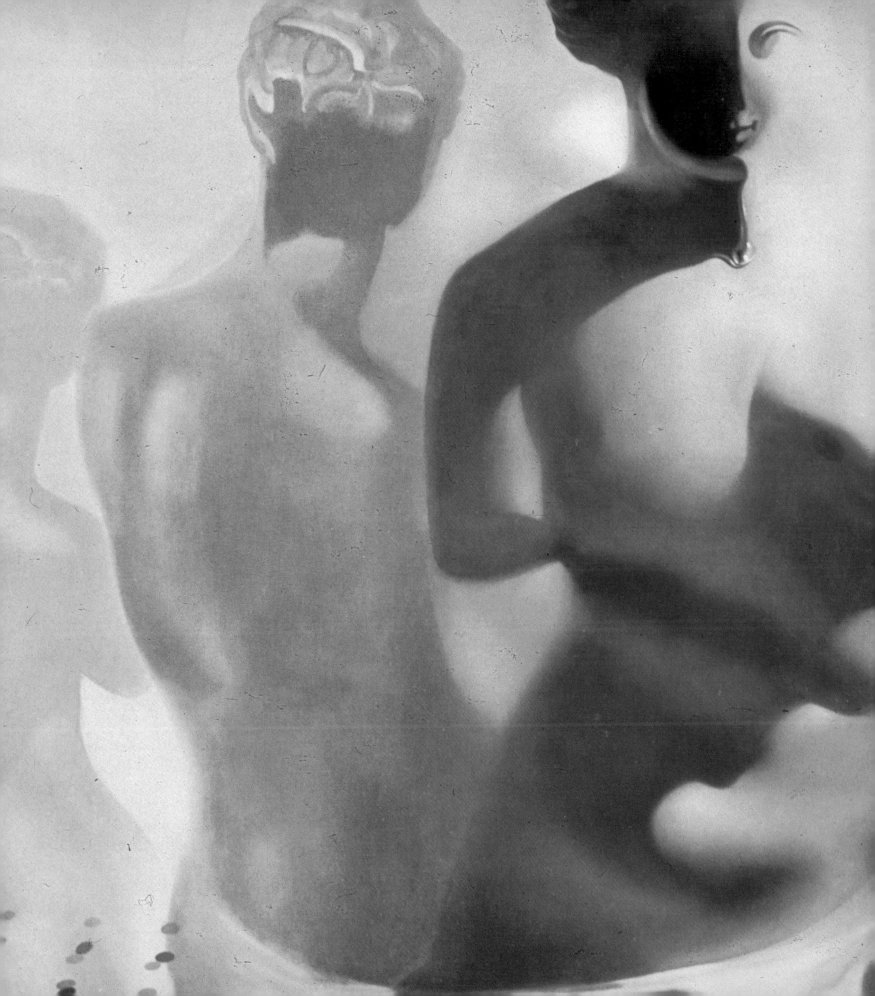

233. Eighth section of *Hallucinogenous Bullfighter*.
234. *Christ of Vallés*, 1962; oil on canvas, 92 × 75 cms. Painted after enormous floods had devastated the Vallés region. Mr and Mrs Giuseppe Albaretto Collection, Turin.
235. *Geopoliticus observing the Birth of the New Man*, 1943; oil on canvas, 46 × 52 cms; The Reynolds Morse Foundation, Cleveland.
236. *The Eye of Time*, jewel-watch; The Owen Cheatham Foundation.

234

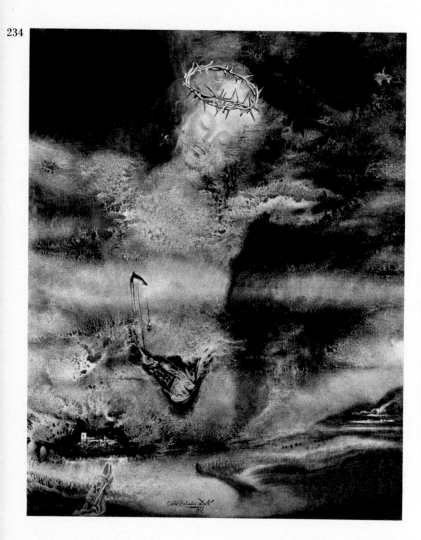

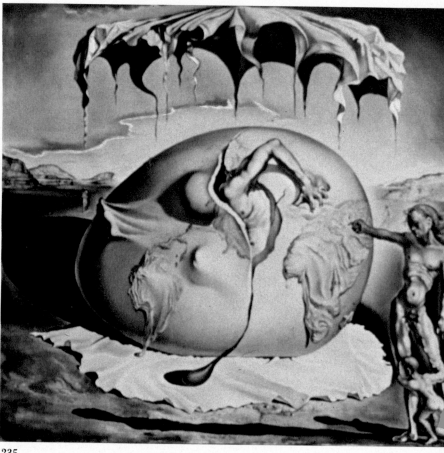

235

which stands out from all the rest: the poem *Lament for Ignacio Sánchez Mejías*, written by a friend who was then in the prime of life and at the height of his career,

> Up the steps climbs Ignacio
> Bearing the burden of death,
> Searches for the dawn,
> But the dawn isn't there;
> Looks for his confident stance,
> But his dream dissolves it;
> Searches for his handsome body,
> But finds his flowing blood.
> Don't ask me to look!

I have not asked Salvador Dalí if, in his bullfighter which lacks a clear outline, in his bullfighter broken down by hallucination or a dream, whose blood we neither see nor want to see, if here there are echoes of Ignacio Sánchez Mejías, whom he must have heard discussed by his friends in Madrid, and whom he must also recall from Lorca's poem. Between the death of El Espartero, now remote in time, and that of Manolete, which seems like only yesterday (not to mention others like that of the unique Joselito), that of Sánchez Mejías, thanks to his own personality and the poetic force of García Lorca, became the literary symbol for the death of a bullfighter.

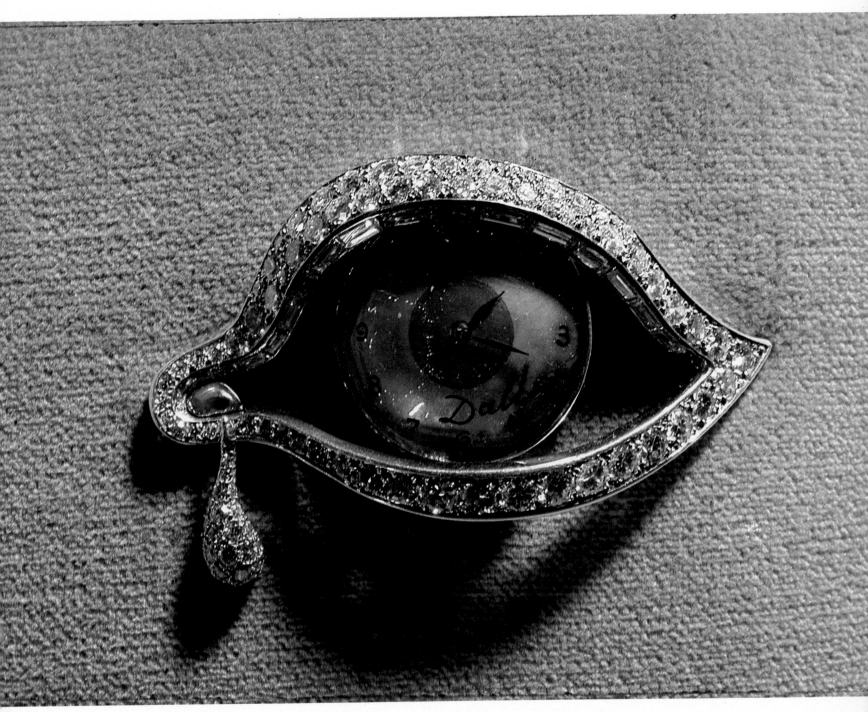

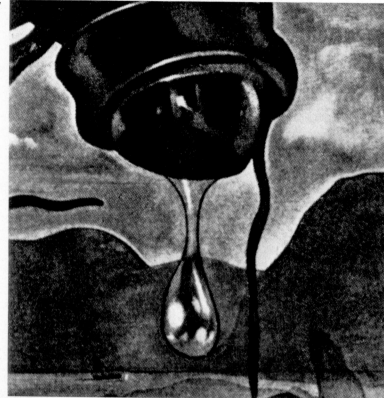

237

238

It is difficult, almost impossible, to appreciate the range of the painter's fantastic personality, another of whose facets relates to metamorphoses. Humans, animals and things —especially human faces and bodies, like the face of the handsome bullfighter— are composed from borrowed elements, at times surprising or grotesque in their new and distinct graphic application or the added significance within the general context of the picture.

Dalí likes these transmutations where something appears to be, or is, one thing but is also something else, and he often delights in constructing them, his consummate skill overcoming great difficulties to create accidental or deliberate symbols and associations, which can sometimes turn out quite disturbing.

They seem to stem from the playful nature of the leisure hours spent with children's comics, which amused us in days gone by, though now adjusted by the malicious skill of his brush and the visionary will of his eye and mind, always inclined to the fantastic or the fanciful, and to the astonishing. When we stand in front of these metamorphoses, these deceptive games with images where the mind of the painter reacts with intuitive speed and his hand then executes with patient, meticulous skill, do we witness the confession of certain determinant characteristics in his personality? Will Dalí not stand out in his pictures, conferring on the canvases an autobiographical power and weight which are more subtle, but no less evident, than what appears in many self-portraits?

Something similar applies to other painters, but the evidence is accentuated in the case of the man who has elevated egotism to the level of art. He never tires of playing the part, but it is so manifest and brazen that it almost ceases to be real. The repetitions and his age now incline

237. Detail of *The Enigma of Hitler (The Munich Conference)*, 1939; private collection.
238. Shot from *Un chien andalou*.
239. *Op Rhinoceros*, 1970; on plastic material especially invented by Dalí to represent the composition of the eyes of flies; 14.5 × 18 cms; private collection.

239

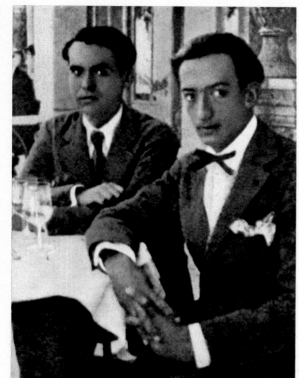

him to play down the role which he has assumed of the perpetual scandalous protagonist, which for many years has been his second nature, if not his first. He himself has spoken of it as "my natural tendency to megalomania".

Dalí-Frégoli, Dalí the lover of disguises, wearing fantastic get-ups, either expensive and superb or as humble as if they had been bought at a stall in an imaginary flea-market. Dalí disguised as Dalí is an improvisation on any kind of clothes: Renaissance man in a purple velvet dress coat and shirt with lace embroidery (indicating his nostalgia for ruffs); in an eighteenth-century jacket embroidered with gold; as a fake sailor with an authentic decoration (though on him one cannot believe it); in severe, atavistic togas; or

Dalí dressed in a thousand and one ways like the hippies —but before they were born— with jasmin in his hair, and on his feet the canvas sandals of a peasant. Dalí is different each time and on each occasion, and when his working clothes do not strike him as sufficiently showy for the audience that he is going to meet, he can always exclaim: "I'm going to get dressed up as Dalí!"

On thinking about all this, it occurred to me that the disguises do not succeed in transforming him; it is he who transforms the disguises, reducing them to the common denominator of his personality. Although this disquisition may appear peripheral, it is orientated in the same direction, since the desire for metamorphoses, for *trompe-*

240. Federico García Lorca and Salvador Dalí.
241. Detail of *Portrait of René Crevel*, 1934; ink and watercolour, 72 × 73 cms; Georges Troisfontaines Collection, Paris.
242. With Bob Kennedy in 1965 in the Museum of Modern Art, New York, before the *Christ of Saint John of the Cross*.

242

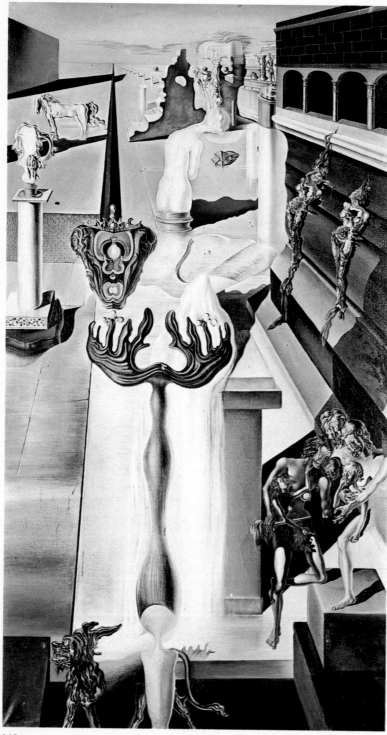

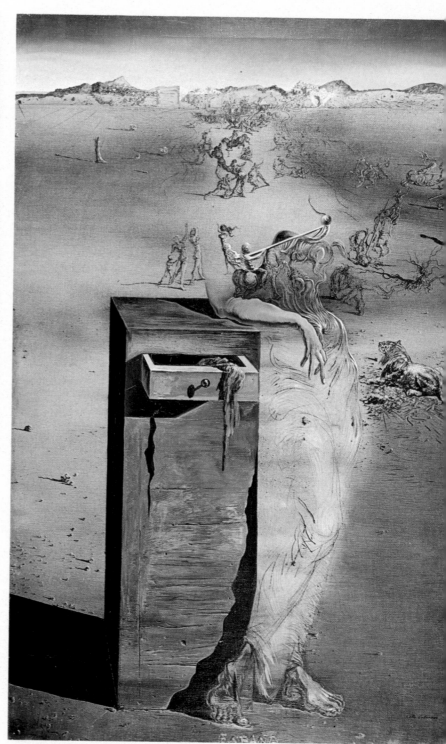

243

244

243. *The Invisible Man* (unfinished), 1929-1933; oil on canvas, 142 × 81 cms; private collection.
244. *Spain*, 1938; oil on canvas, 91.8 × 60.2 cms; New Trebizond Foundation.
245. *The Three Sphinxes of Bikini*, 1947; oil on canvas, 30 × 50 cms; Galerie Petit, Paris.

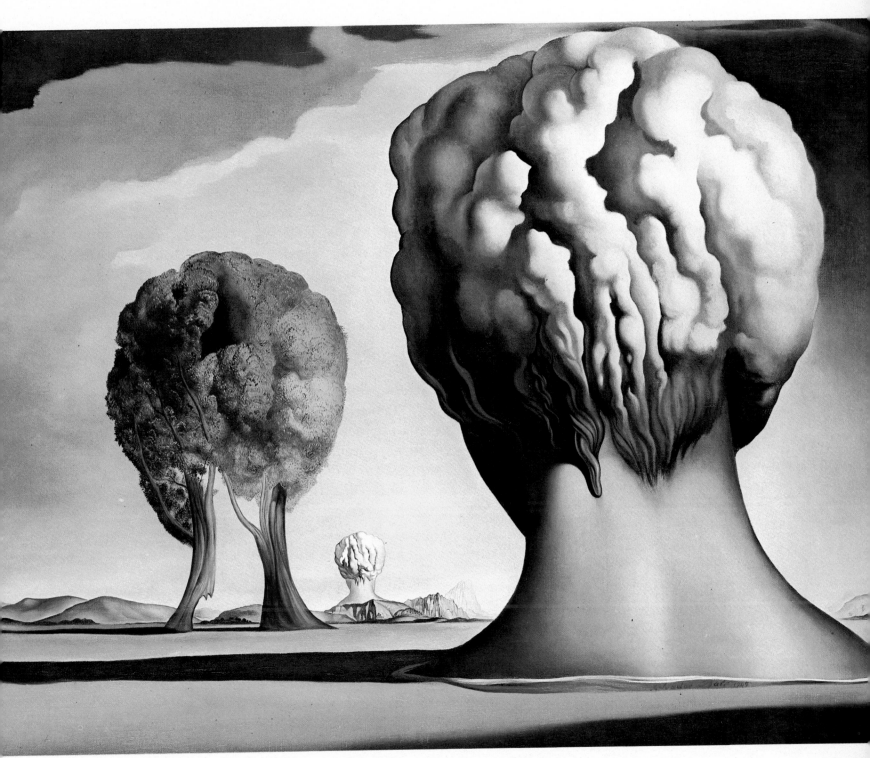

245

246. *The Great Paranoiac*, 1936; oil on wood, 62×62 cms; Edward F W James Collection, S

l'œil, for visual deception, for multiple appearances, are as evident in his person as in the aspect of his work to which we are referring.

Dalí relates that one day in New York, when he was looking at the design on the box of some 'Venus' pencils, he discovered the hidden image of a bullfighter. He showed it to Gala and to various other people, but nobody was able to see what for him was more and more obvious. Hallucinatory visions are nothing new in Dalí's life. He himself relates how he saw the real figure of a woman in his bedroom in Cadaqués when he was young; and his family had to explain away another hallucination which paralysed him with fright when he was still only a child. And, if we are to believe him, there is another story of how his grandmother appeared to his father, descending a staircase with a basket of linen, eight years after her death.

The hallucinatory visions, the things which change into something else, the faces suggested by the effect of the arrangement of a landscape, or the objects and clouds which have an independent significance, made their first appearance in his paintings in a picture called *Invisible Man*, (to the best of my knowledge his only painting to remain unfinished) (22). He began the painting in 1929 and worked on it intermittently until 1933, when he abandoned it. It should be noted that the invisible man is in fact quite visible (23): a little ghostly, he is sitting there composed of fragments of the landscape and a wealth of other elements including clouds for his hair, statues, architectural and ornamental details, two spheres, something which seems to be an inverted chess-piece, the diminutive figure of a man, a decapitated horse, stumps of columns, the valve of a shell-fish... As I understand it, the unfinished part must be the legs. If this really was

the first picture in which he sought to create the effects of visual deception, he found it too difficult to continue and abandoned it unfinished. He has called the invisible man "a person with a benevolent smile".

Even if this were his first deliberate, systematic attempt, its sources might also be sought in Cubist constructions and in the plastic decomposition of the figures which almost have to be guessed at, although these usually show up more clearly in Dalí than in other painters. With his Cubist experiments behind him, he was turning to orthodox Surrealism —the period in which this painting must be placed— and he inverts the points of reference of Cubisn and even of Surrealism (which also presents dream-like transformations), making the figures emerge from the natural context of the composition, or at least so he pretends.

The predilection for fantastic mutations progresses in the mind and brush of Dalí. Metamorphoses abound in several pictures and, from 1929 on, they are found throughout his work, culminating —for the time being— with the invisible bullfighter.

Let us consider the works in which the apparition of faces is a principal theme. We have not found it necessary to make an extensive list; we will simply discuss a few pictures selected in the main from his best-known works.

One might say that 1936 was a fecund year in Dalí's work, and this would be true particularly with regard to these apparitions. In *Perspectives* we discover various faces composed of arrangements of men and women which form rings against a biscuit-coloured plain that resembles a spacious beach from which the water has receded. Though the sea is missing, the rocks in the background are reminiscent of the cliffs at Cape Norfeo. In the

202

247. *Triple Image*, 1940; Catherine Moore Collection, Paris.
248. Detail of *Triple Image*.
249. *Paranoia*, 1936; oil on canvas, 38×46 cms; The Reynolds Morse Foundation, Cleveland.
250. *Invisible Afghan Hound with the Apparition, on the Beach, of the Face of García Lorca in the Form of a Fruit Bowl with Three Figs*, 1938; oil on canvas, 19.25×24.15 cms. Also to be seen in this picture is a double image of Lidia, Ramón de la Hermosa, and other characters. Galerie Petit, Paris.

247

248

249
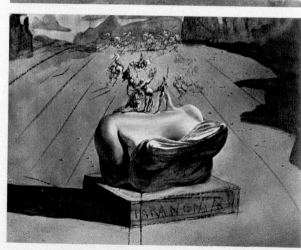

250

same year he made *The Great Paranoiac*, a face which, like an echo or replica, is repeated in a more distant, smaller version, and which arises out of a dancing coven of characters who seem to be fishermen, moving about amid an unreal landscape, with allusions to the rocky configurations of Cape Creus and to a beach with an abandoned boat whose pathetic ribs stick out like those of a carcass. The figures are in desperate attitudes and one of them is weightless. *The Great Paranoiac* presents a pensive, lugubrious expression. Also from 1936 is *Head of a Woman in the Form of a Battle*. In this canvas we see clashes between horsemen, fleeing women, and figures with an exaggerated dynamism, which together form the head of a woman. I am familiar with the original of this work, although as I write, I discern in the poorly illuminated reproduction in front of me a greater

251. *Mae West's Face*; gouache on paper; Art Institute, Chicago.
252. Detail of *Impressions of Africa*, 1938; oil on canvas, 91 × 117 cms; Edward F W James Collection, Sussex.
253. *The Infinite Enigma*, 1938; oil on canvas, 114 × 146 cms; private collection.

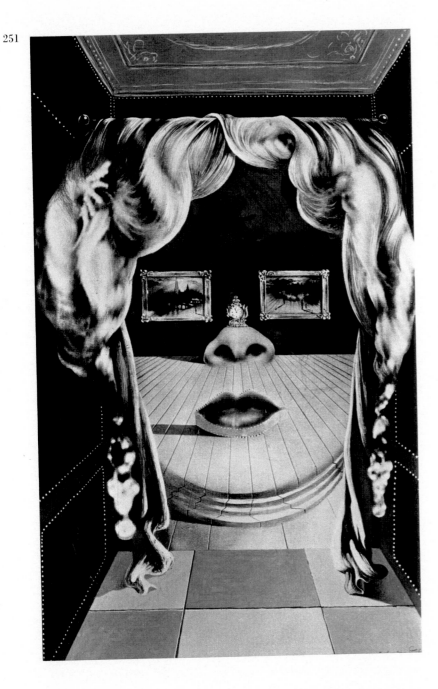

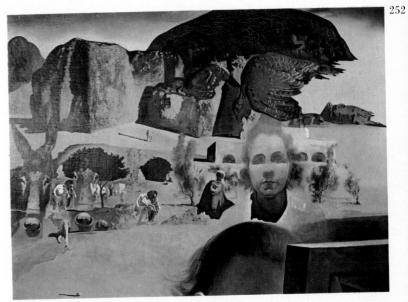

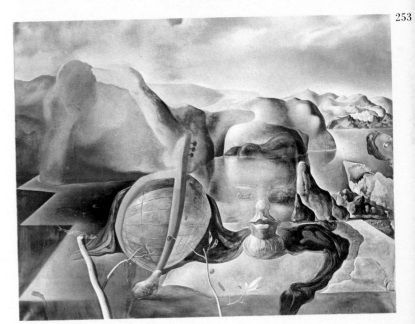

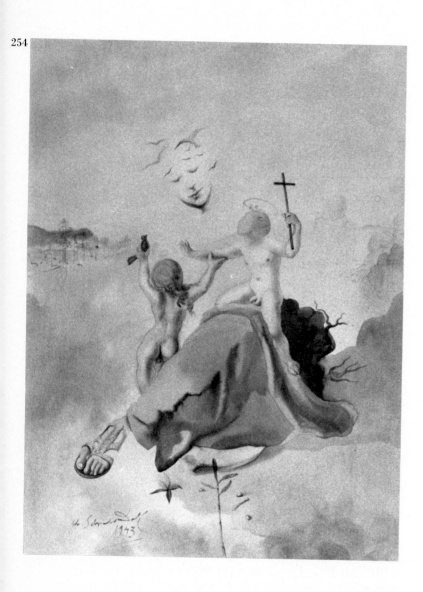

254

reality in the head while the horses and fighters seem to melt away.

Two years later we note the composition *España*, with its allusions to the civil war: clashes between soldiers, spearings, battles, and a lion surrounded by bones and offal. The central figure is a woman leaning on a bedside table which is painted with photographic realism. From the waist down, this standing woman is merely suggested, except for a forearm and both feet. Above the waist she results, or derives, from the charac-

ters who are struggling or fighting. We notice again the two little spheres, which were the eyes of the *Invisible Man*, but here are placed at the tips of the matronly breasts, while her head, leaning to the other side, is reminiscent of the woman in the form of a battle, as if one was a consequence of the other.

There are many heads and faces which emerge in a similar way in various pictures, from the series which has as its common denominator a fruit bowl with figs situated on a beach (of which the best known is *The Infinite Enigma*) up to the one called *Invisible Afghan Hound, with the Apparition on the Beach of the Face of García Lorca in the Form of a Fruit Bowl with Three Figs*. We should point our that there is only an approximate resemblance to García Lorca, and I, for my part, am not convinced that his original intention had been to create the face of the poet. However, what is certain —by accident or design— is that this painting includes Lidia, the fisherwoman from Cadaqués to whom Dalí ascribes the most perfectly paranoiac mind after his own. Her character so impressed the poet that he quotes her in his letters to Anna Maria Dalí. It was Lorca who contrasted her madness with that of Don Quixote in the following terms: "Lidia's madness is a moist, soft madness full of gulls and lobsters: a plastic madness." One could extend the description of works that reiterate the theme of these transformations which he has recently called hallucinogenous, although they appear to be more the results of hallucination: there is the *Study for a Paranoiac City*, a drawing in which the hindquarters of a horse are transformed into the skull of the same animal, but then turn into a cluster of black grapes, and finally into a smiling Gala offering the same bunch of grapes; there are barrows and rhinoceros horns that form Renaissance cupolas which at the same

254. *Virgin of the Birds*, 1943; watercolour, 62.23×47 cms; The Reynolds Morse Foundation, Cleveland.
255. Postcard whose image turns into a Picassian woman's head. André Bretón thought he could see in this the head of the Marquis de Sade with a powdered wig.
256 and 257. *Paranoiac Face*, 1935; 62×80 cms; Edward F W James Collection, Sussex.

255

257
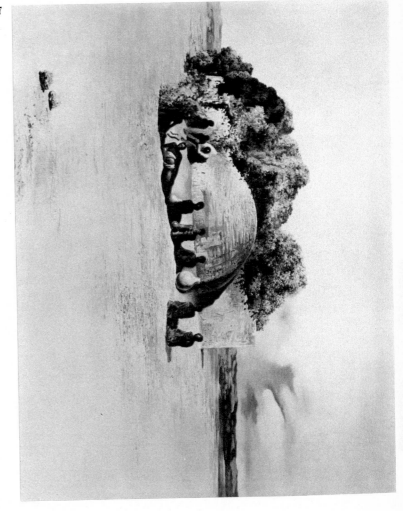

256

time are religious figures; and the delicate *Virgin of the Birds* where the expression on the face of Mary is suggested by the subtle outline of birds; and there is the portrait of Voltaire, as well as many others.

To compensate for the trivial antecedent of the leisure hours spent in reading children's comics, we must now take note of an illustrious precursor: Leonardo da Vinci.

Dalí himself has pointed out to me the anthropomorphic landscapes in certain of Leonardo's

pictures and the same thing in the case of Mantegna. I am inclined to think that these discoveries were made *a posteriori*, something which often occurs to him and which gives him great pleasure. This is what happened when he discovered the model for the bullfighter at a *corrida* which took place in Céret, after which the painting was made. Turning to another example, let us note that the boat from whose hull rises a cypress tree and which is situated in front of his house in Port Lligat, is many years later than those pictures where the same boat and cypress are seen on the beach at

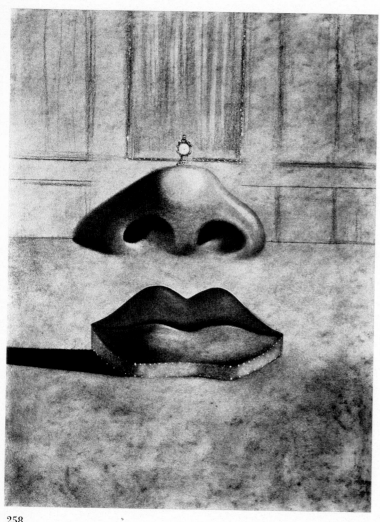

258

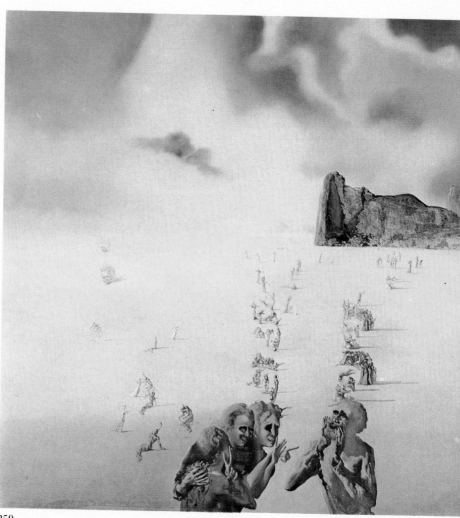

259

Rosas next to his Aunt Carolina. There exist coincidences or parallels between Leonardo and Dalí, like their common passion for science and their shared inventive spirit. The correspondences of the *trompe-l'oeil* I suppose one could attribute to chance, but, while this is not conclusive evidence, there is a book which Dalí lent me which deals with these figures in Leonardo's pictures and which was published in 1952. Nor should one ignore the influence, in certain respects, deriving from painters like Arcimboldo, Bosch, and Bracelli, all of whom are cited by the critics.

Although I am not sure of the degree of sincerity involved, he employs this extremely acute vision which results in this plastic fantasy in a picture called *The Battle of Tetuán* which is unlike Fortuny's painting of the same name in the Museum of Modern Art in Barcelona, though a small reproduction of the latter appears in the composition. He executed this painting in 1962, the year when Algeria proclaimed her independence. The newspapers frequently carried stories about the disturbed Arab world. The groups of Arabs, which occupy the right-hand part below the reproduction

258. *Birth of the Paranoiac Furnishings*, 1937; 62 × 47 cms; Edward F W James Foundation, Brighton Art Gallery.
259. *Perspectives*, 1936; oil on canvas, 65 × 65.5 cms; E Hoffman Foundation, Museum of Fine Arts, Basel.
260. *Raphaelite Head in a Whirlwind*, 1955 (?). Also called *Raphaelite Rhinoceros Virgin*. Oil on canvas; previously Marqués de Cuevas Collection, New York.
261. *Galatea*; oil on canvas.

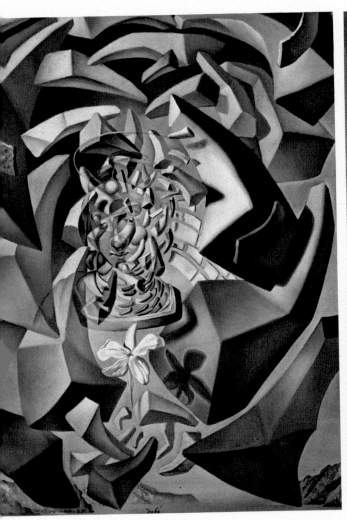

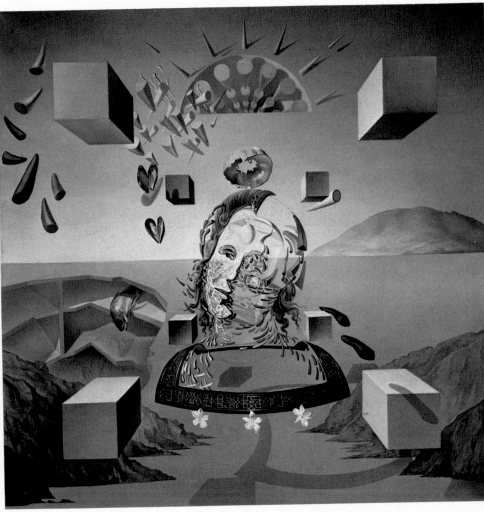

260

261

of Fortuny's painting, were copied from clippings from *La Vanguardia*, out of which, with only a little retouching of the letters and white spaces, he manages to create these figures. Although he was exaggerating a little, he maintained that it was unnecessary to *read* the news; you could *see* it. By way of proof, he did some demonstrations using printed letters.

Around this time he also painted *Portrait of my Dead Brother*. This was an imaginary portrait although it had its starting point in a coarse-grained photographic enlargement of an engraving.

This is not a true portrait of the earlier Salvador Dalí Domènech, who had died a year before the birth of the famous painter. The dots of the graining change into cherries which derive from the disintegration of an eagle. There are also extraordinary Martians or, if you prefer, homunculi coming from flying saucers and being opposed by terrestrial warriors.

From the same period is *Fifty Abstract Paintings, in which one Sees, at a Distance of Three Metres, Three Chinese-Like Lenins, the Whole Forming the Face of a Royal Tiger.*

208

262. Lidia Nogués de Costa.
263. Cypress which rises from a boat in Port Lligat.
264. *Apparition of my Cousin Carolineta on the Beach at Rosas* (detail), 1934; oil on canvas, 71 × 96 cms; Martin Thèves Collection, Brussels.

And a few years earlier he painted *The Skull of Zurbarán*. It was during this period that he reached the extremes in the metamorphoses, the transformations or the *trompe-l'oeil* —(I cannot find the exact words to describe these forms)— and he created perhaps an extension of optical illusion. With *Hallucinogenous Bullfighter* he appears once again to be in a period of classical madness and to be able to derive from his hallucinogenous experiences a pictorial and thematic balance.

262

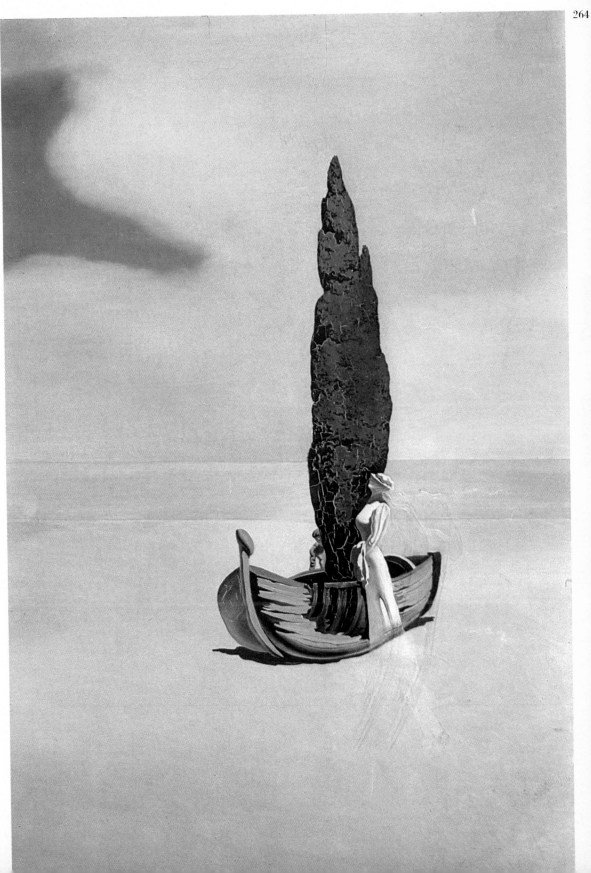

265. Detail, hung sideways, of a painting by Leonardo da Vinci in which Dalí has seen the profile of a condottiere forming part of the landscape.
266. The condottiere.
267. *Raphaelite Head Bursting*, 1951; oil on canvas, 67 × 57 cms; Stead H Ellis Collection, Somerset.

265

266

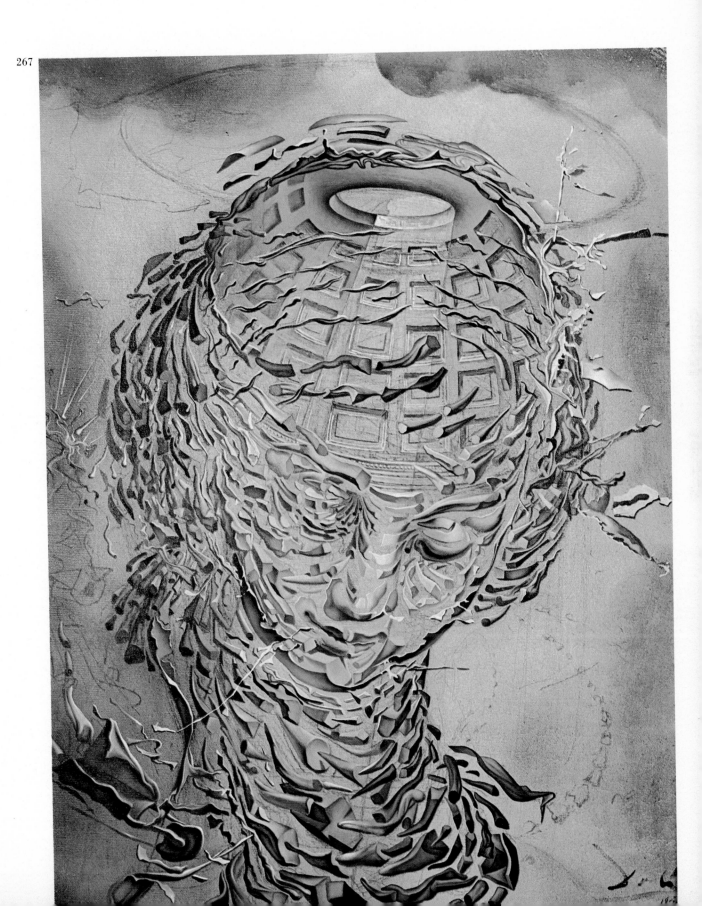

267

268. *Fifty Abstract Paintings in which one Sees, at a Distance of Three Metres, Three Chinese-like Lenins, the Whole forming the Face of a Royal Tiger*, 1963; oil on canvas, 201 × 229 cms; private collection.

268

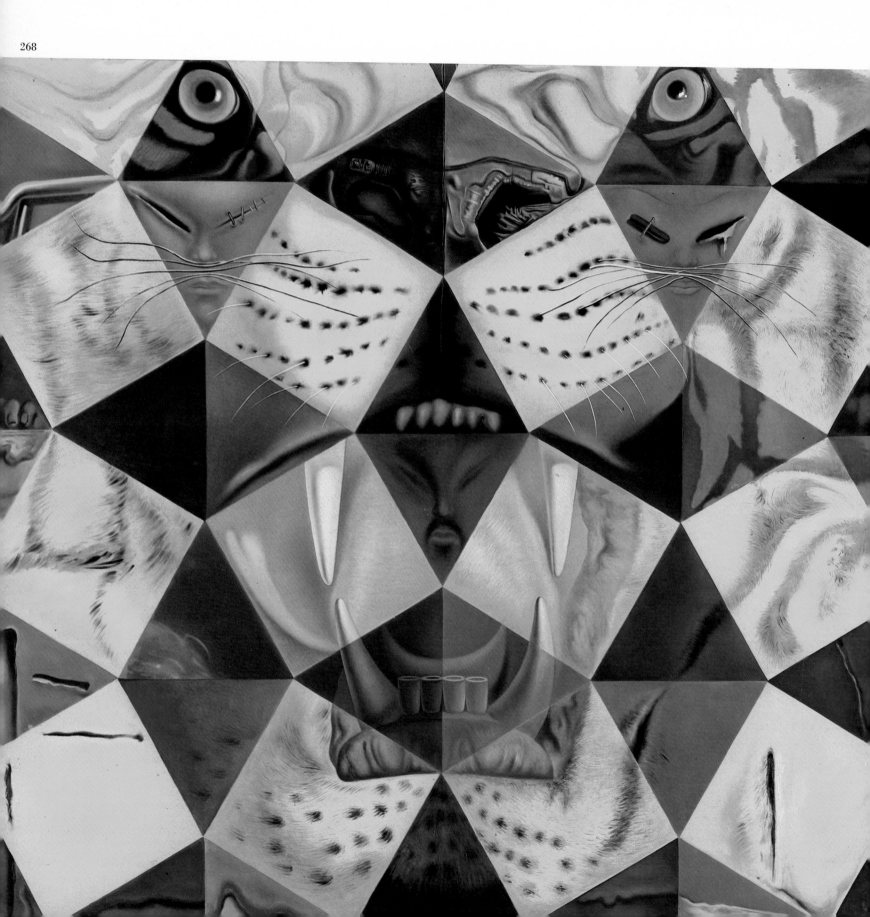

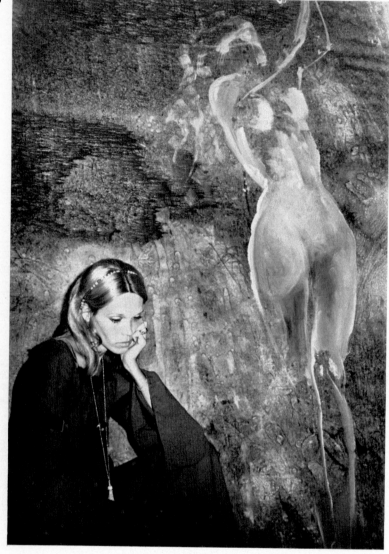

On the left-hand side of the painting we find, with a little difficulty, the moon in a position which, in the case of a human being, we would call modest. A clear moon, in the waning quarter, in an empty and distant landscape. It is the same moon which can be glimpsed from the window where his grandmother Anna is sitting sewing in a picture that I consider one of the best from his earliest period and the most poetic in its composition, scope and colouring. It was exhibit number one

in the catalogues in Tokyo and Rotterdam. If the catalogues are not mistaken, he painted it when he was thirteen. And this evidence leads me to contradict myself in admitting that Dalí was a child prodigy too. If he had not become the painter that we know, one might believe that *Grandmother Anna Sewing by a Window in Cadaqués* was a somewhat accidental result of fortuitous circumstances: the texture of the canvas on which he painted, the simple, frontal conception of

269. Ninth section of *Hallucinogenous Bullfighter*.
270. Model before a picture similar to the saluting bullfighter (unfinished in 1974).
271 and 272. Sketches; in the second can be seen how, in a twinkling, the bullfighter's face might be the image of Gala.
273. Detail of *Hallucinogenous Bullfighter* during the painting.

273

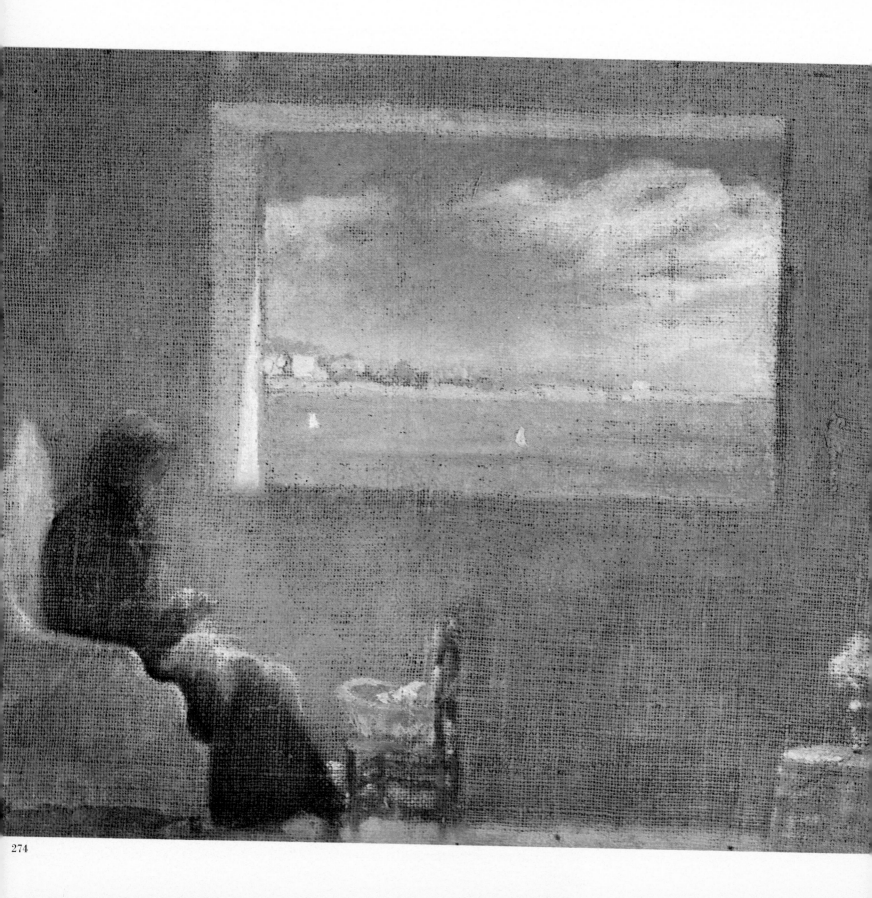

274. *Grandmother Anna sewing in Cadaqués*, 1916-1917; oil on sackcloth, 48×62 cms; Joaquín Vila-Moner Collection, Figueras.
275. Sketch in which appear inverted the main figures from *Cosmic Athlete*; pencil on cardboard, 24×18 cms.
276. *Cosmic Athlete*, 1968; oil on canvas; Ministry of Education and Science, Madrid.

276

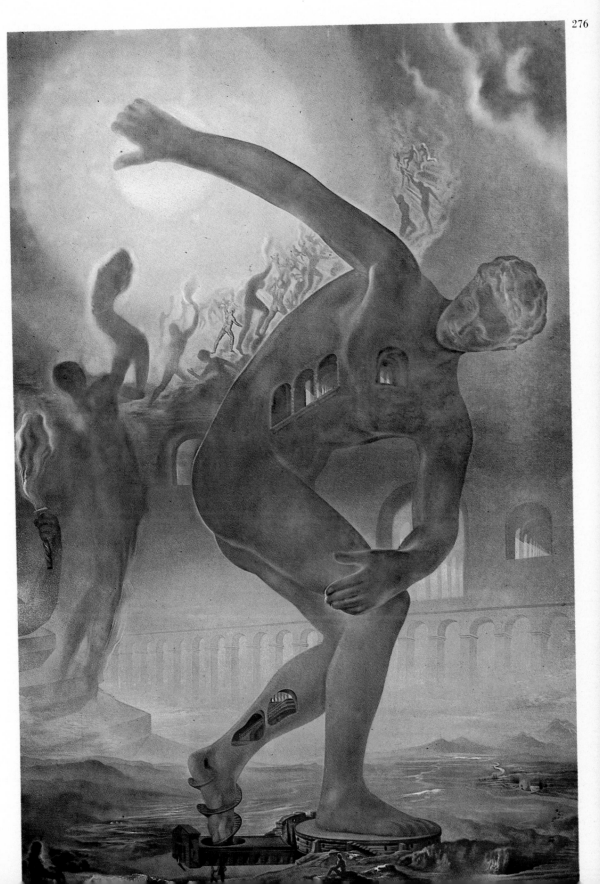

75

277

279

278

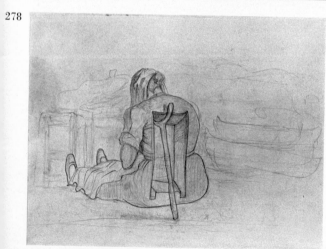

277. Imaginary portrait of Dalí, by Federico García Lorca (much damaged), 1926.
278. Study for *Weaning from the Food Chair*, 1933; The Reynolds Morse Foundation, Cleveland.
279. *Weaning from the Food Chair*, 1934. The landscape of Port Lligat can be seen inverted. Oil on wood, 18 × 24 cms; The Reynolds Morse Foundation, Cleveland.

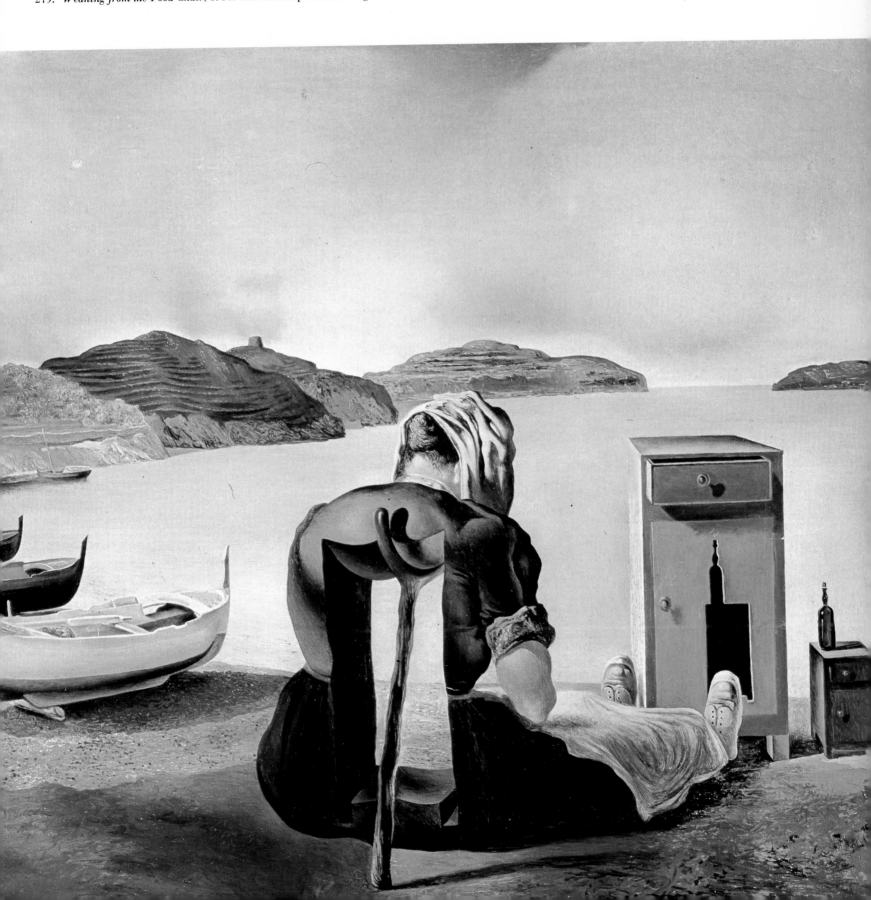

280. *Big Thumb, Putrefied Bird, and Moon*, 1928; oil and collage on wood, 50×61 cms; The Reynolds Morse Foundation, Cleveland.
281. Photograph by Halsman, with moon and Mia Farrow when she was working on *Rosemary's Baby*; Dalí presented her with a capsule containing a lunar meteorite.
282. *Fisherman Soldier*, also called *Bird-fish*, 1928; oil and collage on wood, 61×49 cms; The Reynolds Morse Foundation, Cleveland.
283. *Billy-goat*, 1928; oil on wood, 50.15×60.7 cms; The Reynolds Morse Foundation, Cleveland.

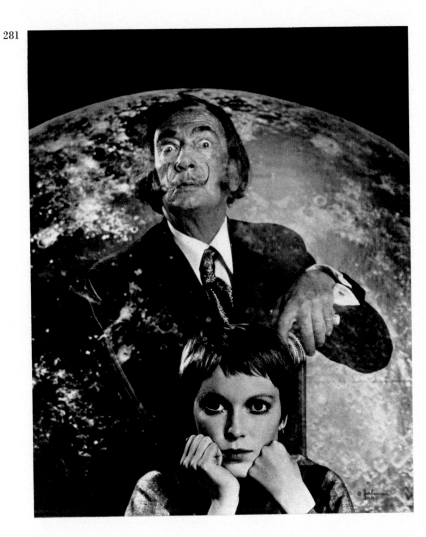

281

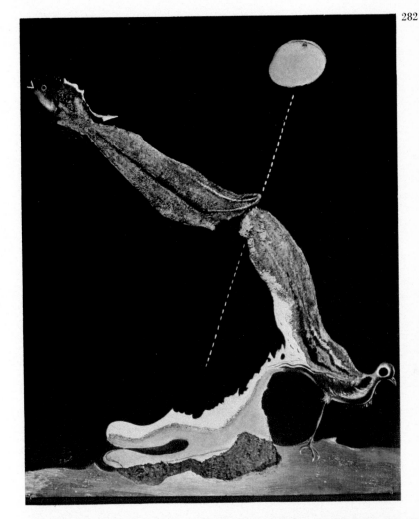

282

283

the theme, the chromatic beauty of the dominant blue. On the contrary, I am inclined to believe that it is the product of a mature pictorial intuition, combined with the inspired emotions of that secretive, hypersensitive, sentimental child which we divine in, and behind, what he relates in literary and pictorial evocations of his infancy. This moon, seen through the window, or in *Hallucinogenous Bullfighter*, suggests a sensation of decay or decline, and it is no coincidence that it is represented on the wane. Did this child, the young painter, deliberately include this moon (and not a different one) in a painting where the only charac-

224

284

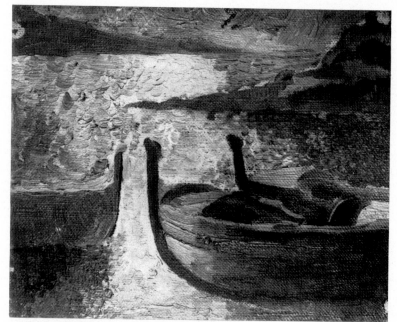

285

286

ter is his grandmother who was to die just a few years later? The picture does not betray any sign of gloom or pessimism; it presents a serene, pure, and even optimistic image of old age. Because children have no proper means of assessing the age of old people; they have known them like that ever since they can remember them. We need to be of a certain age before our eyes are aware of the unambiguous signs of the passing of time: we begin to notice the ageing in people, an observation which is accompanied by a certain melancholy. In *Bullfighter* the moon is found to be associated with figures that are shown in receding perspective, lacking in intensity, size and colouring, on their way to some uncertain destiny. As to the figures, the Venuses seen from behind with their ambiguous heads are to be related to Llúcia, who appears in so many pictures as the central or as a secondary character, lending to the whole a feeling of nostalgia, summoned to the transparent door of some irrecoverable paradise. This is not that vigorous moon which has also attracted the painter, particularly in the last few

287

years when the inauguration of astronomical exploration made it possible to predict what was soon to take place. That over-full moon was seen through a powerful telescope or from some imaginary point outside the earth's atmosphere, and one discovers that it had been anticipated in one of his earlier paintings, *Big Thumb, Putrefied Bird, and Moon.* It is dated 1928 but, due to the vision of the moon and the intention and materials employed, it could be a later work in line with more recent trends in art.

Bird —previously in the collection of Paul Eluard— is a painting from the same period and somewhat similar to the previous one; here he presents us with a moon that is less definite, more *plastic* and conventional. And another realistic one, whose brightness is reduced by the luminosity of the afternoon, occupies the sky in *The Dream.* The moon does not appear a great deal in Dalí's work, which generally has a marked solar character.

It is difficult to carry out research on a painter whose works are scattered over half the globe and are catalogued and reproduced only incompletely. I have tried to find more moons in his paintings. *Still-life by the Light of the Moon* is a Cubist composition from 1927. During the next year he painted *Billy-goat,* where there is also a full moon. Years later, in 1938, we see a moon, this time waxing, providing the background to a scene in which a horse is born from the remains of a motor-car. Is it by chance that these moons appear in one or other phase. Can some importance be attached to this? It was the turn of the waxing moon when he painted the ceiling of the Palacete Albéniz. In certain paintings, like *Hypercubic Body,* there is a lunar luminosity.

I have tried by means of these moons to trace possible influences from Federico García Lorca in the period when their relationship was at its most intimate, for García Lorca definitely was a poet vibrant with moons, which one finds expressed in his poetry in unforgettable images. There is a waxing moon in a crayon drawing that Lorca made. It is a portrait of Dalí with a somewhat magical air, dressed as he is in a kind of hood, one hand holding the palette, the other submerged in a fish-tank, and each finger is prolonged into a fish. Perhaps these are "the great glasses of the fish and the moon", as the poet writes in *Oda a*

226

Salvador Dalí; and later, "our friendship painted like a snakes-and-ladders board". All that remains is this naive, rumpled paper, as if one young man was expressing his friendship for another, though neither of them was young at the time. This paper remains, faded by the years, with the drawing by the poet, not the painter:
Oh, Salvador Dalí, with your voice like olives!

What is he studying, the child Dalí, this polyvalent figure who, born in 1904 and painted in 1969, thus takes on a touch of timelessness? With his head slightly turned and raised, we insist that he is looking at everything: the flies and the dead bull pierced with *banderillas*, the waning moon, the Venus de Milos, both gigantic and diminutive, the hallucination becoming flesh in the Apollonian bullfighter with his tear, his cap, his shoulder pads and his epaulettes. He watches everything: a new world that takes shape before the childish eyes of the young boy we see here, a confused, colourful, chaotic, hallucinogenous world. In the foreground, two statues, not of marble but of flesh, which around the middle of the canvas turn on their stands and change into Apollos or youths, revealing hollow backs like that of Llúcia in *Weaning from the Food Chair* and other pictures. Enigmatic nurse, always seen from behind, the nurse who we know is an evocation of Llúcia because "the absence of a loved one leaves us with a sentimental void", which the painter converts into a physical hole as of the bedside table; but at the same time it is Lidia who in this same posture used to mend the nets like all the other fish-wives in Port Lligat. He also sees the heads of the Venuses, in different sizes, some phosphorescent and luminous, inspired by the tiny stars, those little dots of light that we see when we press on our closed eyes, little lights which are also called flies, and, in the work of the

painter, achieve their greatest representation in the six heads of Lenin hovering over the keyboard of a piano, a painting which is in the Museum of Modern Art in Paris. Dalí claims that these dots of light are "reminiscences of that paradise of the womb which I lost on the day of my birth".

Apoteosis de
VEnus
y.fosenos

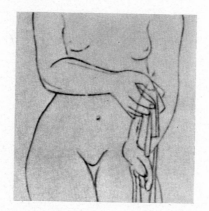

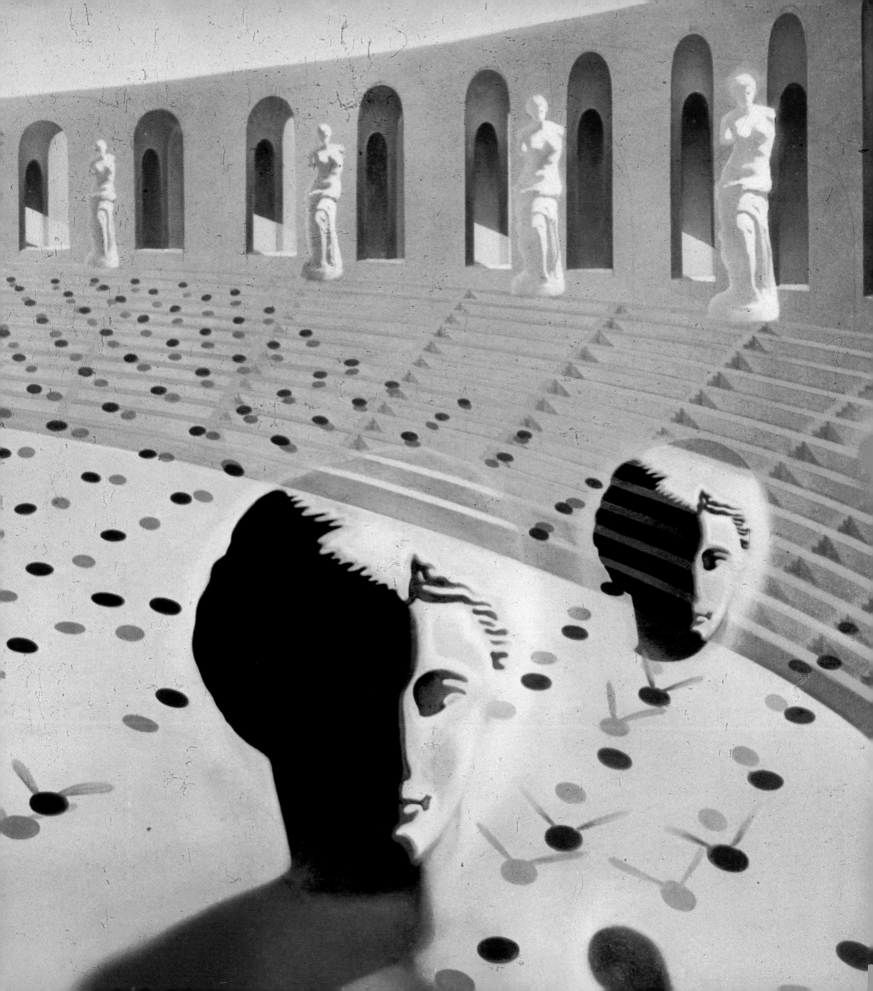

289

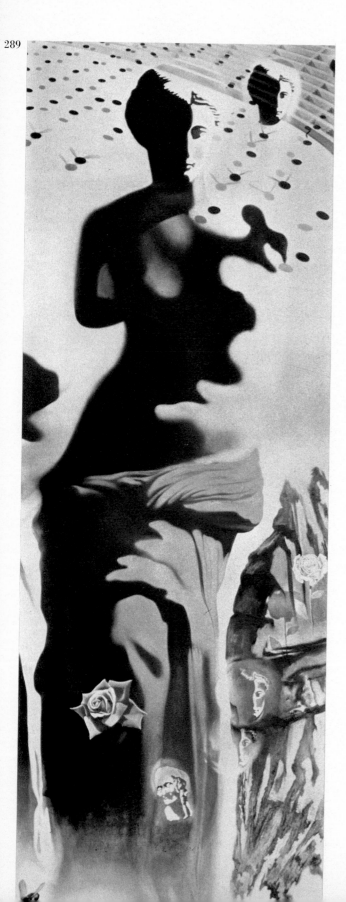

Sr. Venus & Milo
no me a gustado Nunca!

290

By Appointment to Her Majesty Queen Elizabeth II
VENUS ESTERBROOK LIMITED
MANUFACTURERS OF VENUS PENCILS

VENUS ESTERBROOK LIMITED, KING'S LYNN & BIRMINGHAM
MADE IN ENGLAND

VENUS

HB
3810

DRAWING

288. Tenth section of *Hallucinogenous Bullfighter*.
289. Detail of *Hallucinogenous Bullfighter*, Venus de Milo of the bullfighter.
290. Box of 'Venus' pencils where Dalí discovered the bullfighter's face.
291. *Otorhinological Head of Venus*, 1964; plaster, 60 cms high; reconstructed in 1970 for the Boymans-van-Beunningen Museum, Rotterdam.
292. *Venus de Milo of the Drawers*, 1936; 98 cms high; Descharnes Collection, Paris.

291

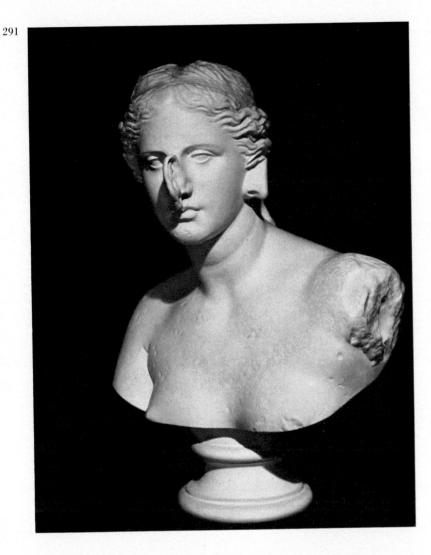

292

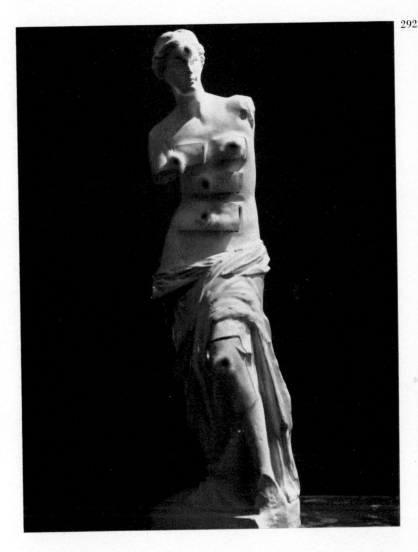

The Venus de Milo, whose matronly figure is reiterated within the impressive architecture of the stadium, (or Roman circus or bullring,) goes back a long way in the personal mythology of the painter. As a child, in his first studio, which was the laundry on the terrace of the house in Figueras, he modeled in clay a Venus de Milo after a reproduction which decorated the family dining-room, a decoration which, as an illustration or in plaster, was common to every middle-class home at that time. Some years ago in New York, he bought the 'Venus' box of pencils, as I have said, and discovered the bullfighter.

First in his rushing, teeming imagination and later with a more cerebral and considered elaboration, after many trials and adjustments, he succeeds in integrating so many figures and elements into the picture. He started the painting in Port Lligat and he required several months over a period of two years in order to finish the twelve square metres of canvas.

The significance of Venus, whether de Milo or not, even if this is to some extent indirect, (since Aphrodite and Astarte come to us from later, literary sources,) is clear, direct and uni-

293

294

293. *Venus and Sailor*, 1926. Homage to Salvat-Papasseit. Oil on canvas, 216×147 cms; Gulf American Gallery Inc., Miami.
294. *Female Nude*, 1926; pencil drawing, 23.35×22.3 cms; The Reynolds Morse Foundation, Cleveland.
295. *Bathers at the Llané*, 1923; oil on cardboard, 72×103 cms; José Encesa Collection, Barcelona.

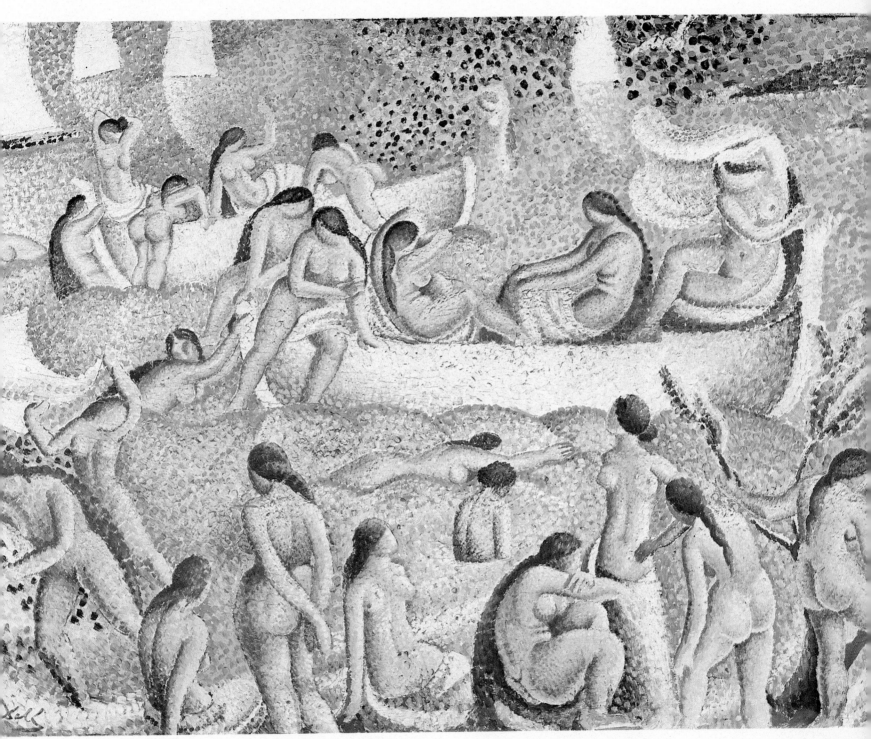

295

296. *Birth of a Divinity*, 1960; oil on canvas, 36 × 26 cms; Mrs Henry J Heinz II Collection, New York.
297. *Venus and Amorini*, 1925 or 1926; oil on canvas, 23 × 23 cms; previously Mercedes Ros Collection, Barcelona.

236

298

300

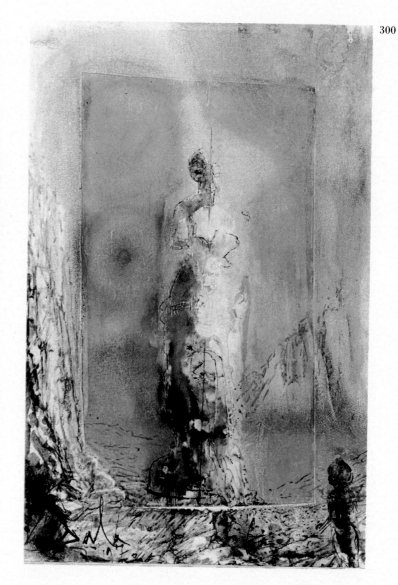

299

298. *Painting*, 1926 (?); Belitz Collection, New York.
299. *Reminiscence of the Venus of Velazquez*, 1972; sanguine; private collection.
300. *Apparition of Venus*, 1970; oil and ink on paper and cardboard, 30 × 19 cms; private collection, Barcelona.
301. *Matronly Venus*, 1923; drawing, 18 × 16 cms; private collection.
302. *Bottom*, 1973; Indian ink on paper, 25 × 25 cms.
303. *Nude*, 1935; charcoal drawing, 17.2 × 14 cms; James Trall Soby Collection.

301

303

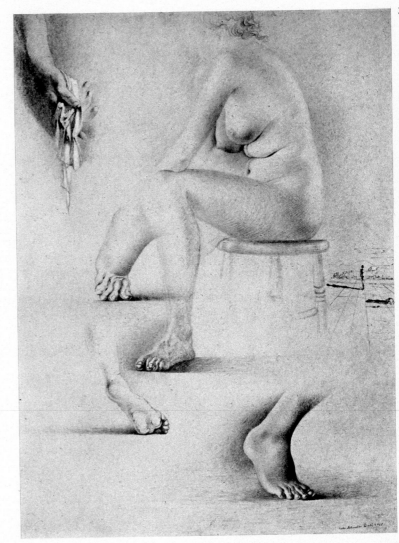

302

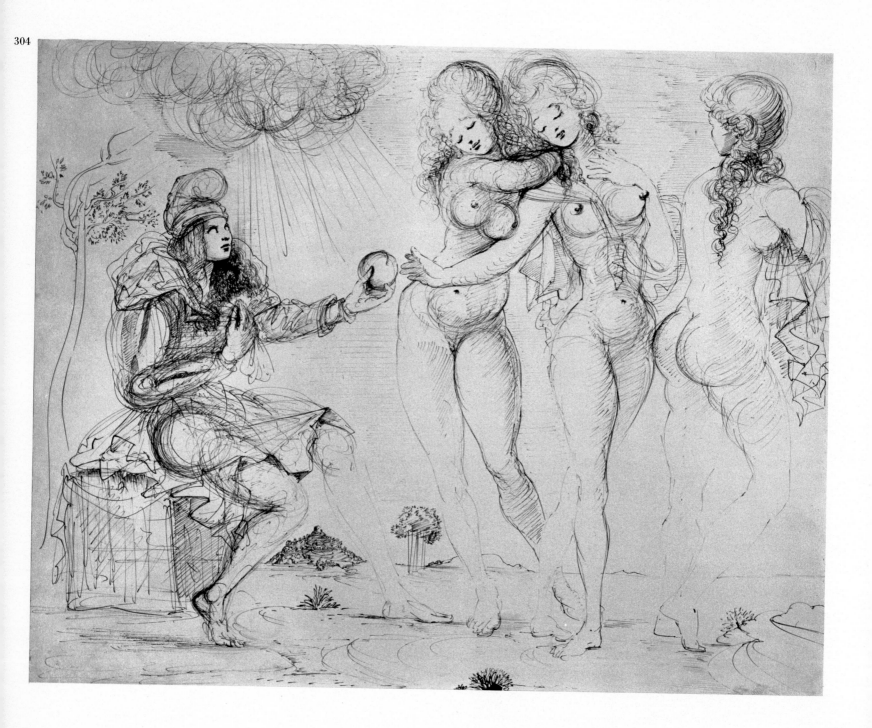

304. *Judgment of Paris*, 1950; Indian-ink drawing, 62.2 × 76.5 cms; Condesa Guerrini Moraldi Collection, New York.
305. *Barcelona Model*, 1927; oil on wood, 198 × 149 cms; private collection.

305

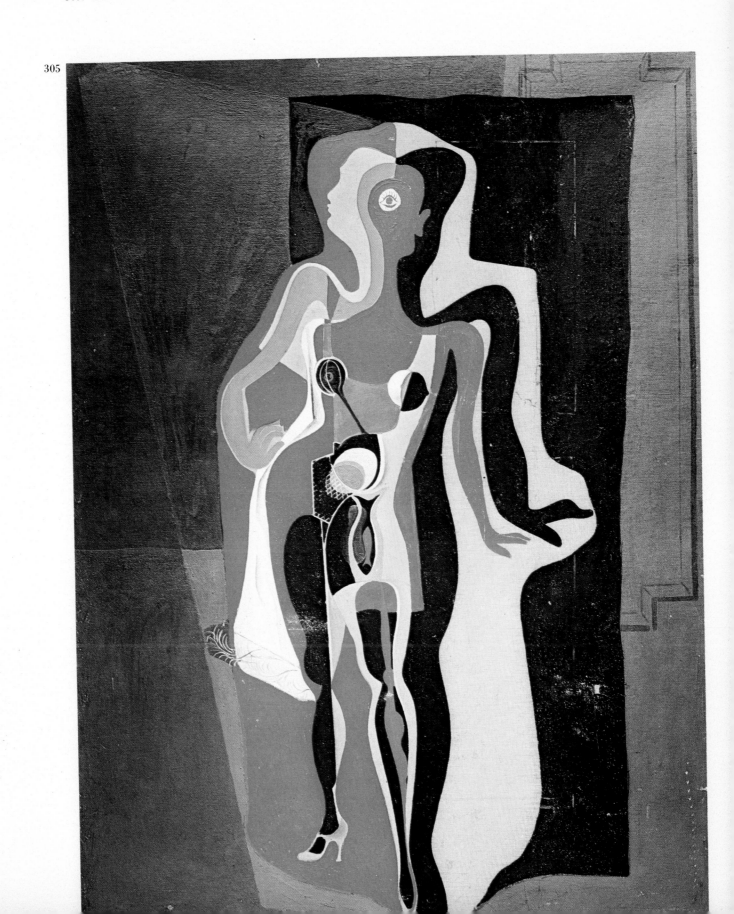

306 to 309. Unexpected dedication in a catalogue for the exhibition in Rotterdam; for reasons unknown, the Venus and the signature have gone through onto the adjacent pages, of which the two immediately following are reproduced.

306

Exposition Dali, avec la collection de Edward F. W. James

307

DALI

21
november
1970
10
januari
1971

Museum Boymans-van Beuningen Rotterdam

versally valid. Dalí describes her facial expression as stupid, and he considers this appropriate for the perfection of feminine beauty, but unsuitable for an elegant woman whose expression should be, or appear, intelligent.

Was this Venus not considered by young lads to be merely a woman naked down to her hips, or down to her bottom if looked at from behind? In Dalí the Primitive, the Cubist or the Classicist, the same in the Surrealist and the periods which have followed, there are a great many nudes, as happened with other painters up to the point when this figure was banished from their canvases.

In a good many of these nudes, excluding the portraits of Gala, we seem to come across close or distant echoes of Venus. In some one might think that the drapes had been snatched away, or drawn down at the back, as happens for example in one of the photographs which illustrate *The Diary of a Genius*.

Considering Dalí's work as a whole, we discover a great number of buttocks, an abundance of bottoms in every position and attitude, of all sizes and meanings. Bottoms of men, or women or unisex, bottoms of angels, deformed bottoms, waterfalls of chaste or lascivious bottoms, ex-

pressionist ones, balanced or repellent ones, some disturbing in their equivocal ambivalence, bottoms with four cheeks, first merely suggested in stylized dummies and later produced in a plaster figure with a certain abstract appearance. Even the haunches of his horses and the form and colour of certain fruits sometimes reveal anthropomorphic traits. It might be claimed that Salvador Dalí is the first painter of bottoms in history, in the history of painting and in the history of the human bottom. In *Hallucinogenous Bullfighter* this accentuated Dalinian theme is excluded, like others to which we must refer. A certain degree

of chastity, which is not usually evident, issues from the composition of this canvas, where even the opulent breasts of Venus are transformed into the bullfighter's nose.

One might consider the bathing woman as another approximation to Venus in the fantasy and memory of that young man who lived close to the beach at the Llané, where modest maidens and sumptuous matrons divested their garments to reveal areas of flesh normally forbidden, thus allowing an industrious mental faculty to reconstruct the whole. For the diminutive bather, half-dressed or half-undressed in her

310

311

310. *Young Venuses*; engraving, 40 × 25 cms.
311. *Nude*, 1954; Indian-ink drawing, 35 × 27 cms; Abelló Museum, Mollet (Barcelona).
312. *Gala Nude from the Back looking in an Invisible Mirror*, 1960; oil on canvas, 42 × 32 cms; Dalí Museum-Theatre, Figueras.

312

bikini, who is lying on an inflatable mattress and lets herself be rocked by the water, assumes a double representation: on the one hand this is a bathing Venus, a woman who rises from the foam or the stillness of the sea, and on the other hand it expresses a floating reality, since inflatable mattresses and boats are taking the place of our fine harmonious coastal vessels.

The theme of Venus recurs in the work of Dalí. A bust entitled *Otorhinological Venus* derives from that of Milo but with the left ear and nose interchanged. Also well-known is the one called *Venus of the Drawers* which also comes from the de Milo. And from his earliest period we may recall two paintings: *Venus and Amorini* and *Venus and the Sailor*. In *Birth of a Divinity* she rises from the sea and her face is fashioned from water. In 1956 he painted a picture in the classic mould: a statue of a mutilated Aphrodite, probably one by Praxiteles or inspired by one by Eschilinus. Despite the fact that it is a statue, one appreciates the carnal quality of the body which remains alive. The mutilated statue of this woman-goddess springs from a shell, and its title and a rhinoceros horn, which passes almost unnoticed, justify the explanation which is given in the catalogue of the exhibition in Rotterdam, relating it to the mathematical perfection of the logarithmic curve and the shape of the human body. The picture is entitled *Rhinoceros Goose-flesh*. In several drawings Venus is depicted: it is Aphrodite who receives the apple in the splendid drawing of the judgment of Paris. In one of the engravings which he made for the publisher Argillet, she reappears in a way which is shocking because it is unexpected. It is realist but hardly orthodox, either biologically or mythologically speaking, because the acts of conception and birth are simultaneous. I have pointed out that there are no portraits of Gala in the manner of Venus. On the other hand,

there is a well-known one where she assumes the personality of Leda.

The heads of Venus and Apollo, when turned away from us, retain an obvious similarity with *Three Sphinxes from Bikini*, which are at the same time nuclear mushrooms, female necks, clouds and trees. One of those receding perspectives that Dalí likes, and which he on occasion simplifies by means of lines tending to converge at an imprecise horizon, here runs through the fugue of heads which decrease in the distance.

313

246

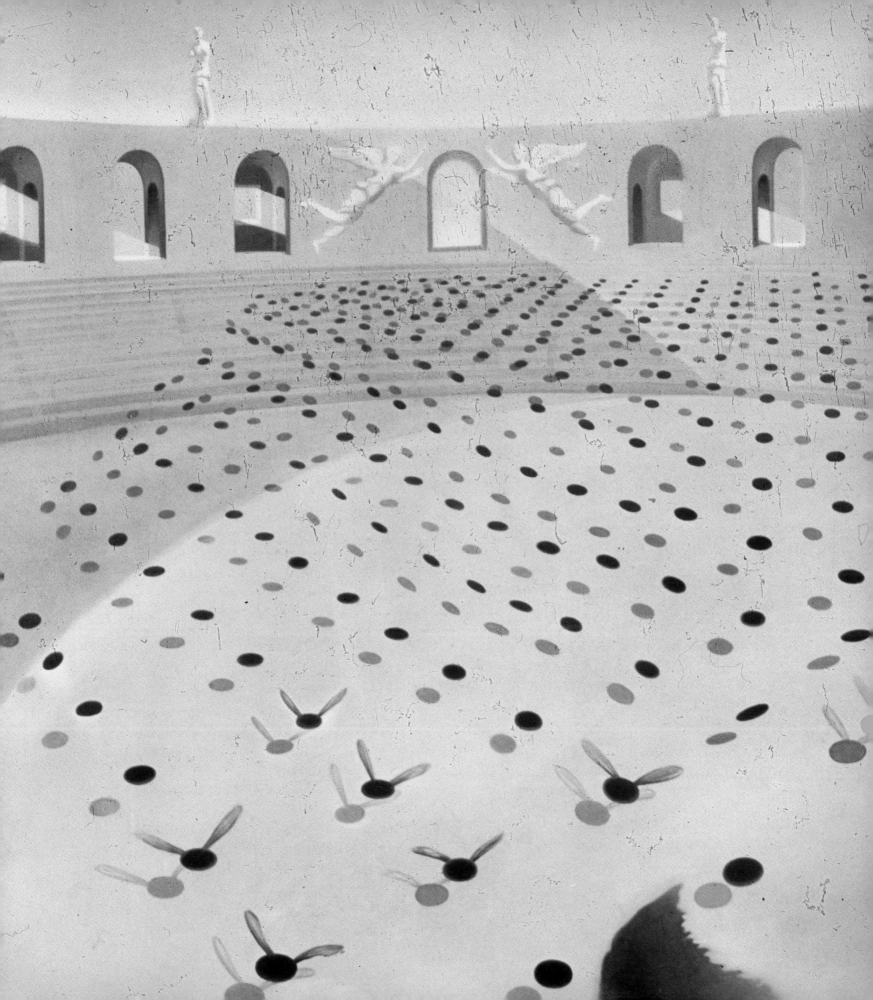

315

Occupying the upper part of the picture, set out with architectural and perspective perfection, are the tiers of a Roman circus or bullring in whose arena any normal bullfight would be impossible. The tiers are surrounded by arches. Two series of Venus de Milos, which the distance and the contrast convert into miniatures, serve as decoration. A pair of angels, situated on either side, lend distinction to the central arch, which could be the box reserved for the imaginary and absent president.

The architectural lay-out of the bullring is magnificent. Dalí, who likes to wear rush sandals to maintain contact with the earth, who has a sense of moderation and respects this even in pictures where he creates those unwonted, dreamlike truths that exist because of his will-power, Dalí the realist even in the ambit of the absurd, on other occasions lets himself be carried away by excesses in landscapes or buildings. The reason might be sought in an influence of the Italian painters of the Renaissance who liked to set their biblical scenes within splendid classical architecture or enormous, anachronistic temples; or again in the example of Giorgio de Chirico. The extensive bay of Rosas, limited only by the horizon, or at an even greater distance by the effect of mirts or clouds in the childish imagination, (reminiscences which in the memory of the painter remain alive and active,) would be the conditioning elements which are transformed to a magnificence both aesthetically valid and emotionally suggestive.

His excessive attitude when faced with certain landscapes is not only attributable to the exaggeration of perspective as a scenographic technique; it is a mark of his realization of the imbalance between man and the nature which surrounds him. There is an obverse to the medal of the pessimistic Dalí: the optimistic holder of a magic wand —his brush. The immensity of the landscape hints at the certitude that man will never embrace it, and if he insists, he will pay the price in fatigue and depression.

The proportions of the bullring suggest the non-functional nature of the architecture, except that the visible semi-circle is conceived as a sacrificial temple and we should banish the thought of the bullring in which the accustomed rites are about to take place. The division between sun and shade is not a border-line between the prices of seats for non-existent spectators; it is the

314. Eleventh section of *Hallucinogenous Bullfighter*.
315. Photographic composition with Indian-ink additions by Dalí in the lower part.
316. *Angel at Port Lligat*, 1952; Indian-ink drawing.

316

concrete limit of the silhouette of a bullfighter's cap. The Venuses arranged around the tiers have been elevated to the category of statues, or reduced to the condition of simple statues, carved in marble or stone, or modeled in plaster, according to whether we find ourselves in a classical dream or on the set of a film. One must tend towards the hallucinatory dream, which gives one an uneasy feeling since it places the spectator inside the dangerous circle of the bullfight or ritual sacrifice.

Two angels, placed on either side of the central arch, with their wings unfolded in a graceful pose, maintain a rigorous symmetry similar to the blotches with which children used to exercise their imaginations, smearing ink on a paper and then immediately folding it over. The results were capricious, symmetrical designs. With a little skill the shapes could be directed: it was not impossible to achieve the silhouettes of angels,

which, with the collaboration of fate, could be even more angelic.

The supposition that a friendly angel inhabits Port Lligat seems to be supported by Dalí, though in paintings and drawings rather than words. There is a painting *Landscape of Port Lligat* from 1950, and a different one with the same title painted in 1959. In both there is an angel which we see in the company of the fishermen. For some time he liked to think that there was an angel near his home, a guardian angel, and this idea turned up in his paintings. In 1956 the Dominican priest Bruno Froissart declared: "Nothing excites me as much as the idea of an angel." This devout idea may be due to the influence of Eugeni d'Ors who belonged to the angelic sect whose cult is more subjective and aesthetic than strictly religious. One might add that there is no great distance between the angelic and the demonic, and the limits of each seem to be imprecise. Dalí knew don Eugeni, who early this century spent some time in Cadaqués and returned there on a sentimental pilgrimage shortly before his death. One of the most extraordinary love stories involves Eugeni d'Ors and Lidia, the fisherwoman who was rumoured to be descended from witches. In about 1910, when he had lodgings in her house, Lidia was already a mature woman (24). The presence of this young and renowned Catalan writer under her roof awoke in her an unswervingly faithful, platonic love which was to defy his absence and years of silence, but which was fuelled by the enigmatic, personal messages that she read into the writer's learned articles or his philosophical meditations which appeared in large volumes. These 'paranoiac interpretations', which have come to me by word of mouth, and which were still very much alive when I arrived in Cadaqués although she was already dead, have captured the attention of Salvador Dalí and he has

317. *The Angel of Port Lligat*, 1952; oil on canvas, 58.4 × 78.3 cms; The Reynolds Morse Foundation. Cleveland.
318. *Landscape at Port Lligat*, 1950; oil on canvas, 58 × 78 cms; The Reynolds Morse Foundation. Cleveland.

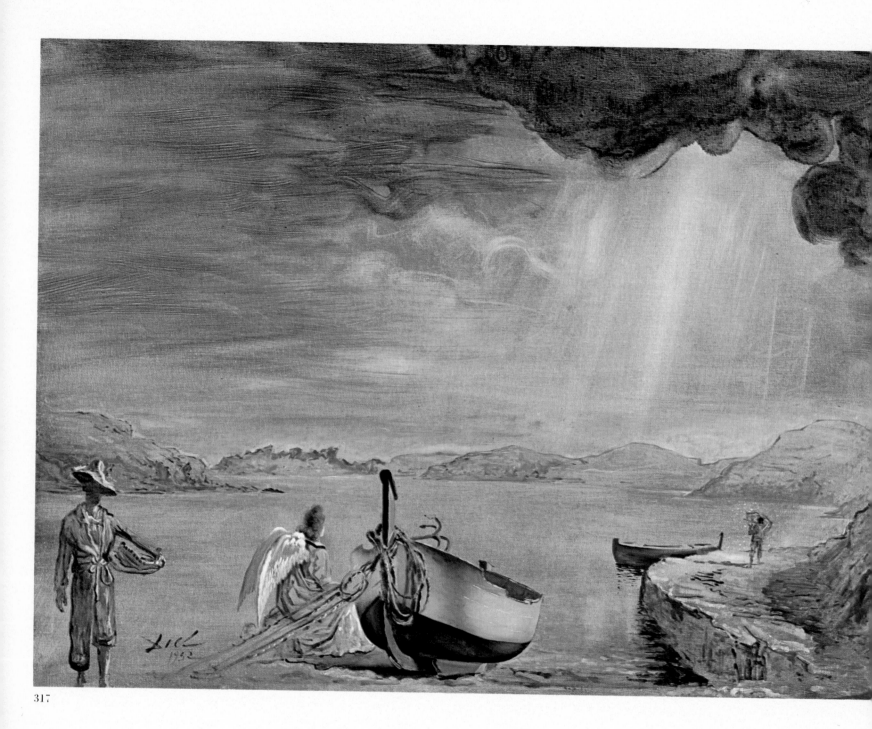

317

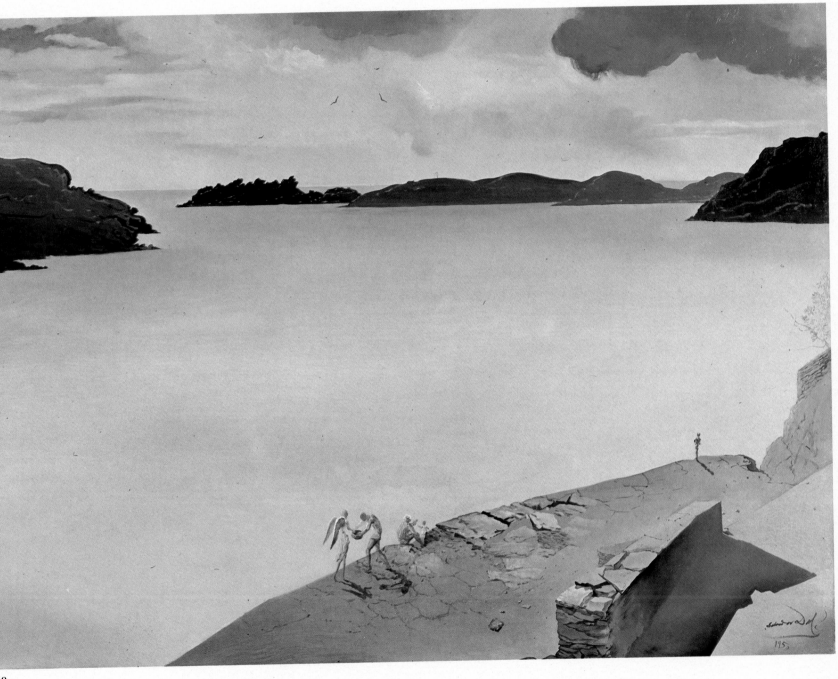

319. *Eucharistic Still-life*, 1952; oil on canvas, 55 × 87 cms; The Reynolds Morse Foundation, Cleveland.

320 and 321. In the cemetery of Agullana, Dalí lays flowers on the ground where Lidia rests; and he is photographed with the grave-digger beside the gravestone which, for reasons of orthodoxy, has not been set in position. The text is by Eugeni d'Ors, and reads: "Here rests, if the *tramontana* will allow, Lidia Nogues de Costa, sibyl of Cadaqués, dialectical magician, who was and was not Teresa; in her name, the angelic exorcised goats and anarchists.

320

321

referred to them in his writings. It might even be admitted that these interpretations, which are spontaneous and logical in the paradoxical terms of the counter-culture, have influenced the genesis of the famous paranoiac-critical method.

Dalí held Lidia in high esteem, and she responded to the young painter with admiration and affection; she knew him from when he was a child and she realized his capacity to comprehend what for others was a subject of scorn and ridicule. Once when he was in a difficult situation, she helped him financially, and later when he was driven from home and family, he bought from her the little cottage in Port Lligat which became the nucleus and origin of his present home. Dalí emphasizes that Lidia was a paranoiac personality of the highest order. When the banished couple Dalí-Gala were isolated due to the evil influence of the paternal curse, and few of their friends would have anything to do with them, the faithful fisherwoman was one of their most constant visitors. Eduardo Marquina also kept up his

relationship with his young friend. The only way by land to Marquina's house at the Sortell lay past the family house at the Llané, so the banished painter used to go by boat across the bay.

In 1954, shortly after the death of Eugeni d'Ors, his posthumous work *The True Story of Lidia of Cadaqués* was published. The illustrations are by Salvador Dalí, and two angels appear on the cover. Apart from their religious value, the iconography has endowed the angels with a somewhat equivocal aspect due to the androgynous nature of their beauty. This aspect of the human form finds its origin in mediaeval sculpture and was accentuated in the painting of the Renaissance. The angels of Dalí are usually represented as being of the same line, (which could well derive from the Bible, when we recall the angels that went to Sodom and what befell them there.)

We meet another coincidence between idealized architecture and angels in *The Broken Bridge and the Dream*, one of his most graceful and lyrical pieces, diametrically opposed to those of his Surrealist period, as if the painter had freed himself from some of his demons by transforming them into angels, a transformation which we know to be impossible, for what really happened was the other way round: the angels were turned into devils. Only the wonderful imagination of an artist is capable of the opposite miracle.

The design of the central arches owes more to Renaissance influences and to the metaphysical painters than to more proximate stimuli, for instance the arcades of the waterfront of Port Alguer which he painted repeatedly as a youth. On at least two occasions, *Old Man at Dusk* and *The Old Man from Portdogué*, Port Alguer and its arches are associated in the mind of the painter with old age. This association, which I feel is not with the arches themselves, may derive from a group of old, retired fishermen who used to gather on the benches in the little square by the beach and relive their big catches and their adventures at sea or forecast the weather through hazardous interpretations of obscure signs. These old chaps would slowly be relieved, death substituting new faces for old ones; and old age maintained its tangible presence on those benches in Port Alguer. The arches were over to the right. There are three, the beginning of a series which was to remain without a proper continuation, but according to one's wish and whim, and in keeping with an imaginative impulse, one's fantasy can extend these whitewashed vaults or arcades out over the blue of the little harbour.

Leaving aside the fact that there are differences between one style of architecture or ornamentation and another, any structure open to the air, like a bullring, will involve the same dominant idea as the early plans for the building of the Dalí Museum-Theatre in Figueras, built on the ruins of the old Principal Theatre.

According to what the painter has told me, the original idea arose out of one of his own exhibitions which took place in the bombed Royal Palace in Milan. They had covered the Room of the Caryatids with a plain ceiling, which made a contrast with the eighteenth-century splendour of the room itself. A photograph, in which the ceiling is hardly visible because of its simplicity and neutrality, suggested the idea to him. So that the same visual perception would reach other people, he drew in Indian ink some high bushy cypress trees which appear to be outside the room. By virtue of this addition, the ceiling seems to disappear. This is so perfectly executed that now nobody can make out the ceiling, nor can one distinguish between where

322. *The Broken Bridge and the Dream*, 1945; oil on canvas, 66×87 cms; The Reynolds Morse Foundation, Cleveland.
323. *Archbishops and Architecture*, 1935-1937; pen drawing, 21.5×28 cms; The Reynolds Morse Foundation, Cleveland.
324. In Port Lligat in 1953, with Eugeni d'Ors, Mercedes Prat de Rodríguez Aguilera, and Luis Romero.
325. Cover of a book by Eugeni d'Ors.

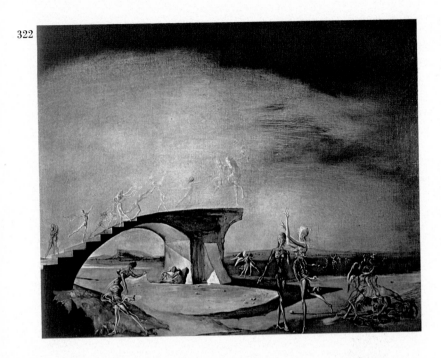

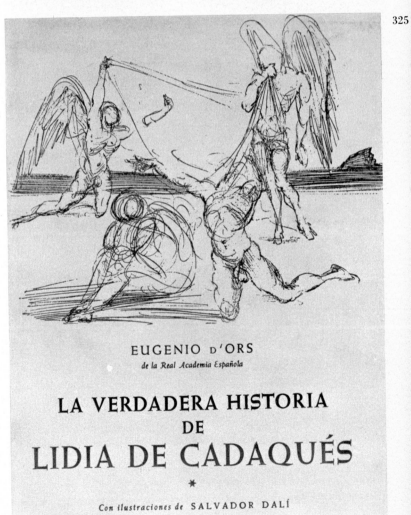

EUGENIO D'ORS
de la Real Academia Española

LA VERDADERA HISTORIA
DE
LIDIA DE CADAQUÉS

∗

Con ilustraciones de SALVADOR DALÍ

326. Detail from *Outskirts of the Paranoiac-critical City. Evening on the Shore of European History;* representing the *Calle* del Call in Cadaqués.
327. *Port Alguer*, 1925; oil on canvas, 36 × 38 cms; private collection.
328. The *Calle* del Call today.
329. *Crepuscular Old Man*, 1918-1919; oil on canvas, 50 × 30 cms; Ramón Pichot Collection, Barcelona.

the photograph ends and the drawing begins. The optical illusion is yet more surprising to me because the visual trick was completed in my presence. The things he used while we sat talking could not have been more elemental: a fine brush, Indian ink, and saliva. The light on the top of the cypresses produces a lovely effect and is very similar to the glossy surface of the photographic paper.

In discussing Dalí's relation with architecture, we cannot avoid alluding to the reticular dome designed by the architect Emilio Pérez Piñero. As with all cupolas, Dalí describes it as monarchic, and reduces by half the saying of Fra Luca Pacciolli, to which we have already referred: "Monarchy is the sphere." While this book was being written, Piñero died in tragic circumstances, thus cutting short his promising career and talent which are clearly detected in the dome installed in the Dalí Museum.

The American Buckminster Fuller has constructed some of these geodesic cupolas using ribs of steel. In Baton Rouge there is one with a diameter of 117 metres. Dalí has pointed out to me the relationship, aesthetic more than technical, between these modern structures and the fantastic ideas of Charles-Nicholas Ledoux, who was also monarchic, given that he designed a spherical palace for Louis XVI, which was perfectly adapted for living and the other functions it was to fulfil. Ledoux, who must have been a brilliant despot with an inclination to organize other people's lives, designed another spherical building to be erected in Maupertuis as a barracks for the country guard.

We have already referred to the ceiling of the Palacete Albéniz, situated in the gardens of Montjuich in Barcelona. It is a canvas of large proportions which he painted in his studio in Port

326

327

329

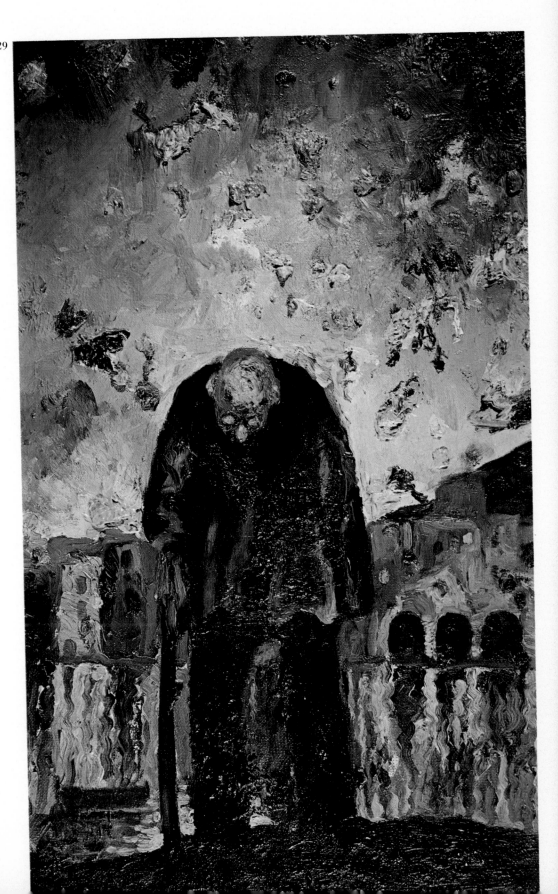

330

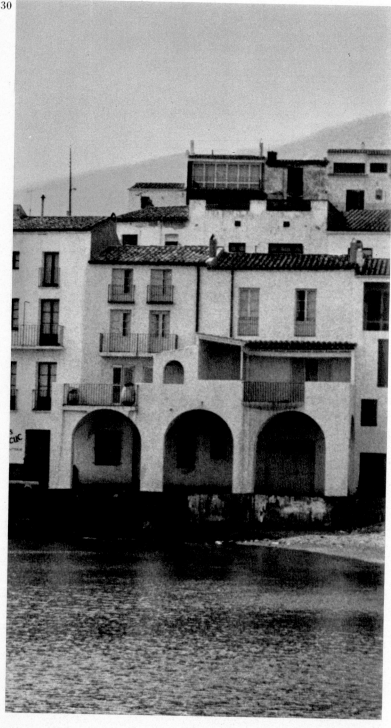

331

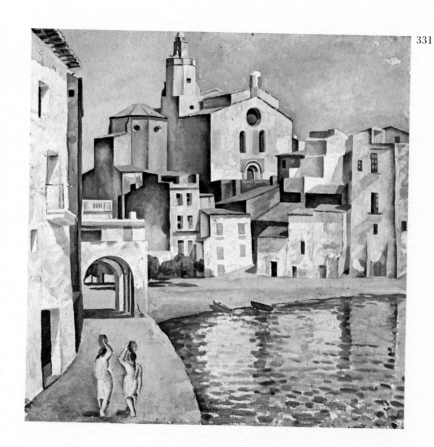

330. Current photograph of the arches of Port Alguer (Portdogué).
331. *Port Alguer*, 1924; oil on canvas, 100×100 cms; Dalí Museum-Theatre, Figueras.
332. *The Old Man of Portdogué*, 1920. Portrait of Josep Barrera, an adventurous character who lived at that time opposite Pampà Point; Dalí installed his studio in one of the rooms in this house. Watercolour, 11.45×12.7 cms; The Reynolds Morse Foundation, Cleveland.

332

260

333. One of the houses of the Pichot family in the Sortell.
334. In front of his house in Port Lligat.
335 to 337. Transformation of the Room of the Caryatids in the Royal Palace, Milan, such that the white ceiling seems to vanish from sight; photograph taken in 1954 during a Dalí exhibition. Hence the central idea for the Museum-Theatre in Figueras.

333

335
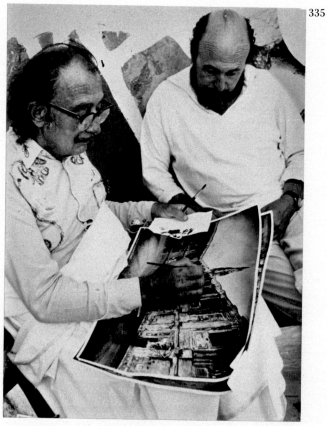

334

336
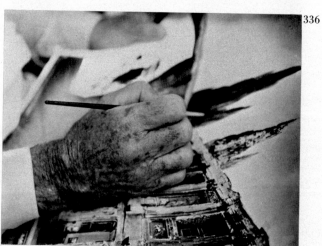

338. Poster for the Dalí Museum in Beachwood, Cleveland, owned by Mr and Mrs Reynolds Morse.
339. *Saint James the Great*, 1957; oil on canvas, 400×300 cms; Lord Beaverbrook Art Gallery, Fredericton, Canada.
340. Invitation to the opening of the Dalí Museum-Theatre, which took place on 28 September 1974.
341 to 343. The Museum-Theatre in Figueras in its early stages.

338

Lligat. By means of suitable perspectives, the flat ceiling has been converted into a dome, and the moon is to be seen through an open window in this fake cupola.

Apart from the ones derived from Millet's *Angelus*, there are other anthropomorphic architectural designs which he produced in 1936 in a portrait of Gala, where she is wearing a bonnet which is transformed into a tower crowned with a dome.

There exists a little known drawing in which the mitres of some archbishops become the pointed doors of a Gothic cathedral; and Gothic ribs from the church of the Dominicans in Toulouse serve as a background for the apostle James mounted on a rearing horse. And here we find the completion of the circle, for these ribs are reminiscent of the structures of Piñero and, though to a lesser extent, the arrangement of the stylized flies in *Hallucinogenous Bullfighter*.

339

340

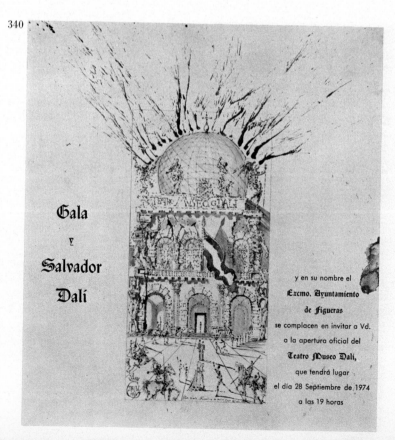

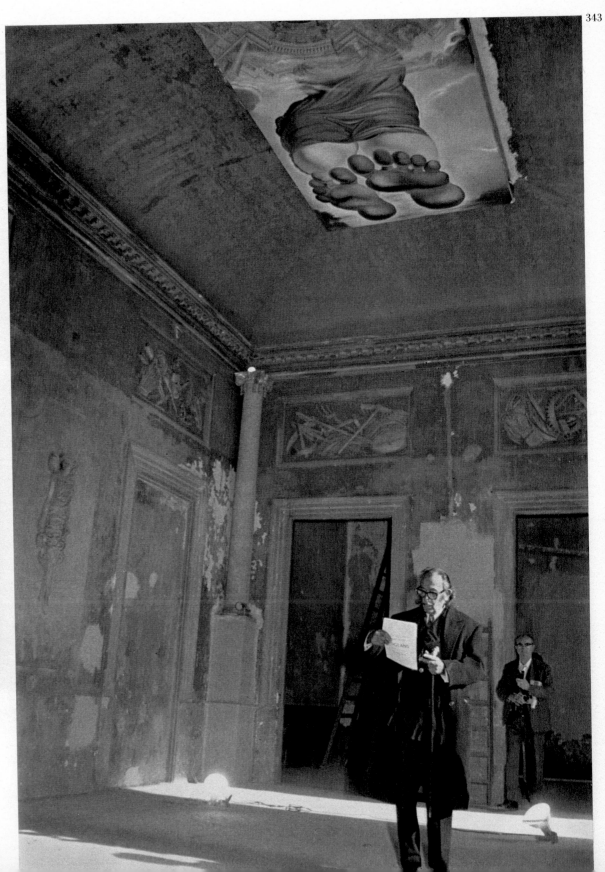

343

344. With the ill-fated architect Emilio Pérez Piñero, contemplating one of the mobiles destined for the Dalí Museum-Theatre.
345. Pérez Piñero's dome on the Museum-Theatre; in the distance the illuminated tower of Santa Maria.

345

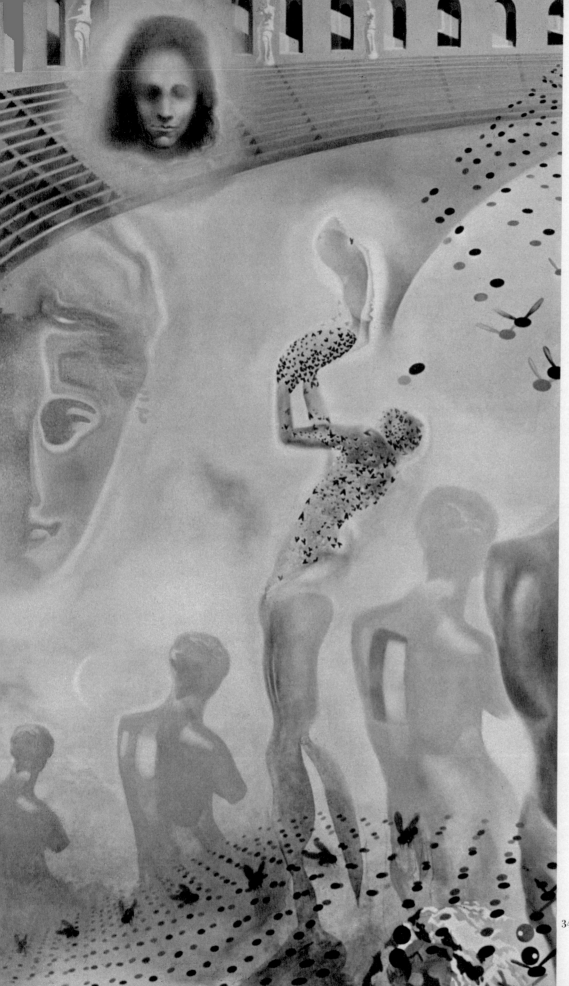

346. Detail in which the bullfighter, who represents Dalí himself, salutes Gala.

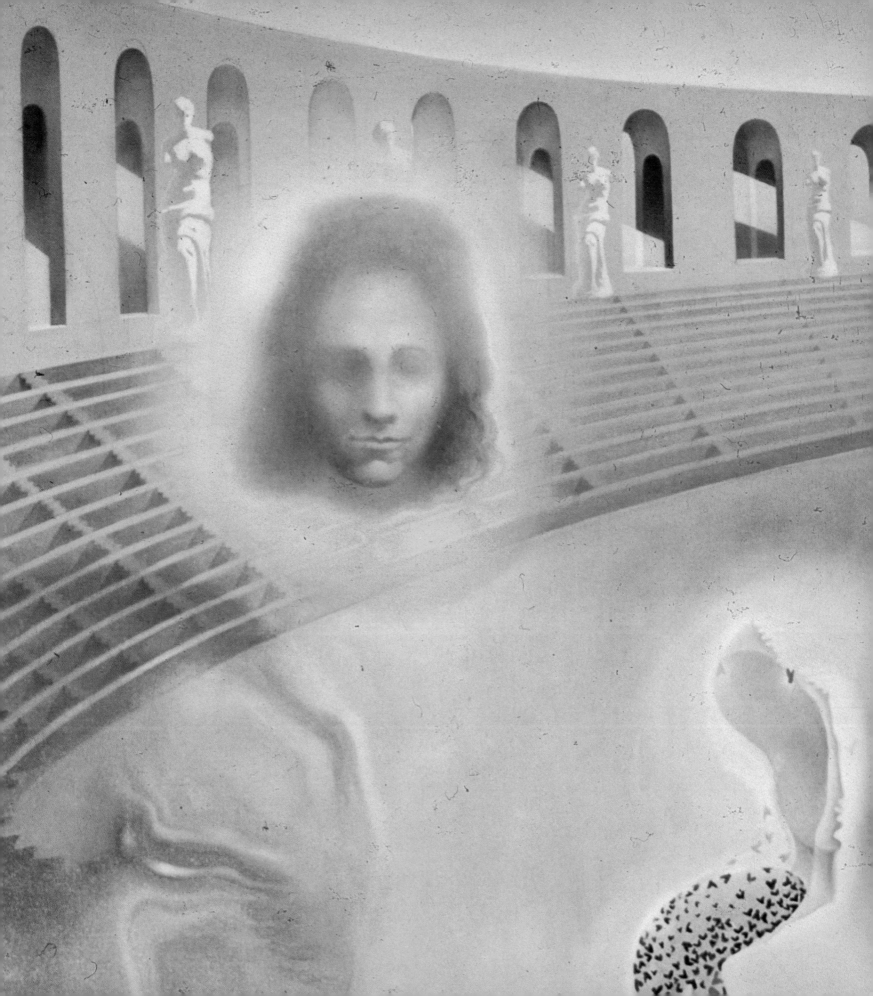

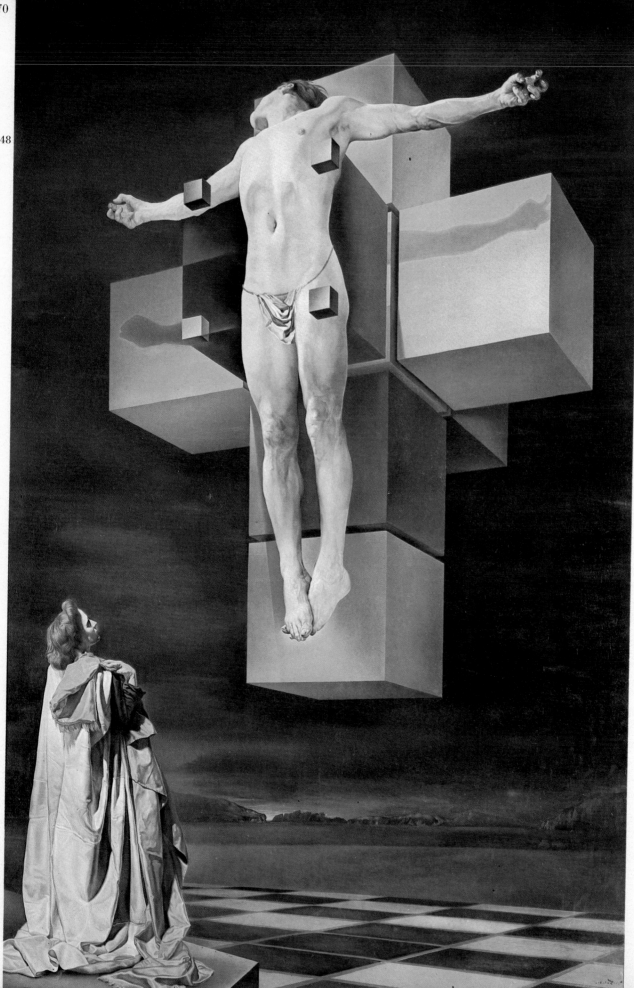

348

349

Gala regarda le Crist

347. Twelfth section of *Hallucinogenous Bullfighter*.

348. *Hypercubic Body*, 1954; oil on canvas, 94×124 cms; Chester Dale Collection, Metropolitan Museum of Art, New York.

349. *Gala Regarding the Hypercubic Body*, 1954; oil on canvas, 31×27 cms; Dalí Museum-Theatre, Figueras.

350. *The Dream of Columbus*, 1958-1959, also called *The Discovery of America by Christopher Columbus*; oil on canvas, 410×310 cms; The Reynolds Morse Foundation. Cleveland.

351 and 352. Two details of *Paranoiac-astral Image*, 1934; oil on wood, 16×22 cms; Summer Collection, Wadsworth Atheneum, Hartford.

351

352

Just as the hallucinatory vision should have been dominated by someone whose absence has left an obvious gap, so the presidential box —the painting's seat of honour— is left vacant. The uninhabited arch or box seems to show the transparency of the sky or allude to the emptiness of the air. The president must be situated somewhere else: in the spot where we see the luminous head of Gala, above the tiers, at the opposite end of the diagonal which begins with the boy dressed in a sailor suit. This diagonal, in crossing another imaginary line —the one formed by the heads of the Venuses— gives a form like a Saint Andrew's Cross.

The second bullfighter —the one who seems to be covered in flies, but whose dress is in fact embroidered with lights— is the painter himself. Gala appears timeless and unrealistic, more an idea than a portrait, and it is to her that he celebrates the death of the bull, of the bull now dead, whose humbled head forms the rocks of Cape Creus. In this composition she dominates the superimpositions from other epochs, the bells that ring in crazy clocks or in soft clocks, which bring to mind the arrangement of the scenes in mediaeval altar-pieces.

The head of Gala, although it dominates the others and stands out from the whole, must be included among the phosphorescent ones: some of the Venus heads which look like burnished coins, and that of Voltaire with an aureole of malicious wisdom. All these derive from those of Lenin which spring from the keyboard that is not being played by the young pianist in the short cape.

One of the many roles which could be attributed to Dalí would be court-painter to Gala. Since she arrived in Cadaqués in the summer of 1929, no woman has been more or better painted over such an extended period as Elena Diakonoff.

When one day a catalogue is made of the complete works of Salvador Dalí, it will be interesting to make an inventory of the number of times that Gala's face and body have been reproduced, in different gestures and poses and with various attires, but still recognizable. However, for the moment such a catalogue seems a difficult task considering the geographic distribution of his works and the fact that certain collectors prefer not to divulge the paintings which they possess. Some of these portraits are worthy of even the most selective of anthologies, for instance the pencil drawing *Galarina*, the figure which appears at the foot of the *Hypercubic Body*, or *Saint Helen in Port Lligat.*

In *The Battle of Tetuán* Gala and Dalí ride at the head of the cavalcade of Arab horsemen; in *Ecumenical Council* she assumes the appearance of Saint Helen; there are two interpretations of Gala in *Antiprotonic Assumption*, one religious and the other in the style of Leonardo; Gala is also the *Atomic Leda*; she is present in *Apotheosis of the Dollar*; she appears in *Impressions of Africa...* We shall not continue this enumeration because, however long we made it, it would always be incomplete. Anyone who is familiar with the paintings of Dalí, knows that he sees Gala in a thousand distinct ways. In some of the portraits she is seen from behind: none of her features are depicted, but all are alluded to implicitly. Gala is the rushing stream, the solid rock, the spur of steel, the muse, the wall of stone, the coiner of gold, in the life and work of Salvador Dalí. He talks of her in all his books, and she is a solid presence in Port Lligat, in New York, in Paris.

While Gala did not invent Dalí, she has been of considerable importance in his biographical trajectory. He was invented on 11 May 1904 —or even before— the day when he was born at

number 20 *Calle* Monturiol in the city of Figueras, province of Gerona, son of Salvador Dalí Cusí, native of Cadaqués, and of Dolores Domenech Farrés, native of Barcelona. One may ascertain, or intuit, the essential facts about his childhood and youth from the intimate secrets which he has written down in the true or false reminiscences of *My Secret Life*. His infancy was enlightened by an intense vitality out of proportion with his age: a wealth of introspective adventures, which at first he managed to resolve while maintaining an exterior that was more or less placid and, we might say, hypocritical, considering the people around him.

But his internal self was dying to escape into the world, and when he tore aside the defensive cloak of hypocrisy, he became that original, scandalous, awkward, prolific, somewhat disorientated, brilliant and irritating character who has continued to develop in contact, and in contrast, with different *ambiances* and people. And to a large extent he has achieved this after the manner of those plants that grow in stony ground and with little water, obliged to force out their roots, capable of assimilating the least humidity, becoming more robust and yielding more delicious fruit than those which have developed in gardens that are irrigated and treated with manure.

When Dalí speaks of inquisitorial trials, he means the necessity of overcoming difficulties and enduring pain. His difficulties in obtaining a cultural and artistic training might have produced in him minor inquisitorial trials. He was born and brought up in the relatively educated atmosphere of a home at the centre of a bourgeois society, both liberal and conservative, as was that of Figueras at the beginning of the century. His schooling was normal, though somewhat disorganized and incomplete. First, there was the ineffable schoolteacher Traiter, whom he has

converted into a character of fiction (although certain possible truths show through the elaborations) (25); then the Brothers of the 'Christian Schools' (not of the Christian Doctrine); later the Marists.

He came to know the art treasures of the world through the reproductions in the Gowans collection, which his father showed him as the latest thing in pedagogy and good taste. He read widely but unmethodically, and he felt that he had to make an effort to reach the one world which attracted him, that of art and culture. For him, French Impressionism meant above all the paintings of Ramón Pichot who lived in Paris; and Voltaire was the man discussed by his father's friends and anathematized from the pulpits. And it is quite logical that his rebellion began in opposition to the social and cultural group formed by his father and his father's friends. Venus de Milo was an illustration in a book, and his revolutionary hero was not Lenin but Martí Vilanova, a local leftist and a friend of his. On the other hand, these restrictions provided the youth with a coherent universe, only hermetically sealed in the question of feelings, but still closed in on itself. Beauty was represented by a neighbour, Úrsula Matas; and authority by the colonel of the regiment stationed in Figueras and by the mayor. And Napoleon was more than anything that vivid figure decorating the tins of *mate*. This concentrated, *inquisitorial* world was possibly of greater pedagogic force than that which at that time surrounded a Roman prince's son of the same age, whose tutor would oblige him from an early age to visit museums and monuments; or than that of the imaginary scion of a Minister of France whose good taste would be formed in the Louvre, in the Gothic cathedrals and in the castles on the Loire.

Two aspects of his early education seem to be positive and substantial: the classes of his draw-

ing teacher, don Juan Núñez Fernández who by the very fact of having initiated and guided his steps in this subject is, and will be, remembered —and the thrilling lesson which living, seeing and experiencing in Cadaqués meant for him. There, dressed in his sailor suit or not, he could run freely, get to know all sorts of people, discover landscapes or a microcosm which excited his fantasy, and meet fishermen, who were careful and exact in their speech, stoical in their elemental philosophy, witty, sceptical, and dreamers.

In Cadaqués people talk of witches, of old smuggling stories, shipwrecks and navigation, and if the landscape leads to weird fantasies, in a contrary manner it also attracts the precise and concrete. One's vision is accustomed to metamorphosis, because if you are rowing past a rock, it will reveal a camel, a spread eagle, the poop of an ancient ship, a monk, an anvil, a skull, antediluvian animals, or a dead woman; and over there, those rocks are transforming too. Speaking of these experiences, Dalí quotes Heraclitus: "Nature enjoys concealing itself," and citing himself he adds: "... and in this circumspection of nature I divine the very essence of irony." At Cape Creus the water and the land reveal contorted structures, rocky filigrees with a Gothic beauty, and shapes whose hardness seems belied by their apparently soft curves. There is a promontory shaped like the Tower of Babel in old engravings, and there are no limits to the propitious and fruitful wanderings of the imagination.

Did he suffer from the inquisitorial trial in Cadaqués? In a minor way, yes, owing to the period with its inherent prejudices. Let us observe a photograph of the Dalí family in summer seated on a rock at the water's edge. The boy is wearing boots and socks which would amount to something inquisitorial. "I was always overdressed." Later he was to strip off and allow the soles of his bare feet to come into contact with the stones, the seaweed, the sea-water. A primitive Cadaqués, not yet freed from its earliest history which was seen in its daily actions and customs, a village with a touch of heaven, will remain fixed for ever in the spirit and retina of the future great painter. It is sometimes difficult for someone who belongs to, and forms part of, one of the major schools, to distinguish between them. Nuñez and the summer visitors in Cadaqués are two excellent masters who are perpetually present in the work of the painter, and even today remain positively active in him.

Among those who exercised a favourable artistic and spiritual influence on those first steps of his path in art and life, apart from his father, we must refer again to the Pichot family, and to Eduardo Marquina, the poet and dramatist who was part of the family because of his marriage with Mercedes. He was such an eloquent versifier that, as Dalí recalls, during a trip which they made to Cape Creus, he spoke throughout the day in verse.

It was in 1921 that he moved to Madrid and entered the Academy of Fine Arts of San Fernando after some amusing incidents which he relates with witty narrative skill and which were connected with the size of the drawing which counted as the decisive test in the entrance exam and which he had managed to get wrong. These mistakes, which continued during the days that the tests lasted, were the source of great anxiety for his father and sister who had accompanied him to Madrid. However, the excellent execution of the drawing was sufficient for him to be accepted, even if it did not fulfil the requirements of size. Due to Eduardo Marquina's influence he managed to obtain a room in the Students' Residence, whose director was don Antonio Jiménez Fraud. It was

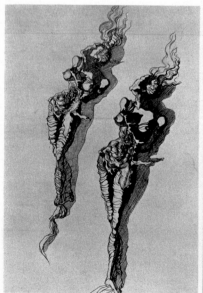

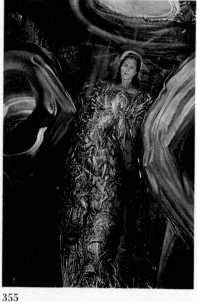

353

354 355

here that there were gathered together the most brilliant and troublesome young men of this propitious moment in Spanish history. Despite his eighteenth-century hair-style, his romantic cravate, his broad-brimmed hat, the pipe that he never smoked and the extravagant gaiters, Salvador Dalí was a shy youth, and he remained so quite apart from his defiant and disrespectful attitude and despite the volcano in his soul and the maelstrom in his brain which he had had since he was a child.

It turned out that in Madrid, across whose roofs blew European winds with a strong Spanish aroma, the rebels of that time —known as *contestatarios*— had banished pipes, long hair, cravates, gaiters, even the traditional cloak, and dressed in sports clothes, wore gaudy ties, cut their hair fashionably short, shaved every day unless they were smooth-faced, and smoked English tobacco. Those who were to become the friends of the painter who had just arrived from Figueras were young, amusing and spontaneous; there were those with talent and those without, and there were pedants; among one lot or another there were some who were given to frivolity and snobbery. At first, as might be expected, there was no common ground between Dalí and them. They watched, they observed each other, they acknowledged each other with pretended or with ostentatious incivility. Dalí retired into his shell, closed his room, disguising his curiosity behind a mask of indifference. Although today he denies it, the truth is that he admired them; at least for their self-confidence and because their appearance was so different from his own. Later he was not content to be their equals, he strove to be their superior.

In the San Fernando academy he had good teachers. One of these was Moreno Carbonero, who gave classes in drawing. At the time, he enjoyed

356

357. *Nude from behind*, 1945; sanguine, 61×46 cms; Mr and Mrs J L Loeb Collection, New York.

358. *Saint Helen in Port Lligat*, 1956. Gala's real name is Elena (Helen), and on the mountain of Sant Pere de Roda, very near Cadaqués, is the Romanesque Hermitage of Saint Helen; the castle which crowns the mountain is called San Salvador. Oil on canvas, 31×42 cms; The Reynolds Morse Foundation, Cleveland.

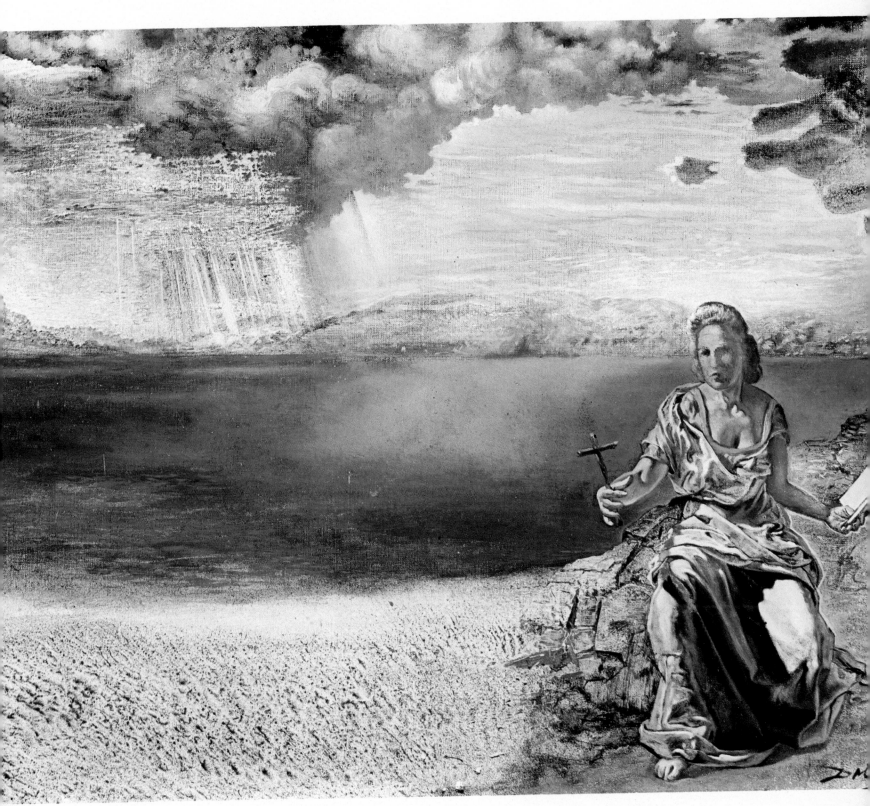

358

359. Detail of *The Enigma of William Tell*, 1933. According to Dalí, the baby in the nutshell-crib is Gala. Museum of Modern Art, Stockholm.
360. Detail of *Gala and Millet's Angelus Preceding the Imminent Arrival of the Conical Anamorphoses*, 1933; Henry P McIlhenny Collection, Philadelphia.

359

great public acclaim and for that very reason was disregarded by the generation which was bursting into the artistic world. Don José Moreno Carbonero, who was in his sixties, was celebrated for his paintings with historical themes and those depicting scenes from Don Quixote. Perhaps one day he will be reinstated; Dalí, the defender of the *pompier* painters, has written in favourable terms of his old teacher whose teaching he appreciated even then. He was given classes in drapery by another widely acclaimed painter, Julio Romero de Torres, whose name appeared in couplets and ballads. Dalí remembers more highly those teachers who, like the ones mentioned, instructed with academic rigour and established strict rules and norms, in keeping with the inquisitorial process, than the others who considered themselves more modern and progressive and restricted themselves to encouraging their students to be carried away by the inspiration of the moment, without any pre-established rules. They learnt from the former, but not from the latter; everyone knew how to be carried away by the inspiration of the moment, without the necessity of school, class or teachers.

The Catalan painter had a sullen and anachronistic appearance and seemed reserved and mysterious, but it was not long before he had established an uninhibited friendship with his boisterous companions both in the Residence and elsewhere: Federico García Lorca, Pedro Garfias, Eugenio Montes, Luis Buñuel, Pepín Bello, Rafael Barradas... Dalí became more elegant, changed his clothes and his hair-style; he assumed the leading role in all the binges and exploits, and was a tangential and desultory member of the so-called 1927 generation. He also used to turn up at the most famous of the Madrid coteries, at the Pombo cafe, which was led by the most prominent figure of the Spanish literary avant-guard, namely

360

361. *Galarina*, 1941; pencil, 61 × 49 cms; private collection.
362. Detail of *Galarina*, 1945; oil on canvas, 65 × 50 cms; Dalí Museum-Theatre, Figueras.
363. *Atomic Leda*, 1949; oil on canvas, 60 × 44 cms; Dalí Museum-Theatre, Figueras.
364. *Salvador Dalí in the Act of Painting Gala in the Apotheosis of the Dollar, in which one may also Perceive to the left Marcel Duchamp Disguised as Louis XIV, behind a Curtain in the Style of Vermeer, which is but the Invisible though Monumental Face of the Hermes of Praxiteles*, 1965; oil on canvas, 400 × 498 cms; Peter Moore Collection, Dalí Museum-Theatre, Figueras.

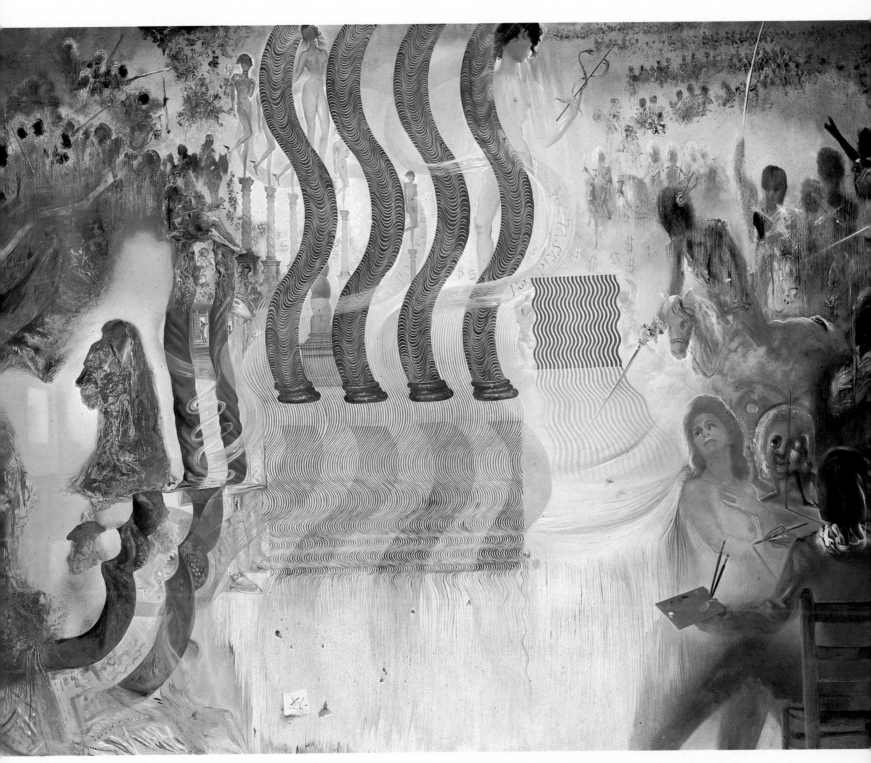

364

365. *Study for the Madonna of Port Lligat*, 1950; watercolour and ink, 49.3 × 29.5 cms; The Reynolds Morse Foundation, Cleveland.
366. *Three Faces of Gala appearing among the Rocks*, 1945; oil on canvas, 20.5 × 27.5 cms.

365
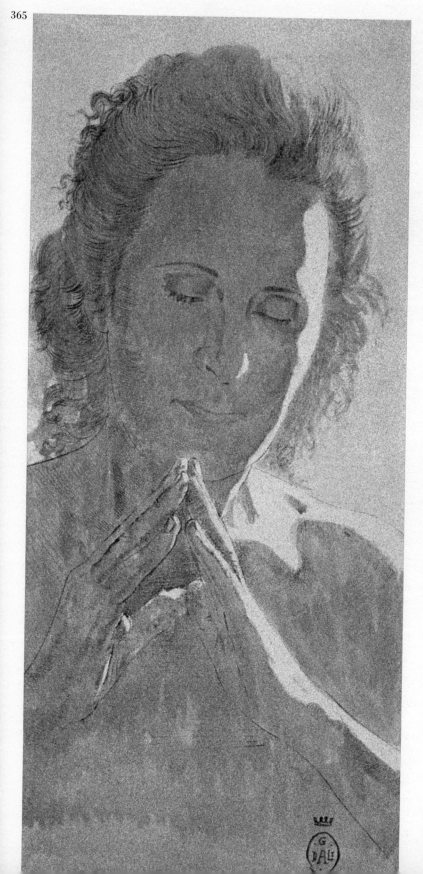

366

Ramón Gómez de la Serna, who should really take precedence over the others. In the Prado Dalí became familiar with the best of Spanish painting and with the considerable samples from the rest of the world. The painter's stay in Madrid, lasting from his acceptance at the Academy of Fine Arts until his definitive expulsion in 1926, though with long holidays in Catalonia, was a period full of experiences; it broadened his horizons and extended the incipient renown of his name, his works and his personality (26), and it brought him friends, among whom two deserve special mention: García Lorca, from Granada, and Luis Buñuel, from Aragon.

García Lorca was influential for Dalí; he was six years Dalí's senior and he was an impetuous and persuasive character. In this great poet the two Andalusias meet: the serious and tragic one of the olive-tree, and the open and sparkling one of the vine. He was carefree, full of imagination, fond of singing and juggling with words; he had music in his veins, he clung to his childhood, which

287

never left him and he never abandoned; he was the wizard and juggler with images and sounds; affectionate, soft, sensual; and popular. But Lorca was also sober and serious, receiver of both earthy and irrational essences, creator of disturbing images, nuncio of the human, the sub-human and the superhuman, fortune-teller and prophet, interpreter of unwritten languages, mathematician of invented figures. I maintain that Lorca influenced Dalí and that Dalí influenced Lorca. In retrospect, their friendship might seem of short duration, but in fact it lasted fourteen years (27).

His friendship with Buñuel, while neither as intimate nor as profound, was nevertheless real and productive: they collaborated on two films, *Un chien andalou* and *The Golden Age*. Two films, two scandals, though today they are shown in every film club.

When the Surrealists descended on Cadaqués —and I put it like this because it was like the arrival of the Greeks at Ampurias or the invasion of the barbarians —Dalí was ready to take the plunge. His experiences of people, of art, of the everyday, had multiplied; his youth was behind him and he was now a young adult, green and mature at the same time. In painting he had entered on his Surrealist period: *Ashes* (1926-1927), *Apparatuses and Hand* (1927), *Surrealist Composition* (1928), *The First Days of Spring* (1929)... and he was now working on one of his most aggressive pictures, *Dismal Game*. The first wave reached Cadaqués in the summer of 1929: the painter René Magritte and his wife —whom Joan Miró had recently introduced to Salvador in Paris— the Belgian dealer Camille Goemans, and Luis Buñuel; not to mention the poet Paul Eluard and, with him, the person who was to provide the most definitive influence in changing his line of flight, who was to help him loyally and

efficiently in presenting himself to a world-wide public: Gala.

It was a stunning encounter. She was his senior both in years and in experience; she came enhanced by the exotic prestige of her Russian origin and the fact that she was the wife of a famous person: Paul Eluard. He was a man in the fullness of years and had just published *L'amour, la poésie*, and he was among the brilliant vanguard of the Surrealist movement. Dalí painted Paul Eluard in a portrait with an abundance of esoteric and spontaneous allusions, exploiting several elements which appeared in other works from the same period. Forming part of the picture surrounding the portrait itself, he painted beings with eyes bulging due to the absence of eyelids, human eyes, but hallucinated, in the heads of wild beasts, visions which anticipated the still unknown LSD. He also depicts the soft, subdued head of *The Great Masturbator*, with insidious, destructive ants, and a woman with a broad smile, part stupid, part vicious, whose neck transforms into a jar.

Before he had met Gala, Dalí had already fallen in love with her. Goemans had introduced him to Paul Eluard in the 'Tabarin', and the latter had promised to come to Cadaqués in the summer accompanied by his wife: this was the moment when passion overtook him. Impulsive, autocratic and egocentric, in spite of a life rich in adventures, experiences and incidents, and having lived in a way full of intense imagination —creative, and with the clarity of a sleepwalker— his amorous past was still very slight. In a constant state of cerebral irritation, with the will-power to be what he was without knowing what he would be in the future, he was enamoured of Gala before he fell in love with her. He was enamoured with love, with himself, and he was yearning to launch himself into something unique and exquisite, something superior. This something, originally

in his imagination, was later given flesh and spirit in the permanent form of Gala. I am referring to events which took place more than forty years ago. This represents many years in the emotional life of a man and woman, even more so since their life has been battered by strong winds —just as the north wind concealed and revealed the nights of Cadaqués during those first poor but idyllic months— but throughout these years Dalí has had Gala as his constant model. She appears in numerous paintings and drawings: in the station of Perpignan, dominating Christopher Columbus' banner, composing and decomposing in *Galatea of the Spheres*, she appears nude at the window in Port Lligat facing the mountains and the windmill, she can be recognized in a postcard with a delicate border of grasshoppers, snails and coloured arabesques. And, according to the painter, Gala is also the miniature newborn baby, whose crib is a split walnut shell at the feet of William Tell, with his Lenin face and his over-prominent buttocks.

Gala is not only present in innumerable portraits; she appears unrecognized in many other paintings. Over the years the portraits have been so numerous —more so than ever in recent years when she has appeared in the majority of his pictures— that certain things can be established by comparing the features of one with another, and bearing in mind the period when they were executed. Dalí, her court painter, has hardly ever achieved a true likeness, either because he has not intended to, or because Gala's face includes each and every aspect of the ways in which she has been painted.

Has she never posed for him to paint her face and its features? Does he carry in his imagination an ideal and approximate portrait, changing according to the theme of the painting and adapted to the role which Gala is to play? Has he intended to portray her at a given moment, or has he chosen to present an idealized vision? Is it possible, with this most experienced, meticulous and craftsmanlike of painters, that the proximity of the trees changes his vision of the wood? Has Gala refused to present a photographic image to the public, preferring a range of approximate, artistic interpretations? I am not convinced that the answers to these questions hold a great deal of interest, at least not for his painting: these are the images, this is the expression, and that's that (28).

Paradoxically and curiously, it turns out that the portraits of Gala which are most like her are those where she is represented with her back to us, as if these really were copied direct from nature.

When Gala arrived in Cadaqués, she brought with her an iconoclastic drive, a fascination with novelty, a systematic and totalitarian aggressiveness, both powerful and fearless, and the violent outpourings from the Surrealist cauldron. And Dalí had grown his wings. Barcelona had opened its door and its heart when he exhibited in the Galerias Dalmau (the spearhead of the avantguard); the reviews had been favourable; he had produced the decorations for *Mariana Pineda* (29), a play by García Lorca; he had signed manifestos and had roused expectations; his lectures and attitudes verged on the scandalous; he was famous in Madrid, and in Granada they were hoping for an exhibition; he was the co-author of *Un chien andalou*, and he was not unknown in Europe. Picasso and Miró, whom he had met in Paris, had awakened in him the desire, indeed the necessity, to explore and exploit ever wider spheres.

He was twenty-five years old and an established painter: Josep F Ràfols, a critic of distinction, had described him in 1926 as "one of those

who this century will bring glory to Catalan painting." (30) He had already painted pictures whose importance has not been dissipated through the passing of time or the subsequent perfection of his talent. But to triumph once is not necessarily to triumph for ever; in fact, in the real sense of the word, a triumph is very rarely achieved. To continue in play, the artist must risk his entire *oeuvre*; in art as in war, no one can sleep on his laurels, much less so when you are twenty-five, when you are just starting out; and you are very conscious of that, of the fact that the road is long and promising —of what and where?— and that many are called but few are chosen.

Something else must be counted among his possessions: a rich, full and active childhood, and a youth which was restricted in terms of the limitation of desires, but abundant in its external manifestations. Armed with vaunting ambition, unshakable convictions, and a profound identification with the countryside which had suckled and nourished him with all the force of the earth; he had undergone experiences which would serve him all his life; hard-working to the point of exhaustion, he had learnt his profession from conscientious masters who had given him more than they themselves possessed. He was aggressive, rebellious, wary and foolhardy, studious and patient in his own way, jesuitical and inquisitorial. In order to overcome the shyness which troubled him, he had leapt over fences that no one else was capable of jumping; excessive, baroque and classical, he had assimilated lessons from the left and the right, from the north and the south. He was afraid, but he did not lose heart, nor did he allow himself to rest. Like a Hernán Cortés of painting, he burnt his boats and, once launched on the great adventure, he never turned back.

At that moment the adventure was called Paris and Surrealism, and it was polarized in Gala.

The Surrealist cauldron was already simmering, but Dalí would make it boil over. He was more surrealist than the Surrealists, he tore down boundaries, his lack of moderation led to excesses and to unwonted, blasphemous speech, because, not wishing to seem the novice that he was, he acted like an extremist —or like the Dalí that he really is.

When he arrived in Paris the Surrealist movement had just suffered one of its periodic crises, which were a necessary consequence of the contradictions which they sought to espouse, and of the idiosyncrasy and extremist attitudes of its members, hangers-on and sympathizers. André Breton had expelled —excommunicated— Artaud, Soupault and Vitrac, and he was in open conflict with Quenau, Prévert, Leiris and Desnos.

A little while later Louis Aragon returned from the Second Congress of Revolutionary Writers in Jarkov and extended an enthusiastic welcome to the new members —Dalí, Buñuel and René Char— whom he considered as the bearers of valuable means of expression.

In his *History of Surrealism*, Maurice Nadeau, who is not especially pro-Dalí, states: "Dalí even succeeded in giving the movement a new youthfulness when he got it to adopt his paranoiac-critical method." Thus, Dalí's catalytic and rejuvenating contribution was considerable. He was also among those who distinguished themselves in the creation of objects, a new experimental field whose interest has diminished with time, leaving less trace than the pictorial and literary works. It should not be forgotten that Surrealism, despite declaring itself to be anti-literature and anti-art, was predominantly a literary movement (Breton, Eluard, Aragon, Desnos, Artaud, Prévert, Crevel, Vaillard, Péret...), but included important names in the plastic arts (Max Ernst, Magritte,

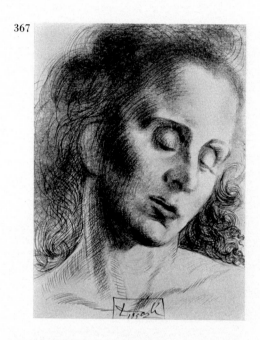

367

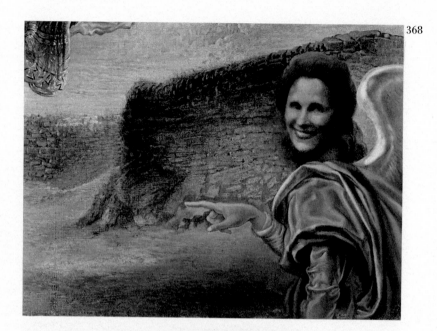

368

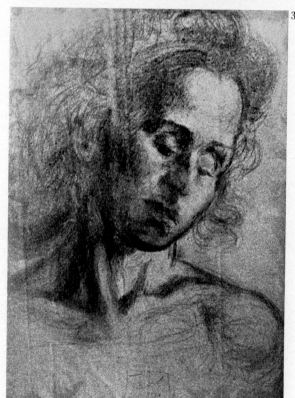

369

Dalí, Jean Arp, Man Ray...) It was in this orthodox Surrealist period that Dalí was to publish most of his early writings. His activities as a writer as well as the search for, and frenetic creation of, surrealist objects produced minor eclipses in his painting, something which becomes clear in a chronological study of his pictures.

Paris had a receptive atmosphere and was a suitable resonating chamber, and it moreover satisfied some of the peculiar demands of his complicated character: entry into a brilliant, eccentric society; meeting aristocrats and snobs; luxury and social acclaim, and feeling the lights of a minority popularity focused on him. The medal has a less optimistic side, marked by sacrifices which were stoically borne and which could not discourage him. Always at his side was Gala, and she was like the fork-crutch which appears in many of his paintings, supporting him, sustaining him, keeping the unstable cart on its wheels. Paris, while giving him notoriety, would try to crush him, to sink him, but the retreat was always there: Cadaqués, which from then on would

367. *Galla Placidia*, 1952. Galla Placidia is the name of the sister of the emperor Honorius who married Ataulphus and lived in Barcelona.
368. Detail of *Antiprotonic Assumption*, 1956.
369. Another version of *Galla Placidia*.
370. *First Portrait of Gala*, 1931; oil on cardboard, 14 × 9 cms; Albert Field Collection, New York.

in effect mean Port Lligat—paradise, laboratory, workshop and refuge. Here he could renew his strength, free his imagination, find nourishment through the soles of his bare feet and through his skin exposed to the sun, the wind and the salt water, through his eyes overflowing with lights and changes, through the countryside, and from a harmony of the classical and the contorted baroque. In Port Lligat there were soothing silences, tales of witches, the howling of the wind, the distracting screams of the crazy neighbour —ex-monk, polygamist and disciplinarian, known as 'The priest of the pipes', because he made them— and some poor fishermen, the proletariat of the cruel sea, most of them hard workers, but a few lazy and conceited; all of them free-and-easy characters.

Port Lligat, physical and metaphysical, invaded his eyes, with its sleepy waters when it was calm, drawn in subtle outlines, constructed in terraces of empty steps where the mildew has attacked the vines, rising up to the windmill without sails. Dark, decrepit boats drawn up on the beach or moored to the dry-stone jetty, microcosms of starfish, skeletons of sea-urchins, sprigs of coral, those little shells called Our Lady's sandals, fossils and semi-fossils, mysterious little curved moons, snails, fan mussels... Port Lligat, luminous in the morning, melancholic at dusk, mysterious at night; always distant. And between Cadaqués and Port Lligat, the cemetery.

After a stay of ten years, which must have seemed a long time, Paris was becoming the spring-board for his next and definitive leap: New York. This city had seen the arrival of many important figures from the Old World (31), and it became an extraordinary and most welcome public address system, launching platform, and culmination for everything that Dalí and Gala

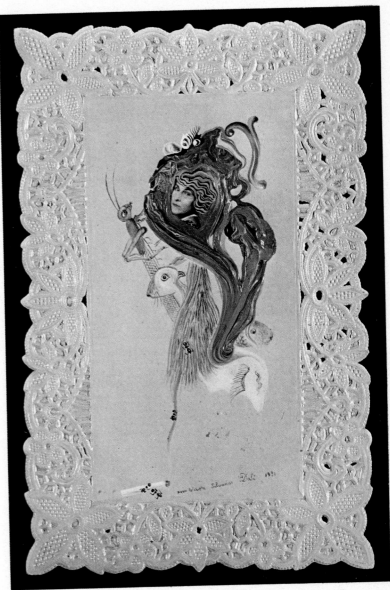

370

371. Detail of *Battle of Tetuán*.
372. *Battle of Tetuán*, 1962; oil on canvas, 308×406 cms; David Nahmad
Collection, Milan.

371

372

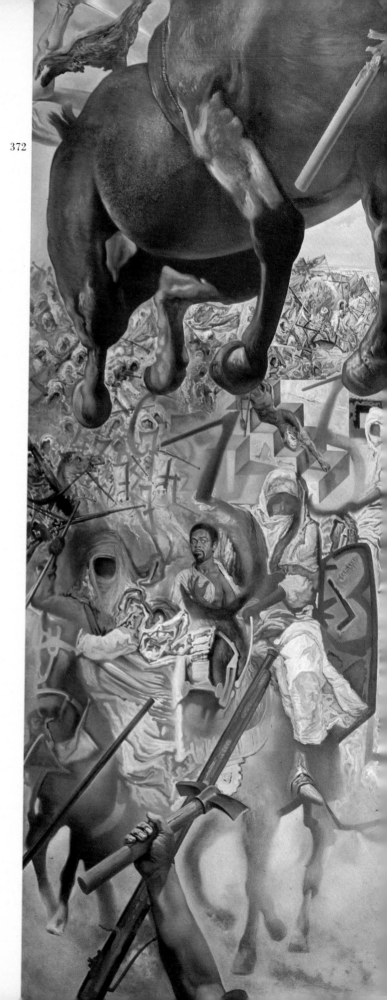

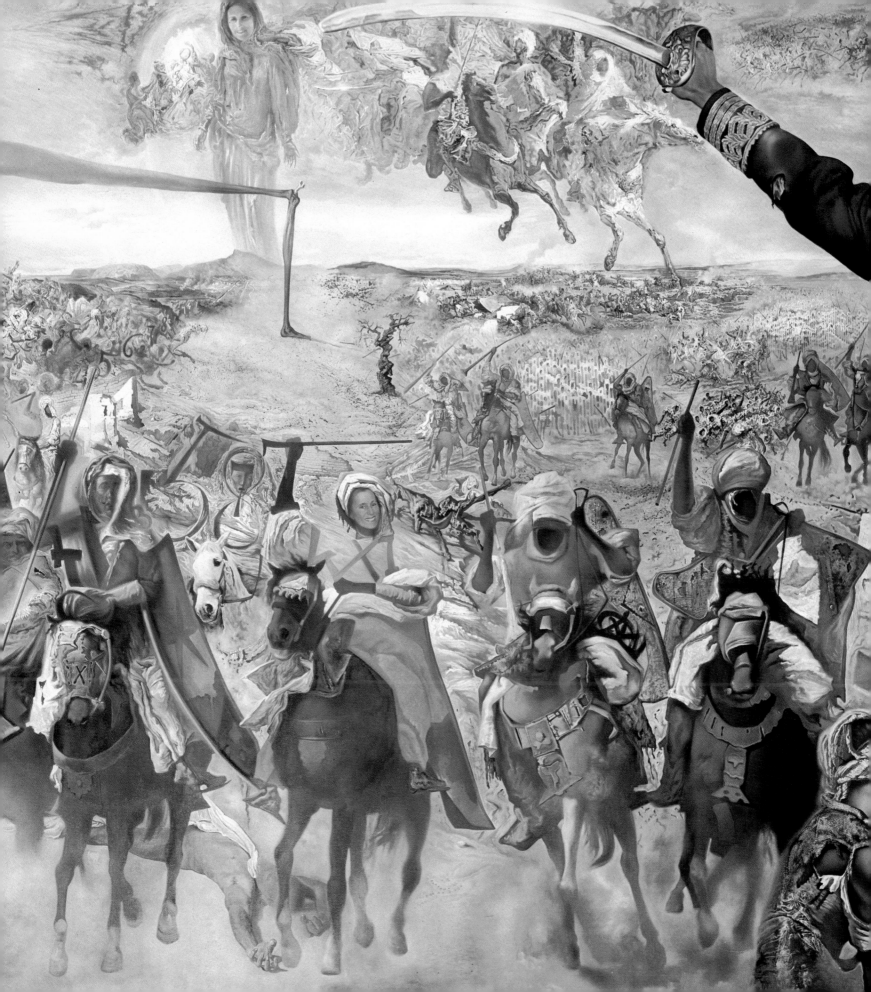

294

373

held dear. New York means dollars, those long awaited dollars which are paid in to secret safes, at first slowly, later with runaway speed. New York, enormous and intimate, represents the certainty of knowing that you are established in the centre of the world's amplifier, focal point for every nation, refuge and nursery for great fortunes, the greatest stage, the city facing the future, creator of futures, daughter of peoples and mother of towns, a melting-pot of museums, home of collectors, corruptor of intellectuals and artists, a catapult for businesses (32).

The United States gave them the feeling of terra firma, after some splendid ships had been wrecked in Europe, leaving gaps of malaise and nostalgia which they managed to overcome installed on this experimental platform, facing the future (33).

After eight years, when circumstances made it possible, advisable or easy, a temporary return to Port Lligat. Widespread popular success within Spain, which was also important. People crowding to see Dalí's thirty-two pictures in the Biennial Hispano-American Exhibition, re-discovering him, because wartime and post-war stagnation had reduced the Catalan painter to a mere second-hand anecdote, to a few flat reproductions and some exaggerated or lifeless echoes of what had happened to him in New York.

After an absence of a few years, he returned to Cadaqués, to Port Lligat. Little had changed; the family feuds which awaited him with renewed rancour affected him less intensely because he was more distant from the family, having created a new, close, minimal family; in all respects he had established himself.

Port Lligat, which had temporarily disappeared from his palette, received a new and authentic presence. It is no longer a landscape evoked

373. *Lapis-lazuli Corpuscular Assumption*, 1952; oil on canvas, 230 × 144 cms; John Theodoracopoulos Collection.
374. Detail of the Castle of Pubol, in the province of Gerona, which he has presented to Gala. Photograph taken before the restoration.

374

375. Dalí as a child.
376. With his uncle Anselm Domènech, who owned a prestigious Barcelona bookshop, in 1925 before the painting *Harlequin with Bottle of Rum*.
377. *The Face*, 1972; oil on canvas, 58.5×44 cms; Dalí Museum-Theatre, Figueras.

375

376

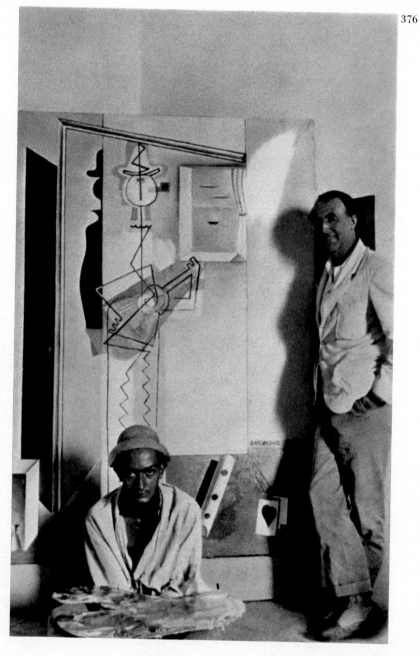

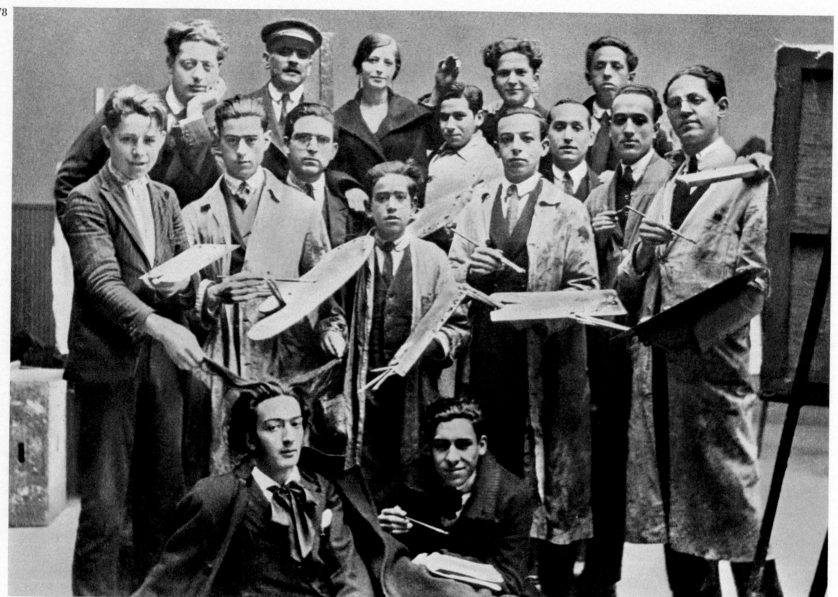

378 and 379. In the School of Fine Arts of San Fernando, Madrid, during the year 1921-1922. He was expelled from the school in October, 1926.

379

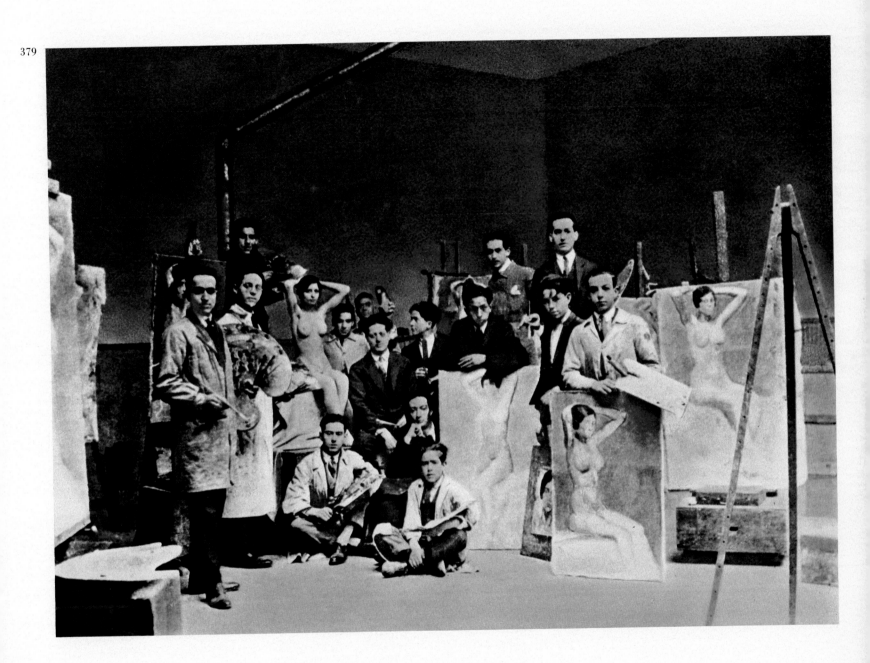

380. Visit of King Alfonso XIII to the San Fernando School of Fine Arts; Dalí can be seen in the upper left section.
381. *Cubist Portrait of Alfonso XIII* which appears in *My Secret Life.*
382. Don Juan Núñez Fernández, drawing teacher at the Secondary School and at the Municipal School of Drawing, Figueras. Dalí regards him as his greatest teacher.

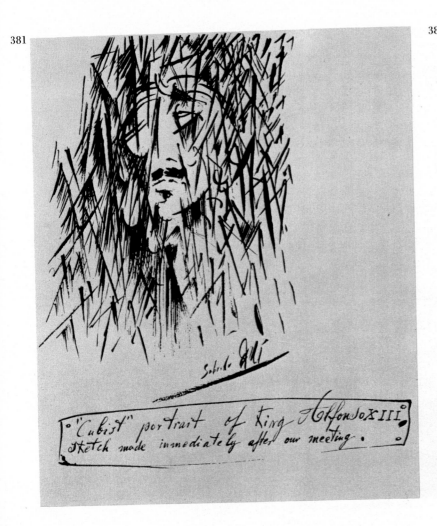

381

382

through mental effort; it is the panorama where he can set his easel at will, the one which he sees from his studio, from his bedroom, and where his olive grove —forming an integral part— is found; the ambit where he can wander, the water where he can bathe. From America he had described with brio and literary precision this very landscape which he had now regained. In Port Lligat he did not pitch a nomad's tent; he reclaimed his home.

His new works were inspired by a desire for classicism parallel to a vague, aesthetic mysticism. His imagination was captured by science, which had made great strides during the precarious universal peace which had followed the war. He read scientific journals, interpreting them after his own fashion. He conjured up fantasies and predictions, he intuited associations and consequences, he related phenomena to each other. Using different means, scientists converted into reality or into valid and elaborate theories certain premonitions which had seemed disparate. It is no longer the subconscious which is his favourite vehicle; now it is the supraconscious; he puts forward extravagantly contrived theories where one finds atoms, rhinoceros horns, movement, parabolic curves and deoxyribonucleic acid.

383. Dressed as a soldier, he was photographed with García Lorca in 1925.
384. Portrait which he made of Luis Buñuel, reproduced in the *Revista de Occidente* in 1925.
385. In Madrid with García Lorca and Pepín Bello.
386. Allusive drawing by García Lorca, called *Death of Saint Radegunda*, 1929.

383

385

384

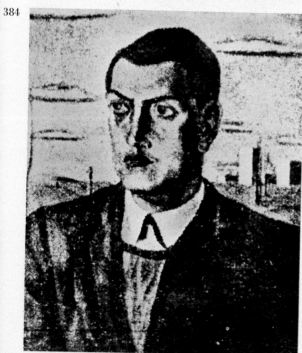

386

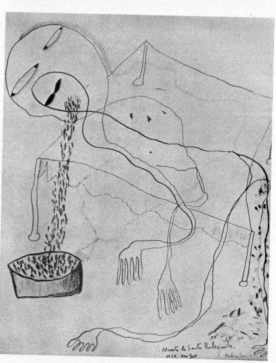

387. Drawing by Dalí with probable allusion to Rafael Alberti's book *Sailor on Dry Land*.
388. *Luis Buñuel with a Bullfighter*; drawing, 18.5 × 23 cms; Fanny and Salvador Riera Collection, Barcelona.
389. Early during his stay in North America.

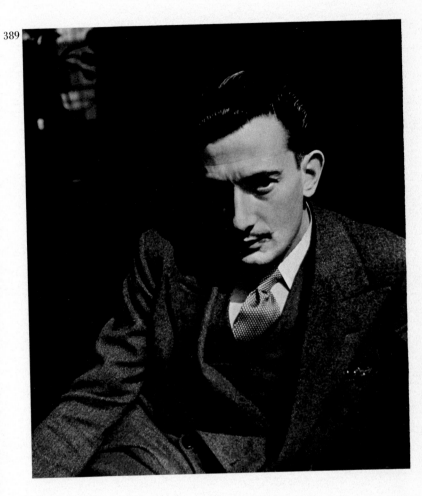

Most of his time is divided between New York and Port Lligat, apart from the season in Paris which gets longer, and the frequent visits to Barcelona, and to Madrid and Italy. Since Dalí shuns the aeroplane as a means of transport, he has no wish to visit new countries. He is accompanied by a certain amount of scandalous publicity which he does his best to encourage and keep alive. There is a new, magic toy which might have been invented for him: television. In meetings, restaurants, hotels and streets, he has managed to outdo the Boy from Tona, not in the disastrous way which his father foresaw, but rather in a great, luxurious and universal fashion.

390. Surrealist object.
391. Port Lligat in the first quarter of the century. The cottage which Lidia sold him, nucleus and origin of his present home, is the diminutive construction which occupies the third space on the left.
392. Photograph about 1930.

390

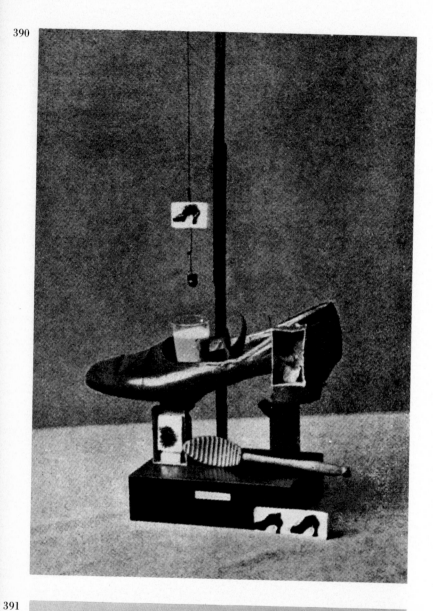

391

392

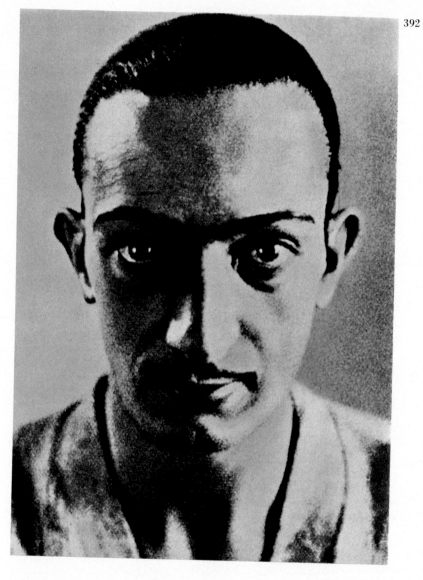

393. Self-portrait dedicated to Federico García Lorca; pen and Indian ink, 22×17; Abelló Museum, Mollet (Barcelona).

394 and 395. Drawings by Ramón Casas of Ramón Pichot (1870-1925) and Eduardo Marquina (1879-1946).

396. The Royal Academy of Fine Arts of San Fernando in the *Calle* de Alcalá in Madrid; the School occupied part of this building.

397. The Students' Residence in Madrid.

393
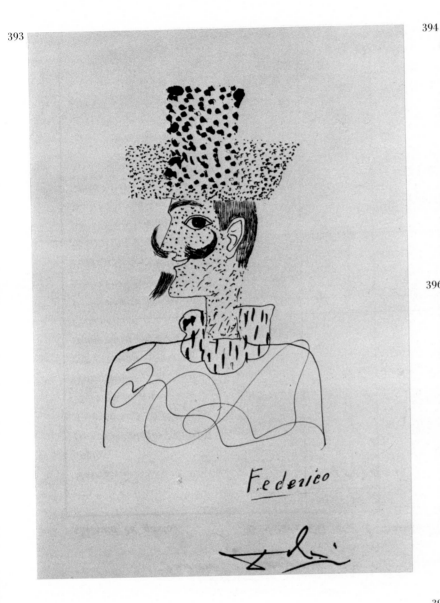

394

395

396

397

He is obsessed with work, painting, painting. The limited easel which we see in some of his early self-portraits has been replaced by a modern device with motor, chassis and inspection-pit, which allows him to paint gigantic canvases, pictures for museums, after the manner of the masters he admires from the era of great paintings. He is at his easel from early morning; he works without a break, and late at night when Port Lligat is deserted, there is still a light burning in the window of his studio. In addition, he finds the time, energy and appetite to write books (34), to make declarations to left and right, to create film plots, to chat, to paint smaller pictures, illustrate books, draw, engrave, to show off, to sail his black and yellow boat, to pour forth inventiveness, to amuse himself with his own brand of humour, extend his house, renew acquaintances, maintain old friendships, exhibit again, worry and work for the Museum-Theatre in Figueras, for the reconstruction and decoration of the castle at Púbol —which was a present from him to Gala— and to live, live at full steam, always, day and night.

Among the qualities that one could not deny in this restless and provocative man, one of the main ones is his intuitive predilection for everything novel and futuristic. This began when he was a child, wielding his brushes under the influence of the post-Impressionists; later he was captivated by Juan Gris, Carrá, Picasso, Chirico, but without ever losing the stable, classical equilibrium with which he was endowed both because of his profession and his artistic integrity, and it is in this realm that he has executed his most lasting work. Later again, there were episodic influences from Joan Miró, and his entry, or rather invasion, into Surrealism, through whose fields he galloped somewhat after the

manner of Attila's horse (35). In subsequent years, without abandoning the characteristic peculiarities which are the very root of his personality, he returned to classical tendencies, considering Vermeer, Velázquez and Raphael as peerless masters, while also praising Ingres and Meisonnier, exaggerating, perhaps with the sarcastic touch of a dissidents' dissident, his view of *pompier* painting (36). The assimilation of these influences (37) may be seen as chapters in his perpetually searching attitude, and it must be realized that when he established himself as one of the leading painters of our times, he achieved this by himself or by struggling against the current, for he is only influenced by the Dalí who is engaged in his own fascinating pictorial adventure. We will have to wait years to know the judgment of posterity; but it is vain even to talk of judgment and posterity, for different judgments will coexist, and one would have to refer to simultaneous or subsequent posterities.

Dalí is the most controversial, contentious and polemical painter of the century. In the thirties, and in Spain much earlier, he was the hero of the most daring and demanding of the avant-garde. Later these very people, or those who became their heirs or successors, would attack him and deny him, reject him or ignore him, forgetting that their previous clamourings were written down for all to see. I am referring to the chapels and cliques that confer credentials, to the theorists of the arcane, to the mandarins; for Dalí has never lacked supporters and has enjoyed interest and enthusiasm among the public at large.

Provocative and paradoxical Dalí, pathological exhibitionist, fount of extrapictorial inventiveness, controvertible and controversial, cathartic, rationalist of the irrational, catalyst of furious reactions, subversive, virulent, caustic to

those who follow other paths (38); permanent news for the weekly magazines, coveted prize of photographers, announcers and television interviewers, promoted by publicity agents, involved or interfering in affairs of the cinema, the theatre or the ballet, in fact in everything; would-be usurper of the throne of Zeus, the Martin Luther of Surrealism, witty and scandalous public speaker, creator of inventions, a surprising clown, explosive, organizer of the disorganized, explorer of the ocean and the obscene, impresario of extravaganzas, archaist, practical joker, master draughtsman, with a degree in fantasy and a doctorate in literary pyrotechnics, and above all, a painter, painter to an unbalanced epoch, providing testimony at this critical moment, fervently faithful to himself, and tracing the solitary, difficult course of art's eternal, universal, and hazardous adventure.

What judgment does the future hold for Salvador Dalí? I repeat my earlier point: which future? If we were to specify the immediate future, my evidence would include the surprise which I felt at the Rotterdam exhibition in 1970: the crowds that came consisted overwhelmingly of young people, even children, who first had to stand in a long queue outside, enduring the inclement Dutch weather, but then swarmed through the rooms with an expectant attitude verging on what might be called fervour. I do not believe that the extravagant publicity had a great effect on these young people, who came in their thousands every day, with clothes that might have seemed outlandish, like those of the artist himself, but which now turn out not to be so. Excluding certain exceptions, and leaving aside Picasso, let us ask ourselves, without prejudice and with due modesty: in fifty, a hundred, or five hundred years time, who will have the capacity or the interest to distinguish, to individualize, among the painters of yesterday, of today, or among those who are already receiving considerable attention and who might make a big reputation tomorrow? We might go on to ask: are we at the limits of painting as it has so far been conceived, or did we have to reach this annihilation, this conscious negation, this destruction in the name of revolution, in order to start with something new which we for the moment cannot predict? Do cycles exist in the art and life of societies which are repeated, always adjusting to the characteristics of each epoch which go unrecognized by the people at the time. The dilemmas facing us today are complicated but seem to demand an urgent response; our courage wavers, for bald statements will very quickly be contradicted.

Dalí has completed a long period as a painter, and his works are to be found all over the world. He has taken the risk of following a divergent,

even distinctly contrary, path to that of most of his contemporaries. He has backed his one card with a stubborn conviction in which one only rarely glimpses a slight doubt; he has fought, with a ferocity that he has never concealed, for immediate success, and he has attained it.

He maintains that painting is at the end of its waning phase, like the moon when it appears to our eyes as if converted into a thin slice of melon, or a fingernail clipping, before the eclipse which is annihilation, disappearance, but which also implies the new moon. After the eclipse will begin the cycle of a promising quarter, waxing until it attains the glorious plenitude of the full moon. Dalí lays claim to a place beyond

the eclipse, at the beginning of this first quarter which will lead to a new, glorious Renaissance.

In the realm of painting, we do not know what the response will be to Dalí's challenge. In a similar way to other human activities, the plastic arts are plunging headlong towards absolute zero, towards nothing; but from that unstable zero-state the ball will rebound. When an artist —not some fake trying to be original, or some crazy opportunist— presents a surface that is perfectly white (not black), we must have reached rock bottom. Could some aspects of Dalí provide the first stone, the first parabola for the rebounding ball? This is a question which I do not dare to pronounce on; and my answer would be vain.

398

399. The Dalí Museum-Theatre in Figueras, which presents a new conception in museums in that the building and its contents form a surprising unity. Inaugurated 28 September 1974. The sculpture in the foreground is by Ernst Fuchs.

399

NOTES

(1) Don Francisco Javier Sánchez Cantón was Director of the Prado and an Academician in Fine Arts, in Language and in History. In the prologue of the book *Gala's Dalí*, he invents a speech for Dalí's reception into the Academy. There he says: "With the spirit of our times, he has managed to give new life to concepts and forms from the past." And also: "... in practising what I might dare to call *spatial limitation*, he might possibly rescue the future of painting."

(2) In a book which appeared not long ago, *The Passions according to Dalí*, the French writer Louis Pauwels has ordered and edited a series of taped conversations on the following themes: Death, Glory, Gold, Eroticism, Monarchy, God and the Angels, the Station at Perpignan, and Subsidiary Passions. The text must be considered as the keystone to the vault in the edifice of his most extreme, iconoclastic, aggressive and, of course, obscene attitudes. In some of them he plays the part of the conductor of subtle and ceremonious perversions, which all of a sudden dissolve into the frustrated or the ridiculous, in the same way that we suddenly come across allusions to frustration in some of his paintings.

Within Dalí forces are at work which in other epochs would have been qualified as demoniacal. They drive him to act or speak or paint or write beyond his own will or his wish to have enough will-power to desist. Irrepressible forces which are most quickly released when someone provokes him, and which might conceivably be traces of old Surrealist attitudes, although their origin is to be sought in his own personality. We live in sceptical times in which it is practically impossible to scandalize anybody; the risk of excommunication has disappeared along with the summons from the inquisitors, the exorcists, the judges or doctors, as well as the warders, constables, asylum staffs and fumigators; and instead, though in some countries more than others, a curiosity somewhere between pornographic and pseudo-scientific is opening wide all the doors of tolerance.

(3) We here reproduce three short comments from the introduction by Mr Patrick Waldberg in the catalogue of the Rotterdam exhibition in 1970: "In the very interior of his painting, he introduced a new kind of game —parody"; "In Dalí, provocation is raised to the status of a way of life"; "The painter's gesture and the actor's attitude are so constant, so intimately interwoven, that in the end they become blurred at the edges."

(4) "Dalí was an early initiate in the works of Freud, but the austere inspector of the hidden zones could not have foreseen the way in which Dalí would utilize his discoveries: not to cure obsessions, but on the contrary, to reinforce them, magnify them, and offer them as an example to the world." Thus Patrick Waldberg.

(5) These myths, of which the one he finds most fascinating is that of William Tell, do not rule out the admiration which he felt for his father or his declared affection for him. The normal father-son opposition of adolescence was reinforced by the generation gap, as powerful then as now, aggravated by the particular circumstances of that epoch of acute change, by the extremely free and disrespectful atmosphere which there was among his companions and friends in the Students' Residence, and by the aggressive character of Salvador Dalí, junior. The antagonism must have been even keener because of the tender and hopeful —but demanding and authoritarian— love which the father felt for his only son, whose peculiar way of behaving and thinking he saw as shattering his illusions, for example for his son to become an art teacher with a fixed, stable income, and including the hope of feeling himself the father of a child prodigy whom he could provide with generous protection.

(6) "... because lust is a storm, more than a storm! Beauty is something tremendous and terrible! Tremendous because it is undefined, and it is impossible to define because God only speaks to us in mysteries. This is where the shores meet, where all the contradictions come together. There is a terrible number of mysteries! And there is a terrible number of enigmas which oppress man on this earth..." A quotation, by way of illustration, in the present book from Dostoievski in the words of Dimitri Federovich Karamazov, despite the fact that Dalí has ranted about the Russian authors.

(7) A concise definition of the paranoiac-critical method: "Spontaneous method of irrational knowledge based on the critical, interpretative association of delirious phenomena." In the paranoiac-critical method, Dalí, as one might do with a sock, turns inside out what was essential to Surrealism and thus made a definite break from the Dada inheritance.

(8) In opposition, or as a complement, to cannibalism pure and simple (that is to say, the normal kind), he has envisaged the cannibalism of objects. To the comment of André Breton that "beauty must be convulsive or it will die", Dalí said, by way of reply: "Beauty must be edible, or it will die."

(9) Fleur Cowles relates a comment, full of keen malice, made by a fisherman who saw Dalí painting in one of his earliest periods: "The waves you're painting are just like the ones on the sea, but they are better because you can count them."

(10) As well as the 'Boy from Tona', Dalí admired 'La moños', a singular woman, always covered in make-up and colourfully dressed, who was a popular figure in the old quarters of Barcelona. She fanned herself summer and winter, and had a light, swinging gait despite her years. She always wore real or artificial flowers in her hair. The children used to run after her, workmen stopped their work and went to the doors of their workshops to see her pass, and men in the bars left their drinks to shout after her some coarse pleasantry. She was like a crazy bird, like a happy, unsettled grasshopper, an irrational and absurd irruption into the life of the town. Furthermore, Dalí has told me, the Clown from Coria and the other jesters in Velázquez "are important people. They were the people who spoke the truth; I am a little like them, and I also tell the truth, and I must be allowed to tell it."

(11) I know of three portraits of Picasso by Dalí: one of them is an oil of Surrealist inspiration and design, the second is an engraving which is a good likeness of the young Picasso, and the third is an engraving from 1968. Dalí has told me about some lost engravings which he made half-and-half with Picasso: one day one of them worked on the plates, the next day the other. These plates, if they still existed, would have great artistic and anecdotal importance. I learnt from Robert Descharnes that they were made in 1938 in the house of the engraver Lacourière. In *La conquête de l'irrationnel* (1935) Dalí dedicates to Picasso a poem from which I feel all poetry has evaporated.

(12) He attended the first exhibition of the Society of Iberian Artists, held in Madrid in 1925, where, among others represented, were Pancho Cossío, Benjamín Palencia, Francisco Bores and the sculptor Angel Ferrant, all of whom were older than him. The most demanding critics, Moreno Villa, Manuel Abril, Eugeni d'Ors, Guillermo de Torre... praised the young painter from Figueras in the capital's best reviews. He also exhibited in Madrid in 1926, when the daily paper *Heraldo de Madrid* organized an exhibition of Catalan art.

(13) The Barcelona critic Rafael Santos Torroella says in a book published in 1952: "Dalí is a painter of multiple resources who does not even give himself much opportunity for personal relaxation, but instead seizes and exploits his resources, almost like quotations, in his work. On occasions he does not even acknowledge their origin..."

(14) It is well known that Dalí has a passion for money; he does not pretend otherwise, and even used to boast about it. André Breton called

him 'Avida Dollars' (Dollar Greedy), an anagram of his name. He liked this sobriquet; it gave him the idea for a title of a painting, and he was sure that it brought him greater economic fortune. The first painting which he sold was a still-life depicting three lemons. It was acquired in Figueras by a German while Dalí was still very young. He recalls that the price was five hundred pesetas, and he adds that his father at once worked out how much he had been paid per lemon.

(15) It is difficult to form a notion of the real extent of his religious beliefs, which go through alternate phases of desecration and exaltation, head and tail of the same coin, accompanied by sarcasms, irreverent comments, and thunderous pronouncements, taking greater pleasure in the sound of the words than in their real meaning. Dalí describes himself as a mystic, for mysticism is the most exalted of all religious manifestations. But if we examine his pictures and analyse aspects of his daily life in the lines which come closest to the normality that human nature imposes on every mortal, the vague religious tendencies which one glimpses, the more or less firm hopes of a world beyond, (and it is for this, for the burning desire to attain eternal life that men such as Dalí and Unamuno cling to religion,) appear to me to be extremely human and sensible. Dalí greatly enjoys the happiness of this life, whose boundaries he has personally extended; in his liking for the words *mystic* and *mysticism*, and in his quotations from Saint John of the Cross, from Saint Teresa of Ávila and Ramón Llull, I tend to regard him as very close to another, almost contemporary, Catalan: Joan Maragall. This poet of deserved renown and widespread influence died in 1911 when Dalí was a child; his fame still lives on today. He was virtually completely Catholic, and he wrote the most *fiercely human* religious poem that has ever been written.

"If this world, Lord, is so lovely, as seen
with Thy peace and through our eye,
what more could we gain from a life hereafter?"

If we regard Dalí's paintings, we cannot fail to notice what has been his true, his most profound, attitude, the only thing to which he has remained faithful —apart from Gala— and the one thing which by its very nature lasts longer than love. Let us listen again to the voice of the Catalan and Catholic poet.

"For this love, always beating as much in my eyes
and in my face, as in the heart that Thou, o Lord,
hast given me... and I am so afraid of death.
With what other senses can you make me feel
this blue heaven over the mountains
and the immense sea, and the sun shining on it all?
Grant me in these feelings eternal peace
and I'll not crave another heaven beyond this blue...!"

Limiting ourselves to Port Lligat and its immediate coast, and leaving aside hyperbole, if Dalí had greater modesty and allowed himself to be swayed by an impulse of sincerity, whether religious or not, he would subscribe to this poem; and he would not be the only one.

(16) The actual question was: "Do you have faith?" to which Dalí replied in the negative. The book by the journalist del Arco is called *Dalí laid bare*, and was published in Barcelona in 1952, although the extended interview took place two years previously. It is a curious document, not least because del Arco admits that his notions concerning Dalí's life and work are very rudimentary. In that *mystical* moment, Dalí says among other things: "I still have demoniacal tendencies due to vestiges of my early education." And later on: "I believe in the resurrection of the body." He also confesses to being an egotist.

(17) He was married in 1958 in the Los Angeles hermitage. The officiating priest was Father Francesc, who until quite recently had been the parish priest in Cadaqués. His wedding was the least Dalinian event of his life. A tourist who happened to be visiting the hermitage took one or two photos. The preparations were made with such discretion that a close personal friend who was working with him at the time was asked on the day before not to come to his house the following day, because he would not be in Cadaqués, but without any further explanations.

(18) Dalí alludes in his writings to bullfighting themes. For example: "You face the white, threatening bull of the virgin canvas, which, when the work is finished, will have been immortalized by the last stroke of your brush."
He also used bullfighting terms in the telegram which he sent to Picasso from New York —and some of these concepts he was to use again in the mystical manifesto of 1951: "Pablo, many thanks. With your Iberian genius intact, you have slain the ugliness of modern painting. Without you, and with the moderation and prudence which characterize and qualify French painting, we were threatened with perhaps a hundred years of progressively and increasingly ugly painting, until we arrive at last at your horrifying, but at times sublime, frivolities and monstrosities. With only one categorical death thrust, you have killed the pedigree bull, and also the even blacker one of the whole of materialism. Now, a new era of mystical painting begins with me."

(19) García Lorca was a superb interpreter of his own poetry. Because of his readings, certain poems became clear which would otherwise have remained obscure. Another poet, Jorge Guillén, recounts how he read to them —presumably in the Residence —his *Romance Sonámbulo*, and the moving and unforgettable "Green, how I love you green / Green wind, green boughs...", and he adds: "He finished his *romance*, and Salvador Dalí could not help remarking in his 'olive voice' (at 24 or 25, more olive than ever), almost like a Castilian imitating a Catalan accent: "It seems to have a theme, but in fact it hasn't!" an observation which, to anyone who knows the poem, will seem surprisingly astute.

(20) It was published in 1931 in Paris by José Corti, in his *Editions Surréalistes*. It has illustrations from the best-known works between 1929 and 1931, but now it is a difficult book to find. It says, among many other things: "Dalí is undoubtedly gifted with prodigious expressive talents... At one and the same time, he is painter, sculptor, poet, philosopher and eloquent orator..." René Crevel committed suicide in 1938, leaving the note: "I am sickened by everything." Dalí was greatly affected by his death.

(21) In a book which deals strictly with Salvador Dalí, we cannot possibly give more space to this theme than we already have. Apart from the whole popular range, not forgetting old romances, and without excluding an enormous number of graphic representations which include praiseworthy drawings, outstanding posters, let us finish by recalling painters such as Zuloaga, Vázquez Díaz, sculptors like Benlliure and Manolo Hugué, poets like Lope, Góngora, Quevedo, Moratín, the Duque de Rivas, Zorrilla, Rubén Darío, Manuel Machado and Gerardo Diego, among many others. Foreign authors have also been attracted to the *fiesta brava*: Hemingway, Montherlant, Jean Cau, Peyré... and Gautier and Merimée!

(22) *Automatic Beginning for a Portrait of Gala* has been described as unfinished, but in Draeger's well-documented book it is not characterized as such.

(23) Robert Descharnes, who knows Dalí's paintings well, says of him: "Beyond the eccentric personality, one must recognize a prodigiously talented man who strives stubbornly, and by every means, to communicate his message: to make the invisible visible! The obverse side of ourselves and of the universe."

(24) As an incidental curiosity, we can point out that Picasso, during his stay in Cadaqués with Fernande Olivier, also put up in Lidia's house.

(25) By the time he was seven, he knew the alphabet and a few more things, and his father decided to send him to school. Instead of sending him to one of the two religious schools in Figueras (later he was to attend both) where the sons of the bourgeoisie were educated to think independently of the ideas of their parents, señor Dalí, moved by ideological-social principles, decided that he ought to attend classes in the municipal school. In those days it was run by a teacher called Traiter, who enjoyed the reputation of being a cultured man, and perhaps he was. According to Dalí's version, although this might be somewhat elaborated, he used to spend most of the lessons asleep; when he woke he would take a pinch of snuff and then pull the ears of the noisiest and naughtiest pupils. The pedagogic experience did not give favourable results. On the one hand, Salvador Dalí forgot what little he had learnt at home, and as far as his social education was concerned, the results were equally disastrous. A child who was spoilt at home, well dressed and fed, nice-smelling even, felt different from, and superior to, those poor children, and this accentuated his tendency towards an aristocratic isolation, and to feel alone and placed above other people. Dalí relates many picturesque and possibly exaggerated details of his experiences in the school run by señor Traiter, an unforgettable character who sported an enormous Tolstoian beard. A conversation with Dalí on this subject always turns out to be amusing.

(26) In 1925 the writer José Moreno Villa published in *Revista de Occidente* an essay where he referred to Dalí and, as a generalization, qualified him as a geometer, and said of him among other things: "He is uncommonly well versed in the art of his time, and since he is a man of strong convictions, he exercises a verbal influence over certain young painters, although he himself has still not been through the raffle." This last phrase, which means that he had not done his military service, alludes to his extreme youth, for Moreno Villa was at the time twice his age.

(27) Dalí relates in one of his writings —and he has also given me a personal account of the event— that some two months before the start of the Spanish civil war, he happened to be in Barcelona at the same time as the English poet Edward James and Federico García Lorca. Edward James had rented a villa in Amalfi and, while they were having lunch in the 'Canari de la Garriga', he invited his two friends to spend the summer there. Dalí accepted, but García Lorca hesitated. When Dalí later learnt of García Lorca's tragic death, he felt a great regret that he had not insisted at the time that the poet should accept the invitation. Edward James owns an important collection of Dalí's works, including some of the best of his smaller paintings, the ones in which he has succeeded in concentrating the most mystery and poetry. Between the years 1936 and 1939, Dalí spent certain periods in Italy.

(28) In the *Diary of a Genius* he wrote on 14 July 1953: "Thanks to the fear which is produced in me by having to touch Gala's face, I shall end up knowing how to paint!" And on 8 September of the same year: "I am at last painting satisfactorily a likeness of Gala." I am familiar with one of the early drafts for the *Diary*. It was a real accountant's book of enormous proportions. He wrote with large letters in a personal and extremely badly spelt French. He said that he used to write it in bed with the book propped on his legs; the pain caused by the weight of the book on his muscles meant that he could not fall asleep.

(29) In 1925, shortly after completing his play *Mariana Pineda*, García Lorca spent some days in Cadaqués and read his new work in the Dalí family home. It opened on 24 June 1927 at the Goya theatre in Barcelona, and was performed by the Margarita Xirgu company; the sets were by Salvador Dalí, who attended the opening with his father and sister. The first exhibition in which he took part was a collective organized by the Society for Intimate Concerts in Figueras. He exhibited twice in the Galerías Dalmau: 14-27 November 1925, and 31 December 1926 - 14 January 1927.

It is also interesting to note that, during the run of *Mariana Pineda* and in the same Galerías Dalmau, an exhibition of 24 of Lorca's drawings was arranged by a group of the poet's friends. Among the organizers or patrons, apart from Dalí himself, we should point out Sebastià Gasch, the poet J V Foix, the painter Rafael Barradas, and the guitarist Regino Sáinz de la Maza.

(30) From Granada García Lorca wrote to Sebastià Gasch in Barcelona: "... in my opinion, there is in this young man (Dalí) the greatest glory of the *eternal Catalonia*. I am working on a study of him, which you might like to translate into Catalan, since I would prefer to publish it in that language." One assumes that the study to which he refers was never completed.

(31) When the war broke out, Dalí realized that his world was sinking beneath his feet. Something which he criticized, namely the corrupt promiscuity of Europe in the inter-war years —aristocrats, surrealists, eccentrics, nouveaux riches, snobs, coke addicts— the twilight society of which he was part was collapsing or had already collapsed. He set his sights on the United States, the nation to which he would later dedicate an impassioned canto. If Europe was burning, and if he was a part of this burning Europe, then he would be re-born in America, like the Phoenix from the ashes.

(32) He made his first visit to the United States in 1934, disembarking in New York with Gala on 14 November. In 1932 he had taken part in the first Surrealist exhibition, in Hartford; his works were included in a collective in the Julien Levy Gallery in New York, and it was here that he had his first solo exhibition in North America. It struck the Spanish reader as curious to read, in *La Vanguardia* of 22 January 1935, an article written by their correspondent in New York, Aurelio Pego. He writes of the success and bewilderment —felt by him and by others— caused by these first examples of Surrealism, and he refers to some well-known pictures. He explains that *Persistence of Memory*, the picture with the soft watches, appeared in the World Fair in Chicago, and how it had previously been given an honourable mention by the Carnegie Institution in Pittsburgh. The correspondent, who appears somewhat surprised, had an interview with Dalí, and finished by telling us he had given lectures in Hartford, at the Instituto de las Españas, at Columbia University, and other cultural and artistic centres. During the war, Dalí and Gala embarked in Lisbon and arrived in New York on 16 August 1940. They did not return to Europe until eight years later, and this was their only long absence from Spain, and from Cadaqués. In 1941 the Museum of Modern Art in New York put on a large retrospective exhibition, and in the two subsequent years his paintings were exhibited in various cities of North America.

His intense activity during his stay in the United States is well known, not only in the field of painting, drawing and illustrating, but because he wrote and published there *My Secret Life*, *Hidden Faces* and *50 Magic Secrets for Painting*. His reputation was also boosted by his settings for various ballets, such as *Labyrinth*, *Café de Chinitas* and *Mad Tristan*; not forgetting his incursions into the fields of advertising, exhibitions, and so on.

(33) *The Case of Salvador Dalí* by Fleur Cowles is as far as I know the longest book that has been published on Dalí. My position regarding what is written in this volume ranges from complete agreement, through various intermediate stages, to total dissension. In general it seems to me that she has followed too closely what Dalí himself has recounted of his secret life, without submitting it to critical review or checking it with other sources. The book does, however, make extremely interesting reading and she includes many known and unknown facts concerning the painter's life in North America as well as in Paris and London; she speaks of the reviews in New York and London, and of his television appearances, and she introduces us to some of the principal

collectors. She presents documentary evidence concerning the meeting in London of Dalí with Freud, accompanied by Stefan Zweig, which is important, bearing in mind the doubts expressed by certain sceptics. The book has been translated into Spanish and on the cover there appears by way of a sub-title 'Biography of a Great Eccentric', though I do not know whether this appears on the original or not. On 29 October 1971 I heard by chance Dalí's voice on the radio, and I listened to his declarations which included a definition of himself as 'eccentric-concentric'.

(34) He has a feeling for the sound and decorative value of words and phrases, a feeling which might also be characterized as extremist. I must restrict myself to his Castilian, but the same thing occurs in his first language, Catalan, and in French, which is the language he normally writes in. A few examples will suffice: complexity, anarchist, fanaticism, exaltation, paranoiac, armpit, catholic, aggressive, narcissism, cosmic, hallucinatory, paroxysm, sacrilege, hysterical, agate, delirium, colloid, hierarchy, desecration, arborescent, polymorph, slashing, morphology, tyrannical, tanning, and: powerful posteriors; tearing off a piece of raw flesh. Discussing this with him he has told me that he likes words that are *striking*.

(35) As is well known, Salvador Dalí was 'expelled' definitively from the Surrealist movement by André Breton in New York in 1940, although he had suffered his first 'expulsion' in 1934, and relations had been rather strained after 1936. It was in 1940 that he uttered his magnificent remark: "The difference between the Surrealists and me is that I am a Surrealist." Certainly he has never ceased for one moment to be, in larger or smaller measure, a Surrealist. It is not that he *was* a Surrealist; he *is* a Surrealist.

(36) Among the people whom Dalí most admires, one must give pride of place to his old and unconcealed admiration for the Catalan architect Antoni Gaudí, who died in 1926, and whose works have only in recent years attained world-wide recognition and esteem. Despite certain common features which one could mention, it would appear excessive to speak of an influence of Gaudí on the painter; it would be better to speak of coincidences for, among Dalinian concepts, the brilliant architect must be seen as a precursor of the hard-soft forms. It must be remembered that Dalí recalls visiting Gaudí's Güell Park during his trips to Barcelona as a child. It is worth remembering that Apollinaire defied contemporary opinion in praising Gaudí's work in glowing terms.

(37) The catalogue for the New York exhibition of 1941 refers to various influences on Dalí, but I feel that these are too rigid with respect to the different periods. Apart from those I mention here, it cites the Italian Futurists in 1921, it speaks of influences from 1925 to 1928 of Cézanne (who is certainly one of Dalí's *enemies*, and is characterized by him as always trying to paint round apples but never quite making it.) Between 1929 and 1933, apart from Giorgio de Chirico and Modernist art, it mentions Ives Tanguy and Max Ernst. It says, with good reason, that he began to talk about his preference for Meissonier around 1930. And it slots into the years 1937 to 1939 his admiration, and the awakening public admiration, for Vermeer, Velázquez, Caravaggio, and the artists of the Italian Baroque, although I would put them much earlier. There is a remark by Dalí that I would put at around 1935, which would to some extent serve to correct these last dates from the catalogue: "My Surrealist glory was worthless; Surrealism must be incorporated into tradition. My imagination had to turn back to the classical. In the same year, in *La conquête de l'irrationnel*, he again cited Vermeer and Velázquez. I believe that he has always admired them. Reynolds Morse brings forward an even greater number of influences; but let us allow the painter the last word: "Everything influences me; nothing changes me."

(38) See *Les cocus du vieil art moderne*, a book where brilliant truths are also to be found.

400. *The First Days of Spring*, 1922 or 1923; Indian ink and watercolour on paper, 21.5 × 14.5 cms; Ramón Estalella Collection, Madrid.
401. *Drunk*, 1922; Indian ink on paper, 21.5 × 14.5 cms; Ramón Estalella Collection, Madrid.
402. *Poor Musicians*, 1922; Indian ink on paper, 21.5 × 14.5 cms; Ramón Estalella Collection, Madrid.

402

403

403 and 404. *Whorehouses* and *Civil Servant* respectively; Indian ink on paper, 21.5×14.5 cms; Ramón Estalella Collection, Madrid.
405. *His First Christmas Nougat*, 1922; Indian ink on paper, 14.5×21.5 cms; Ramón Estalella Collection, Madrid.

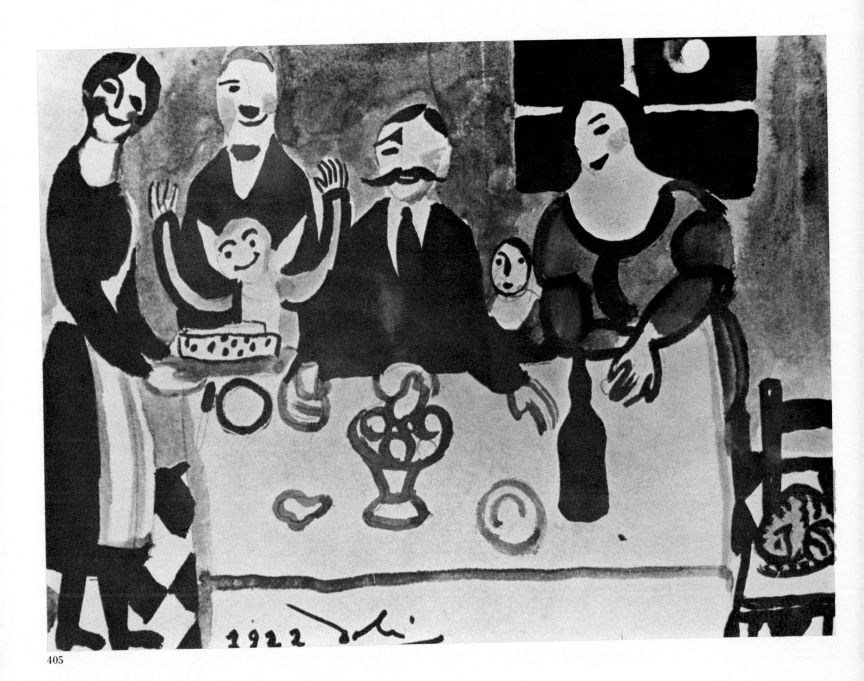

405

406 and 407. *The Poor Lovers* and *Madrid Slum*, respectively, 1922; Indian ink on paper, 21.5×14.5 cms; Ramón Estalella Collection, Madrid.
408. *Self-portrait*, 1923 (?); Indian-ink drawing, 31.5×23.5 cms; Ramón Estalella Collection, Madrid.

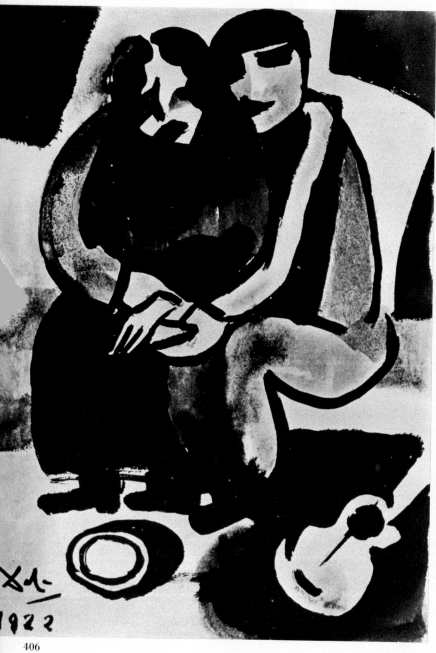

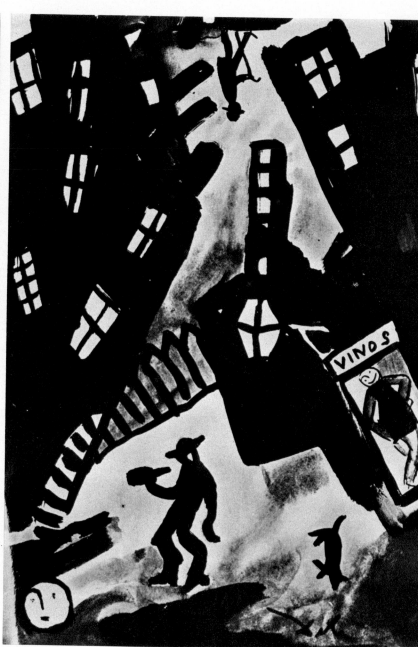

406

407

408

APPENDICES

Concerning the brother of Salvador Dalí, called Salvador Dalí

Thanks to the painstaking efficiency of Mr Reynolds Morse, I am able to throw light on a subject which I consider important for Dalí's biography, and to which he himself and other biographers repeatedly refer: the brother with the same name as the painter who died before the latter was born.

The precise details are as follows: the first Salvador Dalí Domènech was born at 11 a.m. on 12 October 1901, and as well as Salvador he was given the names Galo and Anselmo, which were the names of his paternal and maternal grandfathers respectively. He died at 5 p. m. on 1 August 1903, when he was 21 months old. The cause of death was "catarrh with gastroenteritic infection."

The one who was to be the great painter was born at 8.45 a.m. on 11 May 1904, and as well as Salvador was christened Felipe and Jacinto. Both brothers were born at number 20, *Calle* Monturiol, in Figueras, and the first brother died there too.

Things become sufficiently clear: we observe that at times Dalí commits minor errors in dates, ages and also in the cause of his brother's death, which he attributes to meningitis. But in what is essential, namely the fervent desire on the part of the parents for a substitute for their dead son, he seems to be quite right, if one takes into consideration the dates of the death of Salvador Dalí I and the probable conception of Salvador Dalí II.

More concerning Dalí's religious ideas

In 1969 the writer José María Gironella published a book entitled *One Hundred Spaniards and God*, the outcome of his survey concerning religion. What follows here are certain extracts from Dalí's replies. To the question, "Do you believe in God?" he replied: "Based on my reason and based on what the latest scientific discoveries of our times have shown me, I am convinced that God exists. However, I do not believe in God as a matter of faith, because unfortunately I have no faith. On the other hand, God is not aware of the existence of Coca-cola, or of Salvador Dalí, much less something called morals..." When he was asked if he believed that something in man lived on after death he said: "I believe the soul survives. I do not believe in reward or punishment — notions derived from a Jewish superstition — and I believe that all of us inevitably will return as angels. The only thing which delays this development is socialism because, as Pujols says, the first precondition for being an angel is to be a proprietor. The angelic state is a colloidal state. I also believe in the resurrection of the flesh — individually, and with nutrition and defaecation." Elsewhere he asserts: "Science and Technology will have a decisive influence on traditional Spanish religious sentiments, because cybernetics and the molecular structure of deoxyribonucleic acid confirm genetic continuity from the first living cell created by God up to what exists today..." Later he relates:

409. Publishers and contributors to *L'Amic de les Arts* of Sitges, in 1927: Font, the poet J V Foix, Sebastià Gasch, Lluis Montanyà, J Carbonell with a child, García Lorca, Dalí, and Cassanyes. Gasch and Montanyà wrote and published the *Yellow Manifesto* with Dalí.

409

"As I have already stated in one of my works, in my father's library I could not find anything other than atheist books.

Thumbing through these, I understood with complete conviction, without anything being left to chance, that God did not exist. Every page of Voltaire's *Dictionnaire Philosophique* contained the arguments of learned men concerning the inexistence of God. When I discovered Nietsche for the first time, I was amazed. I saw that he had the audacity to pronounce in black and white: "God is dead!" How was this possible? I had been learning that God did not exist, and now someone was announcing his demise!... Nietsche created in me the idea of God."

The Yellow Manifesto, Sebastià Gasch and Salvador Dalí

In March 1928, after painstaking writing and re-writing, two Catalan writers, Sebastià Gasch and Lluis Montanyá, together with Salvador Dalí,

published the so-called *Yellow Manifesto*, which made a considerable impact in artistic and literary circles in Barcelona and in the rest of Catalonia, and to a lesser extent in the rest of Spain.

As was to be expected considering the aggressive tone of the yellow manifesto, the reactions were also aggressive. It was attacked from all sides, and one critic characterized it as "futurist crap". It was better received in Madrid, Granada, and other parts, albeit by a minority among minorities. It was praised by friends such as Ernesto Giménez Caballero and García Lorca. At that time Sebastià Gasch was a close acquaintance of Dalí. His friendship with the painter came to an end with the letter which was sent from Paris towards the end of December 1931; it began: "Imbecile Gasch..." But during the previous years the relationship between Dalí and Gasch was quite intense, except for the latter part when Dalí was living in Paris; but their respective positions gradually got further and further apart. That was the period when the painter was an active correspondent, and thus Gasch received a large number of letters written in a Catalan which was somewhat arbitrary and had a personal, inimitable orthography. Among other books, Sebastià Gasch published in 1952 one entitled *The Spread of Catalan Art throughout the World*, to which we have already referred, which is sufficiently worthy of our attention that we here reproduce certain extracts:

"Dalí had all the appearance of a sportsman. He wore a brown jacket made of homespun (a rough, coarse material), and coffee-coloured trousers. It was an extraordinarily baggy outfit which allowed complete freedom of movement to his very slim body with its tense or relaxed muscles of steel. A sort of uniform, because Dalí never once appeared without it while he stayed in

322

410. In Figueras on 12 October 1901 a child was born called Salvador Dalí Domenech; he died on 1 August 1903 and is frequently referred to by the very much alive Salvador Dalí Domènech, the famous painter.

411. *Portrait of my Dead Brother*, 1963; oil on canvas, 175 × 175 cms; private collection.

412. Facsimile of the *Yellow Manifesto*, 1928.

410

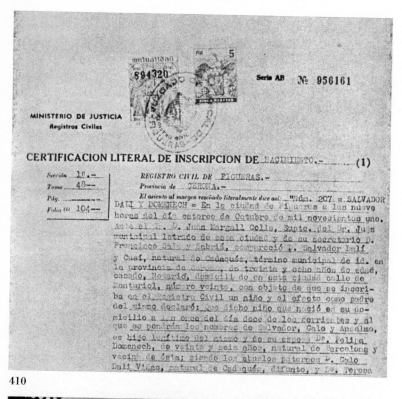

411

412

Barcelona, and it always gave off an odour like that of a bazaar in a provincial town. His hair was jet-black, smooth, and plastered down with plenty of brilliantine. His face, with skin as tight as a drum and as shiny as enamelled porcelain, was brown and seemed to have been recently made up as if for the theatre or the cinema. A wisp of moustache —a very fine line, imperceptible at first glance, as if traced with a scalpel— adorned his upper lip. In that hard, stiff, inexpressive wax doll's face, his tiny, feverish, terrible, menacing eyes shone with extraordinary intensity. Frightening eyes, as of a madman. The timbre of his voice was hoarse, rough, dull. One would have said that he suffered from chronic hoarseness... He had an abrupt, nervous manner in the way he spoke, but *what* he said was incontrovertibly logical. Everything he said was articulate, coherent, and to the point. He gave you the sensation that, having laboriously resolved a series of moral and aesthetic problems, he had managed to secure certain crystal-clear ideas regarding the divine and the human, and now he was explaining this with absolute clarity —a clarity that betrayed his Ampurdán origins. The supreme clarity of the Ampurdán landscape runs in fact parallel to the clarity of thought of the inhabitants of that region, whatever social class they come from...

... What may be stated without fear of contradiction is that in him irony reached the level of incredible cruelty. A cold, dauntless, terribly quiet cruelty. Everything he said and did revealed a total absence of heart. On the other hand his intelligence was exceptional, and disturbingly lucid. In all his doings, in all his sayings, and naturally in all his paintings, the man always appears cerebral, cold, calculating. This is the origin of his congenital cruelty, which became even more acute when he joined the Surrealists."

The twenty-odd pages which Gasch dedicates to his ex-friend are lightly touched with a polemical attitude, and he quotes, among others, a letter from the time before Dalí joined the ranks of the Surrealists, (although the exact date is not given, due among other things to the fact that Dalí did not date his letters.) In that letter Dalí describes Surrealism as "the most *artistic* (a word which was pejorative for Dalí) manifestation in history, the most bitter, the most critical, and the most rotten..." Labels can give rise to confusions and the term *Surrealism*, aside from Breton's intransigent and dictatorial orthodoxy, might perhaps admit interpretations which would fit the works which Dalí was producing around that time, that is from 1927 to 1929. Contrary to the opinion which I am now putting forward, I maintain that Gasch's hostility towards Surrealism, coupled with the faith he placed in the words of the painter, led him to claim in 1930 in a Latin American journal: "The appearance of Salvador Dalí's recent works might suggest to the superficial spectator that the young Spanish painter has joined the Surrealists. Nevertheless, nothing is further from the truth. Dalí is the antisuperrealist type. Nobody hates superrealism more than Dalí..."

I quote here some passages out of a letter from Dalí to Gasch, which I would recommend for its autobiographical sincerity: "Above all I must confess a complete absence of religious phenomena ever since my earliest years. Since then I do not recall the smallest worry of a metaphysical nature; this is probably all indicative of a complete abnormality, but it is at least unquestionable that this abnormality is what has been most intimately bound up in my life. My first period in Madrid, during which my great friendship with Lorca began, was characterized by the violent antagonism of his eminently religious (erotic)

spirit and my antireligious (sensual) spirit. I remember the interminable arguments that would go on until three or five in the morning and which have continued for the duration of our friendship. At that time in the Students' Residence everybody was reading Dostoievski; the Russians were in vogue. Proust was still unexplored territory. Lorca was indignant at my indifference toward these authors. To me, whenever he made reference to the interior world, he would leave me absolutely indifferent, or rather, it struck me as something extraordinarily disagreeable. I rejected every human emotion, and at that moment I became a devotee of geometry; my preferences only had room for purely intellectual sentiments..."

"Anyway, does all this mean that I have lived without emotions, without frights, without passion? Completely false; precisely this absence of religious instinct, of an interior world, has given me ever since I was a child a violent passion towards the exterior world. I recall with exceptional intensity my passion for my toys, but most of all for their qualities, their mechanisms and their colours..." "... the things which aroused in me emotions so powerful that I am only today mastering a technique adequate to create them, these things are the only subconscious theme in my present happiness; I can assure you that I am in complete wonderment at the miraculous return to my earliest childhood. Poetic EMOTION which derives from the purest objectivity."

"... I can assure you, my friend, that for me the interior of things is still a superficial reality; the most profound remains an epidermis. Things do not have any significance other than their strict objectivity; this is for me where their miraculous poetry resides. For Maritain an ear can become poetic because of what it can awaken or signify in our spirit; for me an ear is poetry, precisely because its miracle consists in not signifying anything, apart from its anatomic morphology, its physical constitution, etc. Maritain finds poetry in things because he sees in them the presence of God; for me this presence would be a terrible impediment, for their physical properties are sufficiently divine to give us time to seek emotion in the queries which they raise. I see no questions to be answered in the world which surrounds us, only facts to be confirmed. All philosophy has lost its meaning for me; only science remains bright!..."

"... Over and above what a horse might suggest to a painter or a poet, I am interested in a horse, or the species Horse, which the painter or the poet might invent, or rather, might find. Let us strive for the maximum understanding of reality by using our senses and our intelligence, and instead of imitating it or explaining our sensations or our emotions (that is to say, its repercussions or echoes within us), let us create equivalent things such that their pathos derives not from inside us, but springs from the things themselves, exactly as happens in reality."

Quotations from the writer Josep Pla concerning Dalí and the Ampurdán landscape

Josep Pla, who is one of the best living writers of Catalan prose, (if not *the* best,) has published a series of sketches or biographies which he has grouped together under the title *Great Men*. He wrote Salvador Dalí's in 1958. Coming from the Ampurdán, and as an old friend of the painter, the forty pages which he devotes to him contribute to our understanding, especially regarding the earthy influences which have affected his character, his eye, his brush and his behaviour. Josep Pla's interpretation of Salvador Dalí appears

413. *The Cross of the Irises*; oil on canvas.
414. Stereoscopic glasses.

413

414

to be accurate, and it deserves to be better known by writers, especially foreign writers, who seek to study what might be called principal Dalinian circumstances. It is not so valuable with regard to concrete facts, and anyone looking for precise details concerning, say, his stay in Madrid, would be wise not to take Pla's version too literally.

I will here reproduce a few lines from *Great Men*, beginning with some about the father, don Salvador Dalí Cusí. With his profound and intimate knowledge of the people from this region, and as a specialist in pen portraits, what he relates concerning the notary of Figueras will serve to explain certain influences which were inherited from the father and the reasons for the conflict, at first latent and later open, with the ups and downs which went with it.

Pla says of Dalí's father: "One must not believe that Dalí the notary was simple and easy to pin down. He was a great character. In making this observation, I am not thinking about what in Figueras they call the ups-and-downs, the caprices and the circumstances of the notary. The people who knew him and had dealings with him and who were therefore in a position to form a rounded view of him, do not emphasize these points. In effect, it is too easy to record señor Dalí's contradictions, what I would call his opportunism. But, which of us has not been a turncoat?

"For me it would be extremely amusing to describe the persistent agnosticism of his first, long decades, and even more, the unforgettable scene that took place after the end of the civil war in the garden at the Llané, when he told me with great hopefulness and with many gestures, standing among the broccoli and the lettuces that he grew with such pride: "My friend, this broccoli, these lettuces, don't they support the unquestionable existence of a first cause, of an omnipotent, eternal and universal God? If it is

415. *The Face of War*, 1940; oil on canvas, 64 × 79 cms; André Cauvin Collection, Brussels.

416. Set for the ballet *Mad Tristan*, a surrealist transformation on a work by the eighteenth-century English painter Herring. Previously Marqués de Cuevas Collection.

417. *Study*, 1925; charcoal, 98.53 × 68.58 cms; The Reynolds Morse Foundation, Cleveland.

415

416

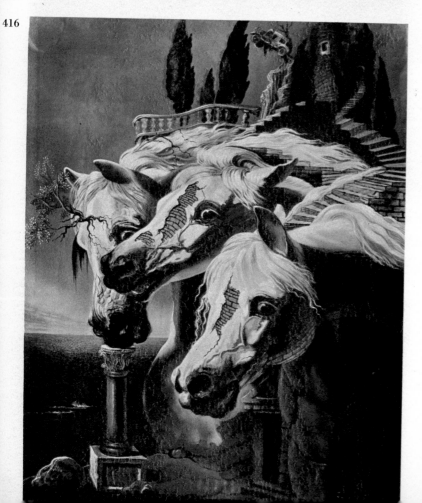

417

not clear to you, either you've got something in your eye or you're lacking in grace!"

"In a static, fixed world, men and women would always be equal. If he could choose, people would never change. What does change, on the other hand, is the life around them. It is what are called circumstances that lead us to practise the most scandalous, vulgar opportunism. One of man's

greatest aspirations is to contribute something, and if he achieves this, he feels satisfied. It gives the impression of security..." "... what people found amusing was the notary's total espousal of the different positions which he adopted, never worrying about their coherence. He jumped on everybody's bandwagon, and every time with his absolutely definite, indestructible, ingrained, granite-like conviction. He was never one to take the defensive, but was always trying to win people over. He always attacked, with sarcasm and gesticulations which reverberated throughout the region. It may be that he travelled along extravagant orbits, but whenever he contradicted himself he did so with impressive conviction, without the least possibility of falling into any form of scepticism. He was never a sceptic. He was permanently militant, both during the period when he did not go to Mass, and also in the period that he did..." "... A difficult man to shake, but curious and with a way about him that his son has perhaps inherited. His son has also let fall certain contradictions, always in the name of the ultimate and decisive philosophy. That is the way of the Dalís".

"I believe that Salvador Dalí is the discoverer of the landscape in our region. In the execution of his work both in the past and in the future, this fact must be considered as a very important, decisive, transcendental factor."

Nobody speaks with greater authority than Josep Pla about the Ampurdán region, which as we have insisted is Dalí's landscape; in describing it, the author reaches sublime heights. Like Dalí with his brushes, Pla analyses the landscape of his region, he feels it, he gives it a profound interpretation, in his most secret self he forms a part of this landscape, and his rational exposition also provides us with a lucid analysis. The words of the author are precise and contain a pictorial quality.

"... Due to the fact that in this region the prevailing wind is the north wind, that is the *tramontana*, there is normally a vast, enormous dome of clear sky, and a pure crystalline air of prodigious clarity..."

"The *tramontana* is a dry, impetuous, bracing, stunning wind which nature appears to have created so as to produce absolutely clear, totally uncluttered skies. Within three hours after the onset of the *tramontana*, the sky is converted into the curve of an immense arc, a dome of pure lines, within which the air and the light are of a static, bright, sharp, glowing, sparkling clarity. In this light one senses the prodigious presence of things at a distance; the horizon seems to come closer, and things like the olive trees, the cypresses, the mountains and the dazzling sea, are seen in obsessively perfect outline..."

Elsewhere, in *Guide to the Costa Brava*, Josep Pla, who is also a well-known writer in Castilian, relates that one evening, a long time ago, he arrived by boat and had to take shelter in Port Lligat, sleeping with only a blanket *à la belle étoile*. "Night had already fallen, and there seemed to have filtered a static silence into the deep shell of the cove..." "At the mouth of the cove, the sea seemed dead, with a thick immobility as if it was bewitched by the sparkling immensity of the sky.

"One very large, pale, reddish star, perhaps Jupiter, gave a vague sheen of rosy light to the water. Far off, and almost lost in the immensity of it all, one could hear the soft, floating rumour of the undercurrent on the cliffs of the coast. This seemed to increase the seclusion of the cove. As this rumour gradually decreased, there came —across the warm night air— the monotonous chant of the crickets in the olive trees, and nearby, the stifled sighs made by the ropes of the anchored boats..." "In Port Lligat the sea and the life of the waters of the sea are so ineluctably present,

that you seem to chew it..." "The landscape has a pure simplicity, a schematic beauty, and the air is impregnated, like an obsession, with the strong, slightly bitter smell of seaweed."

Later he adds: "Port Lligat is ever present in the work of Salvador Dalí. The famous painter has succeeded in drawing and synthesizing the spirit of the landscape. Some of his phantasmagorias derive from obsessions born out of this landscape."

His appeal for crazy people

He exercises a considerable appeal for crazy and otherwise unbalanced individuals; there are some people who become temporarily deranged in his presence, though I assume that they had a previous disposition. While I was at work on this book, I took notes on what I observed in the short space of a week. A Japanese bonze, dressed as such, came —or rather was brought— to visit him in Cadaqués. He only spoke his own language and at most, with no exaggeration, a dozen words of English. He had his photo taken with Dalí and some of the beautiful girls that were in the house that morning. His outfit, apart from the Oriental straw hat, as well as his traveller's or pilgrim's attitude, led me to think of our mediaeval friars in their habits, for though it was of a different cut, his dress reminded me of the habit of the preaching orders. I do not know his mental state, but I would say that he showed unexpected presence of mind. But two days later we read in the newspaper that he had appeared, unable to speak the language and without any money, at the police headquarters in Barcelona. One afternoon he received a young painter whose mind seemed confused. He had brought with him some slides of his own paintings, but

when we projected them they 'resembled' greatly the works of Dalí. We discovered that he had no passport, but burning with desire to see the 'divine', he had crossed the frontier via the woods. He had scratches and marks on his skin and clothes, and he was apparently a native of Wales. Another young painter —I think he was American— also insisted on being received. When he was allowed in, Dalí asked him one or two questions. He stared wide-eyed, made great efforts, but only managed to get out four or five incoherent words: the emotion had paralysed his tongue. But Dalí smiled and remained calm and friendly. The other tried to calm down and to use me as interpreter, and we seemed to get along somewhat better.

It is very difficult to classify hippies, but there are some disturbed ones among them. One group arrived in tunics and crowns of vegetables, and their apparent leader read a poor and excessively laudatory poem.

He received a great many letters, some in curious envelopes, and during that time I read several of them, each more disturbed than the last. In one long missive, a lady threatened him with death; others had extravagant poems dedicated to him. The most curious was one from someone living in Latin America who proposed, with a wealth of reasoning, an arrangement to launch Dalí in one of the South American republics and to promote the sale of his paintings there. To judge from the text, it was probably some rogue who thought that Dalí was a real madman and stupid to boot. But there is a well-known saying by Dalí: "The only difference between me and a madman is that I am not mad."

418. *The Painter's Father at the Llané*; oil on canvas; Montserrat Dalí de Bas Collection, Barcelona.

418

Concerning sight and the blind

I am listening to a recorded tape: "Today is the day I have set aside to paint the bullfighter's tear." Later we talked at length about the sense of sight and blindness. In general he feels hostile towards the blind because, for him, vision is everything; for a painter eyes are of great importance since it is only by means of them that he can impose his imperialistic vision on others. As a child, his parents used to take him to see an old aunt who lost the sight of one eye, and whose cornea was a milky white. In trying to cure it she had poured in some drops of the wrong medicine and this evaporated and concentrated, burning the eye. It made a great impression on him. The opening scene from *Un chien andalou*, where an eye is seen in close-up being cut by an open razor, is well known. (It was not a human eye, but one from a dead sheep.) He also maintains, and he has written as such, supported in his charge by certain paintings, that Rembrandt was blind. Several years ago I went one morning to Dalí's house. I found him on the terrace which looks over Port Lligat, sitting with two men dressed in blue caps like sailors. I sat down and the conversation went on with the same subject as before I had arrived. Dalí asserted that dreams produced certain visible phenomena in some hidden part of the eye-ball, something like vibrations or waves. If it were possible to photograph, or better film, them —he argued— and then play them back to the subject in a dark room, if he was properly relaxed, the reverse phenomenon might take place, namely that the presence of the dream's abstract effects would lead the person to the causes and he would be able to reproduce, even if only in his memory, the dream which had been recorded. The two men listened to Dalí with a serious, attentive air and the conversation continued on this theme. When we were later on our own I asked him who the visitors were, and I learned that they were a famous eye specialist and his assistant, and I recall that they promised to carry out experiments along those lines. As to the twin caps, which for a moment put me off, they must have bought them, knowing that they were coming to Spain where the sun would be very strong.

While it is true that Dalí has introduced me to some madmen, there have also been certain sages, for he assigns great value to scientists, research workers, and so on. Apart from the ones I have mentioned, I would like to recall Mr P Cassagnan, the entomologist, who in Asia Minor discovered an extremely rare genus of Katannini, to which he gave the name *Dalianus*. I also happened to be present when an anthropologist suggested that he visit Africa in order to make some drawings from nature which would provide the illustrations for some monumental work. I seem to recall that he had a grant from some powerful, wealthy foundation and he offered fabulous sums for Dalí's collaboration; but this would have required a journey to Africa. Almost offended, he flatly refused. Later he remarked to me he was less and less interested in seeing new places, and in particular that he had no wish to go "to Africa, Argentina, and such distant places". Apart from Port Lligat, he is satisfied with the Saint Regis Hotel in New York, the Meurice in Paris, the Ritz in Barcelona, and two or three other hotels and cities. And he added that they were instructed always to give him the same room.

Returning to the subject of sight, in the special issue for the fiftieth anniversary of Vogue (January 1972), they published some horrifying photographs of Dalinian inspiration, transpositions on the subject of Saint Lucia. One could see the whites of both eyes and the eyelids were bleeding. In her hands the Saint is holding a plate

419. *Young Jesus*, 1957; gouache.
420. *Saint Salvador and Antoni Gaudí disputing the Crown of the Virgin*, 1960; gouache, 19×25 cms.
421. *Corpuscular Madonna*; oil on canvas.

419

421

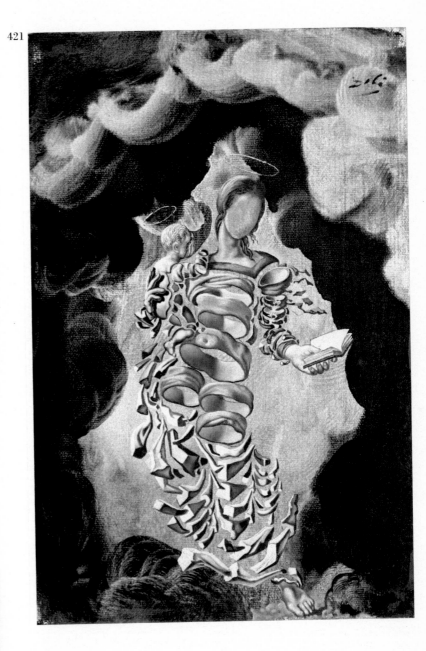

420

422. *Gala contemplating Dalí in a State of Weightlessness over his Work of Art "pop, op, yes-yes, pompier" in which we can see the Two Distressing Figures from Millet's Angelus in an Atavistic State of Hibernation before a Sky which might suddlenly turn into a Gigantic Maltese Cross in the very Centre of the Station at Perpignan, towards which the Whole World converges, 1965; oil on canvas, 295×406 cms; private collection.*

with two eggs which seem to offer themselves for frying.

422

Whether a so-called abstract picture can be danced instead of painted

In the middle fifties —I cannot be more exact regarding the date— there was a performance in Cadaqués of La Chunga, a dancer who at the time was very young but at the height of her success. Dalí told the painter J J Tharrats that abstract or informalist paintings did not need to be painted; it was sufficient to dance them. A small group of us gathered on the terrace of a small building in the olive grove in Port Lligat. Apart from Dalí and Gala, the group included La Chunga and her guitarist, Pilar and J J Tharrats, M and Mme Descharnes, and perhaps someone else. On the rustic floor of the terrace there was a stretcher with a canvas of some two square metres, and Dalí arrived with some tubes of paint. The guitarist began, La Chunga danced barefoot, and Dalí squeezed the tubes and spread the paint around her feet —blues, reds, greens... It was a calm, grey morning and the guitar sounded throbbing and nostalgic among the silvery green of the olive trees; La Chunga was quite absorbed and danced away unaware of what was happening on the soft floor. Everything happened with perfect logic and with exciting beauty and precision. Seated on a stool, Dalí would lean forward to add to the paint which was spreading over the canvas. The feet of the young gypsy girl were getting coloured; at times she almost slipped but without losing the rhythm. When the colours covered the canvas and the material had been sufficiently worked, the guitarist stopped and La Chunga, whose feet seemed to have been bathed by a rainbow, retired from the stage. Dalí raised the canvas and showed

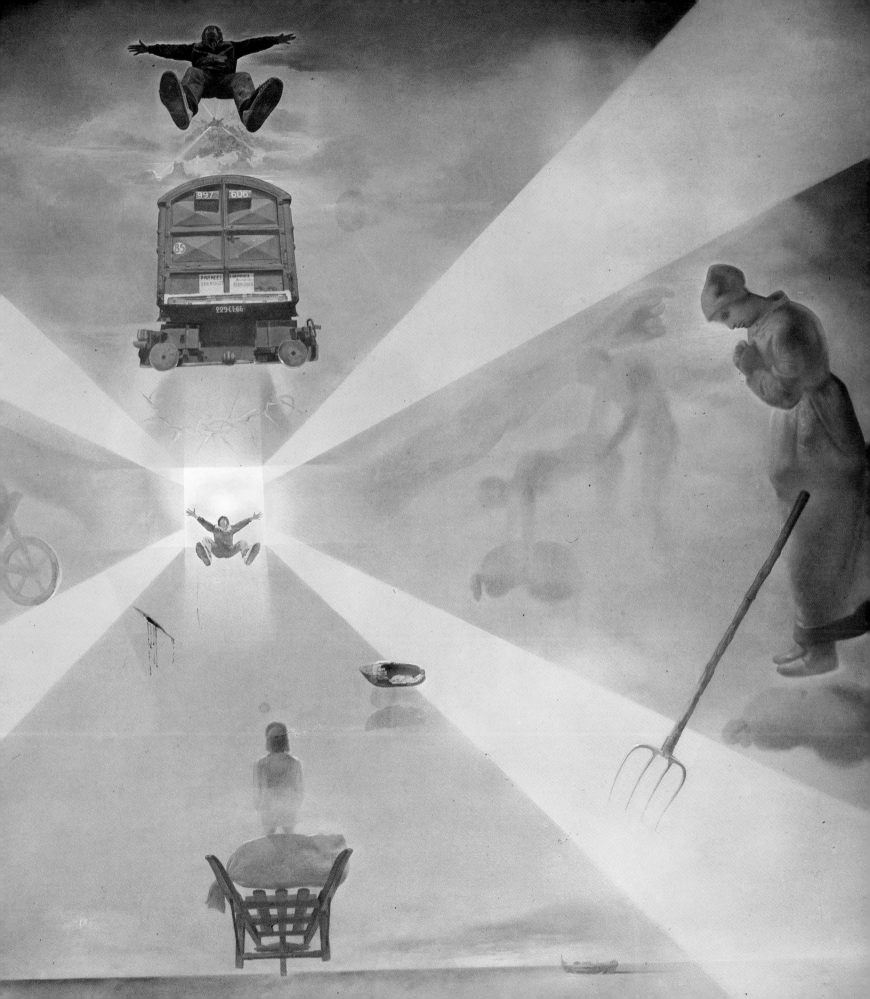

423. *Venus with Memories of Avignon*; 20.5 × 14 cms; Fanny and Salvador Riera Collection, Barcelona.
424. Protest patronized by Dalí when *La Gioconda* was on show in the Metropolitan Museum, New York. The police car is arriving to arrest the not very numerous demonstrators.
425. Envelope with a butterfly wing attached.

it to us with satisfaction: a perfect composition. Turning the stretcher over, the experiment was repeated. The first painting was now resting on the ground and little flat stones and sand stuck to it, distributed in a random sort of way. The second time the dance did not last so long and Dalí was sparing with the paint, which spread better giving a different texture. The two sides offered different aspects in their colouring, form, intensity, in the material employed, in the way in which it had been spread, and in the *brushwork*. I have not seen those paintings again, but I liked them. Were they a product of chance? I do not think so. Their execution was abnormal, but was it not perhaps Dalí himself who, without using his hand, palette-knives or brushes on the canvas, had

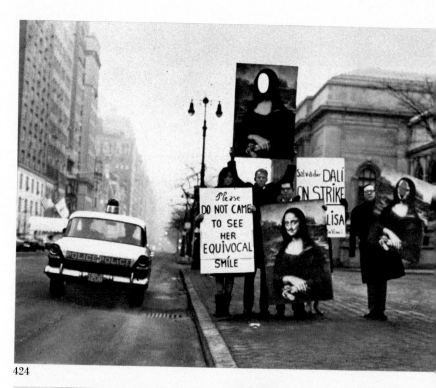

424

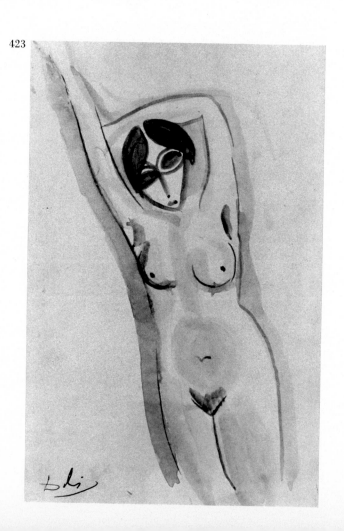

423

425

guided the pictures, who had directed their execution to the accompaniment of flamenco music?

Brief appendices regarding Dalinian culture

It is of great interest to watch Salvador Dalí at work. In general, though no generalization is completely valid, he paints in oils, with meticulous application, by means of short, insistent brush strokes, with perfect execution, using techniques parallel to those which were used by the great masters whom he so much admires. He employs the same application, though with greater agility and dexterity —such as the drawing allows, or even demands— when he wields the pen or the brush in a work in Indian ink or a watercolour. On the other hand, another technique which he employs involves strokes made with surprising speed. He holds the brush or pen over the paper with a jaunty gesture and, starting with the shading, some strokes or flecking, in a few seconds he completes the composition, which he may or may not finish off later with a few supplementary lines. On occasions he enjoys stopping work on a whim, which to some extent is directed or restricted by his plastic understanding, or through volition which anticipates the result. A deliberate spot is sometimes exploited with accelerated zeal, so that out of the shapeless rises the figure, the landscape, the sign, or whatever he had in mind. The directed accident. The whites, and the perspectives suggested by some suitable stroke, contribute to the eurhythmics of these spontaneous drawings or watercolours. More is demonstrated than mere dedication in his decorative and calligraphic skill, in the delight that he finds in the rhythm of a line or in the arrangement of the details. Or in the signature. For Dalí, Figueras is the centre of the universe. "What will they be saying in Figueras?" he asks himself when he gets up to one of his antics in Paris or New York. For instance, when he announced that he had signed a contract with a company, such that after his death his body would be subjected to a process of conservation, thus allowing him to mock at death itself by leaving open the doors for a resurrection, he immediately wondered: "What will the people in Figueras think when they find out?"

After his most ardent praise of the Ampurdán (Figueras and its region, Cadaqués and Cape Creus, plus the Gulf of Rosas) he adds, quoting a remark by another *Ampurdanés*, the writer Josep Pla: "Besides, it's the only country I have."

Talking to Salvador Panniker in Cadaqués he exclaimed: "The centre of the world is this sea and the civilization which was born here!"

What I am calling fidelity to the countryside, and emphasizing as one of the constants in his painting, is in fact something even more profound, for the repeated presence in his work of these landscapes represents the surfacing of a very deep feeling; it is an effect, not a cause. To a certain extent it corresponds to the expression of that ranting Slav, Dimitri Karamazov: "For man to raise himself from the degradation of his soul, he will have to form an eternal alliance with old mother earth." He achieves universality by means of an exaggerated parochialism, and his abstractions originate in what is immediate, concrete, and palpable, even when he tries to shatter reality, turning it upside down, reducing it to the absurd, acting as officiant and master of ceremonies of confusion.

He suffers from (or enjoys) an accentuated corporal narcissism and takes inordinate pleasure in his own physiological intimacy. In his writings we come across examples of evidence for this, and there are tales of extravagant manipulations with an olive or a ball of bread crumbs.

Reverie, an essay published in *Surrealism in the Service of the Revolution*, is a good example because it contains a complicated mixture of imaginative-erotic elaborations.

Again in *My Secret Life* and in *Diary of a Genius* one comes across descriptions of a peculiar, excessive tendency. One of many examples: "My excrement is something very important to me."

Peculiar things are always happening around him and to him: accidents, coincidences, premonitions. He loves these events and is rarely taken aback by them. Among many other things, he has told me of how he received a letter from two nuns. They informed him that they were sending him two important pieces of excrement which had been surreptitiously removed from the site of certain excavations. They urged him to keep it a complete secret and to avoid any public comments. At first he thought it was a joke, but having made certain investigations, he confirmed that they were the droppings of some unidentified prehistoric animal, and they had been discovered in caves in Muav, Arizona.

In order to dispel my mild scepticism, he has provided me with photocopies of certain pages from a work entitled *Contributions to Paleontology*. (I cannot give the complete bibliographical reference, but I believe it was published by the Carnegie Institute, Washington.) Certain plants had been cultivated, fertilized by this prehistoric manure, which had been carefully studied and analysed. He also provided me with some photographs taken through a microscope, which he wanted me to include as full-page illustrations. However, despite their undoubted scientific interest and the calligraphic beauty of their shapes, I have not included them in this book since they seem peripheral to my main theme.

He is most impressed by things scientific, because in his opinion scientists show greater imagination than writers and artists, who hardly interest him at all. He subscribes to certain journals and awaits them with impatience; as soon as they arrive he pores over them with great delight. He does not understand them, or rather he understands them within the bounds of his limited scientific background, but they excite his imagination, and his own interpretations come surging into his head. He takes great pleasure in company and conversation of scientists; he assumes that writers and artists have little to teach him.

"Cape Creus is paranoiac." What can be seen there, however fanciful and fantastic it may seem, is open to all, and everyone comes back to see that rock which looks like an eagle, a monk, or a dragon. On the contrary, dreams cannot be repeated, or shown, or become fixed and concrete. Nothing irritates him more than people recounting their dreams. Dreams do not interest him, especially other people's.

If he is accused of plagiarism through having introduced into his paintings a detail from somewhere else, he laughs. When he copied the dog from Ayna Bru, the German Renaissance painter, and he was accused of plagiarism, it was as if they had accused him of introducing the Eiffel Tower into one of his paintings. He simply took a photograph of the dog and copied it, the same as he would have done with the Eiffel Tower, the same as he does with many figures. What of collage? Is this not also something that the cautious purists would characterize as plagiarism?

Ants, flies and other little creatures originally turned his mind to putrefaction and death, because as a child, whenever he saw them from afar, they signalled the presence of a carcass, and they gave him an agonizing childish fright. Later the flies became sublimated, first when he learned of the miracle of Saint Narcissus ("which was

426. Design for the film *Spellbound*, starring Ingrid Bergman and directed by Alfred Hitchcock, 1945.

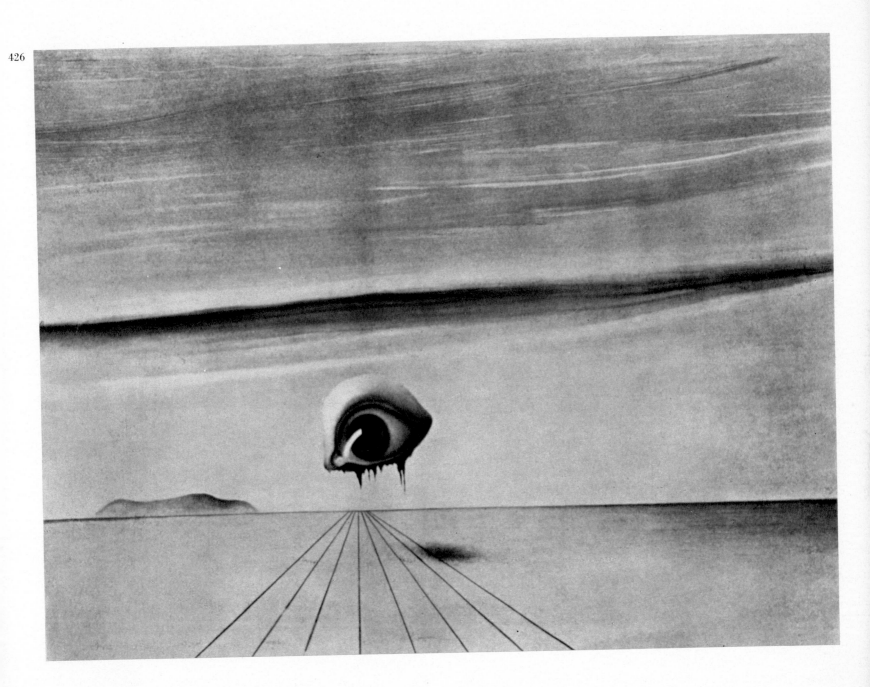

certainly true") which used to be a great talking point. In his home, when autumn came and the flies became more sticky and insistent, they used to say: "Now the flies of Saint Narcissus have arrived." (Saint Narcissus is celebrated on 29 October.) When he discovered that the eyes of flies are constructed like parabolic lenses and produce effects similar to those of moaré, and are thus capable of producing the third dimension, they went up so far in his estimation as to leave the ants a long way behind, and these continued to represent death.

In 1970, in Moscow, a book was published entitled *Surrealism in Art*, by U C Kulikova. Out

338

427. Watercolour for the cover of the magazine *Empordà Federal* of Figueras; 1922 (?); Gustau Camps Collection, Barcelona.
428. *Pep Ventura*, famous nineteenth-century composer of *sardanas*, who lived in Figueras. Drawing; Mataró Museum (Barcelona).
429 to 432. Illustrations for a book by the *Ampurdanés* writer J Puig Pujades; the first book illustrated by Dalí, 1926.

427

428

of the short text, 11 plages are devoted to Dalí and there are colour reproductions of *The Dismal Games, The Persistence of Memory, The Christ of Saint John of the Cross*, and *The Supper*. Perhaps most significant was that the black cover was illustrated with a detail including the soft watches.

When the geological cataclysm took place which created the Bay of Biscay, if Perpignan and

the area round it had not held firm, Spain would have left Europe to become a drifting island.

Beti was an old fisherman who had seen a great deal of the world. He used to row the Dalí family in his boat. On moonlit nights they would go out into the bay. Dalí recalls with especial clarity one night when they experienced the sensation of absolute silence, of total peace. Beti stopped

429

'ONCLE VICENTS

NOVEL·LA

J. PUIG PUJADES

430

431

432

rowing; it was a perfect moment and they were worried by the possibility that some chance sound might disturb the effect. Beti, who enjoyed the stillness, exclaimed: "I am afraid that someone will play the piano." The old salt was an excellent storyteller; he related how a horrendous typhoon had struck their sailing ship in the seas off China. At first, so as to lighten the load, they threw overboard barrels, cargo and luggage, but the ship was still in danger, so they jettisoned tools, spare sails and the few sticks of furniture. But the waves were still battering the vessel and sweeping over the deck, threatening everybody's life, so the captain decided to fling overboard some Manila-Chinese who were part of the crew. On considering with Dalí this hyphenated word, we came to the conclusion that they must have been Chinese who were resident in Manila and had been taken on there.

Among the members of the Pichot family, one should not forget Maria, nicknamed 'Nini', who became the unsettled, wanderlust opera singer known as Maria Gay (the surname of her first husband). She used to send the Dalí family postcards from the various cities where she performed. In the photograph where the Dalí family are sitting on some rocks at the Llané, Salvador is wearing a vaguely Russian blouse, and he assumes that the style was influenced by some postcard that they had received from St Petersburg. He also refers to an opera in which there appears a severed head. (He says that it was *Samson and Delilah*, but, although I have no great knowledge of opera, I am rather inclined to connect it with Herod and Salome, perhaps *Salome* by Strauss; however, the precise opera is not what really concerns us.) He assumes that the childish recollection connected with this opera, the decapitation, and the singer, mingled with phosphenes, has given rise to the heads of Lenin, Voltaire,

Venus and so on. In her memoirs, which were published in Russia, Anastasia Svetaieva speaks of a student friend in St Petersburg called Gala Diakanoff. She begins by saying that since Paul Eluard evokes reminiscences in his poems and other writings, she will only refer to that distant period when they were together. She describes Gala as an independent character, with a fine face that would light up, dressed in a sailor suit, and with flowing hair that she hardly combed. "Her look would penetrate and attract as much as the wilful movements of her mouth." She relates that they spoke of poetry, of the people around them, of art. She also refers to Gala's instinct to reject, and the wish to run away which she felt as a child and adolescent, from the moment that someone or something disagreed with her, and how her restless look would scan the surroundings searching for the best way to go. On the other hand, she is remembered as having an extraordinary sense of humour and that she would burst out laughing: "... the acute shyness disappeared and she would laugh out loud, grasp my hand, and we would run outside."

More concerning flies: another of the principal motives for his admiration —I would even say esteem— for flies derives from the fact that they are useful in certain experiments in genetics because of the rapidity with which the generations succeed each other. Thus, a species of Drosophila called melanogaster has achieved fame through the experiments of T H Morgan into mutations and chromosomes. The painter was one time in Le Boulou —I seem to recall that he told me that it was in the station building, which, going from Spain, is the one before Perpignan— when he noticed a light-bulb around which flies were flying so fast and with such close, precise orbits, that he called their movements 'atomic'. He stood

433. In the Saint Regis Hotel, New York; A Reynolds Morse, Dalí, and the astronauts Alan B Shepherd and Edgar D Mitchell.

433

watching the phenomenon; the repetition of the identical movements, and the speed at which they took place, produced the optical effect of a solid structure. From time to time, one of the flies would leave its orbit and cast itself over another, possibly making an attack, he believes, of a sexual nature. When these two flies swerved off course, a certain confusion resulted because others, in their turn, abandoned their own orbits or changed their speed. The solid body dissolved before your eyes, but after a short while every fly would return to its orbit and rhythm, and the structure became recomposed.

Some years ago, when the *La Gioconda* was transported from France to New York and exhibited in the Metropolitan Museum, Dalí organized a protest with the help of some young people (beatniks, or perhaps hippies, who at that time were beginning to replace them). From an early hour, they mounted guard in front of the museum, armed with appropriate placards. While Dalí was having breakfast the police telephoned him to inform him that some youths who had been arrested were giving his name as the promoter of the protest. By persuading the director of the museum to intervene, he managed to get them

434. Drawing, 1924 (?); 24 × 19 cms; Jordi Gimferrer Collection, Bañolas (Gerona).
435. Interior terrace at Port Lligat.

434

museum, he seems to discern in Mona Lisa's smile that of his mother, and this smile is not enigmatic, but an unequivocal insinuation which on the face of a streetwalker can only mean one thing. At this point, the complex inside our patient explodes, and not infrequently his reaction is to try do destroy the picture.

Marcel Duchamp has also been concerned with the portrait of the Mona Lisa. Once he told me that all those eyes that had looked at her in the Louvre had damaged her. As a young man he achieved notoriety with his reproduction of *La Gioconda* with a moustache and, underneath, the letters "L.H.O.O.Q." which stood for some secret, erotic message in French. (Later he invented another riddle in French: Oh, Calcutta!) A few years before his death, he sent to his old friends who had been in on the secret of the moustache, a postcard of *La Gioconda* without the addition of the moustache —the letters were a joke of a different sort— and, written in his hand, one single word: 'Rasée', meaning that the Gioconda had shaved.

Certain associations which seem unusual derive from events or visions which impressed him during his infancy. Thus, for example, the appearance of grand pianos on top of rocks is a memory of the Pichot family who, on moonlit nights, would sometimes take their piano out into the garden of the Sortell, and there on the rocks they would improvise a concert. In Cape Creus, Dalí has also seen a rock whose shape is like an old-fashioned car (as if from the period when he first saw them) which is beginning to split. He has included this in many of his pictures. Cypresses are a constant theme; they abound all over the Ampurdán and they are useful in making good windbreaks to defend gardens and orchards from the *tramontana*. There were cypress trees at the school of the Christian Brothers, in a place called The Ditches (and both cypresses and

released. Dalí considered Leonardo's picture immoral because, according to him, it is the exaltation of the Oedipus complex. (On occasions like this Dalí can show himself to be intransigent in the question of morals.) The erotic charge, with its accentuated incestuous nature, is perceived most clearly by those who are subject to the complex. This explains, still according to Dalí, the attacks and robberies which the painting has repeatedly suffered. He explains the process thus: a museum is very similar to a brothel, because it is a public place where you can see many naked women. When our supposed psychological case gets inside the

Brothers still exist.) A large cypress grew in the Sortell, at the side of the house which was Eduardo Marquina's. Many were the cypresses that figured in Dalí's childhood; and on the beach at Rosas he had the vision of a white figure, which he understood to be his Aunt Carolineta, who was dead. Beside the ghost, a cypress arose from the hull of one of the local boats. Opposite his house in Port Lligat, there is an old boat pierced by the trunk of a bushy cypress. Up to now the ghost of Aunt Carolineta has not reappeared. (Incidentally, Carolineta is written in Catalan with one 't', pace the preference of certain catalogues and books to italianize this euphonic name by geminating the 't'.)

In his conversation, Dalí likes to allude to the taste of that *madaleine*, dipped in tea, which sparked off in Marcel Proust the evocation of his childhood and, through that, the whole of the more or less autobiographical *temps perdu*. However, Proust, this great writer and explorer of human intimacies, needs four or five pages of *Du côté de chez Swann* to identify the taste which took him back to his childhood in Combray and to the summer breakfasts with his Aunt Léonie, while for Dalí, pursued by innumerable *madeleines* which act on his rich and complex treasure of childhood memories, the evocation is immediate and, in general, accurate, without the affected verbosity of Proust, but with identical biographic effect. The present work contains much information related to the origin, relation, and motive for the figures, characters, objects, events, allusions, and settings which appear in his pictures. A considerable proportion of Dalí's graphic and calligraphic *œuvre*, and even much of his attitudes, can be traced back to his infancy and adolescence, in a constant attempt to recover *le temps perdu*.

"There are people who are not sufficiently intelligent to hold all opinions at the same time;

135

but I am not one of them." This is a remark by Dalí and, considering his propensity to exaggerate, we would do well to reduce it a shade and, instead of "all opinions", leave it as "many opinions at the same time."

Apart from chairs, he is attracted by bedside tables, which appear in certain of his pictures. Abstracting from the piece of furniture itself, he finds the name and the allusion to night-time

436. Rock of Culleró at Cape Creus, photographed by Reynolds Morse.
437. *Don Quixote*, 1935; Indian-ink drawing, 40 × 50 cms; Prince J L de Faucigny Lucigne, Paris.

436

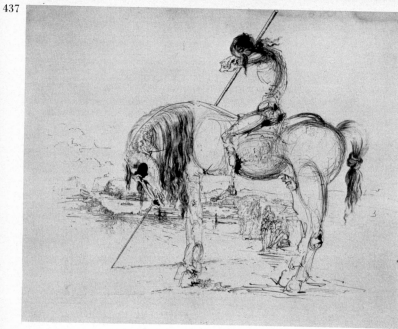

437

suggestive because it has mysterious evocations and because he feels it to be absurd. This piece of furniture, which is becoming absolete, carries in its womb a skull: the chamberpot. Breton, completing the circle, characterizes Dalí as 'Bedside table - Avida Dollars'.

Dalí the Surrealist, the Nihilist, the revolutionary, who used to scandalize the bourgeoisie in Figueras when he was the only subscriber to *L'Humanité*, has an obverse to his coin: conservative, even reactionary, vices manifested in the public declarations of his political position. He is a demonstrative supporter —true, less true, or feigned— of an ultramontane monarchism, and a prophet of the restoration of royalty, first in Rumania and later in Russia; but then he has portraits of Stalin and Willim II hanging in his studio, whether for their autocratic personalities or the hirsute splendour of their moustaches, I do not know, because with them appears Velázquez. Dalí is a conservative too in a less spectacular, but probably more sincere way: he conserves tangible, material things. His well-known interest in money has never been denied. We have already read how Josep Pla, referring to the painter's father, remarked that one of his greatest aspirations was to be a tax-payer, a quality which in Spain, and in particular among the country set in the Ampurdán, is synonymous with property owner. Still talking about the father, he adds: "For a man of the law, a world without documents is dangerous and repugnant." For during the period July 1936 to February 1939 he was unable to practise as a notary because of the revolutionary situation at that time.

In a declaration already recorded in this book, Dalí himself says: "... I believe that we will inevitably become angels. The only thing which hinders this evolution is socialism, because, as Pujols says, the first precondition for becoming

345

¡Y que te crees tú eso!

NUNCA

LLEGUE A SUPONER
DE
VERDAD
que PUDIERA MORIRME!

SI No, me hubiese muerto de miedo.

an angel is to be a property owner." Property owner, ergo tax-payer. When he had managed to collect a little money together, the first thing he did was to buy a cottage in Port Lligat, which over the years has grown until today it is a lovely country house. It is worth adding that Francesc Pujols was a property owner and tax-payer, and so is Josep Pla. The Dalinian paradox arises in that, while the first thing that a self-respecting property owner does is try to avoid taxes, he swears that he does the opposite. In private conversations he has told me: "I have always supported the payment of taxes. I like paying what has to be paid to the government, and I declare everything at the Customs. You can complain about the government if you've paid your dues, but you've no right to if you don't pay the taxes you're supposed to. The best thing about the United States is that you pay a lot. You have to contribute towards the atomic bombs and all that. How do you expect them to make atomic bombs if you start haggling over your taxes?" This conservative background with its far-sighted honesty was demonstrated clearly some years ago when, according to what he has told me, he suffered an acute attack of appendicitis. The first thing that people wanted to do was to call a doctor, but he refused: "First, the priest and the notary." Gala herself told him how urgent things were and of the risk of a possible peritonitis. "Nothing of the kind. Either the priest and the lawyer come first of I'll refuse to be treated." And that is what happened. Despite his fear and his shaky religious beliefs, the result of this test of his evaluations was: 1st, priest; 2nd, notary; 3rd, doctor. On extreme occasions, atavistic springs of the true *Ampurdanés* are released in his soul.

In the preceding pages we have provided an extensive coverage of Dalinian things, with particular reference to his paintings. His engravings are also important, varied and characteristic, but here and now we would prefer to mention his work and success as an illustrator. To a certain extent, and by virtue of the subordinate nature of these illustrations to the text of which they are a part, we are leaving the personal thematic scheme of the artist, since his rôle here is of only secondary interest. Nevertheless, we should like to underline that Dalí's illustrations, which have been numerous, are characterized by the clear Dalinian imprint, and in certain cases are free interpretations of the theme which is to be illustrated.

From very early on he collaborated on books with author friends from Figueras. Later, in Paris, he illustrated works by Tzara, Eluard and Breton, and there are some famous drawings which Skira published in 1934 for *Les chants de Maldoror*. Better known in his recent work as an illustrator: *The Bible*, *Don Quixote*, *La Divina Commedia*, *Alice in Wonderland*, *Faust*, *Tristan and Isolde*, poems by Ronsard, Apollinaire and Mao Tse Tung, and much more. Moreover, one should not forget the drawings that have enhanced some of the artist's literary, critical or didactic writings.

Mr and Mrs Reynolds Morse are not only the first collectors of Dalí's work, they have also devoted many hours, which must add up to months or even years, to the study of the painter's *œuvre*, of the *ambiances* in which he has moved, of the various influences that, consciously or unconsciously, he has been able to absorb along his artistic and human path. Mr A Reynolds Morse has published a book, with a large appendix by his wife Eleanor, entitled *Salvador Dalí... a Collection*, which was produced under the auspices of the Salvador Dalí Museum in Cleveland, Ohio, which belongs to the very same Reynolds Morse. This important and well-illustrated volume came into my hands after I considered that I had completed

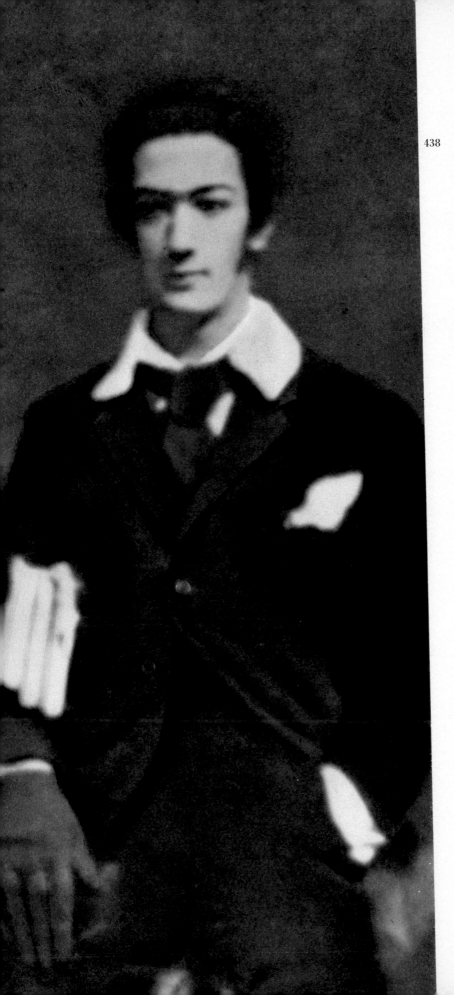

438. High school student in Figueras, about 1920.

438 both the text and the selection of pictures for the present work. Mr Reynolds Morse makes a personal, careful, meticulous analysis of the painter's work, starting from his own collection but not forgetting the rest of the *œuvre*, and with the help of Dalinian documents which he owns or which he has been able to consult. He knows Cadaqués and the Ampurdán with their geographic details; he has made a patient study of the rocks at Cape Creus, and he has photographed them from different angles and in different lights; he has searched in other places for whatever might have impinged on the painter's spirit —for example, Gaudí's architecture, the Paris Metro entrances, the statue of Pitarra. He has also studied the works of those painters, besides the old masters, whom Dalí could have known in his early periods: Picasso, Miró, Tanguy, Max Ernst, Arp, de Chirico, Carrà, and so on. The scientific implications of certain aspects of Dalí's work and other extremely diverse factors (some of which are very curious indeed) lead him to conclusions which, related to certain works, to the styles or details of pictures, engravings or drawings, I consider convincingly supported by the evidence adduced. These enthusiasts, as their copious collection shows, are Dalinians' Dalinians. The Museum which they have founded, the various monographs and published works, and their annual visits to Cadaqués from their home in Cleveland, all tend to show Mr and Mrs Reynolds Morse as advanced connoisseurs and bold interpreters of everything connected with Dalí. This appendix rounds off the series which I have included in this book, and it strikes me as fair that it was added.

439. *Hour of the Monarchy*, 1969; ceiling in the Palacete Albéniz on Montjuich, owned by the City of Barcelona; oil, 3 metres in diameter.

439

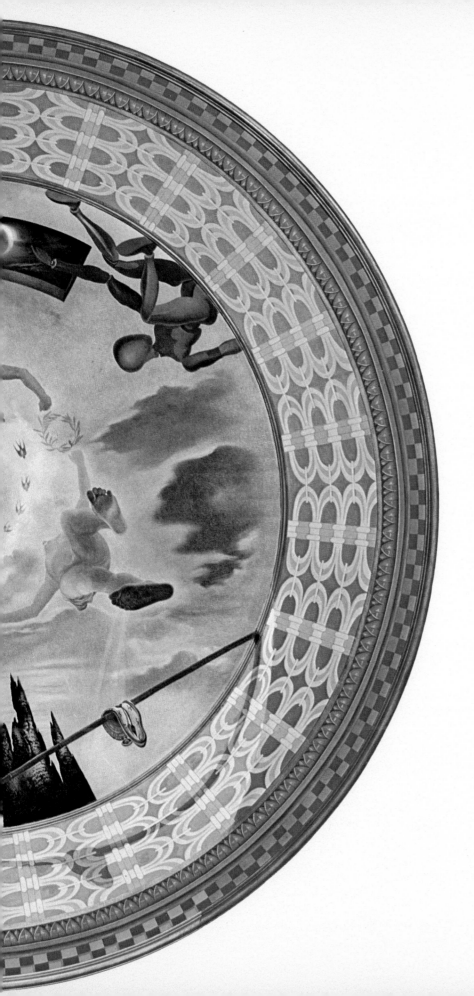

INDEX OF ILLUSTRATIONS

70. With Man Ray in Paris.

71. Accompanying the Duke and Duchess of Windsor in Port Lligat.

72. Cover of *Time*, December 1936, with the portrait by Man Ray.

73. Gala's feet.

74. *Ampurdán Landscape;* Indian-ink blotches, 27×52 cms.

75. *Hallucinogenous Bullfighter,* in sections one metre square.

76 to 78. Tests, trials, progress... In the centre, Dalí posing in front of the unfinished painting, in a photograph by Meli to which the painter has added a few designs with a biro.

79. The child Dalí, detail of *Hallucinogenous Bullfighter.*

80. *Hallucinogenous Bullfighter,* 1969-1970; oil on canvas, 4×3 metres; The Reynolds Morse Foundation, Cleveland.

81. First section of *Hallucinogenous Bullfighter.*

82. *Gala with Two Lamb Chops Balanced on her Shoulder,* 1933; oil on plywood, 31×39 cms; private collection.

83. *Spectre of Sex-appeal,* 1934; oil on wood, 18×11 cms; Dalí Museum-Theatre, Figueras.

84. The well at Port Lligat.

85. Dalí and Gala in 1933.

86. *Midday,* 1936.

87. *The Three Ages: Old Age, Adolescence, and Childhood,* 1941; oil on canvas, 50×65 cms; The Reynolds Morse Foundation, Cleveland.

88. *Homage to Millet's Angelus,* 1934. The humerus of the figure on the right is the stick which the child uses for his hoop in *Spectre of Sex-appeal* and other works. Pen drawing, 19×12 cms. Previously Cecile Eluard Collection, now Reynolds Morse Foundation, Cleveland.

89. Detail of *The First Days of Spring.*

90. *Dalí as a Child, with his Father,* about 1971; Indian ink; private collection.

91. Detail of *The Hour of the Chapped Face,* 1934.

92. Detail of *Imperial Violets,* 1938.

93. When the notary don Salvador Dalí y Cusí, expelled his son from home and family, the latter decided to cut his hair short and to place a sea-urchin on his head after the manner of the son of William Tell. Incidentally, he also had his photograph taken with a starfish on his chest.

94. *The Shadow of Night Advances,* 1931; oil on canvas, 61×50 cms; The Reynolds Morse Foundation, Cleveland.

95. *Spider of the Afternoon, Hope!;* oil on canvas, 41×51 cms; The Reynolds Morse Foundation, Cleveland.

96. Detail of *The Enigma of Desire,* oil on canvas, 110×150 cms; O Schalag Collection, Zurich.

97. Stone.

98. Detail of *Solar Month,* 1936; 60×46 cms; The Edward James Foundation, Brighton Art Gallery.

99. *Half a Giant Cup Suspended with an Inexplicable Appendage Five Metres Long,* 1932-1935; oil on canvas, 51×31 cms; private collection, Basel.

100. Detail of the hand of a French soldier attacked by flies of Saint Narcissus during the siege of Gerona by troops of Philip the Bold.

101. *Seven Flies and a Model,* 1954; pen drawing, 15.2×22.8 cms; The Reynolds Morse Foundation, Cleveland.

102 to 104. Various flies.

105. Fly of Saint Narcissus.

106. *Miracle of Saint Narcissus.* Gerona Cathedral.

107. Fly from *Hallucinogenous Bullfighter.*

108. *Inaugural Goose-flesh,* 1928; oil on canvas, 75.5×62.5 cms; Ramón Pichot Collection, Barcelona.

109. *Sfumatura,* 1972; paper singed and smoked with candle flame.

110. Second section of *Hallucinogenous Bullfighter.*

111. Plans for Narciso Monturiol's submarine *Ictineo;* Maritime Museum, Barcelona.

112. Multiple imaginary artistic impression of the *Ictineo* in the depths of the sea; Maritime Museum, Barcelona.

113. *Narciso Monturiol* (1819-1845), painted by R Martí Alsina (1826-1894).

114. The engineer Juan de La Cierva y Codorniu (1895-1936), inventor of the autogiro.

115. Autogiro.

116. Drawing on an artist's palette, 1964. 29×25 cms; Fanny and Salvador Riera Collection, Barcelona.

117. Dalí as a child with a dog.

118. *The Night of Death,* 1934; Indian-ink drawing. 98.5×72.1 cms; Museum of Modern Art, New York.

119. *Horse,* 1922; Indian ink, 14.5×21.5 cms; Ramón Estalella Collection, Madrid.

120. *The Dream* (detail), 1937; oil on canvas, 50×77 cms; Edward F W James Collection, Sussex.

121. Detail of the bather in the cove at Perona.

122. *The White Calm,* 1936; oil on wood, 41×33 cms; Edward F W James Collection, Sussex.

123 to 128. Rocks at Cape Creus.

129. *The Fossil Car from Cape Creus,* 1936; oil on canvas, 31×37 cms; Edward F W James Collection, Sussex.

130. In their boat *Gala.*

131. Detail of *The Supper.*

132. Sailing with Gala, about 1958.

133. Beti, about 1912.

134. *The Return of Ulysses,* 1936; Indian ink, 24.8×37.2 cms.

135. *The Angelus,* by Millet; The Louvre, Paris.

136. *Archeological Reminiscence of the Angelus by Millet.* 1933-1935; oil on wood, 31.7×39.3 cms; The Reynolds Morse Foundation, Cleveland.

137. Third section of *Hallucinogenous Bullfighter.*

138. *Chair Constructed from Spoons,* 1970. Preparation for a bronze casting, 120×35 cms; M Berrocal Collection, Verona.

139. Illustration for *50 Magical Secrets.*

140. *The Eight-day Clock,* 1923; charcoal. 31.5×24.5 cms; Ramón Estalella Collection, Madrid.

141. *Still-life on a Chair,* by Juan Gris; Museum of Modern Art, Paris.

142. *All Shapes Derive from the Square,* 1923; ink drawing, 23×21 cms; Jordi Gimferrer Collection, Bañolas (Gerona).

143. *Cubist Self-portrait,* 1926; gouache and collage, 105×70 cms; private collection.

144. *Purist Still-life,* 1924; oil on canvas, 100×100 cms; Dalí Museum-Theatre, Figueras.

145. Detail of *Head of a Woman,* 1927; oil on canvas, 100×100 cms; Dalí Museum-Theatre, Figueras.

146. *Anatomic Study;* charcoal drawing. 32×21.5 cms; Gustau Camps Collection, Barcelona.

147. *Rhinoceros Goose-flesh,* 1956; oil on canvas, 93×60 cms; Bruno Pagliai Collection, Mexico.

148. Detail of *Meditation on the Harp.*

352

149. *Meditation on the Harp*, 1932-1934; oil on canvas, 67×47 cms; The Reynolds Morse Foundation, Cleveland.

150. *Cliffs*, 1926; also called *A Figure on the Rocks*. The landscape is Cape Norfeu, not far from Cadaqués. Oil on panel, 26×40 cms; M Minola de Gallotti Collection, Milan.

151. *Cala Nans Adorned with Cypresses*; oil on canvas, 40×50 cms; Enric Sabater Collection, Palafrugell (Gerona).

152. *Picasso*; charcoal drawing.

153. *Portrait of Picasso*, 1947; oil on canvas, 64×54 cms; private collection.

154 and 155. *Scenes from the Ampurdán*, 1925; oil on cardboard, 22×27 cms; M Abadal y de Fontdeviela de Argemí Collection, Barcelona.

156. *Cala Joncups*; oil on canvas.

157. *Landscape at Port Lligat*, detail of 318.

158. Photograph of the same scene.

159. The painter's boat.

160. *The Christ of Saint John of the Cross* (lower section), 1951; oil on canvas, the complete picture measures 205×216 cms; Museum and Gallery of Art, Glasgow.

161. *The Phantom Wagon*, 1933; oil on wood, 19×24.1 cms; Edward F W James Collection, Sussex.

162. *Geological Justice*, 1936; oil on wood, 11×19 cms; Edward F W James Collection, Sussex.

163. *Rhinoceros Disintegration of Phidias*, 1964; oil on canvas, 99×129 cms; private collection.

164. Rock called Cucurucú in the bay of Cadaqués, which appears in the painting to the left and in many others.

165. Profile of the same in Indian ink.

166. *Atmospheric Skull Sodomizing a Grand Piano*, 1934; oil on canvas, 14×18 cms; The Reynolds Morse Foundation, Cleveland.

167. In Port Lligat, with the fisherman Pere Barret.

168. *View of Port Lligat with Guardian Angels and Fishermen*, 1950; oil on canvas, 61×51 cms; Albert Lasker Collection, New York.

169. Port Lligat from the beach.

170. Detail of *Cannibalism in Autumn*, 1936-1937; oil on canvas, the whole measures 80×80 cms; Edward F W James Collection, Sussex.

171. Fourth section of *Hallucinogenous Bullfighter*.

172. *Andromeda*, 1930; ink drawing, 72.5×54.5 cms.

173. *Meditative Rose*, 1958; oil on canvas, 36×28 cms; Mr and Mrs Arnold Grand Collection, New York.

174. *Bleeding Roses* (detail), 1930; oil on canvas, the whole measures 75×64 cms; J Bounjon Collection, Brussels.

175 and 176. *Rainy Taxi*. A creation that consisted of a taxi inside which it rained constantly. Exhibited in Paris and subsequently twice reconstructed in New York. It is a perfected reminiscence of the fossil car which Dalí sees in some of the rocks at Cape Creus. A new version exists in the Dalí Museum-Theatre, Figueras.

177. *Virgin of Guadalupe*, 1959; oil on canvas, 130×98.5 cms; Alfonso Fierro Collection, Madrid.

178. Detail of *Evocation of Lenin*.

179. *Evocation of Lenin*, 1931; oil on canvas, 114×146 cms; National Museum of Modern Art, Paris.

180. *Slave-market with Invisible Bust of Voltaire*, 1940; oil on canvas, 46×65 cms; The Reynolds Morse Foundation, Cleveland.

181. *Bust of Voltaire Disappearing*, 1941; oil on canvas, 46.3×55.2 cms; The Reynolds Morse Foundation, Cleveland.

182. Voltaire in the version by the sculptor Houdon, which appears in *Hallucinogenous Bullfighter*.

183. Detail of *The Resurrection of the Flesh*, 1940-1945; oil on canvas, 91.5×74 cms; previously in the Bruno Pagliai Collection, Mexico.

184. With the author of the present work in 1952.

185. *Women with Flowers for Heads Finding the Skin of a Grand Piano on the Beach*, 1936; oil on canvas, 54×65 cms; The Reynolds Morse Foundation, Cleveland.

186. Fifth section of *Hallucinogenous Bullfighter*.

187. Matisse's fly.

188. Collar button of the bullfighter's shirt.

189. Matisse with Dalí, Leonidas Massine, Lord Berner, and others.

190. Detail of *Sistine Madonna*, 1958; oil on paper, the whole measures 223×190 cms; Henry J Heinz II Collection, New York.

191. Jewel; gold, rubies and pearls; Owen Cheatham Foundation.

192. Book on the painter Gerard Dou from the Gowans series of art books.

193. Detail of *The White Calm*; see 122.

194. *The Chemist from Figueras who is not Looking for Anything at All*, 1936; oil on wood, 30×56 cms; Edward F W James Collection, Sussex.

195. *The Ants*, 1937; Indian ink on paper, 66×49.5 cms; The Reynolds Morse Foundation, Cleveland.

196. Detail from the diptych *Couple with their Heads Filled with Clouds*. The figure lying down, rather than a little Lenin, is Ramón de la Hermosa, who for Dalí was a paradigm of sloth; Brighton Art Gallery.

197. Detail of *Study for the Outskirts of the Paranoiac-critical City*, 1935; Edward F W James Collection, Sussex.

198 to 200. Colour drawings for a Walt Disney film, *Mystery*, which was never completed.

201. Detail of *Vertigo*, 1930; oil on canvas, 60×50 cms; Carlo Ponti Collection, Rome.

202. Sixth section of *Hallucinogenous Bullfighter*.

203. *Quick Still-life*, 1956; oil on canvas, 125×160 cms; The Reynolds Morse Foundation, Cleveland.

204. Detail of the *Sistine Madonna*, 1958.

205. *Soft Watch at the Moment of its First Explosion*; oil on canvas; private collection.

206. *The Persistence of Memory*, 1931; oil on canvas, 25×36 cms; Museum of Modern Art, New York.

207. *Disintegration of the Persistence of Memory*, 1952-1954. Also called *The Chromosome of a Highly Coloured Fish's Eye, Initiating the Disintegration of the Persistence of Memory*; oil on canvas, 25×33 cms; The Reynolds Morse Foundation, Cleveland.

208. *Cala Nans*, on the reverse of the portrait of José M Torres. Oil on canvas, 39.5×49.4 cms; Museum of Modern Art, Barcelona.

209. *Ecumenical Council*, 1960; 399×297 cms; The Reynolds Morse Foundation, Cleveland.

210. Detail of *Hallucinogenous Bullfighter*, depicting bull composed of rocks with *banderillas* and dagger.

211. *Saint Surrounded by Three Pi-mesons*, 1956; oil on canvas; private collection.

212. Fly on his moustache.

213. *Honey is Sweeter than Blood*, 1927. García Lorca called this painting *The Wood with Objects*, but the original title is a quotation from Lidia Nogués. Previously belonged to Coco Chanel.

214. Detail of *Hallucination of Gala*; oil on canvas.

277. Imaginary portrait of Dalí, by Federico García Lorca (much damaged), 1926.

278. Study for *Weaning from the Food Chair*, 1933; The Reynolds Morse Foundation, Cleveland.

279. *Weaning from the Food Chair*, 1934. The landscape of Port Lligat can be seen inverted. Oil on wood, 18×24 cms; The Reynolds Morse Foundation, Cleveland.

280. *Big Thumb, Putrefied Bird, and Moon*, 1928; oil and collage on wood, 50×61 cms; The Reynolds Morse Foundation, Cleveland.

281. Photograph by Halsman, with moon and Mia Farrow when she was working on *Rosemary's Baby*; Dalí presented her with a capsule containing a lunar meteorite.

282. *Fisherman Soldier*, also called *Bird-fish*, 1928; oil and collage on wood, 61×49 cms; The Reynolds Morse Foundation, Cleveland.

283. *Billy-goat*, 1928; oil on wood, 50.15×60.7 cms; The Reynolds Morse Foundation, Cleveland.

284. Beach at the Llané Petit.

285. *Moonlight on the Llané Petit*, 1931; oil on canvas.

286. *Cottages*, 1923; drawing, 30×23 cms; The Reynolds Morse Foundation, Cleveland.

287. *Portrait of Llúcia*, about 1917; oil on canvas; Montcanut Collection, Figueras.

288. Tenth section of *Hallucinogenous Bullfighter*.

289. Detail of *Hallucinogenous Bullfighter*, Venus de Milo of the bullfighter.

290. Box of 'Venus' pencils where Dalí discovered the bullfighter's face.

291. *Otorhinological Head of Venus*, 1964; plaster, 60 cms high; reconstructed in 1970 for the Boymans-van-Beunningen Museum, Rotterdam.

292. *Venus de Milo of the Drawers*, 1936; 98 cms high; Descharnes Collection, Paris.

293. *Venus and Sailor*, 1926. Homage to Salvat-Papasseit. Oil on canvas, 216×147 cms; Gulf American Gallery Inc., Miami.

294. *Female Nude*, 1926; pencil drawing, 23.35×22.3 cms; The Reynolds Morse Foundation, Cleveland.

295. *Bathers at the Llané*, 1923; oil on cardboard, 72×103 cms; José Encesa Collection, Barcelona.

296. *Birth of a Divinity*, 1960; oil on canvas, 36×26 cms; Mrs Henry J Heinz II Collection, New York.

297. *Venus and Amorini*, 1925 or 1926; oil on canvas, 23×23 cms; previously Mercedes Ros Collection, Barcelona.

298. *Painting*, 1926 (?); Belitz Collection, New York.

299. *Reminiscence of the Venus of Velazquez*, 1972; sanguine; private collection.

300. *Apparition of Venus*, 1970; oil and ink on paper and cardboard, 30×19 cms; private collection, Barcelona.

301. *Matronly Venus*, 1923; drawing, 18×16 cms; private collection.

302. *Bottom*, 1973; Indian ink on paper, 25×25 cms.

303. *Nude*, 1935; charcoal drawing, 17.2×14 cms; James Trall Soby Collection.

304. *Judgment of Paris*, 1950; Indian-ink drawing, 62.2×76.5 cms; Condesa Guerrini Moraldi Collection, New York.

305. *Barcelona Model*, 1927; oil on wood, 198×149 cms; private collection.

306 to 309. Unexpected dedication in a catalogue for the exhibition in Rotterdam; for reasons unknown, the Venus and the signature have gone through onto the adjacent pages, of which the two immediately following are reproduced.

310. *Young Venuses*; engraving. 40×25 cms.

311. *Nude*, 1954; Indian-ink drawing, 35×27 cms; Abelló Museum, Mollet (Barcelona).

312. *Gala Nude from the Back looking in an Invisible Mirror*, 1960; oil on canvas, 42×32 cms; Dalí Museum-Theatre, Figueras.

313. The Venus de Milo formed by a printed text.

314. Eleventh section of *Hallucinogenous Bullfighter*.

315. Photographic composition with Indian-ink additions by Dalí in the lower part.

316. *Angel at Port Lligat*, 1952; Indian-ink drawing.

317. *The Angel of Port Lligat*, 1952; oil on canvas, 58,4×78,3 cms; The Reynolds Morse Foundation, Cleveland.

318. *Landscape at Port Lligat*, 1950; oil on canvas, 58×78 cms; The Reynolds Morse Foundation, Cleveland.

319. *Eucharistic Still-life*, 1952; oil on canvas, 55×87 cms; The Reynolds Morse Foundation, Cleveland.

320 and 321. In the cemetery of Agullana, Dalí lays flowers on the ground where Lidia rests; and he is photographed with the grave-digger beside the gravestone which, for reasons of orthodoxy, has not been set in position. The text is by Eugeni d'Ors, and reads: "Here rests, if the *tramontana* will allow, Lidia Nogués de Costa, sibyl of Cadaqués, dialectical magician, who was and was not Teresa; in her name, the angelic exorcised goats and anarchists.

322. *The Broken Bridge and the Dream*, 1945; oil on canvas, 66×87 cms; The Reynolds Morse Foundation, Cleveland.

323. *Archbishops and Architecture*, 1935-1937; pen drawing, 21.5×28 cms; The Reynolds Morse Foundation, Cleveland.

324. In Port Lligat in 1953, with Eugeni d'Ors, Mercedes Prat de Rodríguez Aguilera, and Luis Romero.

325. Cover of a book by Eugeni d'Ors.

326. Detail from *Outskirts of the Paranoiac-critical City. Evening on the Shore of European History*; representing the *Calle* del Call in Cadaqués.

327. *Port Alguer*, 1925; oil on canvas, 36×38 cms; private collection.

328. The *Calle* del Call today.

329. *Crepuscular Old Man*, 1918-1919; oil on canvas, 50×30 cms; Ramón Pichot Collection, Barcelona.

330. Current photograph of the arches of Port Alguer (Portdogué).

331. *Port Alguer*, 1924; oil on canvas, 100×100 cms; Dalí Museum-Theatre, Figueras.

332. *The Old Man of Portdogué*, 1920. Portrait of Josep Barrera, an adventurous character who lived at that time opposite Pampà Point; Dalí installed his studio in one of the rooms in this house. Watercolour, 11.45×12.7 cms; The Reynolds Morse Foundation, Cleveland.

333. One of the houses of the Pichot family in the Sortell.

334. In front of his house in Port Lligat.

335 to 337. Transformation of the Room of the Caryatids in the Royal Palace, Milan, such that the white ceiling seems to vanish from sight; photograph taken in 1954 during a Dalí exhibition. Hence the central idea for the Museum-Theatre in Figueras.

338. Poster for the Dalí Museum in Beachwood, Cleveland, owned by Mr and Mrs Reynolds Morse.

339. *Saint James the Great*, 1957; oil on canvas, 400×300 cms; Lord Beaverbrook Art Gallery, Fredericton, Canada.

340. Invitation to the opening of the Dalí Museum-Theatre, which took place on 28 September 1974.

341 to 343. The Museum-Theatre in Figueras in its early stages.

344. With the ill-fated architect Emilio Pérez Piñero, contemplating one of the mobiles destined for the Dalí Museum-Theatre.

345. Pérez Piñero's dome on the Museum-Theatre; in the distance the illuminated tower of Santa Maria.

346. Detail in which the bullfighter, who represents Dalí himself, salutes Gala.

347. Twelfth section of *Hallucinogenous Bullfighter*.

348. *Hypercubic Body*, 1954; oil on canvas, 94 × 124 cms; Chester Dale Collection, Metropolitan Museum of Art, New York.

349. *Gala Regarding the Hypercubic Body*, 1954; oil on canvas, 31 × 27 cms; Dalí Museum-Theatre, Figueras.

350. *The Dream of Columbus*, 1958-1959, also called *The Discovery of America by Christopher Columbus*; oil on canvas, 410 × 310 cms; The Reynolds Morse Foundation, Cleveland.

351 and 352. Two details of *Paranoiac-astral Image*, 1934; oil on wood, 16 × 22 cms; Summer Collection, Wadsworth Atheneum, Hartford.

353. Detail of *Macrophotographic Portrait with Appearance of Gala as a Spanish Nun*, 1962; Descharnes Collection, Paris.

354. *Gradiva: Study for The Invisible Man*, 1930; drawing, 35 × 24.7 cms; The Reynolds Morse Foundation, Cleveland.

355. Detail of *Antiprotonic Assumption*, 1956; Bruno Pagliai Collection, Mexico.

356. Detail of *Angelus of Gala*, 1935; Museum of Modern Art, New York.

357. *Nude from behind*, 1945; sanguine, 61 × 46 cms; Mr and Mrs J L Loeb Collection, New York.

358. *Saint Helen in Port Lligat*, 1956. Gala's real name is Elena (Helen), and on the mountain of Sant Pere de Roda, very near Cadaqués, is the Romanesque Hermitage of Saint Helen; the castle which crowns the mountain is called San Salvador. Oil on canvas, 31 × 42 cms; The Reynolds Morse Foundation, Cleveland.

359. Detail of *The Enigma of William Tell*, 1933. According to Dalí, the baby in the nutshell-crib is Gala. Museum of Modern Art, Stockholm.

360. Detail of *Gala and Millet's Angelus Preceding the Imminent Arrival of the Conical Anamorphoses*, 1933; Henry P McIlhenny Collection, Philadelphia.

361. *Galarina*, 1941; pencil, 61 × 49 cms; private collection.

362. Detail of *Galarina*, 1945; oil on canvas, 65 × 50 cms; Dalí Museum-Theatre, Figueras.

363. *Atomic Leda*, 1949; oil on canvas, 60 × 44 cms; Dalí Museum-Theatre, Figueras.

364. *Salvador Dalí in the Act of Painting Gala in the Apotheosis of the Dollar, in which one may also Perceive to the left Marcel Duchamp Disguised as Louis XIV, behind a Curtain in the Style of Vermeer, which is but the Invisible though Monumental Face of the Hermes of Praxiteles*, 1965; oil on canvas, 400 × 498 cms; Peter Moore Collection, Dalí Museum-Theatre, Figueras.

365. *Study for the Madonna of Port Lligat*, 1950; watercolour and ink, 49.3 × 29.5 cms; The Reynolds Morse Foundation, Cleveland.

366. *Three Faces of Gala Appearing among the Rocks*, 1945; oil on canvas, 20.5 × 27.5 cms.

367. *Galla Placidia*, 1952. Galla Placidia is the name of the sister of the emperor Honorius; she married Ataulphus and lived in Barcelona.

368. Detail of *Antiprotonic Assumption*, 1956.

369. Another version of *Galla Placidia*.

370. *First Portrait of Gala*, 1931; oil on cardboard, 14 × 9 cms; Albert Field Collection, New York.

371. Detail of *Battle of Tetuán*.

372. *Battle of Tetuán*, 1962; oil on canvas, 308 × 406 cms; David Nahmad Collection, Milan.

373. *Lapis-lazuli Corpuscular Assumption*, 1952; oil on canvas, 230 × 144 cms; John Theodoracopoulos Collection.

374. Detail of the Castle of Pubol, in the province of Gerona, which he has presented to Gala. Photograph taken before the restoration.

375. Dalí as a child.

376. With his uncle Anselm Domènech, who owned a prestigious Barcelona bookshop, in 1925 before the painting *Harlequin with Bottle of Rum*.

377. *The Face*, 1972; oil on canvas, 58.5 × 44 cms; Dalí Museum-Theatre, Figueras.

378 and 379. In the School of Fine Arts of San Fernando, Madrid, during the year 1921-1922. He was expelled from the school in October, 1926.

380. Visit of King Alfonso XIII to the San Fernando School of Fine Arts; Dalí can be seen in the upper left section.

381. *Cubist Portrait of Alfonso XIII* which appears in *My Secret Life*.

382. Don Juan Núñez Fernández, drawing teacher at the Secondary School and at the Municipal School of Drawing, Figueras. Dalí regards him as his greatest teacher.

383. Dressed as a soldier, he was photographed with García Lorca in 1925.

384. Portrait which he made of Luis Buñuel, reproduced in the *Revista de Occidente* in 1925.

385. In Madrid with García Lorca and Pepín Bello.

386. Allusive drawing by García Lorca, called *Death of Saint Radegunda*, 1929.

387. Drawing by Dalí with probable allusion to Rafael Alberti's book *Sailor on Dry Land*.

388. *Luis Buñuel with a Bullfighter*; drawing, 18.5 × 23 cms; Fanny and Salvador Riera Collection, Barcelona.

389. Early during his stay in North America.

390. Surrealist object.

391. Port Lligat in the first quarter of the century. The cottage which Lidia sold him, nucleus and origin of his present home, is the diminutive construction which occupies the third space on the left.

392. Photograph about 1930.

393. Self-portrait dedicated to Federico García Lorca; pen and Indian ink, 22 × 17; Abelló Museum, Mollet (Barcelona).

394 and 395. Drawings by Ramón Casas of Ramón Pichot (1870-1925) and Eduardo Marquina (1879-1946).

396. The Royal Academy of Fine Arts of San Fernando in the *Calle* de Alcalá in Madrid; the School occupied part of this building.

397. The Students' Residence in Madrid.

398. Old engraving of the *Ampurdanés* soldier and politician Josep Margarit, which is displayed at the entrance to the painter's home.

399. The Dalí Museum-Theatre in Figueras, which presents a new conception in museums in that the building and its contents form a surprising unity. Inaugurated 28 September 1974. The sculpture in the foreground is by Ernst Fuchs.

400. *The First Days of Spring*, 1922 or 1923; Indian ink and watercolour on paper, 21.5 × 14.5 cms; Ramón Estalella Collection, Madrid.

401. *Drunk*, 1922; Indian ink on paper, 21.5 × 14.5 cms; Ramón Estalella Collection, Madrid.

402. *Poor Musicians*, 1922; Indian ink on paper, 21.5 × 14.5 cms; Ramón Estalella Collection, Madrid.

403 and 404. *Whorehouses* and *Civil Servant* respectively; Indian ink on paper, 21.5 × 14.5 cms; Ramón Estalella Collection, Madrid.

405. *His First Christmas Nougat*, 1922; Indian ink on paper, 14.5 × 21.5 cms; Ramón Estalella Collection. Madrid.

406 and 407. *The Poor Lovers* and *Madrid Slum*, respectively, 1922; Indian ink on paper, 21.5 × 14.5 cms; Ramón Estalella Collection, Madrid.

408. *Self-portrait*, 1923 (?); Indian-ink drawing, 31.5 × 23.5 cms; Ramón Estalella Collection, Madrid.

409. Publishers and contributors to *L'Amic de les Arts* of Sitges, in 1927: Font, the poet J V Foix, Sebastià Gasch, Lluis Montanyà, J Carbonell with a child, García Lorca, Dalí, and Cassanyes. Gasch and Montanyà wrote and published the *Yellow Manifesto* with Dalí.

410. In Figueras on 12 October 1901 a child was born called Salvador Dalí Domènech; he died on 1 August 1903 and is frequently referred to by the very much alive Salvador Dalí Domènech, the famous painter.

411. *Portrait of my Dead Brother*, 1963; oil on canvas, 175 × 175 cms; private collection.

412. Facsimile of the *Yellow Manifesto*, 1928.

413. *The Cross of the Irises*; oil on canvas.

414. Stereoscopic glasses.

415. *The Face of War*, 1940; oil on canvas, 64 × 79 cms; André Cauvin Collection, Brussels.

416. Set for the ballet *Mad Tristan*, a surrealist transformation on a work by the eighteenth-century English painter Herring. Previously Marqués de Cuevas Collection.

417. *Study*, 1925; charcoal, 98.53 × 68.58 cms; The Reynolds Morse Foundation, Cleveland.

418. *The Painter's Father at the Llané*; oil on canvas; Montserrat Dalí de Bas Collection. Barcelona.

419. *Young Jesus*, 1957; gouache.

420. *Saint Salvador and Antoni Gaudí disputing the Crown of the Virgin*, 1960; gouache, 19 × 25 cms.

421. *Corpuscular Madonna*; oil on canvas.

422. *Gala contemplating Dalí in a State of Weightlessness over his Work of Art "pop, op, yes-yes, pompier" in which we can see the Two Distressing Figures from Millet's Angelus in an Atavistic State of Hibernation before a Sky which might suddenly turn into a Gigantic Maltese Cross in the very Centre of the Station at Perpignan, towards which the Whole World converges*, 1965; oil on canvas, 295 × 406 cms; private collection.

423. *Venus with Memories of Avignon*; 20.5 × 14 cms; Fanny and Salvador Riera Collection, Barcelona.

424. Protest patronized by Dalí when *La Gioconda* was on show in the Metropolitan Museum, New York. The police car is arriving to arrest the not very numerous demonstrators.

425. Envelope with a butterfly wing attached.

426. Design for the film *Spellbound*, starring Ingrid Bergman and directed by Alfred Hitchcock, 1945.

427. Watercolour for the cover of the magazine *Empordà Federal* of Figueras; 1922 (?); Gustau Camps Collection, Barcelona.

428. *Pep Ventura*, famous nineteenth-century composer of *sardanas*, who lived in Figueras. Drawing; Mataró Museum (Barcelona).

429 to 432. Illustrations for a book by the *Ampurdanés* writer J Puig Pujades; the first book illustrated by Dalí. 1926.

433. In the Saint Regis Hotel, New York; A Reynolds Morse, Dalí, and the astronauts Alan B Shepherd and Edgar D Mitchell.

434. Drawing, 1924 (?); 24 × 19 cms; Jordi Gimferrer Collection, Bañolas (Gerona).

435. Interior terrace at Port Lligat.

436. Rock of Culleró at Cape Creus, photographed by Reynolds Morse.

437. *Don Quixote*, 1935; Indian-ink drawing, 40 × 50 cms; Prince J L de Faucigny Lucigne, Paris.

438. High school student in Figueras, about 1920.

439. *Hour of the Monarchy*, 1969; ceiling in the Palacete Albéniz on Montjuich, owned by the City of Barcelona; oil, 3 metres in diameter.

In addition, various drawings and calligraphic notes produced by Dalí expressly for this book.

PHOTOGRAPHS AND REPRODUCTIONS:

Francisco Català-Roca: 12, 17, 42, 54, 67, 184. Reproductions: 2, 35, 323, 239, 300.

Enric Sabater: 4, 5, 10, 11, 27, 29, 40, 43, 63, 64, 84, 97, 123, 124, 125, 126, 127, 128, 130, 158, 164, 169, 188, 212, 263, 270, 284, 320, 321, 328, 330, 333, 334, 335, 336, 341, 342, 343, 344, 346, 414, 435. Reproductions: 3, 6, 47, 72, 76, 77 (from a photograph by Meli modified by Dalí), 78, 102, 103, 104, 107, 109, 144, 151, 182, 188, 215, 265, 266, 271, 272, 273, 275, 290, 299, 301, 313, 315 (from a photograph by Halsman modified by Dalí), 331, 337 (modified by Dalí), 377, 398, 420. Reproductions of other photographs whose rights are reserved: 13, 14, 15, 39, 48, 55, 56, 57, 58, 61, 70, 71, 73, 85 and the endpapers.

Marc Lacroix: 16, 106.

A. Más: Reproductions: 23, 24, 32, 33, 44, 45, 108, 116, 142, 146, 221, 276, 295, 311, 329, 387, 388, 393, 396, 397, 423, 427, 428, 429, 430, 431, 432, 434, 439.

Toni Vidal: 55.

R. Descharnes: 96, 98, 99, 118, 120, 122, 134, 147, 160, 161, 162, 168, 170, 172, 174, 178, 183, 190, 191, 193, 194, 196, 197, 201, 204, 230, 236, 246, 252, 259, 264, 274, 277, 287, 291, 292, 304, 326, 351, 352, 353, 355, 356, 359, 360, 367, 368, all of these being reproductions of works.

Halsman: 281, 315 (modified by Dalí).

Meli: 399.

The photograph of Hallucinogenous Bullfighter and the various sections distributed throughout the book are by Learner of New York.

The remainder of the illustrations derive from various archives, collections, galleries, etc., or have been provided by the painter and others.

The photographic reproductions have been selected
and mounted under the direction of the author.

Printed and bound in Spain by
La Polígrafa, S.A. - Balmes, 54 - Barcelona-7 - Spain

Dep. Leg. B. 7972 - 1979

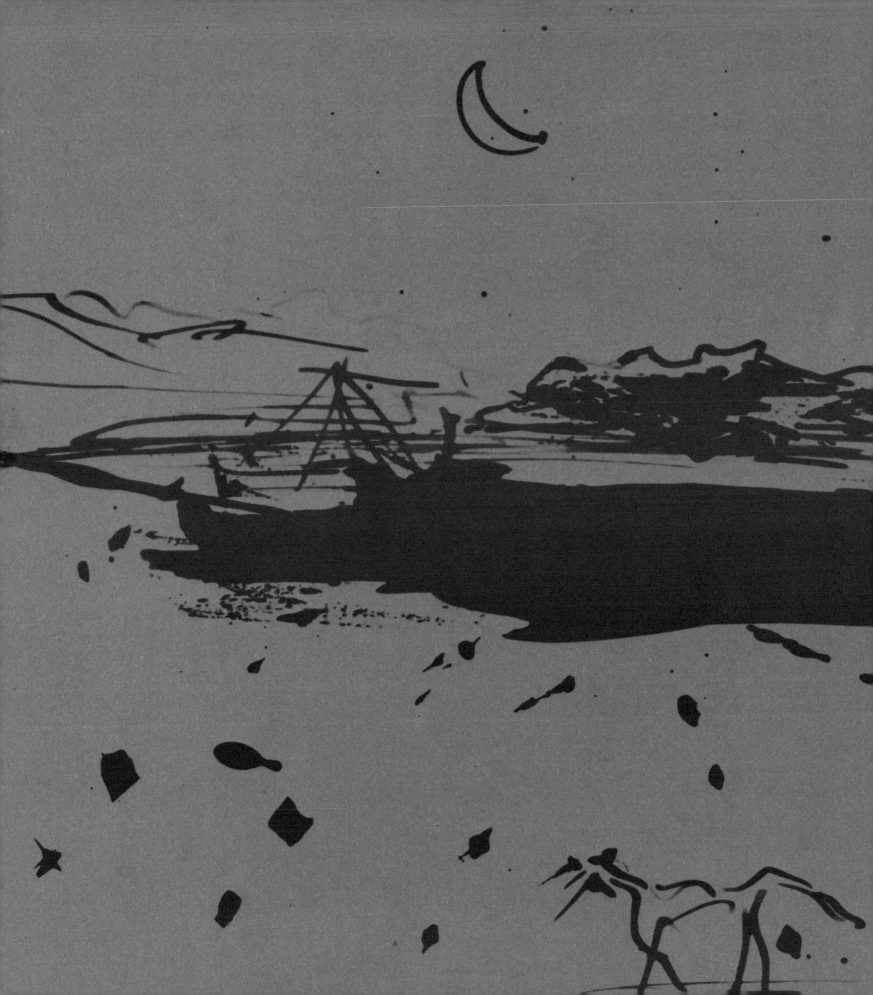